Nick Danziger

Born in 1958 of an American father and an English mother, Nick Danziger went to school in Switzerland, then to Chelsea Art School, later becoming a visiting lecturer at art schools and universities and holding one-man exhibitions of his work in London and New York. In 1982 he was awarded a Winston Churchill Memorial Trust Fellowship to follow ancient trade-routes in Iran, Afghanistan, Pakistan and China. Out of the experience came his first book, *Danziger's Travels*, which became an immediate bestseller.

Nick Danziger's documentary video film *War, Lives and Video-tape* (based on the children abandoned in Marastoon mental asylum in Kabul), shown as part of the BBC's 'Video Diaries' series in 1991, won the Prix Italia for best television documentary, against competition from 32 countries.

In 1992 he published his second book, *Danziger's Adventures: From Miami to Kabul*, 'an astonishing record of a man who is rarely at rest . . . Danziger seeks out death and danger the way other young men seek out sex' (Frank McLynn, *Spectator*). He was the 1994–95 Fellow in Photography at the National Museum of Photography, Film and Television in Bradford and the Bradford and Ilkley Community College. His photographs have appeared in many newspapers and magazines worldwide, and formed the basis of the recent Channel 4 series 'Postcards from the Edge', praised by Lynne Truss in *The Times* as 'quite superb' and by the *Independent* as 'remarkable' and 'outstanding'. Danziger's second series for Channel 4, 'The Fight for Hearts and Minds', has been nominated for the Grierson Award, and in 1996 he was also nominated for Journalist of the Year by the Royal Television Society.

Further reviews for *Danziger's Britain*

'This book is so important that every one of us should read it and weep . . . this is a chilling indictment of what we've let happen in the past two decades . . . At every turn you feel the stress, the rage, the pain and the despair. Through these bitter scenes, Danziger's writing remains fluent, lucid and humane . . . this is prose without presumption or judgement, gathering the stories of the abandoned with a clear-eyed sadness . . . We forget all the people sacrificed on Mammon's altar these past harsh years, because it is easier that way. For providing us with this most potent reminder, Danziger deserves all praise, and the widest possible readership.'

PETE DAVIES, *Independent*

'It was clever and brave of Mr Danziger to plan a journey through the British underclass – or "to the Edge" as he more delicately puts it . . . His excellent photographs provide evidence for anybody who is unconvinced of the sheer bleakness and ugliness of existence in so much of Britain . . . If it is true, as Orwell remarked, that the first duty of the intellectual in our times is to state the obvious, then in chronicling the horrors of modern Britain Mr Danziger has certainly fulfilled his duty.'

ANTHONY DANIELS, *Sunday Telegraph*

'Simultaneously funny, mournful, vivid . . . The book's main strength is its record of individual lives . . . Above all, the journey made him furious: angry at the conditions in which people were forced to live, bitter at the way in which generations had been discarded, and enraged by the wastage of talents and the exploitation of weakness.'　　　BELLA BATHURST, *Scotsman*

'. . . a horrendously bleak, end-of-the-century picture of Britain teetering on the edge in the legacy of the Thatcher years . . . *Danziger's Britain*, written with a sensitivity gained from the close relationships he built up with his subjects, draws out the enormous courage and heroism of those struggling to exist after being abandoned by society.' *The Big Issue*

'Gritty, grainy, powerful images that sketch out the lives of an underclass.' *Evening Standard*

'An odyssey through other people's stories, a photographic and literary testimony to an innocence of ambition that survives no matter what necessity forces people to do . . . Danziger embroils himself to win their confidence, preserving their stories rather than pillaging them. To say he's a good listener is an understatement – he can coax a life-story out of someone waiting for a bus . . . Entering these communities, Danziger is the antithesis of a patronising social worker; he doesn't prescribe or preach, he just listens to people's hard-learned explanations.' RA PAGE, *Tribune*

NICK DANZIGER

Danziger's Britain

A JOURNEY TO THE EDGE

Flamingo
An Imprint of HarperCollinsPublishers

TO MY MUM

Flamingo
An Imprint of HarperCollins*Publishers*
77–85 Fulham Palace Road,
Hammersmith, London W6 8JB

Published by Flamingo 1997
9 8 7 6 5 4 3 2 1

First published in Great Britain by
HarperCollins*Publishers* 1996

Cover photographs by Nick Danziger/Contact Press Images/Colorific!

ISBN 0 00 638249 5

Set in Minion

Printed and bound in Great Britain by
Caledonian International Book Manufacturing Ltd, Glasgow

CONTENTS

ACKNOWLEDGEMENTS

This book is dedicated to all the people who allowed me into their lives during my journey. They inspired me to put into words and pictures their life stories, which tell of resilience and courage in the face of adversity. For obvious reasons, most names and locations have been altered out of respect for their privacy.

It is a rare thing to be commissioned to write a travel book set in the United Kingdom, so I would like to thank my editor Richard Johnson for keeping faith in me; my agent Mark Lucas for arranging the commission; and the National Museum of Photography, Film and Television in conjunction with the Bradford and Ilkley Community College for their assistance. I would also like to thank my mother and Terry for providing a peaceful environment in which to write; Charles Gore for his help in editing and preparing the manuscript; Robin Hinton for keeping my cameras in working order; Barry Taylor and Ian Dickens at Olympus Cameras for their all-round support and Rob Dawson-Moore for the photographic prints. I would also like to acknowledge the help of Lynn Keane, Barry, Theresa, Jenny and Joe Dawson, Rose Ann Coutts, Derek, Barbara, Garry and Peter Kirby, Tom Broadbent, Shona, Claire Armstrong, Jo Armitage, Marian Reid, Paul Morgan, Claire and Mark Woodbine, Brendan Bradley, Murat Ozkasim, Brian and Irene and Dave, Rachel Quick, Armele Tardiveau, Colin Morley, Phil Foster, Willie Murray, Philip Lewis, Geraldine McCaskill and Billingham & Co. And especially the continuing support of Robert Pledge and Dominique Deschavanne at Contact Press Images Paris and Graham Cross at Colorific. I apologize for inevitable errors of omission. 'The Cure at Troy' by Seamus Heaney is reproduced by permission of Faber & Faber Ltd, and the lines from 'On the Dismantling of Millom Ironworks' by Norman Nicholson (from *Collected Poems*, Faber & Faber) by permission of David Higham Associates Ltd.

Finally, I would like to thank my family and friends for all their encouragement.

'A lot of fellows nowadays have a B.A., M.A., or Ph.D. Unfortunately they don't have a J.O.B.'

'Fats' Domino

INTRODUCTION

IT WAS INEVITABLE after such a long absence: the scattered papers across the floor of my room suggested an uninvited stranger had paid a visit. I saw them as soon as I entered the still darkened house to which I was returning for the first time in five months.

That moment marked the end of one journey and the beginning of another. It would not take me back to a remote and distant part of the developing world, but instead through Britain. People say travel broadens the mind, but if you never leave town you would be surprised what you can find. I had already spent four weeks living as a down-and-out in Paris and London, broadly following in George Orwell's footsteps, but now I would embark on a much lengthier series of local journeys. I wanted to get out of the capital because Central London is untypical in many ways – too often the focus of attention as well as a magnet for people who gravitate there because it promises a cosmopolitan life with all its advantages and disadvantages.

Identities are forged out of crisis and that moment of crisis seemed to have arrived on my own doorstep. We are at the end of a century in which England lost the empire it called British. Britain seems to be at a crossroads, caught between its magnificent past and its uncertain present, between beauty and decay. Cities of palaces have for many become prisons. I wanted to travel through a country suspended between its colonial past and an uncertain future, and visit areas of Britain on which the foundations of its empire were based and others which had never figured so prominently. Above all the journey would focus on people, especially young people, to hear their own stories and the accounts of their communities and how their lives have been affected at an intimate, personal level by the legacy of Thatcherism

1

and the changing cultural, deindustrialized landscape with its new unasked-for leisure.

I would travel to Grimsby, which was once the largest fishing port in Europe with 73 deep sea trawlers. Now there are three. Britain no longer rules the seas. She hardly sails upon them. In the mid–1950s, 50,000 Clydesiders were building half the merchant ships in the world; today there is one merchant yard left on the river. British yards accounted for just 1.9 per cent of the world order book for ships of more than 100 gross tonnage in 1993. I would travel to some of the hundreds of communities that once found their living in the shipyards, in the coal mines and in manufacturing. I wanted to lift the stone, as it were, to find out what is going on underneath the surface in our urban and rural areas – places that only their own residents, the postman and the occasional travelling salesman are likely to visit, and where despair has become an institutionalized emotion.

More often than not the journey took me to neighbourhoods where I needed the equivalent of a visa, the consuls being aid workers or friends who had access to them. Sometimes, as in Newcastle, no one had access to the street children. I simply walked into their territory, often carrying my cameras and notebook, until I found someone willing to talk. I didn't set out with a shopping list of people I hoped to talk to, rather I was led by fortuitous, often haphazard encounters. I always explained that what they had to say might be used for a book. People were often suspicious, rarely rude. They despised journalists, most of all local and tabloid journalists, even though they often read such papers themselves. In the so-called 'no-go' areas I sometimes felt intimidated and frightened by taunts from gangs of teenagers, but I was never attacked or threatened although there were occasions, as in Glasgow's East End, where I was chaperoned. When people missed appointments it wasn't because they didn't want to talk, but rather because time had no relevance in their lives. On several occasions when I failed to hook up with people at the prearranged time, I found they had been arrested for some offence or other.

Unlike my journey to retrace Orwell's London, I didn't live on the streets and I only spent one night in a DSS-funded hostel as I crossed Britain. Instead I worked in a similar vein to Jack London in *The People of the Abyss*, spending my days and nights in the neighbour-

hoods, rather than taking photographs from the outside with a long lens, seeing while being unnoticed. I tried to share people's lives and was often their guest when I stopped for nights in their homes.

Most of the stories among the former working-class communities told of great resilience against all the odds. I say the former working-class because, on an estate in South Wales (modelled on a Tuscan village) where 93 per cent of the population were unemployed, a young man referred to himself as a member of the underclass: 'We no longer work, so I suppose I'm no longer a member of the working class.' There were others, like a group I met in a pub in Lowestoft in Suffolk, who told me they were not jobless: 'We have jobs, it's just that we don't earn money doing them.' And a couple in the same pub talked about love on the dole, getting married and having to borrow the wedding dress, a tie and shoes from family and friends and buying a suit from the charity shop. In Ipswich I found a community-based recycling plant with nineteen employees, none of whom received a salary. All but one worked a minimum of $37\frac{1}{2}$ hours a week with only their dole money to support themselves; the nineteenth, the manager, had recently joined a government scheme under which he received £10 in addition to his £32.10 benefits.

When it came to writing up their stories I had to change locations and names so as not to compromise those working outside the law, such as drug dealers, petty criminals and arsonists, but also to protect minors. The same would be true of certain neighbourhoods so as not to stigmatize them any further. Most people were defensive of their neighbourhoods in the same way that I am defensive of Brixton, which the general public associates only with street riots, in reality a rarity. In one case a city's institutionalized racism was so marked that changing the ghetto's name wouldn't conceal the sectarian nature of the city's current history. Most of this city's long-established Somali community came as seafarers, and although most have moved to other parts of Britain their families have continued to disembark here as refugees from a murderous civil war. They are resented because they compete for the same jobs that, in fact, are disappearing under the relentless economic pressures of local and world markets.

As my journey progressed I was constantly filled with doubt. What right had I, an outsider, to pry into lives which were so very different

from my own, whose futures offered as little hope as mine offered possibilities? I was bred, if not born, abroad. I grew up with tastes, desires and ambitions unlimited by nationality, race or language. I have no real roots or loyalty to a particular locality. However, in visiting the British interior as an outsider I was also in search of my own Englishness. The journey would have much in common with my previous ones; it would be an adventure, a time of encounter and discovery.

Northern Ireland and the Catholic community of West and North Belfast were particularly revelatory. Here were communities, as distinct from a community – because despite a newly declared ceasefire they continue to live in pockets in a city where the sectarian map looked like Bosnia's – that had been held together by the spirit of everyday people born of a common culture and identity that could only be preserved by the glue of their heritage of struggle in language, music and traditions, but with the uneasy ceasefire this sense of belonging had begun to break up as drugs and drug dealers and criminals moved in. The paramilitaries on both sides were fighting a new war to control or suppress narcotics and criminal behaviour, policing their neighbourhoods by meting out summary beatings with baseball bats and breeze blocks.

Some readers may find these lives depressing. Christine, the woman I was to stay with in Glasgow, would agree: 'That's our lives, seven days a week, 365 days a year', but she is a hero, scaling mountains to help members of her own community against the ravages of drugs and alcohol, the chemical and liquid coshes that anaesthetize reality. Christine is one of the many people I met who has survived the beatings of a violent husband and continual abuse by her drug-crazed son; in a moment of utter despair she nearly snuffed the life out of her son with a pillow, as he lay on her bed comatose from a concoction of Temazepam and smack. Having fought to set up shelters and community groups, Christine now works every day until midnight to help street women and has been accepted on a part-time drugs and alcohol studies course which she hopes will give her even greater scope to help others.

And there is always hope – just. It's called the human spirit and in the most trying of circumstances it radiates through people, like Jessie, who has lost three of her four children to overdoses and is struggling

to help the last one, out of his head on methadone. There are others, like the young boy in Leicester and the young woman in Cornwall, who thought the best future would be in death and have since tried to commit suicide. Or stunning Nish, whom I met in Brighouse. She had run away from an arranged marriage and an overbearing husband. He and his father had hired a man called the Bounty Hunter to track her down, the father-in-law having threatened to pour petrol over her and set her alight when he brings her back. Nish continues to live her life on the run with her baby son.

I wanted to get to places which were as far off the mental radar screen as Bamako or Ouagadogou. I began by hitching and using local transport, but was eventually forced to borrow a car, because there was often only a once-weekly bus service – nine o'clock on Wednesday mornings in rural Suffolk – or, when I stayed in the Scottish Highlands, my only way in or out of the village would have been the six times a week mail car, providing there was room, and even then it would have only left me with forty-five minutes to do some shopping in the nearest town if I had wanted a lift back to the village.

In my rare spells in Britain during the past few years, I had noticed that the British are in flux, perhaps more than any other nation. They are trying to make sense of their identity. This awareness had come from discussions with friends and day trips which gave me snapshots of many aspects of life that remain quintessentially British. Usually the purpose of these visits was to give a lecture or hold studio workshops with art students. Eventually I found funding for the journey across Britain when I was given the Fellowship in Photography from the National Museum of Photography, Film and Television in conjunction with the Bradford and Ilkley Community College. Part of the fellowship consisted of teaching photography students. When I was growing up in the 1960s and 1970s, life was a breeze compared to now. I was encouraged to develop individuality and experiment in art school, life itself was open-ended. The dream was still there, the no-matter-what-you-can-make-it feeling. Today the students were neither inspired nor motivated; their attitude was no-matter-what-I'm-probably-not-going-to-make-it. Their values as well as society's had changed. Students no longer seek personal fulfilment, but look for financial security. Their institutions have become profit-motivated

learning factories inhabited by educational consumers rather than students. Success is gauged by income or purchasing power. You are what you earn.

What hadn't changed was the mix of accents which makes an egalitarian society all but impossible. Speech in Britain remains as much an emblem of social caste as when George Bernard Shaw wrote, 'It is impossible for an Englishman to open his mouth without making some other Englishman despise him.' My mid-Atlantic drawl was mistaken for American, and that opened doors to me that might otherwise have remained closed. As an outsider I was told dark secrets of everyday lives. It was like driving a cab after midnight: the anonymity offered to the passenger was the match that ignited a moral grease-fire.

I found that in the north of England and in Wales, Scotland and Northern Ireland, Londoners were disliked and mistrusted in equal proportions. As a rabid nationalism has grown in other parts of the world, I noticed in Britain regional differences were growing more acute. One Geordie spoke of the similarities between the north-east of England and the Basque country. 'We're closer to Scandinavia than London,' said another. Neither was speaking in terms of geography. Like many nations I have visited, Britain is a nation torn between allegiance and rebelliousness. Unlike anywhere else in the world, few British people I met knew what, if anything, they liked about themselves and their nation. The English, in particular, are quick to be self-deprecating and disparaging, because many of them think there is a lot wrong with the country. Of course there is, but there is still much that is right and that rarely gets mentioned.

In the Midlands and North of Great Britain, I found myself witnessing a destruction of the industrial and social fabric not experienced since the great crisis of the 1930s. Britain today might not be the class-ridden society it was then, but it is the working classes who still bear the brunt of unemployment. Among the young people I met class is rarely an issue and no longer is anyone prepared to accept their place as it had once been; the poverty of their aspirations, to use Aneurin Bevan's phrase, has been replaced by a wealth of expectations that are rarely attainable. However, there are still enormous obstacles to social mobility, from education and mindset to life in areas that are geographically isolated. There is a growing gulf between wealth

and poverty, both of which tend to be passed on to the next generation. Two classes are being created: the educated and the uneducated. So much still depends on where you are born and on your upbringing that the die has often been cast before you emerge from the womb. Privileged backgrounds still dominate the City, insurance, the law, industry and politics.

Over the past decade walls have crumbled and curtains parted across the world at a remarkable rate. However, between my local council estate and the private housing 200 yards away there is an invisible Berlin Wall separating the haves from the have-nots. The differences are in access to good education, accommodation, food, employment and technological change which is now the engine of economic development – in poor countries as well as rich. If the advances of science enhance the lives of the wealthy and make them more stimulating, but fail to meet the needs of the poor, won't technology help widen the gap between the haves and the have-nots? I wish I could feel more optimistic.

In some parts of the developing world there is a feeling that it is patronizing for Britons to offer them aid when they are not addressing social problems at home. A friend of mine from Turkey, who had been in London ten years before, remarked, 'You can see there's been a big change, you can see the poverty. The middle class is melting down. I don't know what it is. Some countries say it's because they don't have oil, but you can't say that, you've got oil.' In response to the changing world order, a village in Pakistan had recently sent care packages to a village in the north-east of England, Oxfam was considering an aid programme to combat poverty in Britain, and the European Union has started distributing free meat to the poor in rural and inner-city areas.

Few of the youngsters and grown-ups I met on my travels had the security shell of success: they moved about restlessly, living a life of uncertainty. They were at the gates to the arena, looking at the river of gold that never arrives. Society was becoming more dissolute and mean-spirited. Everyone believes in something, whether spiritual or secular. Music and drugs are the new church of Teen: they guarantee a new communion and community that can be heard in my estate's thumping hip-hop, its pulsating rhythms, and the amphetamines coursing through the veins. These are their hymns and their incense.

As I embarked on my journey I would often lose the thread of the search to find an identity for contemporary Britain, for each day on my travels I heard or witnessed some craziness. On the eve of my departure one of the local postmen was mugged close to Brixton town centre. Four youths jumped out of an orange BMW, they stole the rings off his fingers and two bundles of mail. Three hours later the orange BMW was still cruising the streets and its occupants attacked again.

Days before I left, many around me were worried about their futures. The postman was worried that impending privatization of the Post Office would put him out of work. The Dutch want to tender for sorting British mail and believe they can deliver a service in the same time or quicker. The employment office is thinking of making large redundancies among the clerical staff and sending the work by modem to the Philippines, where the cost of typists will be a fraction of current British labour costs.

I began my journey at the beginning of June 1994, as the salutes were being fired in Normandy to commemorate the D-Day landings fifty years before. In the newspapers I read about the Allied war aims, set out in the Atlantic Charter, of establishing 'a peace which will afford to all nations the means of dwelling in safety within their own boundaries, and which will afford assurance that all men in all lands may live out their lives in freedom from fear and want.'

While the British economy has grown since the end of the Second World War and continues to do so, it hasn't rooted out poverty or reduced its prevalence. Some of the poor live in the heartlands of our cities – the poor and the dispossessed that Jack London wrote about are still there. I soon found my way to the land of Charles Dickens where ten- and twelve-year-olds were forced to work or steal in order to eat. In the heart of Europe we have shanty towns of the mind. The ghettos in our cities seem to be accepted as a by-product of our age. However, I was to discover there are many types of poverty, and one startling difference: as the British government rolls back the safety nets for the poor, the excluded and marginalized people of British cities are in many ways less able to deal with relationships and circumstances than the shanty town dwellers in Third World countries. In Britain today I found a world of increased polarization where both ends of the spectrum of material wealth lead to spiritual deprivation.

BRIXTON

One Step Ahead of the Game

EMERGING INTO THE dazzling sunshine outside Brixton tube station, I had been greeted by the sweet smell of perfumed incense and the throb of Jungle from Red Records. Like prizefighters in different corners, a homeless person sold *The Big Issue*, an acolyte of Louis Farrakhan in a neat grey suit and bow tie hawked *The Final Call*, a Bible-basher's loudspeaker crackled as he drew breath for his sermon, allowing the cries of a cigarette lighter vendor, 'Four for a pound!', to flutter over the uproar of cars and buses that forced us all to breathe in their exhaust fumes. On the kerb next to the pedestrian crossing a middle-aged man teetered on his feet, took a swig from his can of Tennent's lager and scoffed at the commuters hurrying along into the bowels of the Underground. I bought a newspaper from Meles, a refugee from Eritrea, who speaks five languages. Across from the illuminated clock-face of Lambeth Town Hall's neo-baroque tower four homeboys sat perched on the back of a bench. In the distance a police siren wailed. The sounds of the big city. The clock struck 8.45.

It took me ten minutes to walk up the hill. On the way I bumped into Stink as she emerged from Raleigh Gardens (said to be the spot where Sir Walter Raleigh stopped on the River Effra as he sailed into the heart of London). A decade before I had taught Stink at art school. We agreed to meet at the Cafe on the Hill for lunch.

Around the corner from where I live, in the row of shops beneath the hotchpotch of red-brick buildings, I passed Bill's sub-post office. You can set your watch by Bill's opening times. A queue had formed and were waiting patiently for the clock to strike nine. The line extended past the adjoining three shops: the newsagents, the closed off-licence and the convenience store. Continuing up the hill, just beyond the launderette I stopped to say hello to Marie who was removing the padlocks from

the chemist's steel shutters. On the shop door there was a small poster demanding the international banning of landmines.

Marie stopped trying to turn the sticking lock to tell me matter-of-factly that her daughter's boyfriend had been murdered on Friday evening. The story came pouring out.

'The upstairs neighbour came down to complain about the noise. George asked him to calm down, not to shout. The neighbour continued shouting. George was only wearing his shorts and he didn't want to be seen not standing up to his neighbour. He didn't want to lose face, so he went to put his sneakers on to go outside to continue the argument. My daughter told George to drop it. He wouldn't. Before he got to the door of the flat the neighbour attacked him. She thought George was being punched. She couldn't see George because the neighbour's back was blocking her view of him. Then George draped his arm over the neighbour's back, he was clinging to the neighbour, then she saw George's face, she thinks he was asking her to help him. The next moment he was sliding to the ground. She saw him clutching his side. She ran to him and moved his hands away from his stomach – his guts spilled out. He had been stabbed seven times. She had to climb over his body to get out of the flat to call the ambulance. He died forty minutes later on arrival at the hospital. The police said there was nothing that could have been done to save him, not only were his guts everywhere, but he had a punctured lung and had already lost too much blood. I'm just glad that my granddaughter Cherie didn't see it. She was staying over with a friend, I told Tammy I don't like her staying out, but for once I was glad she disobeyed me. They're staying with me for the time being.'

'Are you all right?' I asked, not knowing what to say.

'I hope Olive will get here soon so I can . . .' the words were drowned by the shutters' rattle.

At the stylist's on the corner of my street Paul was having his flat-top trimmed. He brings his own clippers, afraid of nicks from a blade that isn't his.

Halfway up my street, Jim the postman shouted from the other side of the road, 'Welcome back! Where you been?'

'Mauritania. Come for a coffee when you've finished your round.'

* * *

Apart from the papers spread like confetti on the Baluch carpet, every-
thing seemed to be in its place; the television set on the kitchen bar
table, my answering machine, my books in piles, because there are no
shelves, and next to them a chair which was used as a stand for the
radio. I opened the blinds and the splendour of the crisp spring
morning illuminated the stale air of the room that served as bed-
room, living-room and office. The other window with its metal bars to
keep out intruders showed no signs of forced entry. In fact there
was no sign of a forced entry, no chink in the window or door locks'
armour. It was only after a second search that I discovered a foot-
print next to the kitchen counter crammed with empty jars and bottles
that needed recycling. I looked up between the two kitchen lights
to discover that the skylight had been removed and not properly
replaced. I felt sick.

That evening Steve, my former flatmate's ex-husband, who lives in
the same road, asked me if I had had my computer stolen. That was
when I realized that my laptop, which had been hidden in a corner
of my room five months before, had been removed. Steve, having been
offered it in the early hours of the morning, had suspected that I was
the only person in the immediate vicinity who owned one.

Until now the adjoining council estate had been an unexplored
place – a shabby, twenty-four-hours-a-day nightworld located less than
three miles from central London. Apart from Steve, his ex-wife and
Paul I didn't know anyone who lived there. The only thing I share
with the estate is a piece of graffiti on one of my windows and scrawled
randomly on many walls and windows in the neighbourhood:
ASSASSIN. The houses are laid out in constellations of terraces in a
maze of pedestrian-only streets. They are corralled on one side by
bungalows that look like mobile homes mounted on brick plinths.
Each one has a balcony with a view of the parking lot below and the
charred remains of a vehicle set ablaze by joyriders. The three other
sides of the estate are a broken horseshoe of multi-storey, wholemeal-
coloured bare brick units more reminiscent of a prison camp than
residential flats. All the houses and bungalows are identical in design,
if not in size, to Steve's house; their walls are clad in roof slates, they
are weatherbeaten, some look like a ship's hull in dry dock with moss
creeping up the sides of the walls.

As Steve guides me through the estate in search of my burglar, I am aware that I see everything and nothing. From the walkways mined with dog excrement I look up into a window. Most interiors are invisible behind net curtains, in others I see bleak rooms with rarely a wardrobe or chest of drawers to break up the regular lines of the matchbox-like spaces; I see a bare light bulb hanging from a ceiling; I see walls distempered to a flaking brown, patched with damp.

Every front door remains firmly bolted. Several have large stickers featuring the face of a hungry rottweiler foaming at the mouth with the caption: BREAK IN! MAKE HIS DAY.

We pass one of the local pubs where an alsatian and a dobermann stand guard on the terrace. They bark ferociously at anyone who shows them so much as a sideways glance or dares loiter for more than a second. It is here that some of the residents get their hangovers installed and serviced. Steve tells me it often stays open all night, 'so the drunks don't get lost on their way home until they sober up.' We pass a traditional windmill which for a moment transports me into another world. To one side there is a sandpit where children play happily; on the other side, leaning against the bushes, there are two men with large plastic bottles of cider who have been indefinitely barred from the pub. At a distance it is difficult to tell who's propping up what or what's propping up who. We pass a friend of Steve's mum: 'It used to be such a nice neighbourhood, we didn't have any of this, there was never any trouble and there was always something to do and somewhere to go,' she reminisces.

Our first port of call is a flat at the end of a first-storey walkway. There's a metal gate cemented into the door frame to deter burglars. On the adjacent window there's a Police Neighbourhood Watch sticker – WE BEAT CRIME TOGETHER. Steve doesn't so much as knock on the door as pound on it until there's an answer.

We crossed the threshold into an Aladdin's cave of television sets and stereo systems.

'Have you seen Andy?'

'Andy who?' said one of the two teenagers with little conviction.

'Scottish Andy.' He had acquired the nickname because of his freckles.

They claimed they didn't know who he was talking about. Steve

went ballistic. They admitted he had been around. 'Yeah, you mean Andy what just come out of nick.' And yes he had offered them a laptop for £250, but no they hadn't bought it, because Andy's gear was too hot – he was doing the estate.

Steve's guided tour continued and as it did the value of my laptop was in free fall: it was now being offered for £150. More importantly, we were still one step behind Andy.

The scraps of information I was collecting about him all led me to some conclusions that proved sadly correct. As a convicted offender he was more likely to have been unemployed than employed before receiving his prison sentence. As an unemployed ex-offender, he was much more likely to commit crimes than an ex-offender with a job. What I hadn't yet discovered was why he had to keep committing crimes.

As Steve dropped in on neighbours and friends across the estate we found many of them slumped in armchairs or in groups on the floor coming down from drugs, a moment of ecstasy to take you outside your own reality, to shut out the grimness of daily life. We tried to find Andy on another estate. I was reminded of the inner-city ghettos of New York and Los Angeles, islands of poverty linked by causeways to islands of affluence with not much else in between, unlike the European model where estates are pushed to the perimeters of cities. Here, the only growth industries are in the non-conventional, alternative economies. Unable to taste success in the official market, they had turned to another market where the currency is stolen goods and drugs. They needed money, by fair means or foul. Petty lawlessness rules. Joyriding, ram-raiding, speed and smack are the carnival rides.

Many residents faced a bleak future with few prospects, certainly few prospects of a decent job. Hopelessness could drive some of them to desperate acts, as I was beginning to discover. As Steve explained, crimes here mostly involved drugs. 'They accumulate in the streets like rubbish, but usually they don't require solving, just hosing away. There's nothing mysterious about what's going on here.'

Steve's own past was a chequered history of dealing to feed his smack habit and going straight. At nearly forty, he was living with his parents and his son. His ex-wife didn't want to have anything to do with him and had moved into my place, not two hundred yards away.

It was three months before he discovered where she was living. Her son and her in-laws had felt it best for all concerned that Steve didn't know. She didn't trust him: 'He isn't going anywhere, unless down the drain is somewhere. And he still has someways to fall.'

But Steve was trying to be as helpful as he could be. We descended on Andy's mother-in-law. It was as if she had expected us – news travels faster than light across the estate. She had been driven out of her home by her own children, as she later explained to me. 'I couldn't take any more, I'd had enough of the Bill coming through my house. Once I had to hide a fugitive for two days against my will. When the Bill came on the third day, thirteen coppers raided the house, but he was gone.' She had recently been rehoused by the council at the other end of the estate, away from her children. When we arrived at her new house she was in a terrible state, her eyes glazed over, tears welling up. She was agitated and her hands wouldn't keep still from nerves: she grabbed a cigarette to try and keep them from shaking. Cigarette ash tumbled on to her black and purple shell suit. I thought she was coming down from something, but as if reading my thoughts she said, 'I don't do drugs.'

Marion was scared. Scared for herself. Scared for her daughter. Scared for Andy. But especially scared for the 'beautiful twins', her granddaughters. She doesn't know we're not going to lay a hand on her. Here all conflicts are settled by violence, and scruples about violence condemn the law-abiding to the status of losers. 'Andy's a plonker, he's been out on parole for three days, if he gets done he'll be back inside for years. He's got my daughter to go out and buy his gear. Sometimes I hopes he gets fuckin' done.' She doesn't know we aren't going to hurt her daughter, Andy or the beautiful twins – yet.

Her friend who had been sitting with her said, 'You don't steal from one house and then try to sell it to the neighbour. I only do shops and it would be like me stealing from Londis and then going across the road to try and sell it to the Spar. We've all stolen, but not from our own patch. Mind you, I've only been robbed once and that was by my brother.'

There is a certain logic to buying stolen gear even if you don't approve of stealing. Few people on the estate can afford to insulate themselves against risk and contingency – against the lawlessness –

because of the exorbitant insurance rates. So when you get burgled you can't afford to go out and replace things at market prices: your only option is stolen goods.

Marion's one ray of sunshine was her daughter, 'a real diamond', and the twins. Steve said no harm would come to them but he warned her, 'Tell Andy he's got twenty-four hours to return the laptop, if not, he'll have an accident with my Volvo. He won't be laughing.'

Later I asked Steve if he was worried the warning would result in a pre-emptive strike with Andy smashing up his car. 'I don't care if he beats up his fuckin' grandmother, I'll take extra insurance out on the car.'

The idea that crime doesn't pay is a discarded convention. There is a recognition that law enforcement is a lost battle. 'Jobs pay and so does crime,' said Steve's mum. Everyone is helpless in the face of criminals, and the police's inability to bring them to book is an extension of the state's inability to deliver justice. According to Steve's parents few people on the estate bother reporting crime. 'Everything is going to pot, they should go back to cutting off their hands and feet,' said his dad when I told him the story of the break-in. I was starting to understand why these decent, everyday working-class people were cynical of government at all levels; why they turned in desperation to the extremes, despising democracy and tolerance. They were discouraged from participating in elections by issues that left them untouched. It is not the sophisticated elite that is threatened by an out of control planet and its wilder inhabitants, it's the sophisticated elite that's out of control. The only flyer to drop through the neighbourhood's letter boxes during the run-up to the European parliamentary election was on a platform to restore capital punishment: BRING BACK THE ROPE FOR KILLERS with YOU KNOW IT MAKES SENSE! printed at the centre of a noose.

Steve's mum used to run a dry-cleaners on Streatham Hill. She stared out of her kitchen window at the kids wandering about aimlessly. 'I had the best moments of my life here. All the businesses are now deteriorating. It's so sad, I could cry. It's the same everywhere, I don't know where the people have moved on to. They should have a hall here. People can't go out at night any more and we can't get the council to build or buy one, because they got no money.'

When Steve dropped me home I telephoned the police. I didn't tell them who had stolen my laptop – that would have been grassing and unacceptable to the local community. The only recourse was to take the law into your own hands here, and such activity, I was beginning to discover, was merging into low intensity war.

The two young constables had a resigned air. They greeted me with a solemnity that on this occasion had something of condolence in their voices. The only time they broke into a smile was when I asked them what the chances were of getting my laptop back. They almost laughed.

The following morning there was a sheepish rap on my door. Andy had come to apologize. He was a pathetic ghost of a figure and I wondered how he had had the strength to lift himself up through the skylight. He had spent the last three and a half years of his young life in prison. 'I'm sorry, I was clocking.' He told me he had been desperate for money to pay for a bag of brown for his fix and had been trying unsuccessfully to burgle the workshops behind me. 'I knew you weren't home and from the workshops I could see the skylight. I've been round to David for your laptop but he's not in. I'll make good anything you've lost on it, honest.' He gave me David's address and promised to refund me if I was out of pocket. In return I gave him forty-eight hours, and he agreed that after that I could and would call the police. As he left, he turned to me, 'I've got a CD player, are you interested? It's yours for twenty sheets.'

David had already sold my laptop for £120, twice what he'd paid for it. But he promised to do his best to get it back, if I would promise not to tell his mum that he had bought stolen property. David was straight: he had a full-time job at an employment office in the day and then worked part-time in the evenings as a steward at football matches and concerts. 'Hey, Steve, did you hear about the Turkish guy who got shot?'

'No?'

'Yeah, Stan got Frank's father's gun, 'cause he had an argument over a parking space outside the minicabs.'

David's friend handed me a flyer he was about to distribute on behalf of the Revolutionary Communist Maoists or RCM for short. On the cover of the leaflet there was a picture of Los Angeles burning.

'In Los Angeles,' read the manifesto, 'the masses did the right thing. In Atlanta they did the right thing. And in San Francisco, New York and cities across the U.S. they did the right thing. The "home of the brave, land of the free?" Hell no! It's the land of the slave, who won't "behave". The people gave THEIR verdict on the everyday brutality and racism of the ruling class in AmeriKKKa . . .' The manifesto called on British people to oppose the oppressive system, to train and educate a new generation of revolutionary fighters who will target the real enemy, the British Ruling Class. As I left, David's parting words were, 'We live in a dog-eat-dog imperialist system just like the US.'

Two days had gone by and there was no news of Andy when Jim, the postman, dropped by for a cup of coffee. He had heard about the burglary and passed on his condolences. 'Those kids are all cockroach cunts. Some of them listen to that shit, devil music – rap. Every Tom, Dick and Harry has got a shooter. One of them lent his father's gun to his friend who had an argument with a minicab driver over a parking place and shot him dead. They're crazy, man. My brother's started on the rock. I don't touch that shit, only the weed to get me through the day doing this dead-end job. Believe me you need it, having to do this same shit five days a week. How come you're not on the buzz?'

I wanted to know what had led Jim's brother to crack cocaine. 'Could you introduce me to your brother?'

'Yesterday I had to go at him with a baseball bat, because he was so desperate for money he attacked our mother – that rock drives you crazy.'

'Well, can you introduce me to someone with connections?'

'I don't want to introduce you to them, they're bad mother-fuckers. Even if you trust them, you can't trust them. It's everyone for themselves out there. Nowadays, even if you're straight you gotta lie, cheat, to get a place to live.'

I had almost given up the idea that I would get my laptop back or be reimbursed for it when the phone rang.

'Meet me at Geneva Close,' shouted an out-of-breath Steve. 'I've just seen the bastard. Run!' I flew out of the door, but by the time I caught up with him we were too late. However, on my way home a trail of dried blood led to Andy's mother-in-law's front door. She

appeared at the door, her young, creased face chiselled from the hammerings of each battle.

'Is Andy in?'

'No.'

'Why all the blood?'

'I don't know, he came barging in here. He bled all over the dishes, he's got that thing wrong with himself, you know. I've had to throw all the dishes out.'

'Where is he?'

'I don't know. Raymond beat up Andy, because Andy beat up Lisa and took off with the twins. Lisa got an injunction on him.'

It was time to call the police again. They told me as soon as there was some more staff available they'd get someone to come for a statement. When they did, I gave them all the details. I also told them when and where Andy would sign on. When I didn't hear from the police the day after he had gone for his benefits, I called to see if he had been picked up. I was told, 'There are thirty-five men with the same name who are known to us and possible suspects. I'm sorry but we don't have a good enough description.' I wanted to say, do you want me to give you the size of his freckles? but I kept quiet and the police said they would be in touch.

They sent me two replies. The first was a letter of commiseration: 'I'm sorry that you have been a victim of a burglary . . . Your crime is being investigated . . .' The second letter was on the Police Division's Strategy: 'Our strategy will remain much the same for the coming year as it still meets the needs of the community. It has proved successful but we must respond to the demands of the public in the way we police the Division. Sector policing has enabled us to do this more effectively . . .'

When I went to see David for news of the laptop, he told me it had been sold on to a minicab driver from Nigeria. 'My mate says he can get it back, let's hope his mouth is as good as his trousers.'

As I set out on my journey the graffiti ASSASSIN was still in black felt tip on my window and the letter box opposite my hall, but I now know its significance. My former flatmate's eleven-year-old son Liam, who is known to his mates by his graffiti-name Swine, raps to the borrowed lyrics of dem gangsta rappers:

The police have killed our children
Justice hasn't passed judgement
The People are waiting for.
That's why we hate
The System.

On the day of my departure I met Stink at the Cafe on the Hill for lunch. David was there to pick up a takeaway.

'What's up?' I asked.

'I'm on my way home to check on the house. Touch wood I've never been burgled by the druggies, I wouldn't trust those losers as far as I can throw them.' He went home from work every lunchtime to make sure no one was messing around.

His mother had had enough. She had moved back to Jamaica, joining the record numbers emigrating from Britain, nearly 150,000 in the last year to all parts of the world.

'Any news of the laptop?'

'The last I heard it's in Nigeria.'

When I got to the counter to order the food Heather, the Scottish cook, looked at me. 'I've been wondering what hole you'd disappeared to,' she said lovingly.

'Mauritania.'

'I've just got back from Cornwall,' she said. 'It's not even four hundred miles away and I tell you, it's like another bloody country.'

I ate her delicious, steaming shepherd's pie, two veg and loads of gravy, shouldered my pack and camera bag and headed for the hard shoulder of the M1 to hitch a lift to Leicester.

LEICESTER

Workshop of the World

I HITCHED THE ninety-nine miles to Leicester from north London. There was a light drizzle, rain coming second only to the hitchhiker's dread of impending darkness, but I was lucky: my second lift took me to the very heart of the city. I was dropped at the train station where signs welcomed me in Urdu, Punjabi, Gujarati, Bengali and English. The taxi-drivers played court, the subcontinent's version of whist, on the bonnets of their taxis as they waited for passengers. The older drivers hailed not only from India and Pakistan, but from many parts of West Africa: Kenya, Tanzania and particularly Uganda, from where they had been forced to flee by Idi Amin's racist decrees. I had many chances to sample their driving, not to mention their verbal skills, as English has dropped to sixth place in the official languages of cab drivers in Leicester.

As soon as I got my bearings, I headed out of the station to stay with an old friend who taught at one of the city's more difficult community colleges. There is a statue of Thomas Cook, honouring the man whose ten-mile rail excursion to Loughborough in 1841 was the first package holiday. I've noticed that British statues are always clothed, while on the Continent the sculptors revel in the forms of the naked body. Maybe it's the weather; but as Louise later pointed out, 'Would you really want to see Thomas Cook without his clothes on?'

I settled into the city quickly. It would be hard not to. From my base just behind the local branch of the British Red Cross everywhere in the city was quickly accessible and taxi fares were rarely more than £4. First impressions are of a clean, leafy city, with cricket matches played in its large central park dominated by the university's three glass, brick and concrete towers. There is an unmistakable feel of the

shire among many of its citizens, and even when its business and shopping centre was busy it always seemed more like a town than a city. In fact, Leicester felt like a comfortable shoe.

Every day I made my way across town towards the Narborough Road, leaving the house as double-parked family Volvo estates, Rovers and four-wheel-drive Discoverys and Subarus clogged the road outside the local private school. Each vehicle contained at least one small person in the back wearing a blue blazer and pressed trousers, and clutching a smart satchel or the latest in brand-name sports bags. Parents wandered up to the school's front door, chatting to one another and waving goodbye to their children. It was in stark contrast to my friend's school, where eleven- and twelve-year-olds arrived having dropped their younger brothers and sisters off at primary schools. Some parents brought their children and stayed afterwards at the school gates to make sure they didn't play truant. But they couldn't stand sentry all day, which is what was necessary, because skiving off came as regularly as mealtimes to some of the children.

While the community college boasted excellent facilities and like much of the city possessed large green grounds, there was no hiding the battles being waged within the renovated school buildings. As my friend gave her class, as she talked about patterns and complementary colours to her pupils, many of them were at some point high either on some kind of tablet, or on something to be smoked or drunk or combined as a cocktail. Maybe it did more for them than patterns or complementary colours could.

These boys and girls are growing up in a hurry and their heads bump against the low ceilings of their expectations. The system had failed their parents, who now saw no further hope or future in it. They stayed at home in bed, and the children either did as they pleased or were told: look after the baby, do the shopping, wait for the electric man, care for your sister who is ill – there was no time or place in their busy schedule for school.

When they did make it there, some arrived in ill-fitting clothes and shoes and were bullied on that account. One of the students confided that she shoplifted outfits because she was embarrassed by the only clothes her parents could afford. 'When my parents ask me where I get my new clothes from, I tell them that my friends gave them to

me. When my brother's only set of clothes aren't dry in the morning after they've been washed, he goes to school in damp clothes.' Many children didn't own pens or pencils, paper or notebooks. The school had to provide them.

The school has to fight for its resources. The government bases funding on the number of pupils that enrol and therein lies the catch: the more the school fights to hold on to children who would be excluded from other schools, the more the overall performance suffers; the poorer the exam results, the less attractive the school becomes to potential candidates; the fewer that register, the less government funding it receives. The remedy is more time, attention and resources to help the disadvantaged children who would normally be excluded to remain in the school system. Instead the policy encourages schools to exclude problem children as soon as possible to maintain overall performance figures, which attracts more candidates and more funding. Those children who are all too often and quickly excluded don't even receive the mandatory five hours a week home tutoring. They are simply abandoned.

Everyone is filled with rage. The schoolchildren against their elders. The parents who rail against the teachers, but never attend the school's open days. The staff who are expected not only to be teachers, but to take on the duties of guardians and police. One of the school's two vice-principals had spent twenty-five years in education. Now aged forty-nine, he was looking to take early retirement in four or five years' time.

'You can burn out in this job. It isn't like it used to be. The kids don't show any respect any more. You've got to change. You have to ride with them. It's the same with the parents. They think we crawl out from under a stone in the morning. We're something to be wiped off your shoe before going back home. Teachers either sink or swim. I would never have believed you if you'd told me that one day I'd be carrying a walkie-talkie. We get two or three official calls an hour. More unofficial. I've been called out four times in the last month, one a week, to remove a kid from class. Yesterday I was called because a group of kids were bullying the gardener, making him dance and do silly things. A lot depends on who's on the rota. The kids know what they can and can't get away with.

'I've seen kids die of glue abuse, teachers die of heart attacks, closures, redundancies. Glue and solvents are a problem. The kids can't afford the expensive drugs, Ecstasy or crack, so they use glue. At my previous school down the road, a kid died from experimenting with lighter fluid. He put it up his nose and it blew him away. We were meant to be celebrating the closing of the old school. But a teacher died of a heart attack in his kitchen and instead we were going to a funeral.'

When the last bell rang, the last class ended, there was a mad stampede for the exits. Rivers of schoolchildren galloping through the doors and into the corridors, above them, towering like masts, the teachers who had also had their fill.

Sometimes I would sit in my friend's office, its shelves filled with enough school directives in folders and books to fill a corner of a library. I would listen to the shouting, the cursing and the laughter drifting away as the last boys and girls passed beneath her window.

It was after one such day, as I walked along Narborough Road past shops that have changed little in the last thirty years, that one of the girls recognized me. Connie was about to leave school and was looking for work. She said she was going to meet up with her sister and friends at the hostel where they were living and asked if I wanted to go with her. She introduced me to her sister who was slumped across a bed whistling a tune, at once very melodic and very simple. That's how I came to know Louise who became my guide to the city.

Her friends were equally divided between those who were hostel residents and those who lived with family or friends. The hostel, a converted house in a quiet road, was a focal point for the young people to gather when they had nothing better to do, which was often. It had been repeatedly raided by a gang of youths – the manager was never there when the gang arrived to knock down the front door, break a window or bully one of the residents to let them in.

Louise was a not-so-thin, pale-faced girl. Her wary expression sometimes reminded me of a hunted animal: there was always a furtive nervousness in her eyes, which had nothing to do with her constantly falling foul of the law or breaching the conditions of her bail. She knew everyone and never exchanged greetings without a mischievous grin.

Most of the young people in the hostel had ambitions. John: 'I always wanted to be in the army since second year. The discipline. Patriotism, doing your bit for the country. I could take apart a gun and put it back together in one minute and thirty seconds.' He failed to get into the army; the closest he gets are the mock battles he sets up in his hostel room with toy soldiers. 'I'm a chef. I decided I love cooking, but I don't like doing it as a job because around here you can only get cafe jobs, doing sandwiches and that's that. The nearest job I've done for catering was for Japanese businessmen, doing proper food, king prawns, dim sum, stuff like that. The job didn't last long, so I got the first job I could find, packing Christmas cards. It's £2.50 an hour, but I don't know how long I can hack it.'

Louise's friend Sheridan wanted to travel, but was working as a trainee at a local supermarket. She got £28.50 for 28 hours, four days a week including Saturdays, plus a day at catering college, of which £5 went to her mum.

'Pathetic slave labour is what it is,' said Louise. 'My brother gets more from benefits. I want to be a journalist.

'Above all I want to enjoy life. Going out and having a laugh with my friends. I'd need to go to college to do me GCSEs to be a journalist because I didn't go to school. I hated school. Never liked the teachers or anything. I used to doll off all the time. When I was at home my mum made me go, but when I was in care she couldn't make me. But my mum worked as a home help, so what I used to do was get ready for school and then go out as if I was going to school and catch the bus into the centre and just sit in the library all day reading books. Then catch the bus home and when I got home my mum knew that I hadn't been at school because I'd dolled off all week and the Educational Welfare Officer had been to the house. Sometimes what I used to do was stay off school for two days, forge a note off my mum saying I was ill, then just stay off for the rest of the week. I wish I had gone to school 'cause at least I would have had my GCSEs, would have got a job then. I don't want a job, I want to be a journalist – that's all I want to do, all I ever wanted to do. I once wrote down on a piece of paper what I'd like to happen in the future; job, kids, married, I've still got that piece of paper.'

Louise used to live with her mum and dad and elder brother and

sister until her parents separated when she was eight. Her stepfather sexually abused her six months later and she has been in and out of care ever since. She was now living in her second hostel in as many months, after the residents had set fire to the first one.

'We threw most of the furniture on the fire and the light fittings in the kitchen. They knocked them all off and then I got this fire extinguisher and squirted this lad called Dave Morland and used it all on him and soaked him through and then Norman and Gordon got a fire extinguisher and wet me through. I went upstairs and got changed, went downstairs and they threw me in a bath of cold water. The hostel people threw Norman and Gordon out straight away, but they didn't move me until they found me somewhere else, it were like a bedsit, but then I got thrown out of the bedsit for smashing a window and then the housing put me in this hostel. It's really, really strict, more than the last one where you didn't have any rules, come to think of it, just keep it clean. Here you're not allowed any food in your bedroom, no smoking in your bedroom, no visitors after nine p.m. No visitors allowed in your bedroom at all, no visitors are allowed to sleep over, though you have a front door key you have to be in at eleven o'clock. If that's not strict I hate to think what strict is. It's like a bloody prison!'

None of the regulations had kept out the gang the previous night, while the hostel manager was busy chasing rent and repairing doors at another hostel.

'We were watching *Police Academy 6*,' said John, 'when these lads burst in at nine, ten o'clock. They set off a fire extinguisher, so I dived to the floor, saw the powder coming, my mate was coughing and choking, he has asthma. Donovan got tapped on the nose. The police came around looking for the lads who did it. They found one, he didn't even go to court. I am totally mixed up. I didn't use to say boo to a dicky bird, I was afraid of my own shadow, that's why I didn't go to school 'cause I was bullied every day, but it toughened me up. Now, well, I'm basically normal. When I got upset I used to go for a walk. I was once with a lass for eight months. She was sixteen, I was near eighteen, she found out I was on the street, her mum and dad told her to leave me. I was real upset. I went to me place and slit me hands, but now I think stuff like that is really stupid.'

I left the hostel with Louise and as we turned out of the quiet residential neighbourhood into the main road to town, she gave me a guided tour of her past.

'I played bingo with my mum at the club that used to be there. That's the post office where I did my thefts and deceptions – I'm barred.' Further down the friendly Narborough Road: 'I'm barred for smacking the landlord over the head with a pool cue. My boyfriend, Salim, lives down the road and I've got nothing to say about him except that I'm going to get brayed [battered] because I'm going out with him – I don't know why.'

What she didn't tell me at first was that she had once tried to take her life, hadn't stopped shoplifting, which she had started before she got into drugs, and had a penchant for Asian minicab drivers. She did tell me she knew the Asian words for sex and bastard. As we walked past a boarded-up cinema she pointed to an alleyway.

'That's a TPSS.'

'TPSS?'

'Typical Pakistani Shagging Spot.

'I want to adopt a kid from Ethiopia.

'I'm on probation for theft and deception, attempted deception, two burglaries, three thefts, receiving and handling stolen goods, breach of twelve-month conditional discharge for the two counts of deception and receiving stolen goods, and breach of bail conditions because I was already on bail for the thefts when I got arrested for a burglary. Not bad for a seventeen-year-old, is it?' she laughed. 'I want to put it all behind me,' she said seriously. 'It's doing my head in.'

For much of the present century Leicester was a vibrant and prosperous manufacturing city. It is also the oldest of the great industrial cities of the Midlands, which was once known as the 'workshop of the world'. No city in Britain produced as many knitted goods or distributed more boots and shoes than Leicester. Daniel Defoe wrote in the 1720s, 'They have a considerable manufacture carried on here, and in several of the market towns around, for weaving of stockings by frames: and one would scarce think it possible so small an article of trade employ such multitudes of people as it does, for the whole country seems to be employed in it.' Now Leicester's decline is visible: obsolete industrial

plants have been boarded up, empty warehouses are padlocked, manufacturers' names hang like broken branches from their fixings. The boards that once advertised vacancies outside the factory gates are blank, and weeds grow among the bricks and mortar and concrete platforms that launched their goods to the four corners of the world.

I went to visit the managing director of a family firm that has continued to manufacture shoes despite the general trend of closures. He sat at his desk in front of a laptop under a portrait of the Queen. Although the firm had been in family hands for two generations, 'I'll eat my hat if my children are doing this. It's relentless, the pressures are too great: wages, rents, rates, National Insurance, taxes – we cannot compete. If I can make a shoe for £9 the Chinese can deliver one here for £1.61.

'We've started to import half the product.' He showed me a synthetic sole. 'This came from Madras this morning. In India the typical weekly salary for shoe factory production workers is £6. In my father's day Britain imported just over a quarter of its shoes, now it's going on for three-quarters. Leicester used to be known internationally as the greatest boot and shoe distributing centre in Britain and the largest centre in the world for the production of knitted goods of every description. Our proud boast used to be, "Leicester clothes the world from head to foot."

'The first thing to go in a recession are shoes. We're particularly affected because we sell comfort shoes to older people and they are worried about paying extra money on fuel and heating bills. People dress down here, shoes are a bolt-on accessory you add at the bottom. Apart from the increasing level of imported footwear, mainly from the Far East but also Italy, we've lost out on the design of footwear, especially in the women's sector, which formed the basis of our industry. We've lagged behind in the pace of technological change with the introduction of new machinery and materials and in the substitution of traditional materials by plastics.'

In Leicester's sunset industries of footwear, hosiery and engineering lack of investment was as much to blame as the desire to make a fast buck. The founder's grandson said it would be impossible to start a new factory today.

'This business was built up over a hundred years, now you'd need

to borrow three million pounds. One of my contemporaries at university runs a nursery school, he's parasitic, he's got no stock, people pay up front – there's no risk. In manufacturing it's all outlays, all risk, the upside potential is very limited. Do we go for a one-inch heel or a one-and-a-half-inch heel or a half-inch heel? Do we choose burgundy or green? If we get it wrong, we've lost sales.'

The firm was housed in a Victorian building which had once belonged to a rival manufacturer. It could be heated, but not cooled. Parts of the factory floor felt like the inside of a boiler room, and it was barely possible to talk over the din of the machinery. Harry had worked as a clicker, cutting leather, for over thirty years: his hands glided around the brass template with great speed and dexterity. Like his boss he talked of the death of the industry. 'There'll be nowhere else to go in the shoe trade, I don't think there will be a manufacturer left, the only jobs will be in the prison service. Where I lived there were six factories in four blocks. When I got fed up I changed factory. I'll kill my kids if they go in the shoe trade. I don't think they will, young kids won't stand on a machine like us, they'll get fed up. They want to go straight in at the top, we started at the bottom, worked our way up, but I don't know if I'd do that again.'

In fact young people did work in the factory. Most of them had a relative on the shop floor, an uncle or aunt, cousin or father – they needed the connection to get the job, but it also worked as an insurance policy for the management that the family would make sure they toed the line. If young people didn't want to work on a production line it was because many saw going through the factory gates as having failed life's first hurdle after school.

The following week the factory was to shut down for the annual fortnight's holiday. Harry explained that when he was a youngster he didn't know anyone who went abroad. 'Now I don't know anyone who goes to Skeggy. I won't be going anywhere. I've just been burgled, they stole my holiday money so I can't go. Normally the thieves have the run of the place during Factory Fortnight: we call it "Burglar's Dream".'

The shop floor was divided into different areas of production, and the tasks allotted according to gender: the clickers were men, the stitching and closing – machining the leather bits together to make

an upper – were done by women; only in the polishing room did the genders overlap. Left to wander around the shop floor I didn't want to interrupt anyone's work for many were on piece rates – you earned according to what you produced. Because I couldn't hear my own voice above the hum that was as constant and incessant as the flow of a river, I started to shout my introductions to an older woman who was taking a break from one of the 1920s stitching machines.

'You don't have to shout,' she said, 'we get used to lip-reading like deaf-and-dumb people, because you get accustomed to the noise. If you can't hear me, we'll have to go to the toilets!' she giggled. She wore a 1960s hat printed with a Union Jack, 'to celebrate the fiftieth anniversary of the D-Day landings'. I asked her about her work. 'It's horrible. I pull out inner linings for repairs to shoes what been worn by smelly feet for £110 a week. I was made redundant at 58, so I just do what I can. I'm getting on for 40 years of on-line work, I used to work in a crisp factory. There was nowhere else to go, no one else to train us.'

Surprisingly for a multicultural city there were few recent immigrants on the shop floor. In this century alone Leicester has seen successive waves of immigrants – Belgians after the First World War, Poles, Yugoslavs and Ukrainians after the Second World War, followed by Caribbeans and most recently Asians.

I sought out the first black worker I could find. He put the record straight immediately. 'When I first applied for work they didn't want to know because I was black. But later, when they couldn't find a white person with my qualifications to fill the vacancy, they were forced to hire me. The factory still has a tough time filling vacancies. Nowadays young trainees don't last three days, they're not interested in the work, it's below them to do manual work, but they've got no qualifications to do anything else – and they don't have the stamina or the will to do it.'

His voice was regularly drowned out by the symphony of machine-made sounds – thumping, sucking, hammering, grinding, like the bass pounding out of a nightclub's sound system – relentless. The floor reverberated, like the deck of a large ship, to the inner workings of his ancient machine. Matthew's face was drenched in sweat and boot polish as he leaned into the machine with a single shoe, his hand

moving with lightning but firm movements to guide the walls of the shoe around the polisher. He complained about the employment practices that have hardly changed over the years.

'There are over two hundred workers here – guess how many blacks are employed? Five, and three women in the polishing room. One's my nephew and that's only because I got him the job. We have to work much harder than the white folk because even after twelve years at the job here we still have to constantly prove we are equals.

'There is always racism, you can't get away from it. If they make two jokes, I make one back. It doesn't matter as long as they don't hurt me . . .' His voice disappeared under the noise of his machine. I couldn't lip-read, but it kept coming back in waves. 'We were brought up British, I support the West Indies versus England, but I support England versus New Zealand and Australia.'

The factory had recently had to make redundancies for the first time. The union had been very understanding: one single telephone call from a client had cost the company an order which was diverted to Brazil. The manufacturer was, however, producing more and more units per person. If you couldn't automate the tasks of preparing the leather parts, cleaning and polishing with computers, you could automate the people by monitoring their work rates. According to Harry, 'I have to work harder and harder, no, maybe not harder, but faster.' Ultraproductivity was the order of the day.

Leaving the factory I passed a workbench where Michelle, a seventeen-year-old, stuck a label to each inner sole, and added laces when required and a miniature leaflet. She never stopped, there was never a hiccup in her movements, ninety racks of shoes a day, a dozen pairs of shoes to each rack, to be accomplished in eight hours. When I asked her if I could take her picture, the foreman shouted, 'It's for a girlie magazine!' Michelle ignored his jibe and nodded yes without breaking her rhythm. A bead of sweat appeared on her temple. Her predecessor was 78 years old.

After I had taken photographs of the pupils sitting their GCSEs Connie gave me a message to meet Louise outside Hussein's minicab office. Louise had switched firms: she had fallen out with her boyfriend Salim, who worked for a rival company. 'He always got so mardy [moody]

when he didn't get what he wanted,' she said. Louise and Sheridan had spent the afternoon carding for Hussein's company. I found them perched on a low wall singing a ditty:

> We are two girls from Leicester
> Sell knickers a penny a pack
> They're fantastic
> They're elastic
> Why don't you buy a pack.
> I knew the boy next door
> He got me on the floor
> He shoved it up ten times
> And then we had some more
> My Moma was surprised
> To see my belly rise
> My Papa jumped for joy
> It was a baby boy.

John had moved into his own place last week and Louise wanted to take me there to meet a twelve-year-old joyrider or twoccer (TWOC – Taking Without Owner's Consent). I was surprised John had found a place to rent – in Leicester the rents are pushed up by the city's expansion of higher education. Students group together and so often have more money than a family to rent property. John's privately rented house was in poor repair and well away from the campus, so students hadn't yet laid claim to this area of town. The nearest they came was the Grand Union Canal which they used for rowing practice.

Louise pushed John's front door open; the catch was broken. She introduced me to Mandy, who was engaged to marry John, and Luke whom they wanted to adopt. Luke thought the idea a load of shit. 'She's scared of me, I don't want it to happen, she's two years older than me.' Luke is twelve, Mandy is fourteen and John is twenty-one.

In addition to John, Louise, Luke and Mandy, there were Nikki and Kylie, Ossie and his cousin Ali. They were all refugees: refugees from their parents, refugees from school, from care, from boredom, from monotony, poverty and reality. They were oversexed, angst-ridden teenagers, who were (or were not) dealing with their problems through

the nihilism and anarchy of their lifestyle. Kylie, Mandy and Nikki were on the run from a children's home, Luke had escaped for the day from the same home, Ossie had escaped from an arranged marriage.

'John, would you like a brew [tea]?' shouted Ali from the kitchen.

'Let it mash!' John replied. 'Nikki, do you want a brew?'

'Why's the front door catch broken?' I asked.

The same gang had been around, the ones who invaded Louise's hostel. 'They've nicked everything, the television, the video, the tapes. I couldn't stop them, they just knocked on the door. If I hadn't let them in they would have put the window through. It's bad. I can't do anything about it. Police are scared of them. We know who they are, not their names, only by sight. The catch got broke this morning, but the landlord wants me out so I'm not fixing it.'

Kylie was rolling deodorant under her armpits. When she finished she handed the stick to Mandy who did the same, and in turn passed it to Nikki. They were all fourteen. They had gawky bodies, seldom washed, munched on biscuits, crisps and chocolates and were completely fixated on sex and drugs which they talked about in a fake-connoisseur way.

Their stories were similar and yet different. Each had a history of abuse and abandonment by their mothers and fathers. Kylie was from Leicester and had only once been beyond the town centre – a family member had taken her to watch Leicester at Wembley in the First Division playoffs. Nikki was from just outside Leicester and Mandy was from Northamptonshire. She told me, 'I was adopted at five. It didn't work out because my mum and dad beat me up, so I beat my brothers up, so I got put into care when I were twelve.' At twelve Kylie had had a baby girl who had been placed with her aunt. 'I sometimes use protection, it depends on who it is and where I am. I can't always afford contraception.' Nikki was pregnant and wanted to keep the baby. 'My parents told me to have an abortion, but I want to keep my baby because I want to. I realized I could get pregnant, it didn't make any difference. I always wanted one. Now I've got one I don't want to get rid of it.'

Mandy, although engaged to John, was different. 'I'm still a virgin 'cause it's stupid to have sex when you're under age. I do drugs,

anything, dope, weed, pot, and draw, ganja and spliffs and smoke smack, magic mushrooms, gas, acid tabs, trips, speed, 'cause it gives you a buzz – you have a right laugh.'

Kylie and Nikki also reeled off a similar list of drugs they did, but 'not regularly'. I asked the three of them how they saw themselves.

'Very daring, adventurous teenager.'

'See myself as adventurous, ongoing, daring, but stupid fucking minge.'

'Same, and stupid in some ways because I take life as it comes, like you want to make the most of it, do what you can, you could be dead tomorrow.'

'Well said.'

'Why do you see yourselves as stupid?' I asked.

'Things what we do. Stupid to others, not to us.'

'People just think I'm stupid. I say they can think what they like. I'll just get on with my life.'

'They'll see me as an ignorant little cow. I don't care. It's what I think. With mates like us who needs enemies?'

'I think people think I'm a stupid little tart.'

They continued to apply lipstick, took turns to put a brush through their hair and turned this way and that in front of a small hand-held mirror.

Luke lived at the same children's home as the girls. His attitude varied: although he had once run away with Mandy, he had since gone back to the home. Mandy, Kylie and Nikki were determined not to be taken back. 'The thickheads know we want to stay here,' said Mandy. They survived by nicking and shoplifting, sometimes alone, sometimes as a group. 'I used to go thieving with Nikki,' said Kylie. 'We used to make jokes about Woolworths, since the advert says Woolworths is right up your street, we used to say right up your street for nicking.' They also stole when they didn't have the money to buy their brothers and sisters Christmas cards or birthday presents.

Unlike the girls who talked as a group, Luke only agreed to talk if we went into the kitchen where they couldn't hear him. He was wan and scrawny. He looked no different from many skinny, ordinary children, but his sullen face and sad eyes reflected his past, his present and his future. He leaned against the kitchen counter taking swigs of

cider from a plastic bottle while with the other hand he drew gently
on a matchstick-thin spliff.

'It relaxes me and makes me tired, it don't harm you. Some people
get giddy if they smoke draw. I don't like people when they get giddy.
Where do you want me to start?'

'Wherever you want.'

'I've got eleven brothers and sisters with two more on the way, my
real mum is having a baby and my stepmum is having a baby. I've
five stepbrothers and a stepsister, two half sisters, two real brothers
and one real sister. I get fed up and bored with what's going on in
my family. When I get fed up I just sit down and watch telly or put
a video on or go upstairs and listen to my stereo.

'Most probably the trouble started because of my parents splitting
up. I ain't really wanted them to split up. My mum got remarried, I
started to get back at my mum. I ended wearing her out.

'I don't see my real mum any more. She kicked me out, she kept
on battering me, beating me up, if she managed to get me in a corner.
She would try and hold on to one of my wrists so she could hit me.
She didn't always get me. I would try and throw ashtrays or cups at
her. Sometimes we were locked together, she'd start swearing and
bitching at me, I'd tell her to shut it up. I started hanging around
with Carl and our James who was always getting into trouble, shop-
lifting and burgling and doing cars. My mum told me to stop hanging
around with them. I still did. I started getting in trouble with the
police.

'Our James had been in care all his life, he were like committing
offences, but not getting caught until he was eleven. I wish I had never
started hanging around with them. It started off with shoplifting, then
I did one burglary. Then when James got sent to a secure unit I started
nicking cars. I'm going to try and stop now. Carl and I were taken to
court last Wednesday, I got twelve months conditional disharge, it
means I've got to behave and do nowt for twelve months. I've nicked
one car since, a Vauxhall Astra SRI, to celebrate not gettin' fined or
anything. If I'd been fined for me age group I might have got £50,
I'm not old enough to get sent down. I would have paid it back from
my pocket money a pound a week, that means the rest of my life, but
more than likely my nan would have paid it for me all at once.

'I wasn't scared of getting caught. I did it for fun, to see what it were like. I liked it so I carried on doing it. At first I thought the owners are getting the cars back and the insurance will pay for it all and the damage to the tyres, the new locks, ignition and plastic around the steering column. I didn't realize until I went to court that would come to £500 and that the owner would have to pay half of it, the insurance won't pay it all. He was looking for compensation, but he didn't get it. He probably sees me as a nobhead, someone who thinks they're clever, but they're not. But I don't think I'm clever. When my friend Damian found out, he called me a wanker. And goes, "if you go nicking any more cars, don't come and see me". I'm trying to stop nicking cars.

'The children's home is all right. Meant to treat it like we were at home, but if we acted like we did at home we'd get sanctioned. If we were at home, we wouldn't go to bed till three in the morning and I'd be out all the time; I wouldn't be coming in till eleven at night, I would be sitting in the living-room watching videos then go to bed, get up at about twelve o'clock in the afternoon, get something to eat and then go out. Just same principle every day. I know it's not really right at my age.

'I still see me dad about four times a week. My mum wouldn't give me a chance to apologize. If she saw me, she'd walk in the opposite direction hoping I didn't see her, don't really bother me 'cause I can still see me dad, can't I? I like me stepmum but not my stepdad. I don't know why. He don't like me and me brothers, any of me real brothers and sisters. I don't know why our James were put in care. I've been trying to find out for ages. He knows but he won't say, keeps changing subject. I've got me ideas that my, his mum were battering him and he got put in care. He just don't like talking about it.'

'Do you mind talking about it?'

'Not bothered. Something to do.'

'Have you ever talked to someone about this?'

'Not really, me social worker about some of the stuff, but not all. She knows about all me family problems, but I don't tell her about all me crimes.'

'Do you think she knows?'

'She knows. I don't know what I want to do in life. I've nothing in

mind. I take each day as it comes. I've gotta get a job – how else am I gonna live? The dole. What's the point living on the dole? How much do you get? £50? You can't get a week's food and then clothes. Dad's a builder, Mum hasn't got a job, she lives on the dole. Nothing I can say about it. Wish she'd go out and get a job. Stepdad can't work, he's got a bad heart – I think it's an excuse. He's on invalidity benefit.

'If I could change something I'd get rid of my criminal record. Stop stealing cars. You get addicted to stealing cars, but you can stop if you want. It's a habit like you like doing it, you don't want to stop, but you've got to stop, so I've got to stop.'

Ali came into the kitchen as Luke was explaining how to deactivate the different types of car alarm. 'How do you know the make of the alarm?' I asked.

'The car usually has a sticker on the window that tells you.'

I had an appointment with Ali and Ossie's uncle at his small shirt factory. Luke asked me if I had a car. I didn't. He looked through the lace curtains into the street.

'If I had a screwdriver I could give you a lift,' he said, eyeing the cars beyond Mandy and Kylie who were doing a balancing act on the garden wall.

Ali and Ossie's uncle Mohendra had belonged to a wealthy family with several businesses in Uganda. One Saturday in August 1972 his father, fearing for his children's safety, told him that he and his brother would be leaving Uganda for good on Monday. They left Kampala with a suitcase each, £200 between them in cash, their British passports and an address in Crawley, Sussex.

'We arrived at Heathrow, bewildered and frightened and almost penniless,' Mohendra recalled as though it were yesterday. 'My brother and I joined two friends in a taxi, they were going to Leicester, we were going to Crawley. The taxi-driver said it's one or the other, they were in opposite directions. That's how I came to Leicester.'

After being turned down for several jobs, he found one as a railway booking clerk, then as manager of a post office. Ten years ago he took over the premises of one of the two hundred hosiery companies that had closed, a small industrial unit housed in a pre-Second World

War brick building on the edge of a residential neighbourhood. Now Mohendra and his family turn out shirts and socks for export mainly to Ireland. Half of Leicester's manufacturing jobs had once been in the hosiery industry; 30,000 – nearly a quarter of all hosiery workers – had lost their jobs in the 1980s. Mohendra complains that there is a shortage of good machinists. 'It's happened two or three times that I've found one, they say yes to the job and never show up. The ones in our factory coming up to retirement are the best workers. We can probably carry on for a few more years, but unless there is an influx of new labour, we could find ourselves with no workforce.'

His workers were mainly married women, usually the second wage-earner in a partnership, who could afford to work for low wages. A single parent couldn't earn enough to cover weekly outgoings – with a wage you would forfeit not only supplementary benefit but rent and council tax rebates. The factory paid £2.75 an hour for a fifty-to-sixty-hour week, a rise of 25 pence an hour on the previous year; the staff had asked for a 50 pence rise. There was no overtime, no day-and-a-half for Saturdays, no double time for Sundays.

Like the footwear manufacturer, Mohendra complained of unfair trading practices. 'Indonesia can sell a pair of socks for 30 pence – that won't even cover our costs for the material. It's the same for shirts made in India. They should level the playing field so that import duties give us a chance to sell our shirts at the same price. Shirts produced in India are threatening the Indian community here. We are here, we pay our dues, do our duties, so we stick up for ourselves – we belong here.'

Ali and Ossie mirrored the dilemmas facing the most recently arrived immigrant community. Ali had gained good A-level results at sixth form college and was going to study accountancy. Ossie had once looked for a job, but had given up. 'I don't like working and that's it. I went for work experience: half the time I felt dizzy and everything. I just went for the first day and then I left at lunchtime. That was three or four years ago when I was in school – fifth year. My parents said if you can't work, you can't work.'

When I next caught up with Louise, on an estate where non-white people were not welcome, I understood why the lot of immigrants in

any country is almost the same. The Ugandan Asians who hadn't prospered were regarded as parasites, those that had done well were envied. I imagined that local people in Kampala had said almost the same.

They call it Dodge City. Everyone I met in Leicester told me not to go there. 'People in Dodge either rob or get robbed,' said John. No one was sure why it was given the name. The local policeman told me it was because it was a bad area, a schoolteacher said it was because it housed one of the highest concentrations of debtors in the Midlands. Dodge's original inhabitants had been obliged to move there *en bloc* when the council demolished the city centre's Victorian dwellings. One of Dodge's few original residents, who was moved there in 1938, remembered her furniture being fumigated before she moved across town.

'The houses were fantastic at first, they still are, we had a garden, electricity, water on hand, everything was sparkling new and shiny. But I remember there was suddenly nothing to do, there was no entertainment, nothing.' Not much had changed. The first thing that struck me were the numbers of children, toddlers playing alone in the streets. They were everywhere. Children played tag on the roof of the locked community centre, they looked into people's houses, they rode miniature motorbikes at incredible speeds without helmets, they were all shouting at the top of their voices.

Louise was forced to move when John was cleared out of his rented accommodation. She was now dossing down at Ian's place in a semi-detached council house. Some of the houses were beautifully kept, others looked all but abandoned, and still others were boarded up with steel grilles welded into the window frames so that they could not be pulled away.

I went into one of the few local shops. The little that remained on the shelves behind perspex and glass display cabinets to stop shoplifting cost at least a quarter and sometimes a half as much again as the same items in the city's large supermarkets. I asked the young shopkeeper the way to Ian's street. 'What do you think of England?' he asked and, without waiting for an answer, 'It's not fast enough, I want to go to America.'

I found Louise, Sheridan and Ossie on Ian's bed. There were no

covers, no sheets – just a bare mattress. Each corner of the room was piled with drifts of refuse as though some storm had swept up everything in its path and deposited it where it could not be blown any further. A toilet roll, torn magazines, fish and chip wrappers, cigarette butts, empty crisp packets, used matches, chocolate foil, a playing card (the two of spades), an empty milk bottle, an unwrapped condom, chewing gum wrappers. Ian sat alone on the floor of his living-room, lost in his thoughts, an empty coffee mug at his side.

I had been attracted to the bittersweet quality of Louise's accounts of her experiences. She continued in her affable, irascible style, while Sheridan watched *Home and Away* and Ossie stared at the ceiling.

'I like reading and writing and drinking, that's a brilliant number – drinking. I like true stories 'cause they make me cry. I write short stories about my life, I don't let anyone read them because they're not good, they're rubbish, really rubbish 'cause I don't know how to write them, I just write how I feel. Like a diary, but not a diary form, when things come into my head I write them down like when I'm depressed and bored or when there's nothing left to do. I see myself like, I don't know, mostly depressed, always feeling bored, and I just wish I had a better life than I had done. It's nobody's fault that I were on drugs, there's no point blaming anybody else because if you don't want to do it you won't. Drugs and offending is what really messed my life up. Because it's the drugs that made me do them and it's really hard to come off them. Most other people see me as nice, someone who can help them with their problems. They come to me with their problems 'cause they know I'll never turn a friend away. "A friend in need is a friend indeed." If you turn a friend away then you're just like an enemy.'

Ian wasn't anyone's enemy, but he was visited regularly by groups of youths offering him protection. He couldn't keep them out: there were so many people at his house at any one time, someone always opened the front door to them. Louise told me, 'I'm going to break both Ian's legs for grassing me. He threatened me for dossing down at his place, threatened me with calling the pigs and going to prison. I thought great, I'll get a decent place to sleep. I told him to call the cops.'

There was a bittersweet quality to Dodge as well. A pensioner told

me she had lived there for sixty years, had really nice neighbours, and 'I really like the wide road and all the trees. It looks beautiful in summer' – which it did. But she also lived like a prisoner.

'I'm seventy-four and I'm afraid to go out at night. All my house windows have locks, my doors have extra locks on them. My car gets broken into every month, I can't believe someone would want to vandalize our car, but they did. I leave it open now, so there's less damage. Late at night I hear drunk people walking down the road and making a lot of noise. I can't tell people I live here because of the reputation of the area. I always tell people I live just off the Narborough Road. I think it's a shame because I have never lived in a more friendly area before. I should feel proud of the place I live in, but I don't. In spite of all this I wouldn't like to live anywhere else.'

I spent much longer than I had planned in Leicester. On my last day I went to retrieve a book I had lent Louise and found her in town outside the minicab office. She had been shoplifting. When I asked her why, when she was on probation and facing a prison sentence, she told me, 'It were for friends, not for me, just jeans. I know it's risky. I think what if I get caught, I'll go to prison, it'll batter my head even more.'

Worse was to follow. When we got to Dodge I found Ian in his customary position in the corner of his living-room, Sheridan on the floor by the window and Mandy stretched across John, her fiancé, on the living-room sofa. She had a black eye and a bruise on the opposite cheek, and she held her hand over her mouth as if she had just been hit.

'What happened to you?' I asked Mandy.

'I walked into a lamp-post.'

They were all out of their heads. John had been arrested for burglary the previous evening, but was released for lack of evidence. The room returned to a silence so profound you could have heard a cockroach sneeze, then Louise called Mandy a tramp.

Mandy called Louise a bitch.

'I feel like someone punched me in the face,' said Louise.

'It's bad, that going with your boyfriend,' added Sheridan.

Mandy had not walked into a lamp-post, she had given Louise and Sheridan's boyfriends a blow job.

'I've brayed yer fucking slag of a girlfriend.'

'I'd never hit back so she brayed the shit out of me.'

'She could have pressed charges, but I'd have been waiting for her, to kill her.'

'You'd have been inside.'

'When I got out.'

John had taken Mandy to the doctor who had given her painkillers for her bruised ribs.

'I told the doctor she deserved what she got. She never did hit back. My mum says it toughens you up. You just take it. That's sticking up for yourself. We'll win anyway, because family stick together like glue, then they [the family] end up beating you up, that's the way it is nowadays. You can't trust your best friend,' said John.

'You can't trust anyone,' said Ian.

After I left Leicester I kept in touch with Louise. In her first letter to me she told me that Ian's house had been trashed – the light fixtures were ripped out, the glasses in the kitchen smashed and his stereo kicked in. The police were called and took everyone to the station, but they didn't know whether it was a criminal or civil matter. No one was found responsible and they were all released. Ian was rehoused by a housing association at a secret location away from Leicester. Louise moved in with her brother. She's now living with Sheridan and her mum who had recently been rehoused after being pressured by drug dealers for the use of her house. John's still trying to sort his life out. He went on a training course to be an outdoor pursuit instructor, but he still wants to join the army. Nikki ran off with a guy she met in a pub and has not been seen or heard of since. Kylie had an argument with the group and is no longer on speaking terms with them. Mandy was returned to the children's home when the police went to Ian's house. Louise told me she thinks a lot about her dead father and uncle Jim who she was really close to and who was always there for her. She goes to visit their graves and sometimes takes flowers.

My second letter from Louise:

March 1995

I feel really depressed today. Life is totally shit. I feel as
though I am just here to be used by everybody even my stepdad
has tried to use me in the past. He sexually abused me when
I was about eight and a half years old. It really hurts me
when he did that to me because I loved him like my real
dad but now I hate his guts for what he did to me. My
own mother didn't believe me about it which hurts me even
more. It still hurts me when I talk or think about whats
happened in the past. Although I've now got used to it. So
far my life has been totally messed up. I've been in and out
of care all my life well since I was about 9 years old so I've
never really had a proper family. My real dad is now dead, so
now I have no family except my brother, my sister and gran
who all love me. I wish I could just end my life right now but
I couldn't do it to the family that love me. I wish my life
would just get better so that I could never feel like this
again.

June 1995

The last I heard from Louise was a message to say Luke had tried to
commit suicide – he tried to hang himself.

HALIFAX

True Yorkshire Grit

OTHER PLACES HAVE suffered three decades of wholesale destruction, frenzied development or both. One after another, town centres have been destroyed to make way for the homogenized, impersonal architecture of shopping precincts. Halifax, by contrast, seems to have entered a deep and dreamless sleep from which it shows little sign of wanting to wake. Developers have passed it by, because it costs too much to demolish its buildings and it is not rich enough to merit the concrete and steel hangars that are a feature of many towns across Britain.

I tried to take the train from Bradford to Halifax, under normal circumstances a fifteen-minute ride. First there was an announcement to tell us that there would be a delay due to congestion at Leeds. A half-hour delay quickly turned into an indefinite one. Then, after the train left Leeds, it hit a lump of concrete placed on the line by a group of seven- and eight-year-olds. Although we had been informed that the train had hit a boulder, the station master told us that due to a signalling fault, 'our computers haven't been able to tell us where the train is'. He assured us that BR 'will get you there as long as it takes'.

I asked the way to the bus. 'Over there, love, by the Town Hall.' Charlie, a teacher at a local comprehensive, was waiting for the bus beneath the town hall's tower, a meticulous copy of the Palazzo Vecchio in Florence. He was on his way to visit his sister on the other side of Queensbury.

Even though railways once commanded the best vistas as they cut through the countryside, the bus ride from Bradford to Halifax was no less inspirational. The bus climbed and climbed as it left Bradford. Great stone buildings that were once Baptist and Methodist churches, woollen mills and dyeing sheds, had either been converted

or abandoned. Where there had once been a pulpit or large vats, there are now discount carpet warehouses. Rising to the crest of the hill beyond Bradford I caught sight of the mills that dot the countryside like abandoned Stonehenges, their great chimney stacks like lighthouses marking the former engines of the Industrial Revolution.

We passed a succession of streets named after the heroes of the Crimean War – Napier, Raglan, Cardigan. Here Britain's links to its colonial past are as ingrained as the marine fossils that lie embedded in a fine Yorkshire stone appropriately called millstone grit. We kept climbing, the bus darting in and out of the clouds. As we reached the top of the hill our view was no longer doused by the clouds and, winding our way gently downwards along the corniche, we had a spectacular view of the eastern edge of the Pennines and the moors beyond. Charlie turned to me. 'My dad told us "this is as close as you'll ever get to flying"; he never thought we'd get to fly on a plane. He was in the RAF.'

According to which town clock I wanted to trust, I had arrived in Halifax at 3.34, 8.27, or 9.17. I had arranged to meet Graham, one of my photography students, outside the train station.

Graham was a tortured soul beneath a veneer of confident determination to succeed as an artist. At turns he was absorbed, frustrated, annoyed and challenged by the goals he had set himself. His dreamy side had a lot to do with his ambitions. His insecurity and awkwardness stemmed from his roots. He didn't want to remember his past and at college he had nothing to remind him of it. For someone like him, memories could be painful at the best of times.

He was introspective: placid sometimes, on the surface, but a person of incalculable deep feeling. When I had asked Graham about his background one quiet moment in college, I was immediately drawn to his story and his neighbourhood.

'I hate the violence, the drinking, the vandalism on the estate,' he told me. 'I'm embarrassed to tell people I come from there. In some ways it's typical of estates in Britain, in others it isn't.' When I asked him to take me to his home, he warned me that he would rather meet a group of armed Afghans than the gangs that roamed his estate.

'Can I meet your parents?' I asked.

'What are you going to do when you meet them?'

'Talk to them!'

Graham's dad had been a wire drawer at Smith Wires, but had been forced to retire because of a bad back. His mum, who was originally from Durham, had stopped working when she got married. Graham was the youngest of eight children. His oldest brother had studied graphic design and had got a job in Australia, the third brother and two sisters worked in local factories, one was a nurse and one was on the dole.

'My dad wanted me to get a job when I left school. I wish I could have been brought up different. We always ate frozen food. I never knew anything else. Not that it's bad for you. I would have just liked to have had something that needed chopping, or dicing, or slicing. We used to go into town once a week. We never went on holidays, the furthest we got was Sowerby Bridge. We once went to Bradford, it was quite some trip. I was so thrilled when I got accepted into art school last year. It meant I was able to move away from home.'

As we walked along the winding lane towards his parents' estate, he explained how an event three years earlier had changed him. 'I was walking along this road when I was mugged. I never saw them, they came up from behind. I have a huge scar on my head, that's why I always wear a hat.' The scars weren't only physical: he had lost his confidence and admitted to not liking the way he looked. He thought his attackers were in all probability people he knew, boys from the same school and possibly the same class.

The back-to-back houses stood in neat little rows. Some were boarded up with steel plates welded in place – blockboard was too easily removed – but we passed one empty house where those trying to break in must have been disturbed. They had tried to break in with a grappling hook that lay abandoned on the ground. Rubbish littered the roads and some of the front gardens. The bus shelter was smashed, the children's swings lay broken like a puppet severed from its strings. The bunker containing the small electricity relay station was covered in a web of graffiti. This neighbourhood was described by the council as one suffering from 'multiple deprivation'.

Mr and Mrs Stanley lived in a cramped but tidy and spotless house. They both rose early, a habit unbroken since the days when they had

both worked in factories. Mrs Stanley immediately set to getting the breakfast and then her daily chores of cleaning the house began. She might scrub the paving stones in the immaculately tended garden, wipe down the spick and span fence, or scrub her doorstep. The front door was never used: everyone, including the delivery men, the numerous door-to-door salesmen, and even the Jehovah's Witnesses knew to knock on the back door. The only objects to break the monotony of the walls were the sacrosanct picture frames with family photographs. Mrs Stanley always wore a nylon overall which was never removed, even after she finished her cleaning chores. When she wasn't cleaning she would look after her children's bairns, her granbairns. Anything more than sitting down for a cup of chugga (tea) would have seemed slovenly. When Mr Stanley was back from tending to his allotment, she wouldn't talk and he wouldn't stop.

I introduced myself, but had hardly finished before Mr Stanley began his Tarantino-style monologue.

'I don't talk much, you call it reserved or something like that. I'm retired, I muck about, had hens. I now spend most of my day tending my allotment.' He still wore his cloth cap and braces that were as much to restrain his belly as to hold his trousers up. He boasted a single bottom tooth as a mark of distinction. Fiercely proud, he never stopped to catch his breath. 'There are tens of thousands of people till you get to me – the serfs. I was a dog's back leg, bringing up ale to all those posh people. Someone was always on your back driving you too much, from arsehole to breakfast time.

'My uncle was a self-made farmer – everything he touched turned to money. He was so rich and so dirty, he'd only had two washes in his life and one was the midwife at birth. When he died and went to Heaven at the gate he was asked for his money and that killed him a second time.

'Have you seen my front door? It says, "We shall expect verifiable identification"– do you know they still had the cheek to nick my front door handle? Even if you have twelve rottweilers, five alsatians and a security guard in the front room, they'll still break in the window. I saw kids doing me car window in with a stone. The kids' mother starts effing more than I have done in all my life. The world's changed, it's full of jails, look at the vicars – 90 per cent are perverts, they should

be put to sleep. Do you know why they say, "From Hull, Hell and Halifax, good Lord deliver us"? It were the Gibbet Law which was retained in Halifax long after it had gone in other places. A man could have had his head chopped off for stealing goods worth a few pence. They should think about bringing it back.

'I've tried to breed decent kids. None of them have ever been on the dole.' (Lisa, his third daughter, was.) 'Our Graham, there's nowt wrong with his plumage, but I don't know what he's doing. He's got plenty of ideas, but he's on wrong side of bloody fence.

'No politicians do anything for us. I'm sixty-eight and I've got no money, I'd like some of that. I want to know how people here have a room as big as can fit my whole home in it. With £30,000 Range Rovers plonked down outside. The more money, the less principles, that's all to it you know. I believe in King and Queen but the rest o' them lot are all tourists. Princess Margaret has had so many men, you know if you were to put them parts together it'd be as long as a handrail from here to North Yorkshire – It's not right to go to bed with anyone, you might as well do it with a caterpillar. Prince Charles is the village idiot.

'Universities are full of ladies' and lords' kids, buggers like that, they ask for what they want and get it. If they'd ask for God he'd come down and shake their hands if that's what they wanted.

'But I'm telling you this is the most beautiful country in the world. It's got the best of awt. The best weather – too much rain, too little rain, everything.'

Graham told him I was half-American. 'He writes travel books, he was recently in Africa where you fought during the war. He came back by plane.'

'Well he didn't bloody swim. Foreign muck, just like Scousers and Geordies and Cockneys, mind you the Cockneys are a breed apart.'

Graham pointed out his tee-shirt was made abroad.

'It was given to me. We invent something, the Yanks take it, and then the Japs make it. You better bugger off back to America.'

Mrs Stanley brewed the tea and made some sandwiches.

'If you're young and unemployed around here, you're probably an offender. You'll be around that lot here, you'll have to watch yourself.'

Graham, his sister Lorraine, who worked at the Nestlé factory, and

I left together. As we walked to the bus stop, Graham crossed the street to say hello to Mrs Green. Her son had been one of his best friends at school. 'He was a brilliant cricketer and a talented sportsman, he had everything going for him, then he got stabbed outside his house and died on the way to hospital. Next week is the third anniversary. I haven't seen Mrs Green for a long time, I told her about your project and she's invited us for tea next week if you'd like to go along.'

On the way back into town Lorraine told me about her job at Nestlé. 'It's a madhouse now. It's so stressful. Before we had a chiropodist and a dentist, it's all gone now. Our supervisor has left, made redundant after twenty-five years. It's more the office staff, management, that are worried about losing jobs. There's more computers. They need us even though we have computers, they still need me to work it. They can't run it with nobody. It used to be called Nestles, now we're to call it Nestlé.'

I tried to get permission to take pictures inside the factory, but it was refused because the photographs might reveal to their competitors the latest technologies used in the works.

Halifax is at one end of the Calder Valley, connected to the outside world by tightly intertwined threads of roads, a railway line, and a greasy trickle of a river and canal which had once been one of the busiest in Britain. All along the valley and into the side valleys lies a confusion of industrial villages and hamlets. The Stanleys' council estate, like so many in Halifax, abutted farmland. Most of the estate's residents knew the farmer by name, if not in person. Two worlds divided by a road: on one side drystone walls, trees, a farm and its outbuildings, sheep and bales of hay; on the other, uncollected beer bottles, used condoms, and discarded plastic bags.

The town was once home to the largest carpet manufacturer in the British Empire, the largest toffee-maker and the largest building society in the world. It was the home of a caste of Victorian industrialists who made their fortunes from the mills. Great stone buildings in neo-Classical, Graeco-Roman and Palladian styles were built in and around Halifax, monuments which gave it the name of 'The Athens of the Industrial Revolution'. Theirs was an age of wealth creation, self-reliance and confidence that amazed the world. Among the

working classes there had been a collectivism, a solidarity, self-respect through shared experiences and the Utopian dream of a better and fairer society. Halifax was not far from the birthplace of the Co-operative movement, the nursery of the temperance movement, and the penny savings banks that were no less beholden to West Riding thrift.

Now it has all changed, Britain has a working class which no longer works, a ruling class which no longer rules, and a middle class which is no longer in the middle but sliding. The Victorian rich who built large houses and gardens on the edges of People's Park have gone and their heirs have abandoned the houses. New tenants have moved in and the Victorian park is sad and neglected. The scale of the orgy of destruction is in itself a kind of masterpiece. The bandstand is wrecked, the park's ornate balustrades have been axed and decapitated, its fountain chiselled and chipped – all that is left are its statues which have been shrouded behind wooden casings to protect them. Someone has tried to remove one of the casings, but abandoned the attempt; someone has written in large letters KILL.

As I walked back into the centre of town I passed a handful of adolescents and young men playing cricket in a backstreet with an empty milk crate for a wicket. At the junction of the main street five more young men sat on the steps of a boarded-up shop, one of them playing with a switch blade. I greeted them in Pashtu and Urdu and quickly made friends with them. They went by their nicknames: Flea, Kilo, Stab, Hussy and Bite. Two of them worked in Indian restaurants, nine hours a day for £9 plus tips, which rarely amounted to more than a few pounds. After a year or two they might graduate to the kitchen for £1.50 or £2 an hour. The dream was eventually to own your own restaurant; as Hussy pointed out, 'There are more people making curry in Indian restaurants than are employed in the mills, coal, steel and shipbuilding industries.' Flea, Kilo and Hussy were unemployed, but Flea, who seemed to be the leader of the gang, repaired vehicles on the forecourt of his parents' house. 'My dad came from Mirapur in Kashmir to work in the textile mill, but they're all closed, he can no longer get work, so there's not much chance for me or my brothers.'

* * *

After spending a day taking pictures of Halifax I often sat in a cafe before catching the bus back to Bradford. I became friendly with Kemal, the Turkish owner, and his two helpers, one a refugee from Allende's Chile, the other a Turkish Alawi. One day as I sat eating a bowl of chilli con carne, Kemal brought a young woman over to my table in the corner of the cafe, helping her as she struggled with a bag of Pampers. She was neatly dressed with beautifully combed hair. I became quickly engrossed in her story, told in a broad Yorkshire accent.

'Kids are not kids any more. I know lots who ran away. My best friend wanted me to run away, I didn't want to drag my child [then three months old] in the back of a car at midnight, raining horrible night, she did it, it's not right.

'I was born here. Until we got to upper school life was all right, then it changed. Parents started to change. My dad was all right, but my mum wanted us to be pure Pakistanis, prayers all the time. They sent me to Pakistan at fourteen years old to meet Pakistanis, see what they are, what our religion is. I thought they were really weird, the full *neqab* covering the whole face. I did it for them over there. But back here, England, people don't do it here. You got to be like other teenagers, you can't be different, to survive. Different in Pakistan areas. If you cook you've got to give it to neighbours like in Pakistan, pass it out and share. You can do it in English areas, pass it on to neighbours if you're cooking. I don't feel English, I feel confused when you've got to be a Muslim, but living in a different environment. Don't know what to be, what to do. I like wearing English clothes and Pakistani clothes, but I feel comfortable in English clothes.

'We had to fight for our own rights. If you've got a different colour, they expect you to be from outer space. Like my middle school, full of white people, even the schoolteachers were racist, but I kept quiet about it, sat in one corner. When I discovered I had a reading problem, I went to the teachers, they didn't do anything about it, they didn't want to know.

'I stayed in Pakistan for a year. I came back, started in a factory at fifteen, pressing. I didn't know I shouldn't be working. I earned £54 a week, I gave my mum thirty quid, £24 for myself. It were really hard, pressing all day, hard on your arms, standing up all day, managers making sure you didn't sit down or go off to the toilets – allowed

twice a day. Half an hour for dinner, ten minutes break in the morning, ten minutes break in the evening. Trying to think. A lot of bitchiness. A hell of a lot of bitchiness, racism, a lot of white people there. I worked five months there.

'Started going out with this guy. I thought I was in love with him. I weren't sure. I used to sneak out of window down the drainpipe. We'd just sit and talk and listen to music and smoke and laugh, enjoy ourselves. My family found out about it. His family already knew. My family wouldn't have it. Boyfriend not accepted, I don't know whether he was superior or inferior. So I took an overdose of Paracetamol with all the pressure around, people saying things to me – I'll never do it again, too childish, you think it's going to help, but it makes things even worse. My mum said go to Pakistan for two weeks. Then I didn't come back, the two weeks were just a lie. I didn't come back! They got me married and my sister at the same time, on the same day. I didn't know this man, I'd seen him, he were my first cousin, my uncle's son. He hadn't been over here, he were born and bred a Pakistani boy.

'We didn't get on at first. But then we started to get on, 'cause there were nothing better to do at the time, sitting around the house all the time. And then they wouldn't let me back to England until I was pregnant. I was five months pregnant when they let me come back to England. Then I had me daughter six weeks early when I came back to England. She had kidney problems, in and out of hospital for three years. Then eventually I applied for my husband to come over. Well, he came over and then my father died. I were really depressed because they didn't understand. They expected me to be right chatty. My father got me married off and then died and left me with something I never wanted! My husband doesn't like the way I am, I'm too Westernized for him. He couldn't get on with my family or with me. I used to ask him to go to places, seaside, park, town, nightclubs, have a laugh, but that's what he didn't want. He wanted me in the house cooking, cleaning, having babies, staying in house. That ain't me.

'I started to stand up for myself but he didn't like that. My family didn't like it, either. They're trying to push me back into being a real Pakistani woman. I'll give it one more try and if it don't work out that's it. I'm going with the dust.

'Once you're married I was told you can wear make-up, cut your hair, wear what you want, but it weren't true, I weren't allowed to do nothing like that. You got to keep your hair in a plait and a scarf on the head. I'm not allowed out of the house without his permission.

'If I come into town, it's not very often at all. If I do, I come in here. Because I know I can talk to someone, Kemal or Osman ask me, "How are you? What are you up to? How's life treating you? Is it good?" It makes me feel a lot better, because I never get asked. They cheer you up, they give me compliments. I'm losing myself now.

'I'll go at half-past [five]. I'll get into trouble. But I'm not doing anything wrong, am I? They'll probably think I've been off with a fella. They'll accuse me of all sorts of things I haven't done. I'm quite a boring person, don't you think?

'I want to better myself, I want to go to college. I want to know how to read things properly. All I ever wanted to be in life is somebody's secretary or head of an office or something. I don't want much out of life. And I want somebody to love me for what I am.

'Aren't you bored with me talking? I think I'm going off my rocker, go mental, that's why I want my child to go away for a few weeks so I can sort my mind out. I feel like crying now.

'Any little thing, whatever she does irritates me. Everything she does pounds in my head. I want to run away, but it's not her fault. It's everything that's around me that's getting on my head, all the problems I'm having. I'd be aggressive with her so that's why she started to be aggressive with me. I've actually slapped her once or twice for answering me back and she's started to do what I've been doing to her, it makes me feel like crying, it's me doing it to her that's making her do it to me. I shout at her, I sit there, look at her, feel sorry for her, cuddle her and feel sorry for myself. I hate myself for it. Because when I was right polite to her, she's polite to me and like when I started changing she started changing as well.

'I never talked about this with anyone, my family, that's all I've got to talk to and I don't with them. Because if I did they'd call me stupid because I'm not allowed to express my feelings. They've always called me stupid. You gotta let yer feelings out, but they don't expect that, they expect you to keep it inside, they expect you to listen to others and do what they tell you to do.

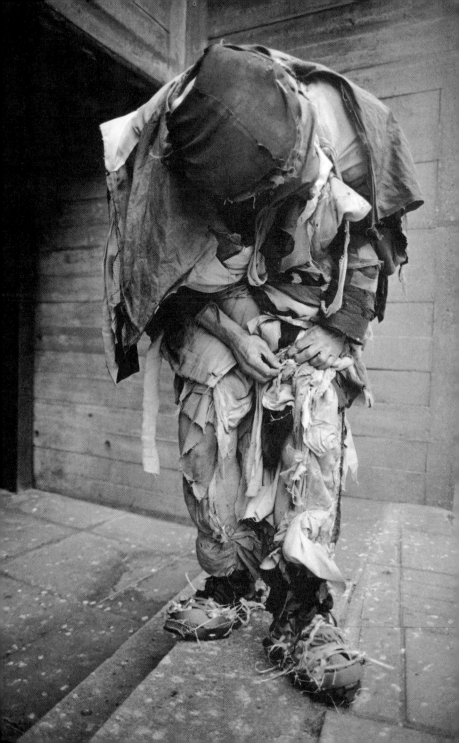

PREVIOUS PAGE Care in the community:
Ian, South London

RIGHT Entrance to crèche, East End,
Glasgow

BELOW Tag artists, Leicester

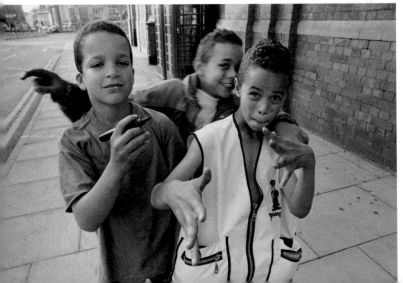

PREVIOUS PAGE Leiston, Suffolk

ABOVE Barrow Island, Barrow-in-Furness

OPPOSITE:
ABOVE Street chic: mobile phone and switchblade
BELOW Teenage runaways

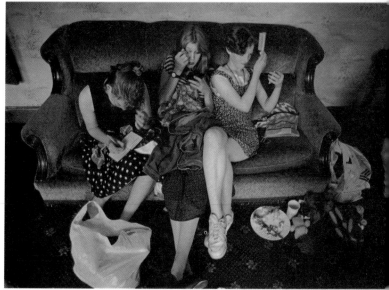

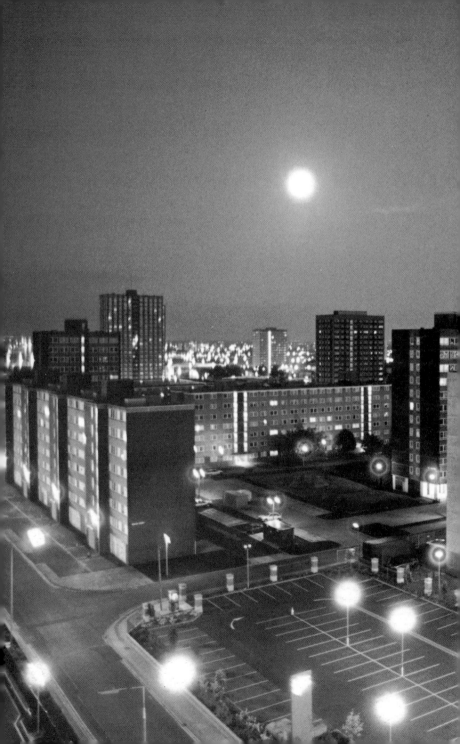

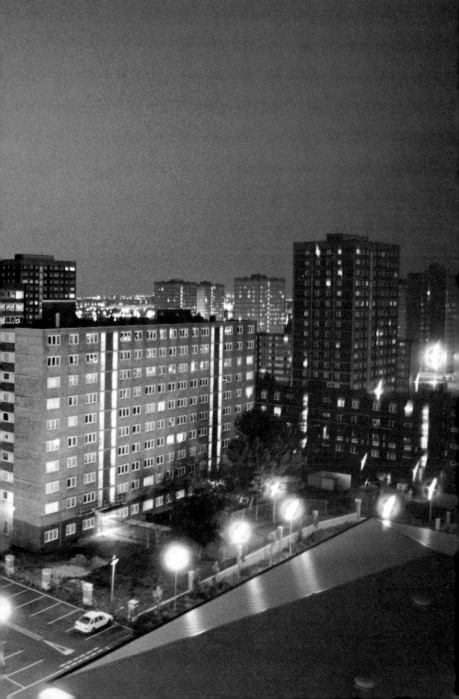

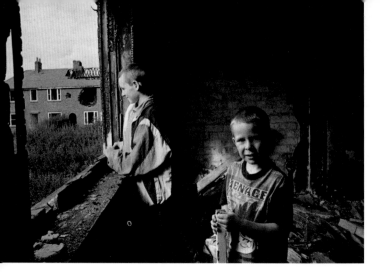

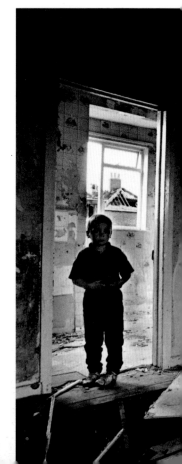

PREVIOUS PAGE Salford

ABOVE AND OPPOSITE West End, Newcastle

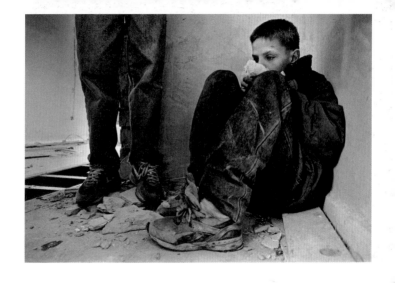

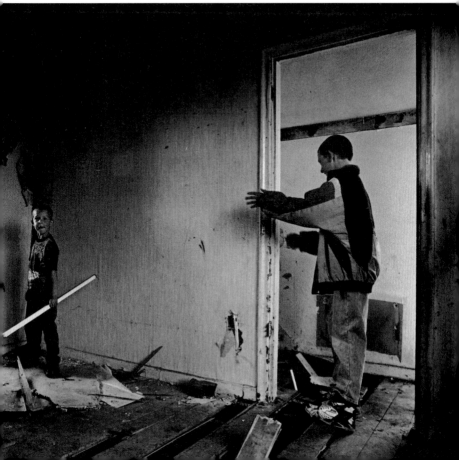

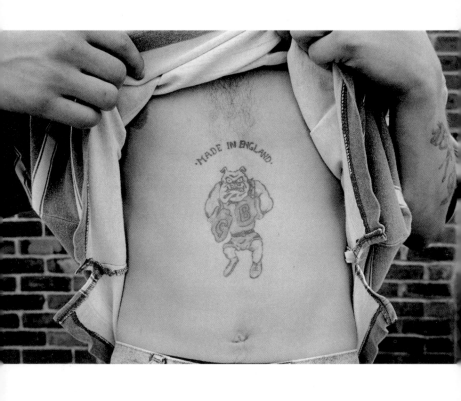

Brighton

'I could go on for days, but I don't have the time because I got to get home. I get slapped by my Mum for answering back, not my husband, he wouldn't dare. But I always sit in this corner where Asian taxi-drivers can't see me. They're like a Mafia. Word would go out.'

I asked her if I could see her again. 'I come on Fridays, same time every week. But you should go and see my best friend Nish, who wanted me to run away with her. Her father-in-law has asked the Bounty Hunter to track her down. He's said he'll pour petrol over her and set her alight when she's brought back. She's got no phone, but I'll give you her address. Tell her I sent you.'

I thought back to Leicester and what Ossie's cousin Ali had said to me about arranged marriages: 'It's stupid, but it's good because you get to know both sides, good and bad, when you marry for love you only see good.' For Rukhsana and Nish neither had found a good side or love.

As I had hitched along the industrial north's M62 corridor from Doncaster to Halifax and later on to Rochdale, Oldham and Manchester, I could see how the old industrial heartland had been hit hard, creating a rust belt. Post-industrialization had created a Bermuda Triangle in which entire families and neighbourhoods had been wiped off the job map. They are not equipped to deal with the destruction of that past by politics and competition and the pace of technology. I kept searching for answers. There was no point in glorifying the past; Lancashire's and Yorkshire's workplaces have been described as satanic mills, and not much has changed. There's more or less the same balance of richness and squalor, only with pubs replacing churches and temples – or maybe the pubs are in fact the new temples. Real change could be effected by the political system, but instead there's a lot of shouting and screaming going on. The way I saw it, it wasn't just Nikes and crack that Britain had inherited from the United States; it had now also inherited its two-party political system, with neither side representing the downtrodden, the tens of thousands of impoverished residents of council estates and hardscrabble rural areas. They are potentially an explosive force, but an unpredictable one because they are as disorganized as they are poor.

Squatters, students and a few militant unionists do not make up

what a shrewd politician would regard as a reliable constituency. I thought of Orwell, who once described himself as lower-upper-middle class, and Charlie, who had escaped from the mills and become a teacher:

'It really bugs me when these middle-class schoolteachers and the likes go on about socialism. What the fuck do they know? When their jobs are on the line they look after themselves. My dad and uncle were die-hard trade unionists. Now of course it's all spreading out, you've got the underclass, but it's the middle class that are starting to lose, they're becoming part of the redundancy pile. When their job is on the line, the middle-class socialists start looking after themselves. The middle class play at being one of the people; when I first came across the middle classes through my dope smoking, they lived in squats, they could always go back to mummy – we had to survive. I tell you one of my favourites, I just finished my shift at the mill, I was in my overalls covered in shit. I went to Bradford to collect Lisa when I began going out with her. I passed the university and there was this guy selling the *Socialist Worker*, he was on a management course. I said, "Fuck off!" '

Charlie's story is worth recounting. He had started his working life as an apprentice engineer in D-shed at the mill. The routine was the same week after week, year after year. Up at six, to work by seven-thirty and into damp overalls. If you were late by more than a few minutes you had your pay docked. He found his escape from his boring life, dead-end job and crippling pains through heroin.

'I took heroin as regular as clockwork. It was as regular as having a wash, or brushing your teeth. It gave me a wonderful peace as it coursed through my veins, but the more I used it, the less the hit. I wasn't a criminal or anything. I would never change those days. I come from a working-class background, now I've made it, I'm a teacher, the middle classes I mix with at work assume I'm from the same background as them. I still occasionally see the working-class people I grew up with. I'm not really part of either group. They would never come into contact with each other. I kicked the habit over fourteen years ago. But I've no regrets – if I hadn't got into drugs I wouldn't have met the people I've met, gone to art school, travelled and seen the world, changed horizons, my life. The shop floor was killing me.'

For me the industrial north had always conjured up images from Lowry's paintings of smoke-belching chimneys, factories, terraces and a multitude of stick figures, people going to and from their shifts in the factories and mills. Early one morning I stood for a moment on Halifax's decorative old iron bridge facing Dean Clough, the mill that had once provided the carpets for Buckingham Palace and the former royal palaces of Europe, for Princess Grace of Monaco and the *QE2*. It was the city's largest mill complex, which had once employed about 5000 men, women and children and stretched for three-quarters of a mile over sixteen acres with twenty-seven acres of floor space. The spectacular setting on the edge of this compact and dramatic hill town could have been a picture-perfect design for Lowry. I waited for the stick figures in their cloth caps to appear on foot from the banks of terraced houses in Boothtown. Instead they came in BMWs and suits from as far away as Leeds and Harrogate. Insurance salesmen loitered on the pavement outside the mill's new offices while discussing their dinner plans and golf. Two secretaries in far-eastern printed wraps glanced at them and chose to ignore them.

The mill is being reborn as a post-industrial service centre with art galleries, a sculpture studio, and theatre companies who will frame the world in abstractions and metaphors because here the figurative has been replaced by the ethereal – the weaving floors where seamless, tufted Axminsters were produced have been replaced by an insurance company, the looms for Saxonies and for plain and figured Wiltons have been sold abroad and have given way to a gym and offices for HM Customs and Excise.

Now the shop floor has all but vanished. The bareness of the moors is mirrored in the empty, derelict spaces of the industrial landscape and the dispiritedness of the descendants of those who deserted the farms to find work in the new industries. Wherever there was space and water, there a mill was built, more than 120 in all, of which only a handful are still functioning. Where they exist the average age of the shop-floor worker is somewhere in the forties. As a managing director explained to me: 'We'd rather have older people, they're slower, but they stick with it.' Management don't want to employ seventeen- and eighteen-year-olds who don't yet know what they want to do. They don't want to employ young childless women because they might have

to give them maternity leave. They don't need to employ people on full-time contracts and concern themselves with non-performing workers or redundancy payments when there is an ocean of labour who will work part-time, for piece-work rates or on commission. Additional work that can't be handled on the shop floor such as burling (trimming knots and lumps) and mending can be sub-contracted to women who can take it in at home.

When I wandered through a mill, everyone had their complaints. The director complained that lawyers and accountants were running the country, and that financially he had lost out compared to his friends. He complained that this was reflected at schools in the low numbers that chose to take maths, physics and chemistry. Manufacturing was relegated to Cinderella status. The workers complained of the working conditions and the monotony of the job. The supervisors who had graduated from the shop floor complained they had become piggy in the middle. One told me, 'I'm only doing what I'm told to do. I'm still one of them, my wages are more or less the same, I went to school with them, but they no longer fraternize with me, I've no personal relationships left here.' Everyone complained about the rates of pay. Most of the workers were on £120 to £140 a week and many had to pay £6 or £7 to get to work. Staff and supervisors were angry that they had been given a pay increase of inflation plus nothing while the bosses awarded themselves double-digit rises.

I thought of the words of Glyn Hughes in *Millstone Grit* on discussions about the weather and life's inconveniences; it seemed to me appropriate to the current circumstances and particularly British: 'This way of grumbling about everything was a sign of being able to contain and accept everything; to say that you "couldn't take any more" was to show that you could still carry on "taking it".'

The workers were made to feel fortunate to still have a job. It wasn't just the machines from the mills that were being relegated to the industrial museum in Halifax, but their former operatives. Charlie introduced me to two former mill workers who stood silently in their current reincarnation as museum wardens, guardians of their own looms that had once clattered and thundered as the yarn bolted from side to side at lightning speed through the iron monsters. The silence within the museum and the respect accorded to its exhibits was akin

to the sacramental reverence accorded to great works of art and cathedrals.

Having heard Rukhsana's story in the cafe I went to find her best friend Nish in Brighouse, better known for its brass bands than as a refuge for abused women. I travelled out of Halifax, each curve in the road offering a different view as if the valleys themselves were moving. In one the sun shone in all its summer brightness, in the next it rained a tropical downpour. I went several times to Nish's house in the middle of a poorly lit council estate before I found her in. She had a boyish, eloquently blank face with plain bones, tight skin and a nose carved of shale. Beneath her cropped hair, which was ebony and not jet black, her Egyptian eyes had lost half a lifetime of light. She was dressed in trousers and shirt. When she laughed, which was rare, it was like water bubbling from a spring, but there was something bleakly bracing in the way she told her story. It expressed all manner of emotions: anguish, ardour, terror, sheer despair.

But nothing could have prepared me for the way she lived. As she told her story with her two-and-a-half-year-old son nestling in her arm I surveyed her room. It was quite obvious why she wasn't keen to let Omar play on the floor with his toys: nails protruded from the bare floorboards. Peeling wallpaper and graffiti covered the walls, the smell of damp was intensified by the condensation given off by the room's gas heater and the cool summer's day. The curtains were shut to avoid discovery by the man hired by her father-in-law to find her. No amount of time could acclimatize me to her surroundings. My breath shortened and my heart began to pound with a feeling like vertigo, not from altitude but from lack of fresh air, the stench of dampness and from the fear of what can happen to someone when they fall. For her not to have buckled and returned to her family gave her a purchase on real heroism. She had no cooker, so all their meals had to come from fast food takeaways. Her only social contact came from visits to her sisters and brothers and the television set, and dreams of becoming a fire-fighter or a paramedic – 'I don't want a boring job and I want to end up with lots of money' – took her outside her own reality and the threat of being found by the Bounty Hunter, the 'fat bastard'.

I had heard of him before, in Leicester, in Bradford and now here. Nish's sister had told her her in-laws had hired him to find her and bring her back to them. Kemal, in the coffee shop in Halifax, knew one of his 'helpers' or henchmen. It might take a few days to arrange a meeting, but, knowing Kemal, he would be as good as his word.

I saw the framed announcements in the *Evening Courier*:

> In loving memory of our son who was taken from us
> three years ago today. This day of heartache is here again,
> And all our tears still flow, Our memories keep us close
> to you son, because we love you so.

It was signed 'Mom and Dad'. There were others from friends and family and a passport-sized photograph of Richard in which he appeared like a parent's ideal young man, well-groomed and wearing a tie and jacket.

We arrived on the estate under a wet black sky, the sides of the valley illuminated by biblical shafts of light from a break in the clouds; it reminded me of the mills I had visited and the bands of razor-sharp light that shone through the windows, highlighting the dust particles that hung in the air. Walking through the estate with Graham it was as if our first visit was repeating itself, winding the video back and letting it run again. Five-year-olds played in the street, three pushers dealt from a Golf GTi and a police van circled. A family of four, father and three sons, ran to the bottom of their garden to greet the policemen with, 'Pigs. Get out of it!' The two policemen took it like water off a duck's back. As we turned the corner into Mrs Green's street the tension felt more like Sicily than Yorkshire, each street with its family or clan, the barometer of tolerance and violence gauged by the reach and temper of its clan members. The police van passed us and slowed to a walking pace alongside a fourteen-year-old boy. They said something to him, but I only heard the boy's answer: 'I don't want to talk to you, dickhead!'

Mrs Green's was halfway down the street. Each house had its pocket-handkerchief of lawn leading down to the pavement. The few cars were either on cinder blocks or shrouded in nylon or plastic covering.

It was easy to imagine how the Greens would have gathered for family events. The chairs and sofas were wide and comfortable and Richard's neat appearance in the photograph was matched by the polished and gleaming surfaces and the soft, warm colour scheme of Mrs Green's living-room. I could smell the faint aroma of furniture wax. In contrast to the immediate tidiness, the picture beyond the band of sunlight that was now falling on the windowsill's dried bouquet and four ornamental ashtrays was of a house on the opposite side of the street that appeared derelict except for the youths that had gathered on the porch to swig cans of beer as they babysat a toddler.

'I've made some tea, would you like some biscuits? There are digestives and cream crackers. I'll leave them on this table so you can help yourself.' Her voice was calm and even, but brooks of emotion coursed beneath the surface. Graham and I sat facing Richard's picture which held centre stage above the brick hearth between a carriage clock and a handbell. Mr and Mrs Green sat either side of the gas fire.

'I used to work as a care assistant, but they closed the home. I'm looking for a job, but there's no money. I want to earn £150, but they tell me to be realistic. If they hadn't shut the home I'd still be working there. We baby-mind three days a week, me grandfather looks after the garden, we faff about, really boring. Can't afford to go on holidays, three grandchildren to look after and we looked after your mum,' turning to her husband. 'We do crosswords and me puzzles. Nowt exciting. Used to be able to go loads of places, now they're all smashed up and you need money; in years gone by you could do anything for nothing. Once you get to forty you're soon fifty. I don't have the energy. They say life begins at forty, that's rubbish. I don't envy you young 'uns, nothing to look forward to. Too much emphasis on money. Today all money, money. Seemed to go a lot further in years past. Granddaughter must now pay a fiver to go anywhere.

'Richard would have been twenty-three this year – the son what we lost. He had two children. Trisha was expecting in October, it happened in July. Just got married fortnight before he were murdered. I'd been working, me. I was sat on the settee. Trisha was here. Stan burst in, "Your boy's been stabbed." I picked up my cigarettes, purse, I don't

know why. I ran to the wrong son who lives other end of street. He'd gone to hospital. She ran me up to hospital casualty. I stood there watching them working on him, only saw his feet. "He's dying." The way they tell you ... "Sorry, we've lost him." Just unbelievable. One moment he had been asking me, "Any bills, Mum?" the next time I saw him, he was laid out on a trolley, dead. Bled to death, stabbed in the heart.'

She talked and talked in a way that reminded me of amputees I'd met who'd been injured by land mines – they suffer pains, cramps and itches in the leg that is no longer there. That is how Mrs Green felt without Richard, feeling his presence where he no longer was.

Going through the events was a ritual of catharsis. Richard had run out of his house after he heard two men and three girls arguing. The argument had been over the key to the neighbour's house and a frozen sausage that didn't exist.

It wasn't only that Mrs Green missed Richard, she was grieving from the memory of the injustice. 'We were told he would get ten years, he got five, he's already out. I'm told, "Don't fight back. You'll make yourself bad as them. Don't let them drag you down to their level." How many kicks do you have to take?

'You get very bitter. In court you're all sat together with his parents. Oh, and you want to get at them. You want to make them hurt, like you've hurt, I don't know why. They never showed no remorse. You don't know what to do these days, help the police or do it yourself. 'Cause they're not there when you need them. I wished I'd sorted the lot of them out, but you're in shock. We heard he got beat up in jail, we're glad, we hoped for that, it's at times like that you wish you knew criminals. It's an awful feeling, it's like living in a balloon in limbo, you're watching TV and there's no sound. I suppose you mellow as years go by. But you never forget.'

Mr Green never spoke. Mrs Green was caught between doing the right and decent thing in grieving for her lost son, and trying as hard as possible not to wallow in her grief. She had tried victim support, the police and the public prosecutor, she clung to the past which seemed better than the present, and she went to the doctor who gave her tablets which blunted her feelings but didn't take away the pain.

The Greens found that church made them feel better even though they were not religious. They spent their evenings reading books about the next world. 'We wouldn't go on if we didn't think there was something afterwards' – a sentiment I was to hear often on my journey. Mrs Green felt better for talking, and she didn't want me to go away with a bad impression of her estate. 'We've had a lot of happy memories. Yes, we've had our share of windows put through, but it's not a bad estate. We've had some laughs. There used to be some right criminals, they've calmed down now.' They took Graham and me to the front door and, as we lingered on the porch, Mrs Green pointed to her neighbour; she used to be one of them. 'If you were a man I'd eat you!' she said to her over the fence.

'Don't let that stop you,' came the reply.

True to form, Kemal had done what I thought was the impossible: he had arranged for me to meet Cobra, also known as the Bounty Hunter. Nothing was beyond Kemal. It was his second stint in England, the first time without papers, the second as a member of a handball team. 'Sheila came to watch me in the finals. The M1 got blocked by snow that night, she couldn't get home. She stayed with me and the whole business happened.' He got married and now has two children. But what I was discovering through Kemal and his business was a black economy the likes of which I couldn't have imagined. He and his wife had set up a duplicate till at home and every evening they would rerun half the day's takings through it. Most of his friends worked 'on the double' because they earned between £1.50 and £2.50 an hour, which by anyone's account was not enough to live off let alone support a family. Jamie, an eighteen-year-old who could never afford more than a single cup of tea in the cafe, could only find a job as a security guard that paid him 78 pence an hour. His boss subsequently came under investigation for using ringed vehicles.

While the dependence on benefit had become institutionalized for many – they rip off the system because it's what they know – it was hardly surprising when you looked at the low rates of pay and the growing divide between the haves and the have-nots in a culture of personal and corporate greed. Some of the dispossessed were using the entrepreneurial skills shunned by employers to work the system

instead. These tasks, whether working the system or on the double, were approached with a spirit and enthusiasm that was lacking in many workplaces. It could never be said of many of the hyperactive children I met that they were going nowhere fast silently. When they took to breaking windows it was not just a means of venting their anger, their sense of exclusion and bitterness at how they had been failed, but a sign of their resolve to be counted and noticed. Joyriding was a remedy for the thrill-hungry with no money for arcade games. Lee, a youth worker and former dealer living next to Nish in Brighouse, said, 'The posh people come on to our estate to buy drugs, but when their mummies and daddies find out and want them to stop, they give 'em a car or a holiday. We don't have that option.' Lee's ambition was to own a Ferrari.

Kemal dropped me off at a sports hall in Huddersfield to meet the Bounty Hunter. He began by asking me why I was interested in writing a book about him, and went on to tell me he had several offers for a movie about his life story; in one he would star as himself. It's possibly something that authors and criminals have in common – a belief that they have something worth communicating. However, few could match the Bounty Hunter's self-righteousness, which knew no bottom. He despised social and community workers, the police, counsellors and women who go out with married men. This was curious in itself, because he admitted to having a girlfriend who was a social worker. But according to his law that was okay because, 'she knew she always came second'. He boasted that he had brought back 270 girls and three boys from as far away as Aberdeen and London.

'Social workers and the police don't understand', he said earnestly. 'The girls and boys always come with me when I find them.'

'Do you use emotional or physical means?' I asked.

'No. Do I have to hit you to be scared of me?'

He didn't.

I looked behind me, where four large, solid men went through routines of exercises and lifting weights. 'Meet my associates: Khaled and Parwan are gold medallist wrestlers, Janghir is a gold medallist powerlifter – he's just done five years for breaking someone's jaw – and Osman is a black belt in karate.' When I questioned him about Nish's father-in-law threatening to set her alight if he found her and

brought her back, he told me that wasn't what he meant. 'God will decide whether what I'm doing is right.

'I'd like to go to Bosnia, help sort things out, but I don't have the money,' he said as I took leave of him.

On my last day in Halifax I went to say goodbye to Graham's parents. Mrs Stanley and her eldest daughter Lisa were in. Mrs Stanley wore her overall held together by a large safety pin. She told me they had been knocked up the previous night at twenty to ten. 'Dad could have had an attack through fright, because he has a heart problem – angina, any fright and his heart starts beating faster, one of these days he'll collapse. I shouted at the kids, "There's nothing up this path for you", and then they threw eggs at my window. The neighbours saw the kids with stolen goods, they threatened to burn his house, hurt his children if he called the police. There's nowt the police can do anyway. Police pick 'em up, interview 'em, release 'em.'

Lisa had been an overlocker sewing boilersuits for oil workers and doctors and chefs' coats for fifteen years until she left three years ago to have her son. She and her partner John had spent the last three years paying off the £700 bills for John's mum's funeral as well as £78 she left owing. They were about to clear their debts thanks to great frugality: they both lived on their dole money.

Graham would soon be graduating. Job prospects were not good. Out of curiosity I went to Halifax's Job Centre. An experienced flatbed machinist was required at £2.75 an hour, assemblers at £2.90 on what was described as an indefinite temporary contract, or for an extra £10 on top of your dole – I calculated that as a total of £42.10 – for a job advertised as, '18 hours Monday to Thursday as a business advisor, applicants should be former manager/ess or clerical person with experience in a financial environment, including book-keeping and word processing skills'. A job-seeker read it over my shoulder and then said, 'The head of ASDA gets a million pound and I bet he can't do all that. Ten fucking pounds, you know what they can do with that!'

As I left Halifax riding the crest of a hill and looking down on the harbours of lights, I got chatting to the passenger next to me. I told her I found everyone so friendly and I was sad to be heading to the

north-east and Newcastle. She said, 'Forget about Yorkshire friendliness, love, wait till you get to meet the Geordies.'

Graham is now working in a pub. The Greens left Halifax for the first time in three years to go to a fête in Rochdale for a bit of excitement. Lisa's John finished paying off his mum's debt and rented a caravan and taxi to tow them to Cleethorpes for their first ever holiday. Nish has moved. Kemal went bankrupt and his wife wants a divorce. I haven't stayed in touch with the Bounty Hunter, but I hear that, although he is wanted for questioning by the police, he remains at liberty and is still waiting to save Bosnia.

Almost a year to the day after I first met Flea, I bumped into him and his gang at the scene of the Bradford riots. On the third day after the riots had started, Manningham Lane was smouldering while not two miles away a cricket match was being played. An ice cream van with a Union Jack painted on the front above an invocation that read 'There is only one God and that is Allah' was parked up near the epicentre selling pop and ices. Unlike his friends, Flea didn't want to know when the next trouble was going to flare up, and wasn't interested in talking to the few members of the press that weren't behind the police lines. 'Our parents had to put up with being called Paki. You can't know what it is like when you aren't brown or black in Britain. You know, we aren't Asians, we aren't British, we are Yorkshiremen.'

Flea had more urgent matters to attend to: he wanted to go 'shopping' where your flexible friend wouldn't be needed. And why hadn't I gone into business with him? After all, he reasoned, 'You know your way around Afghanistan and Pakistan, we could be earning ourselves some tidy dosh with some brown.'

It was a statement, not a question.

NEWCASTLE

They Burn Houses, Don't They?

KEMAL GAVE ME a lift from Halifax to the A1 north of Harrogate. The greatest risk from hitchhiking is to be subjected to the full, unexpurgated version of the driver's life story. Up to now the lifts had mainly been from male drivers who talked about a succession of failed marriages or relationships that made them sound like modern versions of Henry VIII or the male equivalents of Elizabeth Taylor or Zsa Zsa Gabor. In Middle England many white drivers held views and attitudes which would have been better suited to South Africa under apartheid. Only one motorist had caused me some concern. The grinding of gears and the mistaking of the accelerator for the brake would have been bad enough, but she was groping for the cassette player at the same time. When we parted this driver handed me her phone number and I thanked her, not knowing whether this was British politeness, as in 'we must have dinner some time', or a genuine invitation.

I stood at the exit of the service station with my sign written in big black letters: NEWCASTLE. Within ten minutes a Vauxhall Nova stopped with three people in it. Denis, the driver, was a teacher and in the back of the car sat his niece Sandy and her husband Sean, a Geordie bricklayer. He had been lured to Germany by the prospect of a job as a brickie with 60–70-hour, six-day weeks. Sandy worked as a supermarket checkout operator and they had saved for weeks to get him the fare to Dresden in the former East Germany where he had a contact.

'I was told I could earn about 40 marks [£16] an hour, but when I got there there was no work because the Poles and Ukrainians were doing the same work for 30 marks, some for much less. My mate from Doncaster had even paid an agency in advance but got knocked, he

lost all his savings. We slept in a container with four other lads who were working on site, they were paying for the privilege! One of them got injured, no insurance, they just wipe you off the slate and get another one in. Three of us came back on the coach, we had to borrow the money for the bus fare home, only had the clothes we stood up in. The other two even left their overalls behind, they just wanted to get out.'

As we headed up the A1 and then the A19 the scenery was a revelation. Much of the countryside was turning Japanese, with new factories being built on greenfield sites. According to Jean Cau, the French writer and former secretary to Jean-Paul Sartre, the English 'are no longer a people, but a zoological reserve of a species which we no longer examine with admiration and some fear, but with curiosity. Behind the "eccentric" Englishman there was, not long ago, the immense shadow of Britannia: today there is Mr Toyota with slanting eyes.' Europe, and the French in particular, are jealous of Britain's ability to attract foreign investment with low wages. It isn't surprising that Britain is fast becoming the Taiwan of Europe.

In the urban plain of the River Tees there are symbols of continuity and renewal among the detritus of abandoned industry. Dinosaur cranes, cooling towers and billowing chimneys of the steel and chemical works loom everywhere, but above them are the Cleveland Hills. Such a scarred landscape only emphasizes the contrasts of the region, in which a short drive transports you from one of England's ugliest industrial landscapes to some of its most captivating countryside.

However the north-east's mining industry has all but vanished; the Romans left more traces of their stay in Britain than the East Durham collieries. Not even a stone marker commemorates some of the sites that once employed people in their tens of thousands. As with Hadrian's Wall, the only way to visit the mines is to go on a heritage trail or walkway.

Entering Newcastle I counted six spectacular bridges spanning the mighty River Tyne, once the main artery serving Tyneside's industrial needs. Less than a century before it had been one of the world's busiest rivers. Now the last shipyard is threatened with closure, the ships they built no longer sail on the river and the agents' offices and the Customs

House that served the ships and the wharfs that stored their goods are being redeveloped as pubs, restaurants, bijou residences and an arts centre.

From the quayside narrow alleys and steep streets lead up to the heart of the city which sits high on a cliff. Seagulls circled above, sweeping up the banks and out again over the Tyne, their cries carried away on the bracing wind which came in squalls, and then there was sunshine, sudden warmth.

Romans, Georgians and today's architects have used rock and stone, iron and steel to give the city the most solid of foundations. I was dropped at the University Gallery to pick up the keys to the flat I would be staying in. It emerged that flat-sitting was a full-time occupation in some parts of the city.

I now find it hard to explain what drew me to the two neighbour-hoods I was to explore, in the West End of Newcastle. On my initial ride into town they appeared as if I had been watching another world. The streets of terraced houses tumbled down the hill like the teeth of a rake towards the armaments factories and shipyards that had once followed the river's course. There were no cars on these streets, few people and most of them were children. My first impression as I sat in the comfort of the car's front seat was of watching a film of the early fifties, with one big difference. Whole blocks of terraced houses were boarded or bricked up, many had had the tiles to their roofs removed, walls were crumbling like icing on a cake, their letter boxes were encased in steel cages and padlocked to prevent drop-offs and possibly firebombs. The streets were littered with floorboards and plastic sheeting, and bitumen and graffiti were daubed everywhere.

When I returned the following morning I was ill-prepared. Unlike Halifax or Leicester I had only one contact for these neighbourhoods and she had been driven out two years before. When the bus deposited me at a desolate crossroads I felt the same adrenalin rush of fear as I had when covering war zones. Do I proceed? Don't I? Without a car, or the protection of a guide who knew his way round, what were the odds on being robbed? I carried what was for many people more than a lifetime's savings in camera equipment tucked into my shoulder bag. Across the road there had been a parade of shops. Their display windows were cemented over with breeze blocks; the first floor had

iron bars, but the frames were charred where the flames had licked at the brickwork.

I looked for signs of life and found the owner of the local betting shop who hadn't yet embarked on repairing the damage to his windowless, bunker-like premises caused by the previous night's arson attack. It wasn't the first time, he told me. 'When I turn my back, they sneak in here and stuff paper in the sink and toilet to flood the premises. They also push paper under the door and set fire to it.' A pensioner who was commiserating with him told me that every precaution in the book had been tried. 'I deen't knaa, anything you do to protect yourself is as much good as a chocolate fireguard.' They both suggested I try the local support centre for information about the neighbourhood.

I found the support centre having first gone to the wrong door; a notice from the city of Newcastle upon Tyne nailed to its boarded-up entrance read: ATTENTION THE FIXTURES AND FITTINGS IN THIS PROPERTY HAVE BEEN PERMANENTLY SECURITY MARKED AND CAN BE EASILY IDENTIFIED. The centre housed a variety of offices and projects, including victim support and community schemes. The reception room doubled as an office packed with filing cabinets, desks crammed with paperwork and a large Ordnance Survey map of the neighbourhood. The houses on the map highlighted in green were to be demolished, blue were the empty properties (around 15 per cent of the total housing) and red circles were the danger zones where you were likely to get mugged. One of those was where I had been dropped by the bus.

I told the secretary about my project. 'Get me out of here!' she pleaded. 'Only hell is worse than here, put that in your book.' As we spoke there was a commotion outside and I went to investigate. Joyriders had crashed into the fence that holds pedestrians back from walking into the roundabout. The police had given chase, but the four youngsters had managed to escape. A twelve-year-old girl approached, waving a piece of wooden batten in front of my nose. 'If you try to take ma picture, I'll whack ya and ya fucking cameras!' The youngsters, who were now sitting on the fence grimacing at the police taking down the particulars of the stolen car, took no notice.

Neither the arson attack nor the crash involving the joyriders was

reported in the local papers. The police later told me they happened too regularly. 'You'd need another riot,' referring to one that had taken place three years before, 'or a murder.'

The support centre suggested I contact one of the local councillors who was described as 'smashing, he's the boyo and a lovely lad'. When I telephoned he was slightly bemused by my request for a tour of the neighbourhood; however, he agreed to meet me the following day. I travelled back into the centre of town on the bus. Upstairs a group of young boys pulled cigarettes out of their pockets, lit them and hissed plumes of smoke at a passenger sitting on his own. One boy shouted 'Scrubber!' at a woman seated near the back of the bus. The passengers' faces were completely without expression. 'Scrubber!' repeated the boy. There was complete silence and he continued to taunt her: 'I don't know why I looked at you, you're so bloody ugly.' As we arrived at the next stop the boys clattered down the stairs. The driver said something to them, but I only heard their reply, 'You sound like a gramophone.'

'You should go back to school,' said the bus driver. I felt the tension steaming off his voice.

'You don't know your front side from your back!' they jeered as they tumbled off the bus.

As we pulled away, the woman who had been on the receiving end of the verbals commented, 'We've lived around here all our lives. We've got nowhere else to go. It's pathetic. If we want anything we've got to get a bus.' She added wistfully, 'Would have rammed a brush down their throat.'

I got off at the next stop at the river end of a neighbourhood where many of the houses were privately owned, but had clearly provided the same spawning ground for the alienated children as the benefit-income, council-run estate I had just left. Again without introductions, I wondered how best to gain access to these residents. I walked up a street where house after house had wooden boards blanking out the windows and most of the walls had been sprayed with graffiti. Here too the shops were boarded up, the boards protected by grilles. Even among this most impenetrable landscape of decaying streets, a no man's land if ever there was one, it was never completely deserted. People for a variety of reasons were pushed towards shadowy, unsafe

districts, others reminded me of the residents of cities besieged in war who refuse to move on from the only home they have ever known. I was thankful to reach the local high street which appeared to me like dry land to a spent swimmer.

In an estate agent's I struck up an acquaintance with the two women who worked the phones and took clients to potential properties. Marilyn and Helen rarely felt they could sail through a day and enjoy such simple tasks as typing in the particulars of a new property on the market or answering the telephone without a disturbance. They were kept so busy they never had time to dwell on events that for most people would seem quite extraordinary: if it wasn't property boards being removed it was another break-in or fire. But like other young women they were just as worried about their figures; Helen described herself as 'fatter in all' – she was being far too hard on herself – and Marilyn told me that sitting in the office manning the phones all day made her 'oot of shape'. I was having some difficulty getting used to the local accent: they must have thought I was partially deaf as I had to keep on asking them to repeat what they had just said.

I visited them many times during my stay and bit by bit they built up a picture of what it was like working in this area of town. When Helen went to check on local properties, she told me, 'You're waiting to be mugged, they're always after something. One morning at eight o'clock they were scratching away at a building's mortar. You can't say anything, you don't know who these people are, you might get your face kicked in. I walked past saying, "Oh, my goodness". I saw it and couldn't say anything.' So far she hadn't been mugged, but her properties were. Four times in my first week in Newcastle they had boards removed from the same property which they suspected was a repeat of last year when they had been taken for Guy Fawkes night, though that was still three months away.

'You always know when the kids are up to no good, the fire engines are going up the road, twenty to the dozen. I'm having heart failure thinking it might be one of our properties. No one believes just how bad it is. We had a client in London who wanted to sell a three-bedroom house. He wanted £11,000 for it. When he was offered £6000 we advised him to take it. He turned it down and the property was

slowly vandalized to the point where one of the external rear walls was removed for the bricks. He ended up selling the property for £2500.'

I was looking forward to my meeting with Reggie the councillor, for both the people working in the support centre and the visiting residents spoke fondly of him. Reggie was now retired, having spent 45 years of his life in uniform – the services and the police. It wasn't just a conventional tour of the neighbourhood that I was looking for and Reggie did not disappoint. He talked about a different way of life, when the neighbourhood was a 'village' with all the shops you needed so you didn't have to go into town. When there was no need for keys and you borrowed sugar off the neighbour and had outside tea parties. We walked down a street of terraced houses and he pointed to where there had once been a fish and chip shop and a butchers which was now a glaziers.

'There used to be plenty of personal touches. If you wanted half a pound of butter, they cut you half a pound and because there weren't fridges, the corner shop was, for lack of a better word, the local fridge. When they burnt the post office down during the riots, that's how silly they are, now they have to walk miles to the nearest one.'

But Reggie didn't see the past through rose-coloured spectacles. He told me how people blamed lack of jobs for the changes, but this had always been an area with high unemployment, now running back three generations. He talked about an era when the consumer society was in its infancy: no cars, no televisions, no videos. There was no property to steal and little to advertise its availability. Your doors were also kept open so that the street-corner bookie (before the legalization of betting shops) could up and off through your house when the police came down the street.

We crossed a wasteland being reborn as a park created by pulling down houses the council couldn't let. At the bottom Reggie pointed to the main road that separated the council estate from the armaments factory. 'This used to be one of Newcastle's most famous streets and factory.' He was surprised I hadn't heard of the city's most famous song, so he talked me through the chorus:

Oh me lads, ye shud a seen us gannin'
Passin' the foaks upon the road just as they were stannin'.

Thor wer lots of lads an lasses there all wi' smilin' faces
Gannin' along the Scotswood Road ta see the Blaydon Races.

Now there are no foaks and the lads and lassies are no longer
stannin' but passin' through in cars on their way to somewhere else.
'Thirty years ago this area was teeming with activity,' said Reggie.
'The armaments factory was over two miles long, now it's a quarter
of a mile and although it still makes tanks they employ less than a
thousand people where they once employed 25,000. Machines have
taken over from bodies. It used to be the people from this neighbour-
hood that used to make the guns; now that they've got money, they've
moved out of here and drive in to their secure parking spaces in the
morning and out again in the evening. There's no jobs for the young
ones, they want skilled workers. When we started you didn't need
qualifications for the butcher's bicycle deliveries.'

There had been a railway station, but that has long since gone. It
has been made into a cycle track which the council want to extend
over the disused railway bridge to Blaydon, even though they were
worried that joyriders would use it. Dozens of pubs were named after
the part of the factory they were opposite, like the Forge Hammer and
the Hydraulic Crane, but they've all gone now. We passed more derelict
houses and wastelands which were earmarked to go eventually to
private developers; but, as Reggie put it, the neighbourhood had such
a bad reputation that people would never say they belonged here. 'If
you give a dog a bad name, he'll always have a bad name.' Later, when
someone gave me their address for a picture I had taken of their family,
they inserted the name of a prosperous adjoining neighbourhood into
the correct postal address.

As we walked up through the estate no cars passed us in either
direction, but from the distance came a constant whisper of traffic
until a young boy screeched past unhelmeted on a motorbike. 'We
were always scared of the police. Sergeant Cork used to hit you with
a baton at thirty yards if you were on your bike and did something
wrong; you got a clip from him, and you didn't tell your parents or
you'd be clipped again.' Still, there is nothing for the children to do,
the sports centre was not in the right place and it was too expensive.
Reggie called it 'from the blind to the ridiculous'. The children no

longer played hide and seek: they climbed over the church and broke
the windows. The vicar had been burgled three times in two years,
his car more often. The library was only open twenty hours a week
because of cutbacks and the local baths had been closed for the same
reasons: a TO LET sign hung outside.

Two spirited older women waved to Reggie. They were carrying
plastic shopping bags – they didn't walk but seemed to trot, giving a
feeling of scuttling urgency to the streets. We crossed over to greet
them. 'Going to the baths?' Reggie joked.

'I can't wear a bather,' said the first of the two ladies.

'I'll give you three handkerchiefs,' said her friend.

'It's sheets I want,' she laughed.

Reggie knew everyone by their first names and he was called on to
pacify neighbours who had fallen out. 'I'm not a good politician,' he
said modestly. 'I say what I feel. I feel let down over the years. They
put the wrong people in – problem families, they drag you down. You
look after your garden, they don't. They should move them to another
town.

'It's no use moaning at the council; get in there and do something.
I didn't have time to help before, now I've got no work and I'm retired
I've got the time, but it's difficult, windows not being repaired, roads,
lighting not being fixed, drains not being cleaned. I've learnt the hard
way, can't promise anybody anything. I try my best as a local resident,
only when I meet a barrier I say I'm a councillor.'

As we continued our walk some kids threw bits of broken paving
stones at us, but they grinned and I thought there was a gesture of
recognition from the previous day. Understandably, Reggie didn't want
to dawdle at this particular close where the smashed houses looked
like something out of the current Balkan war. Another unhelmeted
youngster did a wheelie on his motorbike, crashed into a wall, was
not thrown and continued riding it along the pavement.

Reggie went on, 'I never expected to see houses built and then
broken in my lifetime. I bought mine prior to 1960 for £2000, it was
a lot of money in those days. In 1980 it was worth around £25,000,
now it's worth around £2000 – it's no longer worth leaving. Form
your own conclusion how it's all gone down the pan.

'You cannot guarantee jobs, but you can give people good housing,

a good environment. I hope it could go back to the sixties when you could go out at night, leave your doors open. The ladies are more vulnerable. The muggers think if they go to the bingo, they've got money.' Someone started shouting 'Reggie! Reggie!' from the porch, in reality a slab of concrete, that led in to a small tenement. We went over to her. She greeted Reggie and then complained that the council hadn't repaired her door. 'They broke in last night,' she said.

'All right, Jeanne, I'll call the housing department,' said Reggie helpfully.

'The flats were being broken into when Marjorie was in.' They couldn't open her front door, so they broke into the neighbour's flat and knocked through the ceiling to get into her attic. 'She's hysterical – terrified,' said Jeanne. Reggie went on upstairs to help, but I thought it best not to burden the terrified woman with an unfamiliar face.

I tried to find a telephone box to call Carole, my one and only contact, who had been driven out of an adjacent neighbourhood. 'There's not a blooming thing up here,' said the pedestrian I asked for directions. 'If someone's got a sick child, they haven't got a bloody chance.' The last phone box had been repeatedly destroyed by vandals and BT claimed that they had to take it away on the grounds of public security. Now there wasn't a single public telephone for more than 1500 houses in this neighbourhood. A petition by locals and an appeal by the police and the fire service on the grounds of saving lives in case of an emergency had failed to sway BT. There were no cars to flag down if you needed to raise the alarm, unless you tried to stop one of the joyriders travelling in a heisty (stolen) car at stock-car speed and using the hundreds of thousands of poundsworth of 'traffic calming' chicanes, roundabouts and sleeping policemen as dodgem obstacles. What did they care, it wasn't their own car.

I met Carole in a pub in Newcastle's East End which this Thursday night was being used for a ceilidh by Irish musicians. She had come to Newcastle as a student and stayed on after graduating. Initially she had moved in with a university friend who had been terrorized because she was from the south. She thought Carole, as a Liverpudlian, would stop the homeboys from persecuting her. When they couldn't break into the house they sledgehammered their way through the adjoining

empty property. When that was boarded up with metal sheets they chainsawed through it – the locals called it a 'Newcastle bypass'.

As the lutes and fiddles played their enchanting ballads, Carole continued with her story.

'They firebombed us out: first through the window above the front door then, when we boarded it up, they pushed firecrackers through the letter box. Didn't know it was firecrackers at first, I called the fire brigade. I was terrified – only one way out which was full of smoke. We got locked out: they had smashed the door so hard the lock jammed and I had my finals coming up, my revisions were inside. Another time we were jammed inside, the only way out was the back door, but I would have had to gamble leaving the door unlocked. It didn't matter if one of us stayed in to deter them because even when we were inside they tried breaking in. We often called the police but that just made matters worse, our windows were put through, we had them replaced, but it happened again and again so we had it boarded up, the only natural light was from the back room. Can you imagine, all this was going on during my finals. That was three years ago. Now that I might have to move I realize the fear has never gone away. I could never go back to that, I couldn't cope. The other day I came home, my window was broken, I thought, "Oh, my God, it's started all over again." I went to my neighbour's, he said it was only kids playing football. They stayed away for two weeks, can you imagine that! They were so shamed by what they had done, they actually stayed away.'

The woman Carole had been sharing her first house with had been an owner-occupier. One day she handed the keys over to the council. This was not an unusual case. I found an Asian family who had had their roof removed while they were at the mosque for Friday prayers and now lived in a boarded-up house with little holes drilled into the blockboard for air. I also became friendly with a Pathan, who went by the nickname H and spoke with a broad Geordie accent. He had tried to give the house he had paid £20,000 for to the council, who refused it. Instead they slapped him with a summons, an £80 fine, for not clearing the debris the vandals had caused. Southerners, Scousers, Asians, students and gays became refugees, forced to move across town as their neighbourhood was being cleansed of outsiders by the teenagers.

I continued to try and find a way to meet the children who were terrorizing the neighbourhood. I even went to the police. They felt as helpless as the residents. One of the policemen had crossed the river from Gateshead, because he had been driven out of his home by a series of attacks against his property. 'We want to start a family, but I can't sell my house, so our lives are on hold.' An older policeman remembered the days not so long ago, when if you asked the children to pick a piece of paper up, they did.

'Now they give you the dead eye and would drop it in front of you. We used to send out a PC to a burglary to check the immediate surroundings, ask neighbours if there was anything suspicious. We'd then send another PC over to assist and possibly a detective to make further enquiries, then always a fingerprint man. Now just a PC. Many don't call us because the children have got radio scanners and the residents are afraid that they'll be found out for reporting a crime and attacked.'

These policemen complained about a lack of resources and the justice system that made much of their work futile, but even when they had back-up – recently they had made safe one of the red circles on the support centre's map, a danger zone for daylight muggings – the muggers moved on to another location. Problems were not being solved, just moved elsewhere. The officer showed me photographs of a surveillance operation. 'Malicious ignition, we call it,' he said, pointing to a child trying to set a building on fire with a flame thrower made from an aerosol can.

I was left with a single choice, to introduce myself to the children without the help of an intermediary. Truth be known, I was scared of them and had hesitated to take this step. I went to find them where they had thrown broken bits of paving stone at me. When they eventually turned the corner as I stood waiting in the middle of the road, my heart gave a lurch: I was sure they would mug me. As they clustered around, nothing suggested they were arsonists or drug users or robbers – they might have been ordinary schoolchildren, with a not abnormal restless energy that knew no outlets. The ones with dimmed, tired eyes could have been mistaken for swots who had stayed up late studying. They were bored and not interested in me, but I was interested in their lives.

'What do you care?' said one of them.

To have said 'I do' would have sounded false to them, to have said 'I don't' would have sounded like an honest answer, but wasn't true.

'Come on, let's git,' said a boy who had already taken a few steps down the road. They followed him, and left me standing on the same spot.

I had made my introduction.

As the days went by, they gradually accepted me and I was drawn into their circle. Nothing was said, but I was warned that if I was a 'busy' – a poliss (the police) or a copper's nark – I was no better than dead. For a long time they wouldn't let me take pictures: they knew that if they were doing something outside the law and the police found me, my film would be confiscated and if I exposed the film to protect them, I could be prosecuted for destroying evidence. They probably had a better grasp of the law than many magistrates.

Every afternoon they emerged from their beds and headed for the derelict houses which they had destroyed. We crossed flattened garden fences and walked through a trail of dumped, rotting refuse and wooden planks into doorless houses. They were also windowless and roofless, all the glass had been smashed, plasterboard had been ripped from the walls and ceilings, the sky was visible where the roof would have been, only a framework of rafters remained. Front rooms often looked as though they had been bulldozed, external and internal walls as though they had been punctured by artillery or tank shells. People still lived in adjoining houses.

I met one neighbour who thought I was from the council. 'I can't get any peace no more, I can't stand it any more, I'm on medicine, I'm taking Temazepam and Prozac for my nerves and depression. I can't sleep. I haven't slept for four and a half months properly. It's so depressing here, I got to get oot!' I tried to tell him I wasn't any kind of official, but he continued regardless, driven by despair as if talking would exorcize the living nightmare.

'If I'm in, we sit in the back bedroom, it's too depressing in the front room. I keep contacting the council to be rehoused but they don't do nothing. I can't sleep. I've lived here thirteen and a half years. I've got a rottweiler in the back garden to stop the thieves. Police do nothing except chase car thieves. Rarely see them around here. I gotta

get oota here, man. I can't sleep. The fire engines come three or four times a night.'

I was an observer in a contemporary Roman amphitheatre. Here the gladiatorial bouts – the bear-baiting, the dog-fighting – were the games the children played with the police and firemen; setting fire to the houses, stealing cars, the children were taking charge of their lives, directing the street theatre. The wrestling, mock battles and public executions were the damage they wreaked both physically and mentally on the locals and their property. There was nothing to keep the children out of mischief, and nothing to save them from the loneliness of their freedom, with no families other than their friends, no jobs and no tasks, but only the slow time in which to choose and to think.

This was their way of obliterating their past, forgetting about the present, ignoring the future. In one of the ruined houses they clambered across the floor, stepping on the joists to dodge the missing floorboards. One young boy curled up against the security of a wall, squatting on his haunches.

David's friends call him a 'creeper': he breaks into people's homes at night while they are sleeping. Eleven years old, he does it to get enough money for a pour, a 50p bag of glue. He'd tried a little bit of heroin, smoked – never injected it. You wouldn't have been greatly surprised if he was the boy doing the paper-round except for the soot marks on his face and clothing from the charred wreckage of the house. Nestling there in the corner of the room he pulled a plastic bag full of glue from inside his anorak. He buried his chin in his chest, the muscles of his face tensed. He lowered the bottom half of his face and nose into the bag, puffed out his cheeks and took a deep breath. His eyes glazed over and became sad and vacant. He steadied himself using his arm and his fist resting on the floor. His facial muscles relaxed, he had the numb, deadened look associated with adult bookstores, it grew into a full, unencumbered smile, his eyes glazed over, he was at peace with himself.

I cried inside.

The urban battles continued to flare like a midsummer forest fire, defying the authorities' wavering attempts to contain them. The fathers always blamed someone else's children – they usually began with

'He-was-such-a-nice-boy-before-he . . .' – but the fathers were also in competition with their sons. When they went into action, insurance companies went bankrupt. On learning a house was going to be vacated, the fathers would race to get the tiles off the roof and the copper and lead piping off the water and gas supplies before the children set fire to the building. 'We can get 30 pence a tile, but if the slates are burnt they're not worth half that, not worth the bother,' said a man built like an outdoor netty (toilet), who had been busy fixing a car in the street. He had spent five years in prison for dealing in smack, a career which had allowed him to see the world: Bangkok, Bombay, Delhi. 'The only place anyone goes to here is Spain.' In spite of that record he told me, 'I wouldn't kick the dealers who sell a pour [bag], I'd burn the fuckers down, melt them into wellington boots.'

I asked him about the tattooed stars that covered his fist.

'That's so if I hit you, you'll see stars.'

He turned around and pulled down his trousers: I found myself staring at a pair of eyes tattooed on his buttocks.

The old folk, those that hadn't been terrorized and driven out of their homes, told me I had to write something positive about their neighbourhood; when I asked them what, they failed to come up with an answer. I found it, but it took a lot of probing and searching. On most days, by one or two o'clock in the afternoon the old folk were back in their homes behind locked doors, while the children were out prowling for new victims to rob, new buildings to cover with graffiti and burn.

Positive stories were as rare as hen's teeth, but some members of the community were fighting back. The first steps were being taken: a locally based credit union had been started in the belief that access to credit is a fundamental human right, and that people in the 'poverty trap' often only needed a small financial loan in order to step out of it. Mainstream banks are not willing to lend to poor people, forcing them to turn to moneylenders and loan sharks who often charged 20 pence a week or more on a £1 loan. These excessive rates of interest draw them into an inescapable cycle of extortion.

Quite often residents turned to the 'Little Brothers', as the two Franciscan monks were affectionately known. They did all manner of jobs, including helping with victim support, the credit union,

baby-sitting, granny-sitting and house-sitting. They had chosen to live with the people and, just as it was a leper who brought Saint Francis an extraordinary encounter with the living presence of God, many Geordies spoke of these neighbourhoods as if they were indeed leprous; you were stigmatized just by living here. The Little Brothers didn't proselytize and when they weren't helping the local residents they worked as part-time cleaners in a bail hostel. Their house, much of it renovated from discarded building materials, had no television or radio, but they had built themselves a chapel in the attic and put on their habits to spend around two and a half hours each day in prayer. At the entrance to their home they had an ironwork grille with the outline of Saint Francis embracing a leper.

I went to visit Anne and her 'bairns and granbairns' on one of the most desolate streets near Helen and Marilyn's estate agent. Either side of her house and on the opposite side of the street the houses were boarded up. But Anne was a fighter, she had worked on the buses and was now a local lollipop woman. Her house was a refuge for single mums and creche for their bairns. She had files stacked everywhere, spare moments were consumed in trying to raise funds to give the neighbourhood's children and their children's children a better future, but Anne felt the stigma attached to being a lollipop lady prevented her from succeeding. In the developing world I had encountered the numerous aid agencies, but I had never been aware of them in Britain. Areas suffering from deprivation were host to outsiders, some brought in at great expense as consultants, to create a culture of dependency.

In her back room the kids played and argued. Two children screamed at another one: 'I'm going to hit you', 'I'm going to pinch you', 'I'm going to cut your head off'. Anne arrived home after two hours of office cleaning, which she did three times a week during the school holidays.

'I'm a glutton for punishment,' she said. 'I don't like just sitting about, I get depressed and bored very easily. Even finishing the job last night, I got back and continued with some of the project work. It was difficult when the little ones were littler. I'm on income support, so I'm only allowed to earn £15 a week. If I could find a full-time job

it wouldn't be worth my while what with the school dinners I now get free, but they're stopping all that. I used to get a voucher for their school uniforms, then they stopped that and gave you £25, a year ago they stopped it all.'

When I met Anne she was trying to raise £320 to take 32 children on a coach trip to a theme park. She was still short of £50.

'The children don't go anywhere. Nowhere to go to on holidays. Not even to Whitley Bay on the Metro line, because their parents don't have the money for the fare. I want to let them know there are other trips than hanging around in the streets. I took me younger son to EuroDisney, but felt sorry for all the other kids here. Entrance, coach, hotel £79 for a kid, £89 for a grown-up. Every child should have the right to go, to see something like that, it's absolutely magnificent. If I'd had the money I'd have taken another two bairns. I tried to set up a fund for the local kids to go to EuroDisney.

'Our area is not difficult, it's the media that's built it up like that, bad news sells newspapers, good news they don't want to know about. I don't know if the residents have been forced to leave. I can understand the fear and being frightened. I think it's blown all out of proportion. There's burglars and things all over, there was a burglary across the street last night, we heard the screaming, my sister and I ran outside up to the top of the street – there was a shoe at the top of the lane. This lass had her bag pinched. Young Malaysian lass, a student, she was terrified, someone had opened her door and grabbed her purse. I gave her tea, and phoned the police. It was her first day here. I phoned the police at 9.10, they came at 9.40, took half an hour! She was very upset – she had me crying. I think that's related to every area. The houses have been boarded up because fires have been set alight, landlords have paid kids to set fire 'cause they couldn't let them or sell them. The area's beginning to lift up now. Housing associations taking over now.'

Her father interrupted her. 'It's them bloody Pakis, I blame it all on them for not getting their houses repaired.'

'I'm not racist,' Anne continued. 'Landlords are now beginning to see a profit. Everybody is into making a profit, making money, these days. You can't blame them. It's the little people that's suffering, at the bottom of the scale – it's the rich getting richer and the poor

getting poorer. They are stopping the school grants now, so the parents are having to fork out the extra money for coats and shoes and extra clothing. You can't get a loan, you're living on the breadline and yet if you go for a loan you might possibly get one – not for school clothing though. And then they can take; one time they were taking £13 a week off me. 'Cause I needed money at the time for clothing for my kids 'cause he's got asthma and eczema and you're meant to change clothing three times a day. They've got no idea in these plush offices how the other half lives. So I had £24 and my child benefit. You got to survive on it – you've got to do.

'Half the kids around here, their meat is corned beef, sausage; mine had iron deficiency because he wasn't getting enough red meat, because it was the thing we couldn't afford and because he didn't eat it, I now can't get it down him. Same with the vegetables. Can't get it down him because I couldn't afford it before. I think it's the same for the majority of children. The government isn't giving the families enough money to keep them, feed and clothe them properly. I don't mean they don't get fed, I mean the right food, they get fatty food. I know from the last project, I mean they'd have a packet of crisps to sustain them all day. As long as the kids are in the street – where I can see them, they're safe, but you cannot keep them in the same street all the time. They got bikes bought for Christmas only been out on them once because of the cars. Stolen cars, twoccers, not from our area.

'My children's future is like my life – struggling – no future – these kids in the yard are our future. The kids are it – teachers, possibly government ministers, you don't know what they're going to turn out like – but with this government, they're going to have difficulty.

'My son will either be a pop star or end up in borstal. My oldest daughter, she was fifteen when she was pregnant. My niece was sixteen when she was, and she's got that one that's eight months. I know it sounds daft, I'm not saying they get pregnant deliberately, but they're not getting the money till they're eighteen. I don't know how to put it, if they're pregnant or get a child they get money, if they're not they don't. It's definitely lack of education. There's loads of pregnant schoolgirls. I know them, my eldest daughter went to a pregnant school-girl unit. My youngest daughter went a couple of times, but she was in hospital six weeks before she had him and he was born nine weeks

premature. I have a son who's seven and a granddaughter who's six.

'It's upsetting, because she's doing exactly what I've been doing – struggling. I wanted them to have an easy life, not scrapin' and scratten like I had to do with my kids. I've had three husbands. The first one drank and gambled for ten years until I divorced him fifteen years after we married. And then I fell for the same sort of one again – you never learn. And then I had the little 'un. My daughter, her children's father is exactly the same, he was in prison, mine wasn't. He came out and they split up. Got a boyfriend, they split up and she's pregnant again. "Why pregnant?" you may ask. It were a mistake. Definitely not planned. It's the life the kids have had, what they have seen when they were younger, it rubs off on them, it must be hereditary because they fall for the same type of bloke. It's madness.'

With a week left I went with some of the children from Anne's neighbourhood to St James's Park, home of Newcastle United Football Club, which the children cheered on as 'Kevin Keegan's Toon-toon black 'n' white army!' Every two weeks during the football season a group of them made the pilgrimage. They couldn't afford to get into the ground to watch their heroes: you had to have a season ticket to get a seat and to be a season ticket holder you had to put down a £500 bond. The local Odeon cinema broadcasts the games live, and these children explained to me they could afford to go, but they couldn't. I soon discovered what they meant.

As the spectators arrived, the children from Anne's streets, who had walked the one and a half miles to the ground, were on hand to provide 'security'. They'd mind your car for a tip, to make sure you still had your stereo when you returned, and they worked the drivers with a much-practised professionalism. They were often tipped 50p, sometimes more. You might come across them if you should happen to be fortunate enough to obtain a ticket, but don't expect to get away without paying a tip to one of the children. That's what one man tried to do. 'I'll look after your car,' said Paul, a ten-year-old in the home team's black 'n' white team shirt.

'There's no need for that,' said the driver.

'Why's that?'

'I've got a dog.'

Paul peered into the car's closed window. The dog leapt at him.

'Does your dog put out fires, mister?'

Of course, they didn't actually stand by the cars. They watched the games outside the ground courtesy of a twelve-inch black and white television set, placed on camera boxes beside the Tyne Tees outside broadcast unit. Each one of the Toon's five goals against the Saints of Southampton was greeted with a deafening roar which was followed a nanosecond later by the jumping jubilation of the group gathered in front of the television set.

The Geordies' pride in their football team, which hasn't won a championship since 1927, extends to many aspects of daily life. Helen from the estate agency usually wore combinations of black and white dresses, blouses and skirts in their honour. You could buy sponge cakes in the shape of a football pitch with the players' names on it and birthday and wedding cakes in the Toon army's colours. But in the same way they took pride in their football team, they took pride in being a Geordie. Many felt they had stronger links to Scotland and Scandinavia than the south of England; one man claimed that Oslo was closer to Newcastle than London was, another said, 'London's so far away, no one votes for the government here. They all vote in the south for the government.' You could buy a Geordie passport, a Geordie driving licence, marriage certificate and even a Geordie Bible written by a minister. Some Geordies spoke in an accent so dense it was a dialect. 'We don't want anything to do with Whitehall. Thatcher deliberately smashed organized labour here. We've been knocked so many times we want to run our own affairs, we are a region with a separate identity like the Basques in Spain,' said a local academic in a discussion about the north-east.

Local people take to the nightlife as wholeheartedly as they support their football team. As darkness descends over Newcastle, thousands upon thousands of people living in colonies of tenements, estates and university campuses all over the city and beyond, head for the Toon's pubs and clubs along the streets from the Bigg Market or 'Gazza Strip' to the Quayside. They come in taxis and by the minibus load to drink and forget their dull jobs, if they have one, and party like there is no tomorrow – it is as close as you could get to a package holiday without taking a plane. The girls wear as little as possible and cosmetic suntans, radiating not necessarily fantastic beauty but fanatical effort. The boys

display all the swagger and strut of male machismo. The genders
remain segregated, travelling in packs, although they share the same
pubs which connect like shops. From their open doors comes the
smell of beer and cigarette smoke and the pounding of the pulsating
clubland dance songs.

There is a ritual: you only have one drink in each bar, so a human
tide moves a few yards at a time from bar to bar, each one packed to
the gills. I joined the queues waiting outside. When it was my turn to
move forward I smiled my way past the bouncers and was carried
along by the tow of bodies as on a wave, two steps forward, one step
back, until I reached the bar which was mobbed, arms flailing as if
we were all stretching to touch James Dean or Marilyn Monroe. 'Giz
a broon ye buggermar!' shouted the lad next to me at the barman. A
pretty woman on the other side ordered 'a packetocrisps te tekoot'. I
got talking to Helena, a young woman who had come from Hartlepool
with a group of girlfriends, one of whom wore a dress stitched with
unwrapped condoms to celebrate her hen party. Girls seemed to talk
to the boys more freely; the boys often needed to have drunk heavily
to summon the courage to talk to the girls, but usually the groups
remained segregated throughout the evening. One young man wore
Groucho Marx spectacles with a phallus for a nose. The streets con-
tinued to fill during happy hour when pints often cost under a pound.
As the bars started to close the bartenders called out, 'Let's hev yor
drinks!' and the crowds moved to the nightclubs, each with its nick-
name, 'grope-a-granny', 'the fanny-magnet', where the hormone that
coursed through the veins could be called preposterone.

At one of the nightclubs I saw Helena again as she emerged from
the floor of gyrating and whirling bodies. She wore a floral patterned
pastel dress that left little to the imagination. The combination of
strobe lights, the fog of smoke, several pints and her good looks nearly
gave me severe retinal damage. I tried to have a conversation, but it
was difficult to hear her over the raving orchestral numbers. I caught
words, not sense: *Newcassel . . . off her fyece . . . ah wes palatick . . .
doon et thufaktry . . .* When the club closed in the early hours of the
morning, we walked across the club floor silted with spilled beer and
cigarette butts. I asked for her telephone number and said I would
call later in the week.

The nights finished in kebab walk-ins, fish and chip shops, and curry houses, manned by the same bouncers or 'door executives' as they preferred to be called, who had earlier sentried the bars. I thought of Desmond Morris, the social anthropologist, whose latest theory was based on 'careful research in certain nightclubs'. He had come to the conclusion that 'the closer girls are to the moment of ovulation, the skimpier their costume will be'. If you stitched all the dresses together in the Bigg Market there was hardly enough material for a tent, let alone a marquee. Either Desmond Morris was wrong or these north-eastern girls were permanently close to ovulation. In Newcastle, the next party begins the night after the last one has ended.

I called Helena and suffered a moment of agonizing embarrassment. In the din of the bar and nightclub I had misheard her name – it wasn't Helena, it was Melanie. She laughed and we agreed to meet near Hartlepool's former docks. On my way there I spent half a day in Easington, a former mining village, and stopped for tea in one of the town's many thrift shops. The two women who staffed it were volunteers: one used to work at a butcher's, the other at an electrical goods shop, but when the miners went on strike there was no longer money to spend, so many of the shops gave up too, including the butcher's, the electrical shop and a grocer's. Despite a local feeling that the livelihoods of their own people needed supporting here, as in all small towns, the chain stores captured what little trade was left; or if you could afford to travel, it was cheaper to go to the big malls, thus aiding the movement of money out of the town and further rotting the community life that had once existed. Both husbands were unemployed, one on a training scheme. 'We call it E.T., benefits and an extra tenner.' The thrift shop sold suits for a fiver, trousers for £2, dresses for £3. My two cups of tea and a toastie came to 75 pence. Only one man entered the shop while I was there; he dropped some money into a box for the Rwanda appeal.

I asked them for directions to the colliery, but the site was being cleared. The unemployed ex-miner who had put money into the appeal box told me that British Coal had taken the thoughtful step of asking the local authorities for permission to store imported coal at his former pithead.

Here, as in the West End of Newcastle, derelict houses were being picked clean like bones. I found two men stripping out fuse boxes, bricks and copper wire. 'Can I take a picture?' I asked. 'As long as you're not from the Nash,' said Frank, a former steel cutter, meaning National Insurance. He and his mate Ted gave me a lift to Hartlepool in their flatbed van. It would take them an hour to strip away or burn the protective coating for £2-worth of copper – they got less if they didn't strip it. If they got caught and fined £25–30 they'd choose to go to jail, they were saving to send their children on holiday. They dropped me close to the marina, where Frank looked at the street's loose paving-stones. 'Ted, what do you reckon we'd get for these?'

'A pound.'

'It's not worth the muscle,' said Frank and they drove off.

I met Melanie in a quaint pub on the quayside. In front, labourers worked furiously on a new shopping mall. This looked like the future for Britain's exhausted manufacturing and industrial base. These modern cathedrals as massive as small townships were springing up all over the country, bringing tourist-shoppers together from distant parts of the UK and Europe by the coach- and plane-load. In the designer, consumer-friendly environments, you had all-weather recreation and leisure centres, shopping themes, cinemas, creches, quiz shows for the family, even vicars who were developing short but lively services for shoppers to show that God was still alive and well and only a short distance from Gianni Versace and Giorgio Armani.

Melanie was twenty-four years old and like 198 out of 200 school leavers in her year without a full-time job: they were in and out of work-training schemes. She was waiting for the youngest of her two children to be old enough for infant school before returning to work. She would do anything, 'a job is a job' she said, which reminded me of something I had read. A book about born-again Geordies and tourism as an industry quoted the Northumbria Tourist Board: 'If you need jobs as badly as Hartlepool needs them, I don't really think it matters whether you are throwing molten steel about or you are throwing cups of tea over customers.' If Britain was becoming the Taiwan of Europe, was leisure-based post-industrial Hartlepool going to be its Hong Kong?

*　　　*　　　*

I had spent much longer than I had planned in Newcastle and it was time to say my goodbyes. I went to the support centre where a candidate for a job as a victim support worker was being interviewed. She could see the series of drawings which had recently been put up on the walls by the local children: all had squiggly pictures with girls or women crying, pearldrops of tears on their cheeks. They had written underneath:

> Why me, why don't they leave me alone I wish I could grab hold of that vandaliser and kill that person.
>
> STOP Why me, why did they ruin my house, next time it will be you.
>
> VANDALISM Man, Mom my window is smashed, I am so sad now.
>
> (Man crying) That was the fourth time this week my car has been broken into.
>
> 4 house windows broken I'm horrified what a thing to come home to.
>
> (Boy and girl crying) I'm so upset! I get at least one window a day broken!!

On the final drawing the child had drawn graffiti on the wall of her house which read, 'Haha Granny, smile Granny'. The room was smashed up, windows broken. 'Why me? What have I done to deserve this?'

During the interview the candidate's car, parked outside, was driven up on to an embankment and set on fire. Her interviewer, a former resident, consoled her. 'Don't worry, hinny, I've had four cars stolen, I've had to go so downmarket, it's ridiculous.' Every time she came into work she filled in a new job application. The stress had affected her physically, she couldn't sleep and had gained weight. 'I want to lose weight, I've been prescribed amphetamines, but no sooner had I got them than I was being offered £5 a tablet.' The residents were like battery hens squeezed into this cage of a neighbourhood, chirping for help. Many of them talked and thought about leaving, about the lack of government intervention, about law and order as Russians during the siege of Stalingrad talked and thought about food. Here, a conservative was a socialist who had been mugged.

I went in search of the glue sniffers, the old folk watching me through their lace curtains like animals hiding in the bush as the silence and stillness closed in. I found two of the children, but they were too desultory to talk. A third took me to a house that had recently been burnt. He stuck his head through where the window had once been. My feet were in a six-inch-deep pool of water. I saw a Thomas the Tank Engine resting on its side in the water, a single shoe, a table, and a sofa turned on its side. In the rubble outside a dog rooted around a board game and odd bits of clothing strewn amongst the rubble. It was black on the walls. The acrylic bath where the fume-exhausted glue had been poured and set alight was still there, as were the holes in the ceiling which they had made to create a draught, but the sinks were gone.

Everyone knew it would go unpunished, like all the previous episodes. David was loitering on the first floor of a battered remnant of a three-bedroomed house that was one of his fallout shelters. I tried talking to him. 'It's a good high. I don't want to get out of my mind – just a buzz. A buzz. Buzz. Buzz. Buzz.'

As evening approached I went to Barbara's semi to chaperone her to bingo. She had told me that many years before you used to have to be 'quite posh to live in the semis – not rich, but well off'. She and Tom, her husband, were waiting for me as I walked up their neglected garden. The neighbourhood had that effect on you: they'd had their clothes set on fire on the clothes line, there was no point keeping up with the Joneses when the neighbourhood became more and more squalid.

'I had a shufti out the window to see if you were coming. I can't go oot o' me oon, I'm frightened to leave the place. When I go oot, Tom has to stay home, we take it in turns.' She waved to the neighbours to say she was all right. 'You got to keep a toot for each other. I wave to police helicopter 'cause I got my venetian blinds open, comes over nearly every day.'

I asked her, 'What do you see for the future?'

'About a foot,' she answered. 'Can't you do somethin', can't you get the television down here? I'm not afraid to speak any more. We don't want to shift, it's our house, we've done it all up, I've only lived in two houses. I'm fifty.'

As we arrived at the bingo hall glaziers were putting the finishing touches to several small panes of glass from the previous night's attempted burglary. It was 50 pence to get in and Barbara bought an evening's worth of entertainment for £6. I sat with Barbara, Florence, or Flo as her friends called her, and Doris. They had all been fetched up (grown up) locally. Flo had been present when the 1926 theatre had opened as a picture hall. Doris, who was seventy-seven, had been a florist and had worked in a nightclub where she had met Tom Jones when he was a lad. 'He's really come on, it's great really,' the others agreed. Flo asked me whether I knew Cassius Clay was married in a mosque in South Shields.

The game began. The magic numbers were called out by a young man behind a pulpit and flashed on a small television screen to the side of the stage. Doris, Barbara and Flo sat glued to their cards, scanning them like speed readers. Their heads never moved, their eyes did the walking and they shouted the chorus to the magic numbers:

One and six, sweet sixteen.
'Never been kissed.'
Twenty-two, two little ducks.
'Quack, quack.'
Eighty, mince and tattee, blind eighty.
'Quack, quack.'
Five zero, fifty-fifty.
'We're off to work, we work all day we get no pay, fifty-fifty.'

They came for the fun, it got them out. On this occasion they didn't win, but if they did they could exchange the vouchers for cans of soup, pop, cereal, cigarettes and Lemsip at the shop next to the ticket counter. 'I've got a stack of vouchers,' said Doris. 'I'll wait till Christmas.'

Barbara was going off on her first ever holiday. 'I've grafted all my life and I'm going to Benidorm.' Tom would have to stay behind to mind the house, they hadn't had a social life together for years – they couldn't remember the last time they'd been out as a couple. 'It's disgusting, pet, but when I come home I'm frightened I haven't got a house left.'

* * *

Recently I received a letter from Barbara: '... yesterday I saw two burglers going over the wall at the back (thought they were going to the shop!) My son seems to be doing well but these days you cannot be sure of staying in work even if you have a good job ... Must finish now as I have to shop around the corner – hope I don't get mugged! Anyway all the best for X-Mas.

p.s. I don't answer the front door anymore it's not safe so ring me first before coming to see me if you feel so inclined. Yours for now, Barbara.'

MACKAY COUNTRY
– THE FAR NORTH

Headlands and Highlands

FROM THE JOURNEY'S conception I hadn't just wanted to visit towns and cities, but also rural areas which are so often the soul of a country. Moira, an artist friend of mine in London, had suggested I visit her parents in the Highlands. In fact the couple lived an unusual conjugal life at opposite ends of the Highlands' northernmost headland; her mother Angela in a crafts village, Bill, her father, in a small former crofting village from which on a clear day you could see the Orkneys. The closest I had previously come to this area was on transatlantic flights over the Borders.

I arrived in Glasgow courtesy of a lift from H in Newcastle; in addition to running his kebab house he sold secondhand cars to the Asian community in Middlesbrough and Stockton and was on a buying trip to Dundee and Arbroath. He wouldn't hear of not dropping me in Glasgow, even though it was well out of his way. I waited there a while to organize the next leg of the journey. Moira had warned me of the difficulties of getting around on public transport and suggested I go by car.

It was a wise piece of advice. When I met occasional hitchhikers they told me of hours and even days by the roadside waiting for a lift. It also afforded me the opportunity to look up Gordon and Rhona, friends from Inverness who were holidaying on the west coast on a peninsula just north of Ullapool. This in itself was quite an eye-opener.

Gordon, Rhona and their three children had been lent a cottage in Achiltibuie with a dramatic view of islands, inlets and granite hills which tumbled down to the white strands of sandy shoreline that appeared like a seaside version of a fabled landscape. It was a perfect

sight, and yet, as I was to discover throughout the Highlands, the land could no longer support the population that had once lived in this remote region. Like their English counterparts, these Scots were self-deprecating. In their houses, in the pub over a wee dram, they told me how they fell into the lowest ten per cent of gross domestic product in Europe. 'We're Europe's Third World country,' they said, with a mixture of pride and bitterness.

In the face of adversity, those that had remained took on several jobs as a means of survival: the crofter is now also the postman and fisherman – where there are still fish. Marine life has become all but extinct because much of the waters have been so overfished. Over bridie and beans I was introduced to some of Rhona's childhood friends who had remained in this community, among them Sheila who said her brother had become the local bus driver. Rhona, who hadn't seen them in years, was surprised. 'I thought he had a degree in sociology?'

'He has a Ph.D. But nowadays you need a degree to drive a bus around here!' It is a highly educated and qualified local workforce.

Parents had no expectations locally for their children. They assumed they would leave and find a future elsewhere, for there was not enough for families living on the land. To city dwellers people in the town of Ullapool were teuchters, country bumpkins; in turn, they considered people from Altandu and Achiltibuie teuchters.

Unlike the village I was headed for, this part of the Highlands made money from tourists, although the work was seasonal: with good weather three months' work in the year was possible. The tourists came in droves for the scenery and space – so many, in fact, that the roads here boast more German and French licence plates than British ones. Sheila's husband was the 'fear an taigh', the master of the house, a much-admired, unemployed, Independent local councillor who had cooked our food and joked, 'The Germans look at our small brick-shaped peats and ask what they are, so we tell them they're called peatabix and are good with your breakfast.'

I had found the ideal place to stay put for a week, but I had already made arrangements to go to Moira's father's village and was not to be dissuaded. After two days with Gordon and Rhona, I pushed on north and stopped briefly in Durness near Cape Wrath. Here, as

elsewhere in the Highlands, talk was less of independence – although I did see two pieces of graffiti, the first for the SNLA, the Scottish National Liberation Army, and the second RISE NOW AND BE A NATION AGAIN – than of the clearances.

In Durness I met Moira's mother and Macleod, a friend of hers who lost no time filling me in about those events which had taken place two centuries ago, but which time and again were spoken of as an open wound, or as Macleod called it, a 'festering boil'.

'The clearances began in the late eighteenth and early nineteenth centuries, when wool was in demand. Inland in the Highlands there was plentiful grazing land; however, the small tenants impeded the conversion to sheep farming and raising deer. If they were moved to the coast, their lands could be rented to sheep farmers and the displaced tenants would provide the labour for kelp-making and fishing. So they were forcibly cleared and moved to the coast. Some families had their houses burned, they were chased out of the glens, while a large number of families suffered removal more than once within a short space of years. Most shifted to the poor land on the coast in small allotments and crofts like the one Moira's father has settled in, others emigrated to Canada, Australia and New Zealand and Glasgow where there are now more Gunns, MacKays and MacDonalds than there are here. Crofters' rights weren't recognized until the 1880s, but we still have landlords who own thousands and thousands of acres – in some cases we can't even find out who owns the land. Some of it is owned by multinational corporations based in the Arab Emirates, Scandinavia and Liechtenstein. There's not a Scots laird in sight. The clearances are still going on.'

Macleod went on to tell me how his forefathers were moved off their traditional lands in the mid-nineteenth century. I questioned him further about the evictions.

'They weren't evicted, they were driven from the land.' There was rising rancour in his voice. 'It's still Them and Us. They are still trying to fool us and we have to keep fighting them. And now we've also got the White Settlers taking over the bed and breakfasts and hotels from the Highlanders. It's different, the hospitality isn't there, you can't eat lunch if you miss the serving by a few minutes.' (He was right about that; later, in a hotel restaurant, they wouldn't serve coffee

after the meal because the kitchen had closed.) Macleod even suggested
that if the Allies were demanding war reparations from the Japanese,
'Why don't we get reparations for the clearances?' Wild as this might
sound, it was bound up with a feeling that, rather than being treated
as a small part of Europe, Scotland, and by extension the Highlands,
remained the worst treated colony of Great Britain.

The Highlands were already beginning to weave their Celtic magic
on me; at midsummer, night scarcely touches day on the west coast
of Scotland. I left Angela working at her pottery kiln and set out on
the last leg of my journey to MacKay country.

Huge drops of rain exploded on my windscreen, but through it loomed
the majestic savagery of the landscape. Spectacular peaks clad in
windswept gorse ranged high above the lochs, clouds clung moodily
to hilltop crags which, when the rain stopped and the clouds lifted,
were revealed in their entirety like a naked breast with a covering of
fine down. The thin line of the road threaded through heathery slopes
like patches of Harris tweed. It is said of this coastline that if you
unravelled it, it would stretch from Liverpool to New York, and much
of it has been fought and feuded over by the great clans.

I had entered another world, a world that would give me some
perspective on what I had already seen on my journey through the
Midlands, Yorkshire and England's north-east. But in one respect this
remote Sutherland village had something in common with many of the
places and people I had visited. I was constantly to be invited into
people's homes, offered a cup of tea, sometimes dinner and sometimes
a place to stay. In this last matter I was fortunate, as the next village was
a good twenty minutes' drive away. The village had no bed and break-
fast accommodation, no petrol station, no clinic or doctor and no shop
other than the post office with a handful of items such as long-life milk,
because fresh milk would no longer have been fresh by the time it
reached the shelves. There was no bus service and the nearest railhead
was forty miles away, a journey time of one and a quarter hours. The
only way out of the village if you weren't going to walk or bicycle was
the post car, and its three available seats might already be occupied.
More importantly, for some of the village's residents, the nearest place
to buy a lottery ticket was one and a quarter hours away.

I looked at my notebook for the instructions Moira's father had given me over the phone. Past the three abandoned houses, their lintels and joists long gone, leaving empty doorways and windows and a hole for the roof. All that was left were the walls, the shell of a building. I found the turning to the single-track road that was three, maybe four miles from the main highway. Left at the village telephone box that could no longer be opened because the grass had grown so tall, past the cattle grid and sharp right. And then I saw the cluster of houses, beyond the one being renovated for eighty-year-old Johnag who for the first time in her life was going to have a bathroom and running water. The first of three further dwellings, all that remained of a once busy hamlet, was Bill's whitewashed croft.

Bill had been waiting, he saw me arrive. 'Come in. Sit yourself down,' he said warmly. 'There's some crackers and cheese, that's my own honey, don't ask, help yourself. It's a long journey, well off the beaten track. Would you like some tea or would you rather have a wee dram?' He was worried that there wouldn't be enough for me to do, he had thought of people I could look up in neighbouring villages, but I knew instantly that I had arrived somewhere rare and unusual, its distinctive culture balanced precariously between extinction and rebirth.

I stayed with the neighbours Geoff and Claire. They too were incomers. After thirty years Bill had been accepted by the community because, in the words of one, he was reliable. Geoff and Claire had only recently moved to the village and, although Geoff's deceased grandfather had lived here all his life, it would be some time yet before they would be accepted. They greeted me on the doorstep of their renovated cottage and I commented on the weather which had changed several times since my arrival. Now the raindrops that had appeared incandescent in the late afternoon sun were gone. 'If you don't like the weather,' commented Geoff, 'wait a minute.'

The village had changed dramatically. There had once been 600 people living here, with three schools, bus services, shops, a bakery, and a ferry that delivered supplies, but all of that has long since gone. The community now numbers sixty and only twelve are descendants of the original families.

The remaining members of the original community had vivid recol-

lections of how it used to be. All of them described the same scenes.
'The straths [glens] were hoachin',' busy with people, said Elizabeth,
a nurse who had spent many years in Peru as a missionary. The sounds
of life had been ever present. 'Cries echoed all around the hills as the
shepherds called to their dogs,' said Mag, one of three sisters whose
family had run the post office for the past sixty-three years. Crofts
had occupied both sides of the valleys from the harbour inland. It was
rough land, just usable for arable agriculture with steep drift-covered
slopes and rock outcrops, and until the loch occupying the northern
half of the valley was drained, poor drainage had created additional
problems. This small piece of reclaimed moorland had once been filled
with the constant traffic of the villagers going about their business
peat-cutting, lambing, haying and clipping. 'We used to carry the hay
on our back and head and then climb up home. It was so tiring. Now
the young ones seem to be tired doing nothing,' said Elizabeth. 'We
complain about the sheep cluttering the road, before it was horses,
dozens of them,' said Jean, Mag's sister and wife to the village's last
fisherman. 'You could hear the garron [small, sturdy horses used for
rough hill work and for bringing back the peats] running free at night.
They kept us awake,' said mild-mannered Robbie, who had spent
the war years in the navy. 'It was so bonnie before,' said Elizabeth
nostalgically, when she invited me over for tea, ignoring what she had
said earlier, that 'Just existing here was a real undertaking.'

The village had also changed physically, something Bill was trying
to record in photographs and sketches. 'From Mary Davidson's to
Grays there used to be a hundred people,' said Jean. Bill's house was
once one of the schools. There used to be more people to a house
than the current total that live in Bill's hamlet. The remnants of
houses mirrored the local graveyard's tombstones: some had begun to
collapse. In several derelict houses black scorch marks suggested a fire-
place, but there were no other traces of human occupation, no electri-
cal fittings or plumbing or wallpaper. Their strips of land had gone to
bracken. Other unoccupied houses belonged to families who used
them as holiday homes, to the annoyance of the few young families
whose offspring had outgrown their houses but had nowhere else to
move to.

'I've seen locals in other communities sleeping in caravans outside

houses that are used two weeks of the year and left unoccupied for fifty weeks,' said Elspeth, Moira's sister and the mother of three young children.

Bill walked me along the road from the village to the former general store and bakery situated alongside the harbour in a pleasant bay with a beach of large pebbles. The men who used to run the Garden Line ships that traded along the north coast from the Orkneys to the Western Isles were true entrepreneurs. It was said that if there was a market for it, they'd deal in it. Their sailing ships, until steamers were introduced, berthed alongside the harbour's small, squat, trim pier which gave shelter inside the bay's bend from the sea that could froth and boil from the full brunt of the North Atlantic with nothing between it and Iceland. They delivered raw materials, ironware and foodstuffs. The other ships to call regularly were the steam puffers with shallow bottoms which used to land here with coal. They surfed up on to the beach at high tide and the horse-drawn carts came to collect the coal. Jean showed me a photograph of the busy pier, her father and grandfather posing proudly outside the bakery they had built with the puffer in the background. No one remembered dates: everything was chronicled according to events, usually births, deaths and marriages. Elizabeth would later tell me a story dating it at, 'My mother, if she'd lived, would have been one hundred', or 'The puffer was still operating'. In fact, until just after the Second World War, it had been easier to get goods to MacKay country by sea than by road. It wasn't unknown for the village to be cut off for weeks at a time in bad weather.

Bill and I stopped outside the abandoned general store built of corrugated tin that had rusted away in places, leaving a patchwork of holes. It was a melancholy sight. We entered the room that had once served the community. The chairs, the sales counter with its scales and bacon slicer rusted from the salt air (its arrival was still talked about as one of the key dates in the community's history) were all still there, but the grain of the counter was etched by years of sand and dust which had worked into it, and into the boarded-up windows, the walls and every other item including a kettle that had been left as if someone had just popped out to say goodbye to a customer while the water boiled for the tea. A fishing boat was beached forlornly at

the side of the building, its wooden strakes worn to the same colour and texture as the store's corrugated tin.

We climbed to the top of a hill behind the harbour. From here we could survey the whole strath and could clearly see the Orkneys in the distance. To the east, in the direction of Dounreay, we could see the headlands of Caithness, to the west, towards Durness, the estuary of a picturesque loch.

Just before my arrival a new chapter had begun in local history. Two incomers, George and Laura, who had refurbished a derelict house, had just had a baby. According to the octogenarian Johnag, it was the first child to have been born in this house for eighty years. Bill, Geoff and Claire asked me if I wanted to visit the baby with them. Claire was wearing a tee-shirt showing the second Duke of Sutherland toppling from his column in imitation of the recent overthrow of East European and Soviet leaders. Underneath the fissured statue was the caption: 'Last chance to see the Duke'. On the front of the tee-shirt there was a description of Highlanders by Auberon Waugh as 'these wretched, murderous, drunken people', which had been reported to the Race Relations Board. I read it slowly and Claire said, 'Enough lampooning of Highlanders has gone on.' The Duke, a landlord imposed by the English government, had instigated the brutality of the clearances; locals variously described him as 'the biggest bastard of the lot' and a 'feudal lout'.

George and Laura were from Devon and had come north seeking an alternative lifestyle. Like others who had come to the Highlands to settle they were looking to escape the overcrowded, lawless, under-resourced cities which had offered promise, but not a corresponding fulfilment. They hoped to return to the land and escape the prison of alienating production lines and the office block culture of the global economy.

The community had adopted them without too much of a stir. They had no electricity, but batteries that were charged on wind power. They were practically self-sufficient, and where necessary George, a talented joiner and handyman, worked for payment in kind. Laura's mother and sister had travelled from the south of England to help with the baby. In such a small community any more incomers would have stretched the original families' tolerance of 'white settlers'.

Although I am fond of babies, it was Laura's sister and her extraordinary looks that kept me mesmerized. She would have been the perfect model for Edward Burne-Jones, she was Ophelia, an English sleeping beauty out of a pre-Raphaelite painting. Her skin was almost translucent, with an etiolated whiteness that shouldn't be exposed to the sun. Gorgeous red hair cascaded over her shoulders and down her back. Her limbs were long and thin, hairless and downless like a doll or waxwork, her toes and fingers delicate like bone china. I wasn't alone: Bill, Claire and Geoff had had the same reaction on seeing this rare beauty.

We walked back to Bill's through a gate with a warning to beware of the bull and traversed the pasture tremulously, not sure where he was among the cattle, but he had us under observation. Rising on his fortress-like legs, the raw-boned bull stalked us at a distance. We paid our tribute by quickening our pace and watched with relief as he turned and disappeared over a hill.

I spent many hours in Bill's company. Thirty years earlier he had moved from Durness, eighty miles away, to be closer to the only secondary school in the area. Living in this village, the children wouldn't have to board, they could travel the nine miles to the next town daily. Bill was now approaching his seventieth birthday, but he kept active. He was originally from Lancashire, but had made the move to Scotland over forty years before. By trade he was a clockmaker, but he also played drums in a local band, sketched, kept bees, made ceramic pieces and was for ever making calculations for his clocks. His skin was stretched like canvas, he had a firm, athletic body and strong, fine fingers that with his mathematical mind allowed him to work with the precision that was required for the unique timepieces sent to him from all over Britain. His workshop had over the years expanded through his house. The workbenches and store were in the children's former bedroom overlooking the glen. One of his more unusual creations was a quartz mechanism fitted to an old His Master's Voice 78 rpm record of Schubert's Ninth Symphony for its clockface. He had been given a whole collection of 78s, but found he hadn't the heart to convert some of his favourites, like one by the Italian tenor Gigli.

Customers sent him grandfather clocks that no longer chimed and

pocket watches that had expired. It was curious to consider that the customers would rarely see the inner workings which are only revealed to the watchmaker. Now that it is a dying art, Bill needed to make the machines that made the parts that fitted the clocks. He handed me a piece of tensile wire the thickness of a hair. 'When I've charged £18 for a part, they complain, "What, £18 for that? It's so small?" I tell them if it were twice the size would they pay double? Picasso took thirty seconds over some of his sketches, what's that worth?'

Bill complained of lethargy, but he was still fired up, designing clocks on his sketchpad which he then built, painting the faces with the moon in enamel, forging his own spandrels in brass, as well as photo-etching the markings in his bathroom and firing the ceramics in his wife Angela's kiln – he was a one-man band who had yet to set himself limits. His *pièce de résistance* was a grandfather clock which worked on sidereal time – time measured by the stars, which he explained to me by holding a lemon in one hand and pen in the other. What Bill regretted most of all was that the knowledge of how to make these clocks was disappearing. 'Most of it can be worked out on computers, but without understanding the mechanisms.'

I had been warned that Sutherland's Highlanders were suspicious of outsiders. I found them open, but shy. However, it took me some time to work out why, when I walked the strath in which the village was situated, I was always catching little starbursts from the windows, as if people in the houses were passing messages in Morse code. The answer was more prosaic. I was being watched. On the windowsill in each house sits a pair of binoculars.

Bill thought the best way to introduce me would be for me always to accompany him on visits. For example, if I went with him to buy stamps at the post office I would meet Mag and Jean. He wanted to see how Robbie, his immediate neighbour, was doing for peats and to give him a pot of honey. Here in the village, you knocked on people's doors which were kept open if they were in, but you didn't wait for an answer. Robbie shouted to come in.

'I've brought you some honey,' said Bill. 'I've found a new colony of bees which had been living under the eaves of the church.'

'That'll be the first time sweetness came out of there,' said Robbie, his thick black eyebrows moving with pantomime rapidity. He had a

mad-sailor glitter in his eye and neatly combed hair. He settled his book, *A Bright Shining Lie*, about the war in Vietnam, on his table. Bill, who had fought in Normandy, told me that he knew where the gunfire was coming from: 'You could hear it, and there were thousands of gliders overhead – you could see them.' Robbie was a vast repository of knowledge and could fill you in on the whys and hows of military history. He had never strayed from his village other than during the war years in the navy, but there was no better example of someone who had travelled without leaving home. The second of his front rooms was a veritable library, with shelves of books arranged alphabetically from floor to ceiling.

Bill made his excuses and left Robbie and me to chat in the living room with its fragrant cloud of peat, whisky and cleanliness. The room was painted Flora yellow and navy blue with the electric sockets in fire engine red. It was spartan and neat, with two calendars on the wall, two radios on the mantelpiece and a ball of string the size of a football – string that he had collected from the weekly parcels containing his order from the shop in the next village. The room's only other object was the television set, but Robbie didn't watch much: 'Too much rubbish,' he told me. As I passed his house one night I saw the eerie blue flicker of his television screen. He was sitting in his worn upright chair in the centre of the room in the manner of a director watching an audition. Robbie spoke with a gentle singsong accent which sounded more Welsh or Norwegian than Scots. He had been christened over his mother's coffin, for she had died giving birth to him.

We sat at a table covered in a checked plastic tablecloth. Every evening he must have set his plate down on the identical spot, as a ring had worn into the surface. He pushed a copy of the *Daily Express* out of the way. In the light of what I had heard about Robbie I was surprised that he would take the *Express*, but he told me he did so 'to find out what the bastards are up to'. Unlike some members of the original community he was keen to encourage and help the dyed-in-the-wool romantics like Bill's son-in-law Stewart, who wanted to make a go of crofting, although Robbie, who was approaching his seventieth birthday, had been glad to give it up.

'It was getting too difficult for me if I'm honest, that's the truth of

it. You have to fill out so many forms, so much paperwork, everything except your birth certificate. You almost needed a secretary. And the government took a quarter of it from us at the bottom.'

Robbie had never married. It would be the end of a long line of family members born and bred here. 'I've never tried taking it back further than my great-great-grandfather in the mid-1800s. Maybe they were here before the clearances or they came during the clearances like hundreds of others who were driven to the seashore.

'There was nothing here. Every square of earth had to be turned over. Even now you couldn't use a machine, it's so steep, so rocky. It was just subsistence. You couldn't just live off the land, you needed to do other work – fishing, jobbing. People left when the jobs left, you went in search of work, where the jobs went. Then they were joined by their families. Everyone has left or died off.

'We had fish, plenty of fish, no one was going to starve. We would have, had we only had money. Like my father who was a crofter, we also fished. There was so much fish they bloomin' nearly jumped into the boat. Now you'd be wasting your time going out. I used to catch salmon, lobster and white fish. It used to be taken to the train to go off to Billingsgate. Now if you caught lobster you could sell it by the quayside, but that's always the way the long story goes.'

Graham was the village's last fisherman, but even he had all but given up, making his money from pleasure trips to Storn Island for the few holidaymakers and campers that made it this far. The island's last inhabitant, Billy MacKay, had left because alone he couldn't keep the settlement going. Robbie had seen small boat fishing coming to an end and had worked for the forestry commission until they started to wind that down. It had gone the same way as road building and maintenance which now employed outside contractors. I'd heard the same complaint in Leicester, Halifax and Newcastle: local jobs often went to outsiders. It was the same story with modern technology which, like fishing, stripped what few precious resources the community had.

As Robbie explained, 'Peats can now be cut by machines. Now they're cutting the hell out of it, soon there'll be no peats left! They told us nuclear power from Dounreay would make electricity cheaper: if anything it has become dearer. Soon we'll be using oil. Everything was so cheap, families used their own labour to build their houses,

but there were stonemasons and joiners. I found a bill the other day from the joiner's shop, twelve shillings for two handmade window frames and the front door.' He pointed to them.

'Can you imagine that on Saturdays two buses wouldn't be enough to take everyone from here to Thurso or Wick's two picture houses. We sometimes had to fight for a seat and even then you'd need the Highland bus as well. Now you couldn't fill a bus if everyone here went. Anyway the picture houses have been closed, they've gone the same way as the Highland Travelling Films that used to come here, the big round O like everything else.'

He no longer left the village. The postman brought him the *Daily Express*. On Mondays he got on his old-fashioned, gearless, sit-up-and-beg bike to go to the post office to collect his pension and bread; the other villagers set their clocks by Robbie's bike rides. On Fridays he'd fetch his parcel of groceries along with his long life milk and leave the list for the following week.

Robbie's byre, which had originally housed the animals, was now an Aladdin's cave, a living museum of his life with his crofting, forestry, and fishing equipment including sea buoys new and old, made of plastic, cork and pigs' bladders which they had once used – 'If you go back to before Jean was born.' He had recently given young Stewart a pair of shears from the thirties, still wrapped in the original oiled paper.

Every morning I would stare out of my bedroom window. The previous day's great citadels of cloud had been replaced by a distant and cloudless sky, a perfect eggshell blue through the window, but inside the light barely penetrated, it was like looking at a painting in a gallery. I stared out at the valley and the fields. Stewart's sheep dotted his croft, there were the solitary houses in the distance and a few scattered outbuildings. The glass barometer pointed permanently to Change. Stewart would again be shearing the sheep in a bid to profit from the good weather before the rains came.

Before I left the house, Claire would ask me, 'Have you got a piece?'

'No.' I was quite happy to pass on the sandwiches for lunch.

'Are you sure you don't want a piece before you go?'

They were the perfect hosts and left the house as soon as they had

finished breakfast to spend their days in Melness at a Gaelic festival. Geoff was fluent in Gaelic and Claire was fast becoming so. In fact, they also spoke Spanish and Galician. With them in their living-room there seemed to be a magic and power, a fusion of world views, European, Highland, Gaelic and Galician. They talked about the links between Gaelic and the Galician language and I later read somewhere that Spain has its own version of the bagpipes – the gaita of Galicia.

Stewart, who lived in one of the village's three council houses, worked Bill's croft. He made many sacrifices to do so and his regular work as a plumber suffered from the time he dedicated to making a go of farming. He'd even joined the crofters' union. The system originated in the early decades of the nineteenth century. A croft is simply a small piece of land, usually made up of rectangles of arable and permanent pasture which are often laid out in a line, with an annual rent of less than £100 enshrined in labyrinthine crofting laws. If you buy your land, which a tenant has been allowed to do since 1977, strictly speaking you are no longer a crofter. Bill had bought the land and given it to Stewart to do as he pleased.

According to the book *Crofting Agriculture*, written by Fraser Darling in 1945: 'Intensification is open to those who have crofts on the western seaboard not more than a hundred feet above the sea, and should particularly be followed by crofters who have a bit of light soil in a sheltered position just above the high spring tides. The mild climate, free from early and late frosts, allows the fullest working and heavy manuring of such ground.' This gives an idea of just how hard it is to make crofting a viable proposition. The older members of the community were divided between those who supported Stewart's ideal of returning to the land and those such as Elizabeth who said there weren't enough people in it, you couldn't recreate what's gone.

There were strongly held views about the young ones coming in, from the antagonistic – 'They come up from the south, not long here and start trying to change it' – to the tolerant – 'You get used to them.' But in such a small community you had to be a consummate diplomat, a chameleon, a master of the bob and weave, because you had to get on with folk. In the past an argument over a penny between Mag's father and grandfather led to her father emigrating to South

Africa. And there was only the single track out of town where you were bound to bump into your neighbour.

I found Stewart whistling to his dog to round up his sheep while Johnag and Robert waited to herd the ewes into the pen. Once they were all in, Stewart and Robert would wrestle them one at a time to the ground until they were on their back. They then clamped the ewe's head between their legs as it continued to struggle. If the ewe got a purchase with its feet it could right itself with great force. Once they had been shorn of their wool Johnag would mark them with a dab of paint. She bellowed instructions, she never talked. Stewart and Robert were still new to this game. Stewart had done clipping the year before, Robert remembered helping his father do it during his childhood; this was their 'classroom of the hills'.

Clipping was just one event that returned them to a time that cities have forgotten. As Johnag explained, 'Sometimes we didn't have a penny in the house. Dad worked at sea and went on boats as far as Great Yarmouth to sell his fish, then he worked on the road gangs and crofting. We were dirt poor, but no one went hungry. Those with helped those without, there was always someone chapping at the door with a scrap of something for the pot. It was a neighbourly thing, everything was shared out.'

Johnag was Robbie's cousin and she had been born in his house. 'We had father, mother, mother's sister and me, our grandfather, mother's niece and nephew under the same roof. I had a brother, but he died after a few hours. Then we moved the 200 yards from Robbie's house to the one I'm in now. I've been there for seventy years.'

The council had recently insisted on modernizing her house and it was most distressing for her: she had managed without an indoor toilet and running water all these years. She recalled the days before the village had mains electricity and water, which only arrived here in 1950 – the year the cow got struck by lightning and the horse died.

'We had a power cut last winter, I used a paraffin lamp like the old days, it was much warmer to use paraffin.' She told me she didn't have time for television and until her eightieth year she had never travelled further than cycling to the next village for half a crown for the parish's widows. In her eightieth year a Red Cross car came to take her to Inverness for a medical scan for her arthritic neck. She

remembered Inverness as a big place, but hadn't had the time to explore: by the tone of her voice she had been no more than curious.

The light faded as the clouds darkened overhead — Johnag called it greich, bleak. We hunched our shoulders, expecting rain, but none fell. Jet fighters roared overhead and we broke for lunch. On the way to Stewart's, he told me how Johnag only left the village if a letter needed posting. 'She won't post a letter here, because she once saw a boy looking at her letter with the light behind it.' This habit still extended to the postman, who would arrive with the mail and announce, 'That's the social security, that's the lecce [electricity], that's a personal one from London'; and if you weren't in he would drop it off with a family member. In days gone by the mail bus would arrive carrying an assortment of goods. People would gather at the post office and the names on the letters would be read out and handed over plus any that the neighbours could deliver. The remainder would be taken round by the postman on his bicycle the next day.

I think this closeness was getting to Elspeth, Stewart's wife. She explained to me how a friend of hers had come to visit her every other weekend. 'She had the same car as the district nurse, so when I went to the post office the other day, Mag and Jean congratulated me, they thought I was pregnant.' Lucy, her oldest child, had just returned from visiting a friend in Thurso and had taken ill as she always did when she came home. I could imagine it was possibly psychosomatic: there wasn't a lot for a child to do here. Lucy's younger brother and sister went to the next town's Gaelic school where it was hard to attract young teachers. It was proving difficult for them to hold on to Mary, their Gaelic teacher, who was from the Orkneys. As Bill said, every young woman is married or has left. 'They're lost to here. "If you're bright you bugger off" is the saying.'

His wife, who had grown up in the village, wasn't as enamoured of the lifestyle as Stewart, who had grown up on an estate in Thurso. Elspeth felt stifled by the intimacy of everyone knowing everyone's business. When I dropped her on the main road to catch another lift from a friend her father remarked, 'So it was you getting into Nick's car.' Mag told her, 'You passed a car going to Geoff's', and Jean told her who had been in the car. However, recently she had found a way

to break the isolation of living miles from anywhere. She had bought a computer and modem to link up to forums on the Internet. It seemed the heaviness around her eyes was tiredness, not from the harsh outdoor life of crofting, but from being glued to the electronic screen in the early hours of the morning. In the way she spoke about the Internet, I felt she was entering into a dialogue with her correspondents in a compulsive manner that was more than the way in which you play with a new toy: the conversations with a designer in Barcelona, a travel agent in Ohio and a Baptist preacher in London had become the quicksand of addiction. It is strange that the more ways we invent to communicate with each other the less we seem to be actually communicating. We are creating artificial environments built on electrical pulses which, unlike the seasons that cannot be slowed or hurried, know no time zones.

Elspeth's frustration wasn't just with the geographical isolation. Life would have been a lot easier if she and her family had more space. Stewart, Elspeth and the three children shared two bedrooms and a living-room that had to accommodate the children's toys, Stewart's filing cabinets and Elspeth's computer system. There was nowhere for them to move to. The other two council houses were no bigger, and in the unlikely event of a house coming up for sale, it would be beyond their means or anyone else's in the community. As in the past, it would either become a second home for the wealthy or a peaceful retirement home.

They weren't the only ones facing an uphill battle. Robert, who was in his late forties, had returned to his native village and the family home. Like many he had left in search of work.

'Life changed. When the nuclear power station opened in Dounreay people went there to get jobs. It became a race to get the first washing machine, the first electric cooker, the first dishwasher. It was money, people started caring less and being less concerned about their neighbour.' Robert had found a job as a crane driver, but had recently been made redundant. 'I've had six months' work in the last two years. I can't get work through the newspapers, it's only my former employers who'll call me when they've got work. I'll work anywhere.' We continued to chat as he returned to the job of clipping Stewart's sheep. 'Mind you, I work harder now than I've ever done.'

Robert couldn't start crofting because, as he explained to me, although grants were available through the region's status as one of the EU's 'Less Favoured Areas', you had to pay out to begin with and without an income you couldn't borrow from the bank. His daughter would have liked to return, too. 'She'd murder to get back here, but there's no housing.'

With the benefit of several decades of perspective, Robert talked about the different types of poverty. He thought being denied education is poverty; it wouldn't have been as difficult for him as for his parents to have gone to college, but he felt successive governments had made that goal more difficult for his children. You now needed to be well off to cope with the loans. He felt the quality of life used to be much better. 'We were a lot poorer, but gentle poor, everyone had something to eat. It was a physically gruelling life, but fit young people shared the burden. Everyone helped out; you did the peats for the old people and the clipping if you hadn't your own to clip. I suppose it was close to what you call communism.'

The theme of the quality of life returned often in conversations with the older villagers and none spoke more eloquently and with more conviction than Elizabeth. Like Johnag, Robbie, Mag and her sister Annie, Elizabeth had never been married and I could not help asking myself why this handsome, energetic and intelligent woman had never found a spouse. She lived at the end of a gravelled roadway in a pink cottage, and wore pink slacks to match. The cottage was tucked into a huddle of low sheds at the foot of a dome-shaped hill not far from the track that led into the village. She removed her wellingtons and apologized for having to shut the door. 'There'll be no door left, everything is on its last legs. If it slams shut once more, I might have to climb out the window.'

Elizabeth's life had been guided by her devotion to God and the Church. She belonged to the Free Presbyterians whose ministers in the past denounced, among many others, Cliff Richard for leading the young astray. The Free Presbyterians are also known as the Wee Frees as opposed to the Split Peas, the APC or Associated Presbyterians, a breakaway group of Free Church members who left in solidarity with Lord Mackay of Clashfern, the Lord Chancellor, in 1990. Lord Mackay

had been disciplined because he attended a Catholic requiem mass. This seemed in keeping with its strict Episcopalianism: it was said the village's chickens dared not cluck on a Sunday, *port-a-bheul* – mouth music, song and dance – was banned, and you had to travel to Tongue, the nearest town, to find moderates.

Elizabeth offered me tea and chanaca, Peruvian molasses, which she had been sent recently by friends she had made there. She asked if I minded her saying grace before we drank the tea. In one respect she differed from the other older villagers I had spoken to. She had carved out a life for herself elsewhere and had only returned to look after her sick mother who lived until she was 93. She considered leaving one's parents on their own a fate worse than death and had borne her duty in keeping with her Calvinism. 'What's for us, won't go by us. What's for you, won't go by you,' she told me. She clung to the Bible as to dear life itself. She quoted passages from the Bible and told me the community's difficult moments had been foreseen in the famine when the Israelites passed to Egypt. 'Poverty saves you from abuses and excesses,' she asserted. 'There are so many questions that only within the Bible are the answers to be found.'

'I get so confused,' she told me over tea. 'As Robbie Burns said, "Facts are chiels, that winna ding" – now everything is in a state of flux, confusion seems to be part of our heritage, there are so many appeals, leaflets, so many deserving causes, I don't know which to give to', so she gave to all of them.

We sat 'blethering' for so long that I found myself invited to stay for lunch. In the quiet that ensued as she prepared cold meats and salad, the pipes gurgled and the water whined. I looked around her compact, dimly-lit front room. She had several ornaments from Peru, a calendar and a small stack of books on her shelf that included the Bible, *Pilgrim's Progress* and *The Holy War* by John Bunyan, and the complete works of Shakespeare. Elizabeth said grace again before we ate lunch. She had never tried to hide her disdain of most incomers; she compared the community to a bowl of browse: water, oats, salt and cream – cream on the browse, like cream on the milk jug. 'People who've lived here all their life are the cream on the top of the jug, rich and thick, underneath it's thin and watery.' It was an image she returned to often. As it was, her amusement and suspicion of incomers

led her to believe that they were only the sharp end of the wedge: 'We'll get out of this into worse.'

Elizabeth's belief that it was a fallacy that people were coming back, that the community was getting too old and would simply die off for lack of enough fit young men to sustain a viable living wage, isn't necessarily a foregone conclusion. There were signs of renewal, none more so than the revival of the Gaelic language. Johnag and Robbie's grandfather's generation didn't speak English, they needed interpreters; the English of their fathers' generation had been as rocky as their children's Gaelic. Johnag and Robbie hardly speak Gaelic now, and then discreetly, a hangover from the days when it was banned by the English. But they were proud of Stewart's children being brought up to speak Gaelic and proud that *Am Bratach*, an independent news magazine, carried the occasional article and letter in their parents' mother tongue.

The outside world did occasionally intrude in a positive manner. Peter and Liz, incomers who had settled here in the seventies, had brought touring musicians, French mime artists and a dance troupe from Burkino Faso, to the village hall. It was a return to the days when the villagers packed the hall every fortnight when the Highland Travelling Films came to town. The locals had put up the visiting artists in their homes and the community had been enchanted with the Africans, who described this remote corner of Britain as 'a wilderness with water and a desert without sand'.

Nothing can better exemplify the faith in the future of the community than Robbie continuing to plant trees to protect his house and Stewart's strip from the howling winds. They would take thirty years to grow, but 'they were doing nicely', he said reassuringly. As young, aspiring new crofters like Stewart took charge of their destiny the loss of pride which former generations of crofters had felt because of their dependence on landlords and governments was disappearing. The historical grievances will take much longer to heal; two centuries have done little to resolve them and the mini-empires of absentee landlords are still present.

In the evenings Geoff and Claire would light a fire. Geoff tried getting me to enter into the ethnic experience by bringing in the peats, but I

didn't fall for it. We joked about this and I came to realize that one would do well to learn how to accommodate people's habits. For the most part the incomers had made a decision to be part of a community. They had turned their backs on individual achievement. We sipped whisky as the room filled with sharp, sweet peat smoke and in the firelight's shadow-theatre we all looked slightly insane.

The journey along the single-track road out of the village seemed interminable. Bright rays of sunlight tore through the clouds like powerful searchlights – even the small loch seemed to sparkle. I tried to imagine the traffic that had once plied this route: George MacKay and Gordon Brown in the butcher's van from Thurso nicknamed the Trojan, Mag the current postmistress in the big delivery van she took to driving when her father died, the coal carts from the beach head, the milk truck, the fish van, the women bringing the cows home, knitting as they walked between the strath's many hamlets, the men carrying the creels, the two Jewish gentlemen who came with samples of material, the district nurse, and of course the tinkers who were never turned away empty-handed.

In a sense the community had been made even more remote by the improvement of the road: the crofters had left the land and flocked to the towns and cities, desperate for money to buy a better standard of living for their families back home. But they didn't return; they called for their families who followed in their tracks, leaving behind an increasingly beleaguered community.

As I continued along the bleak moorlands only the broken lines where the villagers had sliced the peats for the winter months varied the overwhelming isolation. The only word to describe MacKay country is sublime. Before I had even reached the end of the track I knew that one day I would want to return to the stunning scenery and the sense of being on the edge of the world. Even the simple act of getting here had been a unique experience, but I could not help contemplating the developed world's growing concern for the preservation of these environments which often ignored the people who inhabited them.

At the junction of the A836 Thurso to Durness highway, I stopped the car and turned to take a last look at the track. A little hand-made sign had recently been attached to a post: it read *Hall: tea, coffee, homebaking, snacks, games*. Most foreigners turned back halfway along

the four-mile track. The sense of detachment from the world, of not being able to drive at speed and keep to a timetable, deterred people from going any further.

I didn't have the heart to ask Elizabeth why she never married. Some questions were better left unanswered.

A few weeks after I left both Robbie and Bill celebrated their seventieth birthdays. Robbie received his first birthday present since childhood from Geoff and Claire. Bill's son returned from New Zealand and his daughter Moira from London for his birthday, and there had been much drinking and good craic with Geoff, Claire and Robbie.

During the following severe winter when night hardly ever makes it into day, as the winter unleashed its full fury with its soul-chilling winds blowing off the North Atlantic across the mossy moors and rocky crofts, Stewart lost sixteen lambs.

Elspeth, Stewart's wife, no longer wants to stay put. The remoteness is getting to her, and new friends on the Internet haven't shortened the distance between friends and family who were still miles and miles away.

GLASGOW

Tonight We're Rockin'

I LEFT THE far north of Scotland in July, having discovered that social intimacy comes at the price of privacy: everybody knows your business. The day I arrived in Glasgow the rotting body of a pensioner was found in his flat eight months after he died. Neighbours hadn't seen the quiet eighty-two-year-old for months, but no one had reported him missing. Council officials only took an interest in Malkie when his rent fell into arrears and they moved to evict him. When the police battered down his door the Christmas cards were still on the mantelpiece.

It is difficult to speak of Glasgow. In 1990 it found new prestige as the cultural centre of Europe, but at first sight it is not a pleasant place, this sprawling metropolis with its grim twenty- and thirty-storey tenements and claustrophobic closes. For many Glaswegians it is not cheerful, or easy, or safe, or reasonable; it is, however, a passionate place, where both young and old, the hopeful and the disillusioned, find a life lived constantly on the edge. The city breathes with a vitality like no other city in Britain. In this Glasgow has much in common with New York.

I drove into Christine's close at a snail's pace, through toddlers playing in the street oblivious to the traffic. As I pulled my bag out of the car a young man called up to a third-floor window, 'Do you want any rugby balls?' In Newcastle they were known as jellies or wobbly eggs because of their soft centre; here the prescription sleeping pill Temazepam is also nicknamed after its shape. I was soon to discover that this drug was almost as popular as oxygen.

Appearances can be deceptive. Christine's sandstone tenement in the East End is framed by a thin border of pleasant shrubs, but a steady stream of young drug addicts, both men and women, use the

pavement for making their deals. They are rarely older than their late twenties, and often as young as fifteen and sixteen. In Christine's presence they were not malicious, and they often asked her, as a former local community activist, for advice on rehabilitation centres.

When I telephoned Christine ahead of my arrival she asked me, 'Wherr ur gawn tae stop?' I wasn't sure. Less than two miles out of Glasgow city centre, there were no boarding houses or hotels. When I said I would find something in town she told me off. 'Ach don't annoy me! You're gawn tae stay with me.'

'What about your sons?' She lived in a compact two-bedroom flat.

'Duncan is in Tenerife and is no home till Saturday week and Alistair lives with Patricia and the wean.'

So I pitched up with a bottle of malt whisky, knowing that with this pillar of strength in the community, who had enough energy and bounce to make an active person dizzy, there wouldn't be a dull moment. I was not to be disappointed.

Christine is one of those larger-than-life figures like so many women I was to meet in Glasgow. Like many of them, too, she had discovered the nation is too big to look after the little things and too small to take care of the big things. Like more and more people living in small communities, Christine was one of those who recognized and dealt with problems at a local level without recourse to the state. Politics had, in her words, become like the supermarkets, 'More for less'. She took her battles to the male-dominated local councils, which she saw as impenetrably bureaucratic and chauvinist as well as hopelessly irrelevant and out of touch with the day-to-day reality of local people. She had won battles to help set up a creche, a drugs advice centre and a family flat for young children and their parents. The women were the driving force, but success also bred resentment, petty jealousies and envy, particularly from the men who were out of work. When the women had fought successfully for funds to set up support groups, the men wanted a piece of the action; they wanted to be given the job of running them.

Having helped set up the community's self-help groups, Christine had moved on to working with street women. At the end of the week, after four two o'clock to midnight days, she was ready to try and

obliterate her clients' harrowing lives from her mind; but, as I was to
discover, everyone knew Christine and wherever she went they brought
their problems to her. She had, however, learnt to set the problems
to one side and allow herself to have a good time.

'Tonight we're rockin',' she said soon after I arrived at her place.
'It's Patricia my daughter-in-law's twenty-fifth birthday and we're goin'
to the pub to meet Catherine, Jenny, Olive and Little Frances. I hope
you dain't mind.'

'Why should I mind?'

'They're only women, no men.'

As we prepared to go to the pub, her son Alistair came banging at
the door. 'Where's my fookin' giro?'

'Sorry, Alistair?'

'Where's my fookin' giro?' he screamed. He stormed into the flat,
took one look at me. 'Meet Nick. Nick, Alistair,' said Christine.

'Fook you.'

'Leave me alone.'

Alistair left the flat cursing his mother. 'Bitch! Cunt! Fucking cow!
Liar!'

His wiry bicycle-frame of a body was spry and wan, and he looked
older than his twenty-eight years. For years he had been abusing his
body with sachets of smack and capsules of jellies.

'I wish he were dead. I don't want him to die. I love him because
I'm his ma, but I don't like him. Can you understand that? I'm so
tired, he must be so tired.' Christine had lived through a marriage to
a violent husband and had two sons who were like chalk and cheese.
One had inherited the violence of her deceased husband, fuelled by
an addiction that had driven him to steal her wedding ring; the
other son, Duncan, was as polite, supportive and helpful as could be
dreamed. 'Alistair has his father's insane jealousy. If I'd had an argu-
ment with his da or a fight he'd go out and hit someone out of spite.
I had a girlfriend to stay last month and Alistair accused her of being
a lesbian. He smashed her car window and slashed her tyres.' I cringed
at the thought of my borrowed car parked right outside her tenement
and I had reason to be worried: the neighbour found his new car's
tyres slashed the following morning.

When Patricia came to collect us, she was agitated. She knew Alistair

as well as her mother-in-law did, and yet she continued to show unstinting devotion to her husband. As Christine readied herself, Patricia confessed that, 'The best birthday present from Alistair would be if he went away for eight weeks. I hardly ever get a shag, he's so wasted. And I'm afraid to be out at the pub because I'm worried about leaving the wean in his care.' The two women joked about his behaviour: Christine laughed off the threats Alistair made whenever he saw her drinking in a pub with a male friend, and Patricia did an imitation of Alistair promising to give up his habit. She called to Christine in the bathroom: 'Are you using that new mouthwash I bought you?'

'It's not a mouthwash I need, it's a sheep dip.'

We left the tenement and passed the teenagers in scrums on street corners hustling their deals. We passed the railings to the factor's office hung with bunches of flowers in memory of Willie Lyle, victim of a gangland execution two days before in broad daylight in the middle of the street. An official sign on the factor's office read, 'A look on the bright side of town'. Daubed on a wall close by were the words: 'Willie Lyle is a grass' and 'Willie Lyle is a police snout'. I read some of the cards on the bouquets: 'Proud to be your pal', 'All the lads from the Apple' (the local wine alley), and 'You were many things, but never a grass'.

Glasgow is a tale of two cities, 'Cathlicks and Proddies', Celtic and Rangers, Green and Blue. Christine looked at several of the bouquets. 'It's terrible,' she said. 'Even in death they won't leave it alone,' pointing to the orange lilies tied with a red, white and blue ribbon. 'Willie would have liked that and laughed.' Everyone knew Willie Lyle and in the pubs they were still talking about his death, but the dozens of witnesses weren't talking to the police.

'He'd gie his last penny,' said Catherine over a pint.

'It wasn't his money, he'd robbed it,' said Christine.

'I was staring down the barrel of a gun. Two men in masks – I thought it was a joke. I thought they were raising money for charity. I put my hand in my purse for a couple of quid. Realized they were for real. Jenny started shouting at one of them. I realized one of them was Willie. Afterwards I told him, don't you ever point a gun at me. He said, "You know I would never have pulled the trigger." You never

know, and his partner who had the gun at Jenny is a fucking psycho. He's in Barlinnie for murder.'

I went to the bar to buy a round of drinks. The barman wouldn't take my English £10 note. 'We don't take £10 and £20 English notes, there are too many sniders floating around.'

'But I don't have any Scottish money,' I pleaded.

'Are you from New York, the city that never sleeps? Ha, try changing Scottish money in the Big Apple.'

As we talked, the pub filled. Like all the pubs I was to visit with Christine, the windows were bricked up and no natural light penetrated inside other than from the entrance. Men played snooker, others hung around the electronic gaming machines or watched the races on a television set while a steady stream of shoplifters hawked their merchandise. A man found no buyers for a pair of size eight brown suede shoes. An extremely attractive woman Christine worked with, who was facing five years for possession of 932 jellies, offered several blouses and woollen skirts still on their hangers. Another had pairs of designer sunglasses: she crouched in a corner next to Christine in a foetal potion, her young, pretty face ravaged by her addiction, with deeply drawn lines and hollow eyes. Christine tried to comfort her in the only way she knew, but the lure of the next fix was greater than Christine's powers of persuasion and she disappeared into the ladies to keep her appointment with the needle. After the clothes and accessories came other merchandise including a joint of meat and bottles of perfume.

Catherine was one of the many who had witnessed Willie's murder. She had been shopping with her four- and six-year-old nieces.

'Willie left the factor's and was walking across the road, five guys started running after him. Willie started to run, he nearly got away, one of them got hold of his jacket. The first one slashed him across the stomach, the second into his neck, the third into his side, four of them kept stabbing him, they screamed, "Willie Lyle grassing b—!" Sorry, I don't like swearing. The women in the street started shouting "Cowards!" They screamed, "Lyle, you're going to die, bastard!" God forgive me for swearing. It was all over in a second, so quick that when they ran off they knocked into my sister's two weans. I don't

know what they saw. The lassie next to me said she knew first aid, but she was too scared to go over. I said, "Hold my hand." He was lying in so much blood, his face was so white. I think he was still alive when the ambulance arrived, but I knew he was going to die. We took the weans home – one had blood on her dress. I recognized one of the murderers, he hangs around here, but I couldn't tell the polis, they'd get one of my family, George or someone else.' Catherine had witnessed four murders in sixteen years, including a mistake when the man they were aiming for jumped out of the way of the car that was to have run him down and it killed his girlfriend instead.

She had been a bus conductress, a wages clerk, a telephonist and a shop assistant. 'When I was a kid you could change jobs like changing your socks. Now I can't find work. I could have got redundancy if I hadn't left my last job to look after my dying husband. The supermarket closed when I wasn't working. I had worked there fifteen years. They want young women now, but I'm thinking of getting educated on computers.' We were interrupted by a young man who pulled a handful of vacuum packs of smoked salmon out of his coat pocket. 'Half price for youse,' he touted and for the first time that afternoon there were takers.

Two foot-soldiers from the Salvation Army were hawking their newspaper the *War Cry*. 'I'll give,' said Catherine, 'but when I'm giving I want to make sure it's going into the weans' belly, not to the maggots. They're lining their pockets with thousands of pounds.

'Look at the way things are going. There's nothing for us. My granda sweated to build them ships. My granda worked for eleven and six a week. Now they've closed the yards. The great cranes along both banks of the Clyde are gone. The yuppies have moved in. I'm greetin' [crying]. There'll be anarchy, and I'll be honest with you, I'm for the anarchy, I hope there'll be trouble. I'm all for a revolution, there needs to be, to renew, to start again.

'The lottery is our only hope. The working classes need hope. Surviving is not enough! The only industries we've got left here is football and rock. And I'm not spending me money on lottery when they're giving £58 million to opera, to the fuckin' toffs. I'll pay for half a ticket, and I begrudge even that.'

Christine fetched a birthday cake that had been held behind the

bar. Everyone sang 'Happy Birthday' and Patricia was about to start greetin'. 'I feel a bubble coming on.'

As Patricia cut into the cake, Catherine told me, 'My first birthday cake was at forty-five. My da had a dumpling for me birthdays, and I've not yet been to a pantomime.'

Double-jointed, rail-thin Little Frances took to the pub floor and did an erotic snake dance, then used one of the pub's concrete pillars as a tango partner. We laughed so hard we nearly split our sides. Helen, Little Frances's sometimes partner, started to greet from helpless laughter. 'She's got no teeth in her head, but she's shit hot.' And she was.

We all tumbled out of the pub at closing time. 'D'ye fancy a curry?' asked Christine.

'Yeah.'

'Right, c'mon!'

Christine, Patricia, Olive and I walked home. We passed a group of ten- and eleven-year-olds too busy skinning up on the steps of the Social Services to take notice of us. We ordered our curry at the Chinese takeaway which, like much of the neighbourhood, had been daubed with the words: WILLIE LYLE IS A GRASS.

I slept fitfully. As the sound of the traffic died down I could hear the children playing outside. Tin cans were being kicked, skateboards were being used to hurdle the curb. The night air was still, making the sounds all the more raw. A child screamed and another started crying. I lay there turning it over and over in my mind. How old could the child have been? Five, six, possibly seven years old. That child's bleating continues to haunt me.

Next morning I woke to the clatter of the police helicopter. It hovered over the tenements like a gigantic bee, moved this way and that, the beat of its rotor blades chopping against the sandstone walls. It hovered again, and eventually moved away – it had either found its prey or had moved on to another quarry.

Christine cooked me an enormous breakfast. There was a knock on the front door. 'That'll be Alistair coming to apologize for last night.'

Alistair stood in the hall, his emotions playing volcanically on his face. 'My giro! Where's my fucking giro?'

'Alistair,' she tried to reason with him. 'The post hasn't come.'

'You were out drinking in the pub last night.' Alistair accused her of talking to a man. 'Do you remember your marriage vows?'

'Yes,' Christine started to smile, but she daren't relax. '"Till death do us part." So there. Your father's dead.'

'But you're not dead.'

I was looking forward to renewing my acquaintance with Big Frances. I had first met her a year before with her friends Carol, Frances and Margaret in The Refuge, a bunker-like flat in an otherwise unoccupied close in one of Glasgow's most notorious schemes, or council estates, ten minutes' walk from Christine's. These are the mothers whose families have been torn apart by the prevailing drug culture. Big Frances has nine children; when I last met her all were unemployed, five were heroin users, two were dealers, and her seventeen-year-old daughter was in prison for her tenth shoplifting offence. The two girls who were neither drug users nor pushers couldn't escape the drug world – they were robbed regularly by their brothers and sisters. While some of Big Frances's grandchildren had never been inside a car, their parents were experts at taking and driving them away. It was extraordinary, in the circumstances, to hear Big Frances's sunny outlook on life. She was not self-pitying; she remained energetic and positive, and considered herself fortunate compared to the poor people of Somalia and Ethiopia.

As I entered the small living-room in the Refuge family flat, Big Frances greeted me warmly: 'Good to see you, Nick. How are ye doin'?' Like many of the people I had met on my brief visit a year before, I felt as though I had known her all my life. I remembered Big Frances's stories of her childhood. Like so many, she had shared a room with five brothers and sisters. 'We were five weans and me ma and da. There was no room on the floor in a wee room like this, you had to go from bed to bed to move around the room. I shared a bed with two others. One was a bed-wetter, so I chose to sleep in the shallow end.'

I asked Big Frances if she could carry on her story from where she had last left off. 'Those were the good days,' she reminisced. 'My ma worked in the bakery. God rest me mum. I don't think me da ever worked. He was a gambler. How can I put it, I think he dealt with

businessmen, he was a street fighter. He was in heavy with the bookies. Made money all right. Never saw the money, treated my mummy terrible, beat her up terrible, we used to see that. He'd throw all the washing down the lobby and scream, "Who would like to do C. O. W. McCluskey's washing?" She hurt him with a breadknife, 140 stitches in the head. He was going to attack us. They were hard days, when I was young. You're talking about ration books.

'My mummy suffered with him. I don't know why. Never called her by her name. He used to say, "Go out and get some teas for my friends." She'd say, "I've only got four pence." And he'd shout, "Don't ask me for money!" Glasgow men got a curse way of talking to you. People always say Glasgow men are mean bastards to you, but they'll always give you their last. My daughter Anna's staying with a mean fuckin' bastard. If I knew a contract killer I'd pay him a hundred pounds to kill him, that's how much I hate him.

'I never knew what drugs were. We played games in the street with chalk, we called it peerie. We used to go dancing. There were six dance halls around here. Then we had jobs, stacks of jobs. Kids have nae jobs nowadays, so many O-levels and A-levels and they're cleaning the streets. Sad intit, sweeping the streets? And the good brains they've got, Mother of God. The drug scene started with unemployment here. They got bored, not much activities, nothing set up for the boys and lasses. It started with purple hearts, then hash, then heroin. Everywhere I look here my pals' children are taking drugs. They've become so set in their ways. I've got three sons. I've hardly seen my boys outside of Barlinnie. They keep telling me they're getting too old for this. I'm getting fed up with hearing them say that. I've heard it a hundred times. They tell me, "Don't worry about me". I tell them it's their body, their mind. I haven't got enough money to get up and see them. All I can give them is £2.50. They got stacks of friends outside when they're shoplifting, none when they're inside, where are the pals then?

'I'm getting fed up. I'd like to know the feeling they get when they're taking drugs, why they're on them. I've three boys and six girls. Nathalie came out of prison two weeks ago, five of them have been inside, now only one of them doesn't do the drugs and hasn't been inside – last year when you were here there were two – the last one who doesn't take drugs has taken to drink. Don't get me wrong,

drink is no better than a tablet. My man's all gone with the drink, shaking arms. He takes two whiskies and feels better, better with more strength, cheekier, and aggressive with the drink.

'With my lasses it's always, "Ma? Ma? Ma ... What's that youse say Ma?" They're more mellow with the drugs. Without they're a fiend from Hell. God forgive me. If they'll steal off their mum they'll steal off the Devil. They'll steal a fucking lousy pound from the weans for a tablet. I feel sorry for my man, he's coming up to sixty-five and he's looking after the weans again. I'm looking after three grandweans; Caroline who's Bernadette's three-year-old, Rosie who's Paul's five-year-old and fourteen-year-old Elizabeth, who's Young Frances's daughter. Dora's lost her three beautiful children through drugs to foster care. The lawyers fought it and got me access to see the weans every six weeks for an hour. They said I had too many weans already, couldn't find it possible to give me them. And because my man's sixty-five, against it because of his age.

'Dora's got nae hope of getting the weans back, she's too far gone with the drugs, sleeping in the back of closes. Her boyfriend's inside, in the jail. Her weans are beautifully dressed, well-educated, the social worker takes me there and they don't want for anything. It's best the weans don't see their real parents in their state, they've already seen them jacking up. Weans keep asking if their mum's getting any better. I don't know what to say to them. In the first place my daughter shouldn't have had weans. Hasn't got the mentality. I blame the parents. They let them do anything. If they scream they give them a pound. My mum couldn't afford to do that. If the parents showed their weans more discipline, the weans would show more respect to their parents. They say to their parents, "If you don't give me a pound ye bastard, you'll see." And the parents answer back the same way. I'm serious. It's got worse and it's going to get a lot worse. There won't be many grannies and grandads left in the 2000s, drugs'll get them. They're already wasting away. Think about it; every time they take a hit they're doing in their body. My daughter has nae veins in her body. She was rushed into Royal Hospital and they couldn't find a place in her body for a vein. The doctor said we'll have to inject in the neck.

'I've often asked myself, where've I gone wrong. Six lassies had jobs,

two machinists – the two youngest – two carpet girls on the looms in the carpet factory, two in a dispensary, they called it the Sannex factory. They got paid off, all six, in time all the factories closed down. Machinists switched to computers, only eighteen of them in it now, Sannex went into liquidation and the carpet factory moved to London. I really think that contributed to it. They started hanging around the street corners. Got fed up sitting around the house. The brew money [dole] was nae use to them neither. Tapped too much before you got it. By the time you got it it went to pay off debts. Tried to get other jobs, but couldn't get them. Once you lost one job wouldn't give you another, most vacancies are full: "Sorry hen, someone before you." It disheartens you. I keep saying to myself, why are my family taking drugs? Not as if they were deprived then. It's definitely happened to most families here. It's getting worse now, eleven-year-olds go to parties and come out steamin'. I'd give them a doing for it. Parents trust their weans but don't know what their kids are getting up to.'

Carol, who had lost a daughter to an overdose since I last saw her, came by to say hello. She was still dressed in her red cleaning apron with the contractor's name stitched on it. The dirt was still ingrained in her skin and under her nails. 'Ur ye goin' to put the kettle on?' said Big Frances.

'Ah canny really be bothered bilin' up a kettle,' said Carol. 'It's hauf four the noo, an Tommy'll be hame fae his tea.' It wasn't possible to visit these women in their homes: they were afraid of their husbands. Both Big Frances and Carol had part-time jobs, as well as looking after their grandchildren and their demanding husbands. Carol was earning less than she had the previous year. 'I'm getting £47 for fifteen hours, they know you're so desperate for the job, dirty rotten pigs.'

'I must be going the noo,' said Big Frances. 'I've got to pick the weans up from the creche. I threaten my lasses, I won't look after their weans next time they go inside, but it doesn't deter them. It's me who has to battle social services each time they take them away into care.'

'Here's Gordon,' said Big Frances.

Gordon had come to collect me. No one wanted me to walk around the scheme on my own. 'They'll murder you in broad daylight, stab

you in the back. Used to get you in the close in the dark, and usually a square fight,' frowned Big Frances. 'Gordon will see you all right,' she broke into one of her radiant thick smiles and we all went with her to fetch the weans.

The creche belonged to the same tenement as the family flat, only it was two closes along. The vandalism was so great that the windows had been replaced by perspex and couldn't be opened because of the steel rabbit mesh that was welded to the windows to prevent burglaries. The only air came from a single circular hole the size of a small child's face. I know that precisely, because the children climbed up on either side of the perspex and held their faces against the hole, making the children on the inside look like convicts and those on the outside like refugees. We entered the close and Gordon rapped hard on the creche's steel door. His knocking echoed along the unlit corridor's graffitied walls. I could hear the two steel drop bolts sliding back and the door creaked open. Big Frances's and Carol's grandchildren were always clean as pennies with their hair combed neatly and their nice clothes pressed. They ran to their nanas, delighted to see them. Big Frances pulled up Caroline's stockings and placed her in the pram, Frances held on to her hand and in this fashion they walked home to tea with a toy each, borrowed from the toy library for 20 pence a week. Only Young Frances's fourteen-year-old Elizabeth wouldn't be home for tea. After school she worked at the Markers Pleasure Centre, wearing a bear suit to entertain toddlers for £1.50 an hour. She also worked in the sweet shop, made coffees and teas and cleaned the tables.

Carol and Big Frances went home to their men. Big Frances said I could come round to her place on Wednesday, 'Once I've got my daughter Margaret off to Barlinnie, 'cause I've saved £5 for my sons and the bus fare for her to take them their presents.'

Gordon's guided tour of the neighbourhood began outside the creche. 'This use to be our Maginot Line. It was like a brick wall: if you lived north of the line you didn't cross to the south of it and if you lived south of it you didn't cross north of it – you'd have got stabbed. You couldn't walk from A to B without someone saying, "so-and-so was up here, I wonder who he's looking for?" He might just have been going to the fish and chip shop. It used to be like the Gaza Strip, a head case of a place. There used to be chibbin' [stabbings]

morning, noon and night. We had thirty murders in five years, but it's a lot better the now.'

As we went along the tenements, it became apparent why Christine, Big Frances and Gordon didn't want me walking around the neighbourhood on my own with my camera equipment and insisted on chaperoning me. As an outsider I stood out like a beacon or a Martian. Children, adolescents and young men loitered, using the closes' railings as a seat or backrest. The older ones chewed gum, their eyes glazed and bored, but they kept us under close scrutiny.

'If boredom could kill, they'd be mass murderers,' said Gordon. I asked if they were chasing the dragon, and he laughed. 'They're chasing the fucking rabbit if you ask me.' With a nod he indicated which ones were doing smack, jellies and DFs, which ones dealt and which ones didn't. 'Without their fix, they're like fish out of water. Six years ago when Johnnie was at school we were saying he's such a sensible boy, his cousin Margaret's such a pretty lass, they won't end up hard junkies. Now we're burying them. In the crematorium they're all their age or younger.'

When they died, the families asked the two Franciscan monks if they would do the funeral. Like their brothers in Newcastle, they were welcoming and friendly and again lived in a sparsely furnished flat. Gordon left me in Brother Greg's company, promising to pick me up in an hour. A group of young men played cards in a corner of the living-room as they did every day; it was a way of giving them something to do, a way to keep them off the streets. The banter was lighthearted.

'Why did God give us a brain?' said Joe, looking up from his cards.

'That's pretty good for someone who only believes in him part of the time,' said Brother Greg.

'When I need money.'

'It doesn't work that way.'

When they buried the youngsters who had overdosed, family, friends and neighbours would attend the funeral. Quite often there would be a collection to help pay for the expenses, even if the deceased had been among those who had broken into their houses. Dealers donned suits and then changed back into their jeans to deal on the streets. During the burial Brother Greg tried to say some helpful things – for

example, Freddie might have been addicted to drugs, but it hadn't always been so. Brother Greg felt the church no longer belonged to the people; it was no good talking about the Resurrection and Easter, and people no longer fit into the neat moral categories that had once existed.

There was virtually no traffic on these streets. Delivery vans and outside contractors were afraid to leave their vehicles for any period of time: only the postman could, because they needed their giros, and the two ice cream vans which also sold essentials at exorbitant rates, for example milk at 51 pence a pint. The social workers either drove into the one secure car park or left their cars in the modern-day version of a corral, grouped together in a block as if there was safety in numbers.

Gordon walked me beyond the scheme which had once been ringed by several large employers. To the north he took me to where the steelworks had once been. We passed through a hole in the blockboard wall beneath huge advertising hoardings where the land fell away to a former railway cutting. The nearby station had also gone. From the embankment we looked down on a vast open space littered with rubble and rusting machine parts. Gordon told me the forge used to employ going on 20,000 people in three shifts round the clock, seven days a week.

'They shut it in 1979 and over where there were yards, they built the new shopping precinct and they're now building a bingo centre and indoor market.' We walked passed Sakol furniture manufacturers which has remained open, but with a smaller workforce, and Holland Mill, which once produced cloth and tweed and had employed over a thousand people until it was closed in 1983. Finally Gordon took me to William Arroll, the former manufacturer of big overhead cranes, now just a large empty wasteland with piles of cemented bricks, rusting pipes and shards of corrugated iron sheets, but also discarded tyres, cars burnt out for insurance claims and stolen purses and suitcases with their valueless contents: old clothes, a postcard of Toronto, and smashed bric-à-brac spread out in rotting heaps.

'Unemployment was the best thing for the government. All activists, trade unions, those that knew how to negotiate, get things going, the ones that scared the shit out of them were broken,' said Gordon

angrily. 'Do you know Glasgow's trams used to be built here? The rails, the trams, the ticket collecting machines, even the paper. All that's gone. The council wanted to buy locally made furniture for its new building, but couldn't find any office furniture made in Glasgow. Before, we had aspirations, do better than my father, get a better job, be better educated. Fathers are unemployed now, there are no jobs, no identity, positive role models are rare, school, that's if they go, is one of the few places where children can come into contact with an employed man who is not a polis.

'I once worked in the boilers. I could only stick it for a couple of months, then I'd do some hookie' – that is, he was in a gang and did robberies. Gordon had been out of trouble since he'd turned forty.

'Aren't you tempted?' I asked.

'Ach, no. Money isn't everything. Fuck no. There's a stage when you get too old to do that. In yer twenties all right, thirties okay, but I'm over forty now, to go to jail would be daft. I missed the weans coming out of their pram. She [the wives were never referred to by their names: it was either she or her] said after my last offence she wouldn't stand by me. I said, what do you mean – you'll divorce me? I give you money. She meant what she said. She was tired of the lifestyle, tired of the polis coming around.'

Walking back to the scheme Gordon brought the place back to life. We passed the ground-floor façade, all that was left of Arroll's former offices, daubed with IRA crossed out and replaced with UVF and 'See you Judas, yer nothin' but a clype!'

'This is where the women used to wait on a Friday at six in the morning, two in the afternoon and ten at night. They wanted their man's pay packet: if they weren't here they went looking for them in the pub. Sometimes the moneylenders were there, it would be a fight between the wife and the moneylender.

'The pubs, there were a lot more of them then, were full. The work was very physical, you needed to drink to replace all the fluids, the sweat, the exhaustion. We taught the children how to handle their drink.'

In this not much had changed. The men still went out drinking when they had the money, although now the women followed suit. But Gordon had still never washed the dishes and when Jan, his wife,

was in hospital, his mother-in-law came round to do the housework. But in many aspects Gordon was a model citizen, devoting every waking hour to the community. When he had access to a vehicle he ferried children and parents to Butlin's, he helped in the various community centres and worked nights in a pub. He rarely slept for more than a few hours a night and that was only if the alarm to the creche didn't go off – Gordon was the key holder. He would have once been described as a hard man and a criminal. In his time he had done banks and wage snatches. He told me about the night he went to burgle a judge's house in Kirklee, 'a nice area of Glasgow', with James and Matt.

'He had some nice antiques and we needed some money, we were skint. Sometimes we'd get loads of money for a job, sometimes we'd get fuck all. What would you know, the bastard was ill at home. We thought we'd try another house. We found this posh house and got the punch and toffee hammer and took the glass out of the window. The next thing I know there's a gun to my head. My water gone away from me. I peed in my pants. They were screaming, "Tell us who you are! IRA? UDA?" It's hard to talk when you got a guy's foot on yer head and yer hons in handcuffs behind yer back.

'There was a high security alert, because of the IRA bombings in England and they had been watching prominent people's homes. They'd got us on video and camera. We'd broken into the Chief Constable of Glasgow's house. We weren't meant to have been able to have shattered the bulletproof toughened glass. They hit us where you couldn't be hurt before, everywhere was sore. They wanted us to show them how we'd done it. When they realized we were house robbers, the Chief Constable started to laugh, he started with his hands around my throat. The police doctor wouldn't say that, he said I fell down the stairs.

'They dropped the charge of housebreaking, because they didn't want news of it to go to the newspapers, they dropped it down to summary charge with a maximum sentence of nine months instead of three years. The wife told the lawyer, "That arsehole better get time or I'm going to kill him." I'd promised her I had given up burglary.

'I went in front of Judge Smith Andrews. He hated me, I'd been in front of him so many times. He read out that I was going to do a

judge's house, he might have thought it was his. He sat up, looked over his half-rimmed glasses. "You've got a horrendous record, Gordon Stewart, shoplifting, car stealing, burglary." I thought I'm going to get nine months. The way the wife looked I could have done with nine months. James pleaded guilty through the lawyer, so did Matt. The lawyer whispered, "Collapse, faint." I collapsed when the judge read out the charge, then as I was lying on the ground, the judge collapsed, I swear on my weans' life. "M'Lord! M'Lord!" they shouted as they hustled him off to his office. I was handcuffed and taken off. The lawyer said he might have had a heart attack.

'My lawyer put up my case to another judge. "I hope you can see your way to a non-custodial sentence." James was fined £100, Matt with his atrocious record got £250. "Gordon Stewart, you have a horrendous record, in normal circumstances I would give you a custodial sentence," I went white. "Taking into consideration you've recently been out of trouble, you have three children and a wife, I fine you £450, at £5 a week. Is that acceptable? Take that grin off your face." "Yes, sir." I've been out of trouble ever since.'

Even Gordon was intimidated by the new young men, though their gangly looks were no match for his. He was squarely built, with a thick trunk and shoulders like a buffalo, and, almost lacking a neck, his head perched on his shoulders. When he smiled, a grin stretched across his illuminated face like a gash in a melon. 'They don't have the same morals, what I and the others did, doesn't happen anymore, they can't be bothered to do their screws in the posh areas the other side of town. They mug old women, snatch bags, and bangles off the weans. Breaking into houses of people they know don't have anything. The dealers are not even animals, animals have scruples. Scum of the earth isn't strong enough.

'It don't look rosy, but we're turning the corner,' said Gordon as he was about to introduce me to another reformed character. Anson, who had almost achieved cult status locally as a gang leader, explained that in the early sixties to the early seventies you had to belong to a gang or you'd get the shite kicked out of you.

'Even if you wanted to collect your brew money in Parkhead, twenty of you went and you were all tooled up with knives – just to go to the post office to cash your giro. Petty crimes were socially acceptable.

Our das would give us a good battering if we got caught, but we would go out and do it again because not only was it something to do but there was money in it. I grew up looking up to the gang leaders. It was a great thing for us to see them, even if they were only hanging about the street. But even when I became a gang leader, my ma would come out and hit me over the head and drag me away. I'd say to her afterwards, "Do you have to do that in front of them, ma?"'

Long after Anson had chucked in leading the gangs he was stabbed in the back outside what was then the community development office. Thinking he was dead, and for all the community solidarity, three people came for his job the following morning while he was on a life support machine. There were several theories, according to who you listened to. Someone was trying to make a name for himself by killing a former gang leader, it was a revenge attack, or he had been too open in protesting against the Protestant Orange march through the scheme. Most members of the community thought it a good thing that all religious marches were banned; one resident told me, 'There are enough fucking divisions without having that as well.' Religious divisions had always run deep, Christine's parents, who doted on each other and had been married for fifty years, refused to be buried next to each other because neither wanted to lie in the consecrated ground of the other's faith. Christine's father, an alcoholic, had even promised to give up drink for six weeks, if she didn't marry a Protestant. 'Tae Glesca men, convertaen is like bein gay, you just donne convert, it's like admitting youse a nancy,' Christine explained later.

I asked Anson why the gang fighting had stopped. 'My personal belief, the gang warfare started to stop when the Colombian drug scene started. Shipments of smack and coke moved in, the gangs used the fear factor to make money. There were great opportunities to make money and a lot of people took it up. The fat cats have moved out to big houses.'

Anson and Gordon had been part of a plan to help rejuvenate the neighbourhood. 'We didn't ask questions. We assumed everybody had got a criminal record. Doesn't mean we only employed ex-crooks. We treated everyone on an equal basis. It really worked. Vandalism was virtually stopped overnight because we employed people from the scheme, although the polis wouldn't admit it because of fear of cuts

in their manpower, and the neighbourhood started to regain some self-esteem. Professors started calling it "community empowerment". We were being asked to go to universities to talk to students about this. The only thing I regret is that it wasn't for the whole area – we had to compete against other schemes. Each area gets stigmatized in turns. It's like divide and rule. Like the classes, there's the middle classes, the upper classes, there's that many classes, you've now got your gutter-level classes. What we don't need is patronizing letters and arty-farty social workers. You ask Big Frances, they're tellin' her how to look after the weans and they've never had any! Some of them wouldn't know how to look after a fucking poodle. It's all right for them they've all got the NIMBY syndrome – "as long as it's Not In My Back Yard".

'We no longer get to make the decisions. The bastards making the decisions aren't elected bodies or committees, they're Quangos. Getting the government out is one fucking problem, getting the Quangos out is another matter altogether. They're just looking after themselves, they look down on us bastards. "Get off your backside!" they tell us. It's the story of those who have and those who have not. Those who have not want to give you what they've got. Those who are all right forget their skid marks. When they've made it, they hold on to it, because they're scared of losing it. The whole system is wrong. More and more money should be put into education of young lads and lassies. To be honest, I worry about my kids.'

All the children growing up in this area were stigmatized by the location of their homes and the shadow of gangs had not been completely extinguished. Christine's son Duncan had been forced to quit college in another area of the city, because youths his age had threatened him for coming from the wrong end of town. He now works in a factory making string, but still has ambitions to return to college elsewhere. Gordon's eldest daughter, Rosemary, had got the best marks in her class and she was going to university to study Accounts and Business Management. This, as Gordon proudly stated, put an end to the shoulder-padded class's theory that if you came from here, 'You'll probably end up pregnant at sixteen.' But nothing can explain why one sister can lead a contented life while the other one is frustrated and endlessly seeks happiness in different ways. I caught up with

Gordon's fourteen-year-old daughter Tina at the end of the day. She had been accused of threatening to write her name on another lassie's face with a Stanley knife. 'It wasn't true,' she told me. Subsequently she was expelled from school for electrocuting another student. 'For a laugh. It was quite funny. I wanted him because he was the quiet one in the class, I always picked on him. His fingers went black. He was all right. In the new school there's no punishment, no extra exercises. I'm doing nothing wrong. I've stopped CO [carrying on] and fighting and arguing with teachers.' Tina was doing better since she had moved to the new school where she enjoyed the drama and music classes. She was finally emerging from the shadow of her older sister and cousin, as she explained: 'I didn't like the other school, I wanted out, because my cousins and sister were there and they expected me to do as well as them. I couldn't do as well. They were always comparing me to Rosemary.' Before the summer holidays Tina had written an excellent essay on alcohol abuse and had begun to write poems, one of which she showed me when I asked;

> Drugs are for mugs
> You're out of your tree
> There's Jellys and morphine
> And Ecstasy
> Smoke is like dope
> You long for a toke
> Acid messes up your head
> Take some Coke
> You end up dead
> Take it or leave it
> The choice is yours
> A smack in the face
> When the acid pours
> Injected with the poison
> Is really bad for you
> I would rather smoke Hash
> Than buzz the Glue

Like many of the children I spoke to, Tina had her dreams. 'I'd like to go to Jamaica. I like the way they dress, their culture.' Like the

other children who lived either with or in close proximity to their cousins, nieces and nephews, and grandparents, Tina wished her family would get better. 'I wish there could be a cure for my uncle's bad leg, I wish my mum would stop drinking and my aunt would stop kit – jagging [injecting].' And yet she confessed, 'I'm sure I'll try eccy and speed, jellys and trips when I start going to the dances and raves to get a good bounce.'

The children, like the grown-ups, had sometimes given up on themselves. It was as I had once read: 'They felt their parents had deserted them, their fathers felt like dispossessed chieftains, and their mothers felt like emotional and physical punchbags. Everyone felt trapped by communal and financial constraints, and they looked for escape by any means necessary – into crime, oblivion or death, it made perfect sense.' Who or what else could they turn to? Here that commodity called hope was, as Nietzsche believed it to be, 'the worst of all evils, because it prolongs the torment of man.'

The sun was now low across the roofs of the buildings opposite and cast long shadows across the street that had once been nicknamed Nightmare Alley. Tina had to see her social worker and I had a date with Big Frances. Young Frances came to collect me half an hour after the prearranged time: she had forgotten the appointment. She told me, 'Big Frances can't see you. Margaret didn't take the money and presents to her brothers in Barlinnie – she stole them.' Gordon was coming up the road and he'd heard the news: 'It's terrible.' I agreed. I wasn't shocked – I was dumbstruck at the extent of the misfortune to such a kindly, generous woman. 'Carol can't make it either. A crisis can happen at a month's notice for Carol,' said Gordon. 'Glasgow holds so many sad stories it would bring tears to a glass eye.'

My stay in Glasgow was coming to an end, but not the friendships I had made. Well, not just yet: I had signed up with a group who were going by coach to Blackpool during Scottish Week for the illumina-tions. And there was still Christine's friend's surprise sixtieth birthday party, to be held at the Celtic Football Club. Unknown to Jessie, a collection had been made to send her on holiday – they had booked her on the Blackpool trip, leaving by coach the following afternoon.

We took a minicab to the Celtic club where a table had been reserved

for us in the dance hall. Our party busied themselves decorating the table and the adjacent wall with congratulatory banners. Jessie rarely left her flat. She had lost three of her four children to overdoses and she spent her days in a chair staring out of her window. As she would later tell me on the coach trip, 'My wee pal buys half a bottle, to tell you the truth a bottle, and on Fridays maybe we go to a wee club that doesn't cost us a halfpenny.' For the moment, she was in the bar and Christine asked if I wanted to visit the football club's trophy room.

The room was chock-a-block with silverware and pennants from teams all over the world. There was also a signed photograph from President Gerald Ford to the 'Glasgow Celtics'. Of more interest to me was the bar with the old-timers who seemed as old as the club itself. I might have been influenced in this conclusion by the man at the next table who wore a hospital name tag on his wrist. He took his time lifting his two-litre tankard, a souvenir from his trip to Basle in Switzerland for a European Cup quarter-final. Several of the men tut-tutted at the women's presence, but Christine told me, 'They know not to be saying anything to me or I'll be chopping their heads off.'

When Jessie entered the hall, she was ambushed with a chorus of 'Happy Birthday'. Her eyes became rheumy but she didn't greet (cry). It was a time to hug old friends, many of whom were related although they weren't sure how. There was Liz, now living on the other side of town, who she hadn't seen in years. I had been struck by her appearance in a long, black hourglass dress and red bow. I didn't talk to her much during the first part of the evening, the bingo and the dancing, but the night was to take a course that I could never have imagined as I set out for the birthday party.

As the women reassembled at Christine's after our evening of revelry, I got talking to Liz and at one point we found ourselves alone in the kitchen. I said she looked stunning. She told me the first time she had been paid a compliment was when she had returned to school at the age of 35 to take O-levels. 'I told the teacher not to ask me to speak in class, I had no confidence; later she said I was smarter than I let on. I started greetin', no one had ever paid me a compliment, not even my husband. He's dead now and I'm happier. I know that's a terrible thing to say, but he was a real bastard. I have two ambitions left in life and I've decided I'm going to have one of them tonight.'

She leaned forward and we kissed. We went for a walk and returned when all but the last stragglers had left.

Christine was shocked, because out of all her friends she believed Liz the least likely to have been so forward. As we lay awake in each other's arms in the early hours of the morning, the noise of the party was memory, the sounds had played themselves out except for the children who were still in the street. 'When I was younger I laid awake listening to the steel works, the roar of the blast furnace and the locomotives shunting over the points,' whispered Liz.

The following morning we sat in the living-room as Christine nursed a hangover. She couldn't quite get over what had taken place. 'Good on you, but Nick, you'll need a nine-foot candle. As for you, Liz, you'll need one the size of the cross that Jesus carried up to the Calvary – I can't count how many lashes you'll get. There's thirty lashes for Nick and twenty for me for being there.

'C'mon you better be gettin yourself ready for the now.' I felt quite miserable to be leaving. I'd had a great time and renewed acquaintance with some wonderful people who had looked after me in the kindest way possible. I hugged Liz goodbye and asked her what was her other ambition. 'I want to learn to swim.'

Christine walked me to the coach. As we left her tenement Alistair was in a scrum on the opposite side of the road. The dealers and drug users were often one and the same, some raised their heads to acknowledge Christine, but most were gowching – they looked asleep but weren't.

'I've planned Alistair's funeral a hundred times. He's going to die. I know I'll feel guilty. I've picked him out of the dustbin, sick all down him, wee'd in his pants. I've put him in the bath. He's been dirty, filthy. He's stolen his wean's clothes to sell them. He's taken her duvet to buy jellies.' Christine started to cry. 'I've tried killing him, he'd overdosed. He was on my bed, I put the pillow over his face and put my knee down on it. He jerked, I thought, Holy God what am I doing. I called the ambulance.'

Wiping the tears from her cheeks, she was cheered by the thought of her other son Duncan, returning from Tenerife. Outside the grave-yard a man was spraying out the words 'Lyle is a grass'. I asked him what he was doing.

'My brother wasn't a grass.'

Christine said, 'He isn't a full shilling.'

'What?'

'He's got no stairs to the attic. That's not Gordon's brother.'

We carried on through the cemetery. At the far end a man came running towards us. Christine turned to me as he flew past. 'You know if someone is running he's just done something, or he's being chased. I wonder what it would be like to live in a place where thoughts like that never came into your head.'

I had hoped to say goodbye to Big Frances and Carol, but Big Frances had another crisis on her hands. Her daughter Anna had had both her legs broken by her partner with a baseball bat when she refused to go out and get him a curry. She had an injunction on him for beating her up two weeks before, but she wanted to go back to him because, Christine told me, she said, 'What he did shows he loves me.'

Carol and her daughter had Carol's husband arrested. The police charged him with assault on Carol and the grandchild. When the husband was released (he spent one night in custody), he had his daughter arrested knowing there was a warrant out for her because she had failed to appear in court on a charge of shoplifting.

The man Christine and I had seen running had mugged a mentally disabled woman (she had also been mugged two weeks previously). She died a week later from an epileptic fit which was unrelated to the mugging.

Five people were stabbed to death the weekend I left Glasgow. The following week another person overdosed in the community I had visited. Christine sent me the clippings from the newspaper's memorial pages placed by the mother who had now lost a daughter in addition to a sister and a son:

> In loving memory of daughter Christine, sister Julia, son Paddy:
>
>> As I wander to their graveside
>> Each flower I place with care
>> No one knows the heartache
>> When I turn and leave them there

My heart still aches with sadness
And secret tears still flow
For what it meant to lose you
No one will ever know
St Jude pray for them.

If tears could build a stairway and memories a lane, I'd walk
straight up to heaven and bring them back again.

BLACKPOOL

To the Pleasure Dome

THE NOBLEST PROSPECT a Scotsman ever sees, Dr Johnson observed, is the high road to England. And so it seemed during 'Glasgow Weekend', at the end of September, when thousands and thousands of Glaswegians take to the high road for Blackpool.

Like everyone else, I had paid for the weekend in advance to Mary, who had organized the boarding house and the coach trip to Blackpool for forty-two holidaymakers. We assembled at her house at midday. Suitcases, holdalls, boxes of crisps, crates of soft drinks (especially Irn-Bru), cartons of vodka and beer lined her hallway. Mary and her two brothers Tommy and Tim were orchestrating the proceedings. 'Heh, Frankie!' shouted Mary to her cousin. 'Wherr ur gawn the noo with that lot?' as Frank picked up a box of crisps. 'Good joab fur you ah'm in a good mood, pal,' said Tommy to one of his team of aspiring footballers. Five of this Scottish youth team had joined the coach trip even though they were from outside Glasgow's East End where most of our party lived. Mary's house quickly filled with expectant holidaymakers. Some hunched over the kitchen table downing cocktails of vodka and Irn-Bru, others hung around the quiet cul de sac, hands in their pockets, waiting eagerly for the coach to arrive.

'See that,' said one of three Bettys on the trip, nodding at the coach that was pulling into the scheme. 'Reet on time.'

'Fuckin' great,' said one of the young footballers.

'About fuckin' time, intit,' said another.

The footballers all had identical hairstyles, gold earrings, black trainers and tee-shirts with matching sweatshirts and trousers. They looked as though they had all just stepped out of a dry cleaners.

'C'mon,' said Mary back in the house. 'Let's git goin'.'

Everyone started in with the bags – you could have been forgiven

for thinking that we were going away for a week, such was the quantity of luggage. The coach driver pushed and pulled the bags into the different holds and Mary continued to give orders. 'Don't just be staunin' there!' she shouted to the boys who had gone to welcome a friend who had arrived in a black Mercedes that matched their outfits.

We all piled on to the bus. A round of musical chairs ensued.

'Izzat yer seat?'

'Ach, naw.'

'Anyone sitting here?'

'Oh aye.'

'Fucksake sit down!' screamed Tim, and bit by bit everyone took their seats. Mary and Tim tried to take a head count, but some of the boys wouldn't stay in their places. One of them shouted something at Tim.

'Whit did he say?' asked Tim.

'He didnae say nothin'.' And the boys and some of their girlfriends giggled.

We pulled out of the scheme, with friends and relatives on the coach waving to their friends and relatives left behind. By the time we reached the motorway the traffic had come to a standstill. Tommy offered me a second bottle of Budweiser. 'It takes longer to get through Glasgow than to get to Blackpool.' It had already taken nearly an hour to get barely two miles from Parkhead, and the coach was steaming up from the sweaty atmosphere that had transformed it into a sauna.

As the coach gathered speed for the long haul towards Carlisle and the Lake District, the exodus of Glaswegians turned into something of biblical proportions – cars, minivans, buses and coaches, bumper to bumper, mile after mile, heading south along the M6. The singing and laughter grew with every passing mile and drink. One raffle followed another. 'This ticket's a pound for the coach driver,' said Stella tearing off a cloakroom ticket, the other half of which was thrown into a supermarket bag for the draw. This scene was being repeated in every coach we passed and which passed us. In the lulls between the raffles, everyone joined in raucous singing. The grandmothers on the lower deck sang, 'Ye cannee push yer granny off the bus, ye cannee push yer granny, 'cause she's yer mammy's mammy'. Meanwhile upstairs, the young footballers were writhing in their seats to the hot,

thumping sounds of rap from their boom box: 'For all you mother-
fuckers ... Put yo' ass on my face, I love the way yo' pussy taste ...'
then they would join in the chorus: 'Girl you know you are the one,
shake that ass and make me come.'

Jokes came thick and fast. As we passed Gretna Green, Sheila, one
of the grandmothers, ogled Drew, the youngest of the footballers, who
had come down the stairs to collect his raffle win of three packets of
crisps. 'You could be my toyboy, we could elope. I'm happy to be a
bigamist.' When we arrived at a service station for a break, this little
corner of Cumbria had been transformed into a satellite of Glasgow,
but their strong sectarianism had travelled, too. Striker, a powerful
eighteen-year-old footballer built like a bantamweight boxer, with a
rugged, wiry build and a 'Made in Scotland' tattoo on his ironboard
chest, pointed to a boy from another coach. 'See his ring.' I looked:
the ring had GPB in large gold letters embossed on it. 'Govan Proddie
Boy,' said Striker with disgust.

Tim was unemployed and coached the young boys for nothing. He
was fiercely proud of his team, who had competed in international
soccer tournaments in Germany and the United States. 'We want to
teach them football, but above all to stay off drugs and away from
violence. We raise money a year in advance through pontoon, tote
and dances. Four of my lads turned pro last year.' The team's most
successful footballer had been Mo Johnston, who became an inter-
national, revered both sides of the border. Tim and his brother Tommy
could have almost passed for twins. There were so many brothers and
sisters in their family that some of the children to the oldest sisters
and brothers were the same age as their youngest uncles and aunts.
Tommy had once worked in the docks at Rosslare. 'I started at £5 an
hour, then it went to £4, then to £3 with or without experience. And
there's always someone to take your place. A job used to be for a
lifetime. I think they're trying to get us to outsweat the Chinese. I
went to college to do a course in sanitation and I've now got a full-time
job with the council. I also work every other Saturday at Rangers as
a steward, although I support Celtic.'

As the coaches and minivans filed off the M55 towards Blackpool
it felt as though we were part of an invading army. It was like the
time I travelled on the Chelsea Football Club's supporters' bus –

everyone in the street stopped to look as we passed, scarves and banners billowing from the windows, and the whole bus shook to our singing and stamping. E.J., sitting next to Striker, made unmentionable gestures with his fingers and tongue to girls we passed. A bet was made for the first person to spot Blackpool Tower. 'There it is!' screamed Eddie, pointing to an electricity pylon. Everyone roared with laughter. 'Dozy bastard!' they hollered. It must have been the same for the millions of Yorkshire miners and Lancashire millhands in years gone by as they travelled into Blackpool, leaving two weeks' rent on the mantelpiece at home, knowing they would blow every last penny on their holiday. These annual migrations still exist, as I had witnessed, when entire industrial towns such as Leicester and Halifax shut down and migrate to Skegness, Newcastle to Scarborough; but more often than not they now migrate to Spain and the Canary Islands.

Mary told me how, when she first came to Blackpool, landladies and landlords turned everyone out of doors between breakfast and teatime. 'When I first came the boarding houses advertised the use of the cruet, some rented you the bath tap.' When the Blackpool Tower was spotted a huge roar went up and the ladies on the lower deck sang, 'Oh I do like to be by the seaside'.

Our coach parked in front of one of the many small hotels in a row of converted terraced houses. Mary read out the names of the hotels we had been allocated and who we would be sharing with. I was at the Elysee Hotel and sharing with Robert, who had come with his fiancée but wouldn't share with her as they were both born-again Christians. The East End of Glasgow was simply reassembling on the same Blackpool street two hundred yards behind the beach. Neighbours now shared the same bathroom, sat at the same table for dinner and drank at the same bar. England's replica of the Eiffel Tower, the Blackpool Tower, was not visible from our rooms. Instead, across an area of wasteland used as a car park, we had a view of that jewel of British architecture – the gasometer.

Once inside the hotel, the first sign to greet us read: 'To assist with your holiday budget, guests are asked to pay on arrival'. The bedroom was minuscule: there was barely enough room to climb into the bunk beds. It made me feel as though I was staying in a hybrid between a railway carriage and a submarine. Both the hot water for the shower

and the television were coin-operated: you almost felt you would have to pay for the oxygen you breathed. I wondered whether there was a fire escape. The previous night two people had died and six had been injured in a fire in another hotel.

I went to explore the promenade with Robert in the fading light and rain and quickly discovered that not all is what it seems in this mecca of fun which attracts more visitors than Greece. The Winter Gardens are not gardens, but a shopping and conference venue; the Pleasure Beach is not a beach, but a fairground. It seems few if any people would want to swim in the sea: Robert called it the Costa del Sewage. I later discovered its tobacco-coloured water is given a daily dose of sodium hypochlorite, a chemical found in household bleach and used to disinfect drinking water and swimming pools. 'It kills bacteria and inactivates viruses,' said a kindly official in the tourist office, but I didn't fancy the choice between swimming in muck or disinfectant. Recently the second word had been dropped from the slogan, 'Blackpool, Health and Pleasure Resort'. 'It's a pretty safe place so long as you don't swim and you don't eat too much,' advised Tim, who didn't understand why anyone would want to swim in the Irish Sea.

Everyone did their best to make me feel included. That evening Jessie, who had had her sixtieth birthday party in Glasgow, asked me to go out with her group and we joined a long queue outside a social club. The air of festivity had already infected the crowd, who joked and laughed as we waited for the doors to open. The hall quickly filled and the comedian was eagerly awaited. Rounds of drinks were bought and it dawned on me that there would be no time to sober up during Glasgow weekend.

The comedian was greeted with boisterous applause.

'Welcome, ladies and gentleman.'

The crowd roared their approval.

'Did you know that Blackpool once resembled a South Sea island?'

The crowd went silent.

'That was 150 million years ago. On my way here tonight, I was stopped by the police for not having a back light. I couldn't believe it.

'I said to him, "You've stopped me for not having a back light –

someone right now is being robbed, mugged, raped, stabbed, shot and you stop me for a fucking missing back light!"

'I got out of my car, took a look and started crying. The policeman said, "It's only a broken back light." "Yeah, but where's my caravan?"'

The stand-up routine continued without a pause through skits, toilet jokes, and innuendos.

'Mrs Jones was at the DSS filling in forms for her pension. "Your husband, is he working?" "No, not any more." "He's signed on?" "No." "Why not?" "He's dead."

'"What was the cause of death?" "A hunter." "Was he shot?" "No, luv, a Hillman Hunter. He was knocked down by a Hillman Hunter. A car." "That must have come as a shock." "Yeah, it must have been. He couldn't have been expecting it."'

The audience roared their approval, but were too shy to be enticed on to the stage as helpers, so the comedian walked among the tables making our hearts pound in case he plucked one of us from our seats.

After a heavy night of drinking there weren't many guests at breakfast. Some of the previous night's revellers were too hung over to get out of bed, or else they hadn't got into it yet. Some of the young footballers said they didn't need the food, they'd get enough protein from the drink. They survived most of the day on packets of crisps.

Holidays are seductive, but this was not a holiday that would be remembered for hot days and everlasting sunshine, fresh sea air and unspoilt scenery. Even on a bright day no one wanted to lie on the beach and experiment with natural radiation. There were more donkeys on the wide golden sands than people. The donkeys are part of Blackpool's heritage and enshrined in Article 2 of the 1942 'Regulations with Reference to Asses on the Foreshore', which still gives the animals a day off (Friday) and forbids – Article 6 – 'persons over 16 years of age, or over eight stone in weight' to ride them.

I walked along the promenade with some of the older members of our group, the satisfyingly gusty breeze bringing a flush to our cheeks. We strolled down the central pier where pensioners dressed in chunky sweaters, blazers and polished shoes rested on the wrought iron and wood benches. They read, drank welcome cups of hot steaming tea from thermos flasks, or fell asleep on each other's shoulders.

The promenade is a long strip of amusement arcades, joke shops, pubs and chippies and fortune tellers. Candy floss and beer perfume the air. The sounds of electronic games and passing trams punctuate any conversation. An auctioneer in a shop behind the promenade hawked electrical appliances and cheap hi-fi equipment: 'Three may I say? Three to start me. At three there, three may I say? Three-fifty. At four. Four-fifty. Five. At five. Five-fifty. At five-fifty going at five-fifty. Thank you madam.' The mantra was deep, musical and hypnotic. Lisa, Robert's fiancée, who was standing next to me, bought an electric carving knife for £5.50. I'm not sure she really wanted it, but such a knock-down price was hard to resist.

Most of our group went to play bingo. In the early afternoon I headed for the Blackpool Tower, which was celebrating its hundredth anniversary. I took the lift to the top of the tower, which gave me a bird's eye view of the town and its three piers sticking out into the Irish Sea. To the south was the Pleasure Beach fairground, to the north the grand hotels. I could just make out the street behind the promenade where my guest house was situated, one of many hundreds of private hotels and bed and breakfast places. Further inland away from the glitz and fun parlours was the town's industrial sector.

Most startling of all was the ballroom enclosed by the Tower's four giant legs, its Edwardian interior a grand Louis XV rococo fantasy of gold leaf swirls, gilded cherubs and painted panels of heavenly skies. The motto from Shakespeare's *Venus and Adonis* above the stage read, 'I will enchant thine ear'. An organist, no longer the Reginald Dixon of 'Beside the seaside' fame, but with the same deft hands, played the Mighty Wurlitzer with its train whistles, castanets, sleigh bells and glockenspiel. It made my hearing jangle. A handful of *Come Dancing* couples, including two pairs of middle-aged women in pleated skirts, glided across the shiny wooden dance floor to 'Strangers in the Night', 'Tea for Two' and 'The Anniversary Waltz'. The faded grandeur and ghostly elegance evoked the time when the crowds packed the ballroom and took day trips on pleasure steamers.

That evening I was invited to join the young footballers, with Tommy and Tim and his wife Liza and their children, for an evening of karaoke. From outside the footballers' door I could hear the same rap song they played on the coach reverberating through their bedroom

wall: '... got to suck my dick, and you've got to suck it quick...' I found the five young lads in their room knocking back a bottle of potent Buckfast Tonic Wine.

'Nick, are you gawn tae the karaoke the night?' shouted Striker over the din of the rap music.

They were all preening themselves for the ready. 'You cannee have bad breath or BO,' said E.J., rolling deodorant under his arms.

'My motto,' said Striker. 'If it moves, tear off its bottom an' bonk it; if it don't, take off its top an' drink it.' Striker had a way with words: he could sell the clothes the women were already wearing for twice what they had paid for them. Aged eighteen, he had two children from one partner before her sixteenth birthday. He had been taken to the police station after the first was born and charged with unlawful sex with a fourteen-year-old, but it never went to court. A second child was born a year later, because Striker didn't like using protection.

Tim called into the room to tell them to turn the volume down or off. 'Hurry up, lads, we'll be gawn soon.'

'Meet ye inside,' said Boot as Tim left the room.

'See ye efter then.'

'No if ah see youse first!' shouted E.J..

Before reassembling at the pub for the karaoke, Tim, who went to the bookies every week to place bets on the football results, tuned in to *Final Score*. He needed ten home wins. 'Arsenal versus West Ham home win, Chelsea versus Crystal Palace home win, Wolves versus Portsmouth home win...' Tim began to hold his breath – he needed two more. 'Airdrie versus Clydebank home win' – he needed Raith Rovers to beat St Mirren – 'Raith Rovers versus St Mirren home...' The full result was drowned out by the jubilation. Tim punched the air with his fist and we all cheered. He called his cousin, the bookmaker in Glasgow: for a £1.10 stake he had won £77. It was time to celebrate.

We celebrated at Brannigans which is on the site where Gracie Fields sang 'Sing as you go'. We pushed our way to the bar, then squeezed our way towards the small stage. Liza, Tim's wife, told me he placed bets with her money, 'but that doesn't count. He said he'll take me to dinner when we get back to Glasgow, as long as we get back before football.' We watched a young compere in fishnet stockings introduce the singers of the next karaoke number. We stood across from the

stage and I marvelled at how good some of the singers were, although even the bad ones got a tremendous round of applause.

Striker, E.J., Frankie, Drew, Josh and Boot eyed the young women. 'Plenty of nooky!' shouted Boot into my ear. 'I seen her doon the tekoot about hauf an hoor ago,' said Striker, pointing. The girls and boys roamed in packs, day trippers came from as far as Essex and Taunton intent on one thing and one thing only – to have fun. Liza shouted in my ear, 'You love it or you hate it, or you love to hate it!'

After an hour at the karaoke the young lads and Clare and Michelle tumbled out of Brannigans on to the promenade. We took in other pubs where DJs punctuated songs with one-liners: 'No Russian roulette, use a condom.' Our group was feeling peckish. We grabbed some chips and mushy peas from one of the many buy-it-over-the-counter-and-eat-it-on-the-pavement places. Michelle and Josh had an argument. Josh was telling her off for wearing body-hugging jeans and saying goodbye to a group of lads they didn't know.

The promenade was heaving with pedestrians and day trippers in cars and horse-drawn carriages, clogging the road to see the illuminations that had turned the Golden Mile into Lancashire's Las Vegas. Double-decker trams ablaze with lights outlining ships and space rockets rattled along the seafront festooned with Ninja Turtles, Hollywood stars, Ronald McDonald on a surf board, Postman Pat and pound coins which now glowed in the night.

We passed a joke shop selling itching powder, wobbly pencils and black-face soap. E.J. bought Miser Matches that wouldn't leave the box and a Willie Warmer, which the package claimed 'keeps yours warm, willing, ready and waiting'. A souvenir shop near the Tower was doing a brisk trade in 'Kiss-Me-Quick' hats and baseball caps and tee-shirts emblazoned with slogans like 'Wine Me, Dine Me, 69 Me', 'Over Thirty and Feeling Dirty' and 'I Got Laid in Blackpool'.

All the youngsters were saving their money for the Palace Night Club. We queued to get in, which gave everyone a preview of the talent within. Boys ran their fingers through their hair and straightened their shirts, leaving one or two of the top buttons undone; the girls in stiletto heels indolently shifted the weight off one foot at a time as they waited their turn to move forward. E.J. pointed to one young woman in a crimson leotard with a bottom as round and hard as an

American football helmet. Body language was important to success; it was a line-up where the boys could once again dream about their first kiss or a girl of her first boyfriend.

Our group was getting impatient. 'Giea's a fag, Boot,' asked Drew. 'This is the last ah've got.'

'Giea's a drag, then.'

'No.'

'Fur fucksake.'

Once inside the Palace, the evening offered a little bit of everything: intrigue, love, adventure and passion. Those emotions that couldn't be acquired naturally were on offer in tablet form: 'black doves', 'disco burgers', or simply E were readily available. For one pulsating night, through the narcotic magic of music, drink, and hallucinogenic amphetamines, the sun-surf-and-sand idyll of bronzed gods and goddesses became real and the turmoil and trouble of our daily lives were washed away like the outgoing tide.

At 2 a.m. some of us started to make our way back to the hotel. Boot and Striker had found two young lasses and were taking them on somewhere else. The promenade's pavement was still heaving with platoons of young people swollen with beer and mashed from Ecstasy. Discarded plastic cups and plates littered the ground. The occasional beer bottle exploded on the pavement like the percussion of a distant grenade. Seaside rock sellers were doing a brisk trade in cider-, whisky- and gin-flavoured rock. Street hawkers with electric yoyos and glowing necklaces were having a harder time of it. The only sign that the world existed beyond England and Scotland was the sticks of rock lettered in Arabic and the phone kiosks with instructions in French, German, Spanish, Italian and Welsh. 'I'm going for a fish,' announced E.J. 'A what?' I asked. 'Ah'm a bit shoart, ah need a pee.'

We got back to the hotel to find some of the guests complaining about the noise, but it was the proprietor who had apparently been making most of it. Stop and talk to anyone who works in Blackpool and you'll find an interesting story. The owner of our hotel was a former joiner from Birmingham. Earlier in the day I had got talking to a tram conductor who had been a miner from Barnsley before he had used his redundancy money to buy into a guest house which went bankrupt. He was now too poor to leave Blackpool.

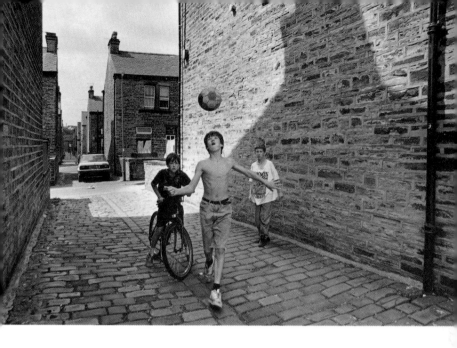

ABOVE Boothtown, Halifax BELOW Gibbet Street, Halifax

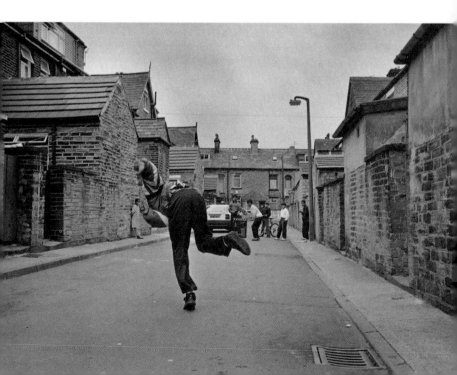

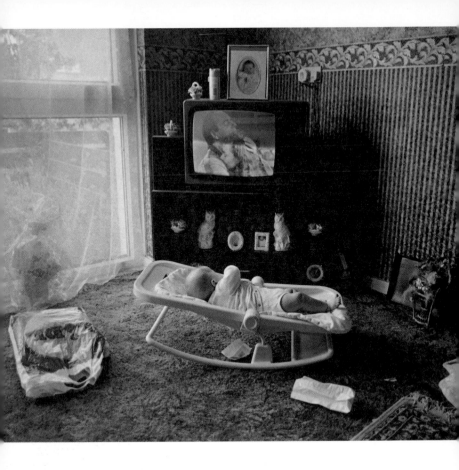

ABOVE Neighbours: Penrhys, South Wales

OPPOSITE:

ABOVE A close: East End, Glasgow
BELOW Quranic school, Oldham

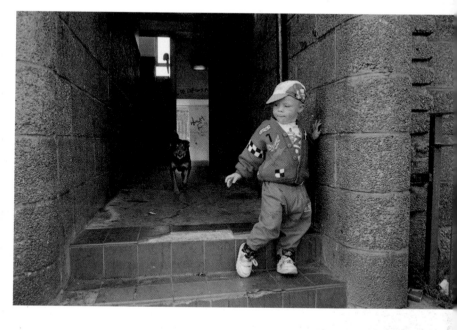

PREVIOUS PAGE Mother and child

ABOVE AND OPPOSITE Market day, Norwich

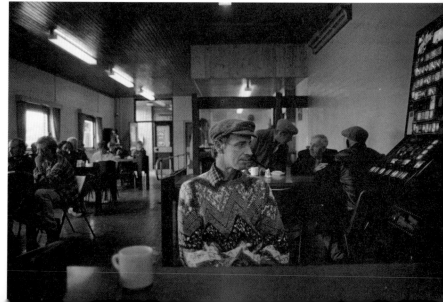

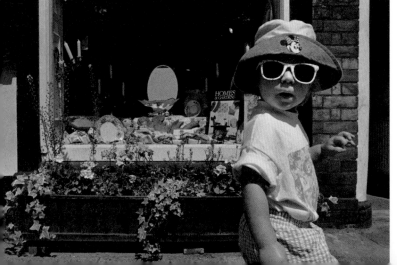

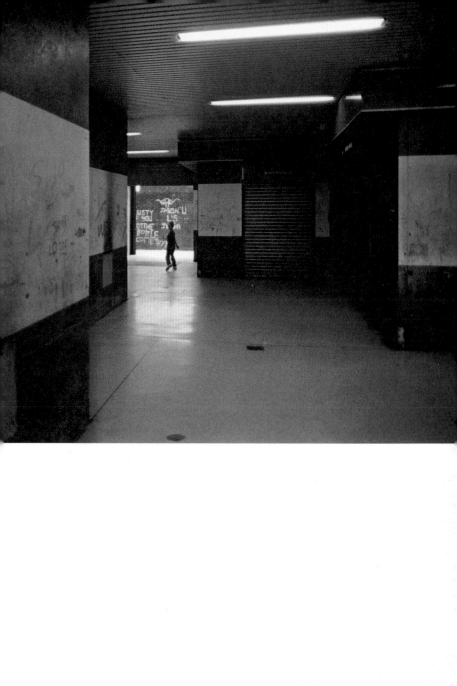

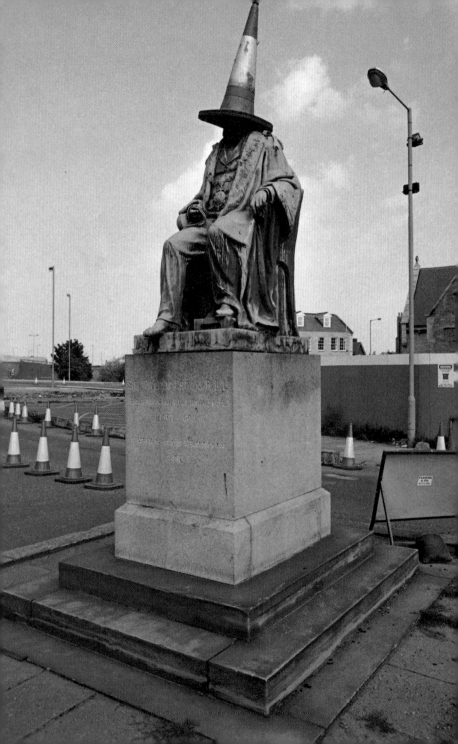

The hotel owner persuaded some of the complaining guests to have a nightcap. Lisa, who had spent the day at bingo, sat in a corner with her prize, a battery-operated talking parrot. She proudly showed off her new pet's trick.

'I'm knackered,' said Lisa.

'I'm knackered,' repeated the parrot.

'Your lonely days are over.'

'Your lonely days are over.'

'My lonely days are over.'

'My lonely days are over.'

We laughed, 'Hahaha.'

'Hahaha.'

'Haha . . .'

At first we found it amusing, but now the parrot was mocking our drunkenness in a high-pitched, croaking copy of our own foolishness. With a flick of a switch Lisa silenced the poor, tropical-coloured bird. 'That's you turned off, ye head nipper.'

'Wherra hell did you get tae?' I woke to find Lisa angrily reproaching Robert for his absence. I couldn't remember if I had seen him in bed when I returned from the Palace. I could only remember the horrible sound of the plastic undersheet as I had struggled to find a comfortable position for my heavy head.

'Ah wis wittin fer ye at Yates wine lodge,' said Robert, trying to placate his fiancée.

'Whidye mean?' She stared at him, then at me. I wished there was a way of getting out of bed and into the shower to leave them to it, but I couldn't reach my boxers.

'Ah mean ah was wittin for ye at Yates,' again trying to placate Lisa.

'Kin ye no tell the truth?'

'Whit ur ye gerrinat?' Robert sounded offended.

'Diju go tae Yates or no?' she said softly, pleading for the truth.

'Ah steyed late fer ye, but when ye didnae come I went to Brannigan's wherr they told mae yer wherr lookin' fer mae.'

'Ah'm gonnae nik doon an get some brekfast. Ah'll see ye there.' Lisa sounded satisfied. They were silent for a moment and then she left to go downstairs.

I had an appointment with Tim and his team, to go to the Pleasure Beach together, but the young lads had not stirred. I could hear Tim trying to get them out of bed – the only time I can remember the walls not reverberating to their rap music.

'It's time fer ye brekfast.'

'Gerrimootahere,' said one of the lads.

'Izzofiz head,' said another.

I put my boxers on, grabbed my towel and made my way to the shower.

After forty pence worth of hot water, Tim was making a second attempt to get them up.

'Kinyi no hod jur bevvi?' he goaded them.

'Izzin tha munni, he thinks he kin do as he pleases,' said E.J., whose head had appeared from under the sheets.

'Ji wanna belt oaroon the head?' threatened Tim.

The lads were beginning to regain their sense of humour as they stirred, but they hadn't got out of bed.

'Whyra helza burds no here?' said Josh.

Everyone looked at Striker, who had disappeared the previous night with Boot and hadn't come home with our platoon.

'Ah spent £17 romancing her, it didnae work, ye git tae be ruthless. I hate it here,' said Boot.

Everyone was still staring at Striker. 'Ah didnae even get intae her knickers, she didnae even winch me,' he said dejectedly.

Over breakfast the guests read the *Scottish Sunday Mail* and the *News of the World*. Ather, who'd fallen asleep at the bar the previous night and been carried up to bed, but had been locked out of his room by his wife, read aloud a story about Chris de Burgh sucking his girlfriend's toes. 'That's what Madonna's into,' he interrupted. 'So is Fergie, she gets her toes sucked,' said Lisa with her parrot at her side. Jessie chipped in: 'I wouldn't mind some of that.' Frank, a burly, middle-aged man, looked up from his toast. 'I remember the days when men were men and women were women. Now men are wearing tights. Fuck, I'm glad there weren't any around last night, I had so much to drink I wouldnae know the difference.' Striker leaned over to take a slice of his toast. 'Yous touch my toast again and I'll fuckin' murder ye, ye cunt.' Toni, who was from Glasgow but wasn't part of

our group, had started to comment about toe-sucking, but probably wisely desisted. He had previously explained to some of us that he was a transsexual. 'I'm a woman in a man's body. I'm going to have the operation, because I'm in love with women, I'm a lesbian.'

Before setting off after breakfast, Liza asked Boot, 'Jiwaanta cuplasprin?' He didn't and we gingerly set out for a walk that would eventually take us to the fairground. The previous night's human tide had been reduced to a trickle of elderly and middle-aged couples walking arm in arm. We stopped outside Gypsy Sarah Petulengro's fortune-telling stall on the North Pier. No one wanted to spend money to discover their destiny, so instead we read the futures of the rich and famous. The Duchess of York's read, 'Fergie and Andy are still very much in love. They will secretly meet to try and rebuild their relationship, but it's too late. Her daughter may cause her worry, so there will be a few outbursts in public and this will show the end for a strict nanny.' Michael Caine, a Pisces, was advised, 'You should be concentrating on your future financial security,' and Sarah Petulengro predicted that Elizabeth Taylor would have a 'Reoccurrence of health problems, but new medicines will help. An offspring may cause concern.' The current British Prime Minister John Major would have 'A difficult year, but he will come out a winner.'

Eventually we made our way to the Pleasure Beach, which ranks as Britain's most visited tourist attraction and the world's sixth. We stood outside an arena where two wrestlers stood either side of the ringmaster who introduced them: 'On my right please welcome Shah Khan, champion of all of Kashmir, on my left please welcome Jamaica George from the Caribbean. You give me £5 to step forward and take one of them on and I'll give you not £20, not £50, but £100 if you can beat the one you choose to challenge.' There was silence. The ringmaster repeated his offer. A man in the crowd shouted derisively: 'They're garden gnomes!' Another piped up, 'I've fought bigger birds than that. Pakis can't fight. How much to beat the Paki about?' 'Five pounds,' said the ringmaster. 'He looks like a bag of washing,' said a man as he stepped forward to take up the challenge. 'Alstauniya fer a bagga-chips,' said Boot to Striker, trying to get him to challenge Jamaica George. 'Why's he wearing a mask?' he asked. 'For security,' said the ringmaster and someone screamed, 'What, Social Security?' Everyone

laughed. 'Send him back on his banana boat,' ordered another. But our group had started to break up and E.J., Drew and Striker were chatting up a group of British Aerospace secretaries on a hen party from Derby.

Although admission to the fairground was free, the rides weren't. So with still one more night of partying left it was decided that rather than go for several show'n'ride or family ride tickets we'd plump for the Pepsi Max Big One, the world's tallest and fastest white-knuckle roller-coaster, which dominates South Blackpool and on a clear day can be seen from as far away as Morecambe and Southport. As we queued the screams of passengers in the sleds that tumble in virtual free fall filled us with dread and anticipation. Someone said their legs were beginning to wobble and someone else answered with false bravado, 'Get your hormones together.' The person next to him muttered, 'What kind of pension are you on?' As we neared the front of the line I began to harbour doubts: my adrenalin began to pump as I climbed into the sled, and while the cogs clanked under it as it was drawn up the slope my brain struggled in a battle between thrill and terror. We reached a height that would have had us looking down on Nelson's column in London's Trafalgar Square and then as we crested the peak I saw my life pass in front of me. I gripped the safety bar as we hurtled down the precipice and did my best to stop my breakfast from jumping out of my mouth. No sooner had we reached the bottom than we were climbing again. By the end of the ride we would have accumulated enough penalty points on our driving licences to be banned for life had we been caught at such speeds on the motorway.

Once the ride was over we heaved sighs of relief. E.J. called it amazing, Striker and Boot said they'd lost their bottle, and Michelle labelled it 'different class'. There were no two ways about it – the buzz had been pure magic. During the ride it seemed too long, but now we regretted it had been all over too quickly. Souvenir photographs were bought, and we marvelled at the photographic gallery of regulars who had plummeted down the monster slope cleaning their teeth, playing cards, talking on mobile phones, holding their own or their partner's breasts.

After the ride we passed Ripley's Believe It Or Not, part of its showcase window filled with a picture of a black head-hunter in Africa

and a black man, his mouth impossibly distended by what appeared to be two tennis balls and a golf ball. It started to rain and the boys headed back to the hotel while I went on to one of Blackpool's many weatherproof activities – a music-hall tavern which advertised an English Sunday roast lunch with a gala of stars. I missed the lunch, but found myself in another world, with ushers in boaters, bow ties and rich red waistcoats. The room was draped with heavy curtains, the small stage looked like a set from *A Little Night Music* and the room was filled with people who would have once packed the golden beach on deckchairs, worn knotted hankies on their heads, bought Donald McGill postcards, eaten jellied eels, and listened to brass bands playing tiddley-om-pom-pom.

One woman was introduced as Eva – 'She'll be ninety-five in January' – and she still sang beautifully. The songs had everyone tapping their feet and joining in the choruses, which they all seemed to know by heart. The song that drew the most applause and was sung with the greatest gusto by the audience was one by Joyce Grenfell about an old-time dance club with not enough men to go round.

So gay the dance, so giddy the sight, full evening dress is a
 must,
But the zest goes out of a beautiful waltz when you dance it
 bust to bust.

I went back to the hotel with the chorus going round and round in my head, took an afternoon siesta and woke as the light was beginning to fade. On the way back from the shower the boys in the next room told me, 'Stop staunin er in yur pants, c'min. Teka drink.' They were swigging back beer and wine, and passing round the Buckfast and cider. The rap's steady, thumping rhythm was loud and familiar: 'Girl you've got to suck . . .' Boot was on the floor looking under the beds; he had to shout to make himself heard above the noise. 'Di ju see ma munni kickin aboot?' No one answered him. Striker asked me, 'When'a helza perty stertin?' The thought of another drinking session made me want to flee, but I reasoned it was the last night. The boys weren't going to the party being held in the hotel, they were going to try the pubs and clubs for girls.

'Di ju see mae belt?' pleaded Boot.

'Fer fucksake!'

'Mae troosers'll faw doon.'

The hotel guests, some belonging to our group and others that didn't, began to assemble in the dining-room, which still smelled of gravy and vinegar. One of the three Bettys started to regale me with a story which she claimed made her Britain's first glue sniffer.

'I went to get me teeth done. I had 'em all out and new ones put in the same day. When I got home I couldn't keep 'em on. You know how it is. When you first get them, you can't keep them in for too long. So I took them out and my son, he's twenty-four, well he wasn't then, he was just over two, sawed them in hauf. I was getting ready to go to call the numbers at the bingo. I had to go. So I glued them together and put them in. I had a couple a haufs at the bingo hall before starting. Then I started calling the numbers: "three one, thirty-one, on its own, four". The next thing I know, the machine starting chucking all the numbers out in one go. They were all over the ceiling. So I tried to pluck them one by one from the ceiling: "two and one, blue twenty-one, four and four, black forty-four". People started shouting "get her off". The manager came on stage and led me away – I said, "I can't go, there are still numbers stuck to the ceiling." I kept trying to pluck them off the ceiling as I was led off the stage, I was still calling the numbers. The manager asked me if I was all right. I said, "Yes, it's just the numbers are all over the ceiling." I remember feeling light-headed. They sent me home. My husband asked if I was all right. He could tell I wasn't, he knew I couldn't drink much, I couldn't take so much as a tablet, he asked me how much I had drunk. I told him two halves. I took my teeth out and he asked what all the muck was over the front of them. I explained and he realized it was the glue making me funny. It had been melting and I'd been swallowing it.'

Jessie told me she had gone to convent school. 'Some of the nuns really battered us. One punched my head against an artex wall, another hit me across the head with an umbrella. Me mum had a child every year. I've got six sisters and four brothers. It wasn't she didn't love us, but she couldn't manage us all. Some of us were put in the local orphanage run by nuns.'

Jessie showed me her family pictures. Three of her four children had died of overdoses, and the saddest pictures were of their grave-

stones: the first inscription read: 'Ginny loved always from Ally, Paddy and Ian'; the second: 'Ally loved always from Paddy and Ian'; the third: 'Paddy loved always from Ian'. Like his sister and brothers before him, Ian was addicted to heroin. 'He's on the methadone, and I pray to God he doesn't go like the other ones, he's all I've got left.'

The dining-room had filled up, some of the guests arriving in fancy dress. The hotel owner wore a Heidi ponytail, Karyn wore a Yasser Arafat headscarf, Lisa came made up as a clown with a rainbow-coloured wig, Ather wore fishnet stockings which, even after large amounts of alcohol, wouldn't have fooled Frank who came as himself. Toni, the transsexual who wanted to be a woman because he fancied women, told us he was having an affair with his cousin: 'She denies it, because she's embarrassed.' He complained loudly to anyone who would listen, 'They don't seek me out because I appear to be a woman. They seek me out because I have exactly what I want to cut off.'

I started to take pictures. Shelley sat at a table with her two toddlers. As I raised my camera to take a picture of them she pulled her long sleeves down over her wrists to hide the bruises and put her hands under the table. It was common knowledge that she had been battered by her husband just before she left Glasgow. She was still scared. I had only wanted to take a family portrait as a souvenir to send them and had insensitively not thought about the bruises appearing in the picture.

'Git a picture of wee Pat, you'll no see him in the pub at haeme.'

'Thirteen years ah've been banned from the pub, could've been convicted for murder and already been oot,' said Pat.

Drink flowed like a river in flood, guests disappeared and reemerged, alcohol was consumed neat. 'Condoms!' shouted bingo-calling Betty to Frank. 'It's not going in till you've got it on. No, not there, on yer head, you fucking ugly bastard.'

The following morning those that had made it to breakfast ate in silence. The boys emerged from their rooms to spend their last few pounds on presents for their families and girlfriends back home. Boot had the idea of paying a pound for two throws of a basketball at a stall at the Pleasure Beach. 'Fer each basket, ye get a cuddly toy,' he argued. We trooped down to the fairground. Striker went first, sank

both baskets and got two cuddly cats, one for the mother of his children, one for his girlfriend. Boot was next, and sank one out of two. Josh, E.J. and Striker again were sinking the baskets quicker than the stallholder could hand out the prizes. 'You can only have two goes,' he ordered, but was confused as to who had already gone twice and who hadn't. We put up a feeble resistance, then went back to the hotel along the seafront on the open-air tram, the boys struggling with their trophies under their arms. The pleasure of doing so well at the fairground was muted by the knowledge that we would soon be heading north.

At the hotel Boot discovered his radio had been stolen. Striker breathed a sigh of relief that it hadn't been his boom box. Some of us went with Boot to the police station where there was a long queue waiting not so patiently for help. The first woman in the queue was in her seventies: 'My coach left without me. I'm going to cry, it's so upsetting. It's my first time in a police station, I hope it's the last, I never thought you'd be so busy.' The police officer took the details of her group, where they had come from and which hotel she was staying at, and reassured her that it happened often. 'Take a seat, love, we'll see what we can do. Who's next?' An elderly couple stepped forward to explain they had lost their eight-year-old grandchild. After they left a woman sitting next to our group said, 'The older ones sometimes like a drink – the kiddie probably wandered off to have a good time.' We looked at each other, but no one smiled.

The couple in front of us told the police officer that their 6'4" son had been held up at knifepoint by three seventeen-year-olds in the Coral Island amusement arcade. When Boot's turn came the policewoman said they would send an officer to the hotel to take a statement. On our way back we saw several people who'd missed their coaches: they sat in the street, disconsolate, surrounded by their luggage.

We climbed aboard our coach. If our arrival had been raucous, our departure seemed like a wake, but Mary and the other grandmothers, having checked no one was left behind, did their best to get the fun going again. The first of many raffles was held. 'First prize is a trip to Blackpool. Only joking,' said Tim. 'First prize are some china cups, second prize is half a bottle of vodka, and third prize is a packet of

biscuits.' The boys upstairs had run out of money; they put their heads down on their bags and cuddly prizes. Striker wound his tape back and as we joined the M55 the sounds of 'Don't Stop' began: 'Yeah, it's the outhere brothers – coming back at yo' ass for the nine four. For all you motherfuckers who didn't know we coming back...'

Conversation was sporadic. On the lower deck the women played cards and sang songs beginning with 'New York, New York'. I had asked Mary and the coach driver if I could be dropped at the motorway exit for Barrow-in-Furness, my next destination. Everyone asked me if I'd had a good time. 'It was great, I've had a great time.' 'Pure fucking brilliant,' said Josh. 'Who's asking ye, ye git?' said Boot. As we approached the exit for Barrow, I grabbed my bags and went down the stairs. I hoped to see some of my new friends again. 'And you can phone me when my Tim's not in!' shouted Liza. 'He's at football Tuesdays and Saturdays.'

As the coach glided up the motorway ramp I said my goodbyes and the grandmothers sang, 'We'll meet again, don't know where, don't know when, but I know we'll meet again one sunny day.'

Ather and Nancy returned home to find their flat had been broken into the day we left Glasgow. In addition to filling two holdalls, the burglar had pulled the sheets off the bed to wrap up everything he couldn't get into them. Their son's friend recognized him, but was threatened. The burglar stayed for two days during which he removed everything that could be carried out: he'd even paid a taxi-driver in 5p coins from the daughter's piggy bank. He is currently in prison for another conviction and Ather and Nancy have only retrieved one holdall which contained some of their daughter's clothing and her quilt.

I wrote to Chief Superintendent McKay at Blackpool police headquarters asking for a list of recorded crimes during Glasgow Weekend:

Attempt to pervert course of justice	1
Warrants	5
Drugs	3
Forgery	2

Burglary	7
Robbery	5
Criminal damage	5
Public order offences	8
Arson	1
Assault	8
Malicious wounding	2
Drink/driving	10
Unauthorized taking of vehicle	5
Criminal deception	8
Theft	18
Breach of peace	9
Drunks	5
Handling stolen goods	1
Breach of bail	5
Mental health	1
Miscellaneous	8

To which the Chief Superintendent added the following:

> The above list is by no means an exceptional workload for this Police Station for an Illuminations weekend ... tens of thousands of visitors enjoyed a happy and uneventful visit to Blackpool followed by a journey through the world famous Illuminations.

The list did not include approximately fifty people who missed their coaches home.

BARROW-IN-FURNESS

When the Boat Goes Out

SHOULDERING MY PACK and camera bag as the coach disappeared, I made my way towards the exit for Ulverston and Barrow. I hadn't even reached the turning when a car pulled up and offered me a lift. There are seldom moments of agonizing silence when neither driver nor passenger knows what to say: the driver is usually looking for company and therefore quite happy to talk and, although many hitchhikers hitch out of necessity, they share both a sense of adventure in travel and an interest in the people they meet. I was not to be disappointed.

My driver for this leg of the journey was a submariner – a navigator on one of Britain's Trident nuclear submarines. He was everything you would expect of a naval officer: bright, well-educated – a maths degree from Liverpool – and debonair. 'Submariners don't get to see the world,' he explained, 'we spend months at a time submerged. I always look forward to coming home, but after a while I look forward to going back to sea, but I don't tell the wife that.' Like Tommy and Tim from Glasgow, who had told me that when they had started work they expected the job to be for life, so the submariner had believed when he joined the navy. Now for the first time ever there were going to be forced redundancies, although he didn't believe his own job would go. The service, like most industries, was shaping up to a new future. 'The navy prefer to take university graduates or pay for their training as the last of the navy's own colleges has closed,' he told me, confirming my impression that in today's world it is increasingly difficult to find a way to finance your own higher education. And even a degree, which is now more than ever a necessity, offers no guarantee of a job.

Barrow-in-Furness has since the end of the nineteenth century been synonymous with engineering and shipbuilding of world renown,

particularly the construction of warships for the Royal Navy and most recently nuclear submarines. Here the name of VSEL, Vickers Shipbuilding and Engineering Limited, has long played a major role. The company's order book is a barometer of the town's employment patterns and its inhabitants' welfare.

I was returning to an area I had only briefly set foot in, but I had been deeply marked by that visit. I had gone to give a lecture in Ulverston and was taken for an afternoon visit before the lecture to Barrow-in-Furness by the chairwoman of the organization that had invited me. Her husband was an accountant with Vickers and he explained that the demise of the shipbuilding industry had much to do with the developing world preferring to buy the technology to build their own ships, in order to give jobs to their own people as well as reduce their indebtedness to the industrialized countries. The West's power and dominance were justly being eroded; however, as I witnessed in Barrow, this was a major cause of the severe hardship being suffered by tens of thousands of British families. As one of the company's high-flying accountants, the chairwoman's husband was being offered either redundancy or a job overseeing the closure of Cammell Laird shipbuilding in Liverpool, owned by the same company, with early retirement after the closure. No one was spared the global economic restructuring.

After that initial visit to the area I read in the papers that even in the week that Michael Heseltine, then President of the Board of Trade, was in Barrow-in-Furness to launch an employment regeneration organization called Furness Enterprise, 390 more jobs were to go at Vickers. In the previous three years the workforce had been cut from 14,000 to 10,000; by the time I arrived in the region two years later, it had been reduced to 5000. No one saw any reason to build more nuclear submarines, but Mr Gorbachev was to blame, not the recession, reasoned the managers.

But I saw a much more obvious reason for the job losses than the end of the Cold War. Companies were being forced to internationalize: they could extract benefits from sovereign governments; they could move their money around the world; in the case of large transnationals they were beginning to have more power and influence than governments, able to switch locations at will and transfer vast sums of money

in the process. This system of financial manipulation by captains of industries, brokers and analysts, traders and arbitrageurs controls not only the destiny of people and places they have never come into contact with, but also the destinies of nations. The Cold War over, the ruling classes and transnational corporations were no longer faced with a restraining, competing system; they have the field all to themselves. The world has a new order – world-wide totalitarianism, the totalitarianism of money. The power of money is all-consuming and I had returned to Barrow to see the effects of this power on the ordinary person.

The road to Barrow-in-Furness only just touches the dramatic countryside of the Lake District, but as you travel along its southern arm, its lakes, undulating hills and rivers fill you with the spirit of the place. There is a feeling of transience here, of the seasons and the lives that have flowed through it. As we approached Ulverston, I decided to look up Andy, a friend of a friend, who'd once worked at Vickers but was now helping to run a bed and breakfast hostel.

When I had last visited I had found a dearth of entertainment in both Ulverston and Barrow, so now that I was here for a longer stay I asked the naval officer what there was to do at night. 'There's nothing really. Drink. The navy gives us a living allowance for our accommodation in Barrow. You either pay good money and get a decent place to live or you get a miserable place and spend the rest on drink, because there is nothing else to spend it on.'

Andy was most welcoming and suggested I spend the night at the hostel: I could have a room for £10 including a cooked breakfast. 'Tea?' he asked. 'I won't be more than a few minutes – why don't you have a look around and then I'll be with you.' He hadn't yet had a chance to explain who the residents were. The rooms were usually occupied by long-term 'guests'. They strolled aimlessly around the magnificent late-nineteenth-century Methodist manse and up and down its large wood-panelled staircase and hall, seemingly without purpose. When I put my head around the door of the communal kitchen one of the residents was withdrawing his waterlogged clothes from the washing machine after the prewash cycle and another clutched a toilet roll to her body as if it were the Holy Grail. When Andy caught up with me

he set about explaining. 'The government dishonestly refers to them as "clients",' he said. 'They are vulnerable people, former psychiatric patients who were previously residents of asylums.'

Andy had been employed by George, the owner of the hostel, as warden and administrator to try and get the business in shape. As he talked, Andy set about cooking dinner in his office-cum-bedroom. His filing cabinets were filled with the latest drugs that had been prescribed to his guests. He held up a bottle of tranquillizers. 'These are to suppress the hallucinations and delusions of two of my residents who are schizophrenics. It helps them to control days of bizarre behaviour, providing they swallow them, but I can't be sure they do. These are antidepressants to lift the mood of one resident who suffers from great periods of melancholy. Many of them used to be locked up in those great Victorian temples, the asylums and hospitals, until the authorities started closing them and letting the inmates out. The government calls this – the care of psychiatric patients outside hospital – care in the community. There's no care in the community, there's fuck-all.'

George had arrived at caring for the mentally unstable through a course of events that reflected his own change of circumstances as well as the region's economic ones. He had inherited a newsagent's shop and ran it with his wife Ann. They also started to work in the tourist industry, which gave them the extra income to purchase a guest-house. They had bought it as the recession started to bite and, in an area increasingly dependent on tourism, their new business began to suffer. They sold the newsagents to pay for the mortgage and took in contractors who came from outside the area to work on local projects, but because there was less and less demand for tradespeople there weren't enough of them to pay the mortgage.

George explained to me after dinner. 'There was a period after that when Ann and I finally split. She lived in this part of the house, I maintained the bed and breakfast. I started to take an interest in people with mental health problems, as I'd experienced some of the traumas myself, the effects of a sudden divorce after twenty-two years, I think it was perfectly normal to go into a period of whatever, feeling down. I took in people with schizophrenia, not specifically, but a couple of people here had that complaint and I was trying to help them out and provide meals for them. I've also had to take piecework in general

forestry with some local nobility, quite considerable landowners, but if it rains you don't get paid and a lot of the time it comes piddling down here cats and dogs.'

Andy now assisted George, but the strain of the job, for which neither of them had any professional training, showed on both of them and in their personal relationship. There was little privacy: twice during the course of our dinner residents came into Andy's room to ask for toilet rolls, and the telephone rang with queries and requests from social services, the day centre and the Salvation Army, some with possible future referrals. 'It's a challenge, running this place,' said George with great British understatement. 'I always liked a bit of a challenge, it keeps your mind going, it occupies yourself.'

'A bit of a challenge' had included taking in young people from remand centres. As can be imagined, the other residents of this well-to-do neighbourhood weren't at all pleased. 'We were getting a lot of complaints from the neighbours, deservedly I must admit. I could understand them – they wanted to protect their investment. Now I'm very careful who I take in.' George described some of his former residents as 'way out' people: 'they should have been locked up. One chap lobbed a brand new TV and video through a window – luckily the TV still worked – and a fire extinguisher through the front door. Every morning we were putting new windows in. Glazing became as regular to us as breakfast.'

Andy told me how he had come on the scene. 'I am a chef by trade. I hated catering because of the crap hours and the crap pay. I spent two years catering at a college in Kendal. I went catering all around the Lake District, left to go into the shipyards because there was no future in catering.' He laughed at the notion that there had once been a better future in the shipyards. 'I joined Vickers in '86, I can't remember the exact date, I started as an ancillary, worked my way up and ended in the stores. I can't tell you what I did because I signed the Official Secrets Act, everybody has to sign it! In November '92 I was made redundant. After that until I got this job this July, I worked full-time on a voluntary basis helping to run a day centre for some of Barrow's homeless people. There's a great demand for these sort of places, although we don't run this to capacity, there is usually accommodation because people prefer the large towns like Barrow.

We act as an overflow. Although as of tomorrow we're full for the week.'

'These places are needed,' added George, 'but nobody wants them on their doorstep.'

Dave, one of the longest-term residents who had lived there for the last four years, entered the room. He flicked his cigarette on the floor and began trying to humiliate Andy in front of us. Andy offered him his medication, but he refused to take it. Dave was obnoxious, filthy, with half his dinner spilled down his shirt and vest and rude to the point that would have reduced a less understanding person to tears. When he left the room, Andy explained no one else would take him in: 'He has a knack of getting you into an argument.' Dave also had the habit of peeing into cups and outside his room. 'It doesn't occur to him to go to the toilet,' said Andy, who sometimes had to clean up the mess. 'If you complain he says he's got an exemption from the doctor. He plays on his old age.'

Of the nine residents only two weren't mentally unstable. John was a quietly-spoken, well-mannered eighteen-year-old who had been here for the last year after a stint on probation. He had had no contact with his parents since they had divorced and referred to his dad as a dickhead. The other man, Jim, was some ten years older than John. When Andy and I met him on the stairs he complained that he'd had £10 stolen out of his room. 'I'm flat on my ass now. I've got £4 left to my name.' Jim went around the house with a black dustbin liner tucked in his belt collecting rubbish. It was a means of trying to keep occupied. He was shadowed by another resident who rarely left the house and, when he had to, kept to the side streets as he feared being followed. Andy told me he was a paranoid schizophrenic with complications of religious mania and, although he referred everything to the Bible, he wouldn't go to church because he believed everyone was watching him.

In the morning I found Andy helping a new resident fill out forms for housing benefit and disability living allowance. 'It's all so much bullshit – look at this.' He pushed a thick questionnaire across the table. 'There's twenty-eight pages in three sections about your personal circumstances, your mobility and about yourself. They baffle you with flipping questions. I don't know how most people, including those

with all their faculties, fill them out.' They probably did what the new perplexed resident was doing, hand it over to someone else. 'The government has imposed upon hospitals something called the CPA, Care Programme Approach. It's meant to be a formalized plan of follow-up after the patient is discharged.' He handed me one of the lengthy forms. 'There's well over a hundred items to complete, it takes well over an hour to fill in.'

After Andy had finished some other urgent business we took the bus into Barrow-in-Furness and he gave me a guided tour. We started at the Cistercian monastery which had originally been founded by Benedictines. Here I learnt that the fathers and sons I had met in Newcastle weren't the first to strip buildings of their valuable materials: Cromwell had stolen the lead off the Abbey's roof.

'When I was unemployed I used to come down here to read,' said Andy. 'I looked at the abbot's house and imagined the fireplace. Think about it, Robert the Bruce warmed his arse here. The abbey was the second most powerful Cistercian foundation in England at the height of its power and influence. It got its wealth through farming and trade. Robert the Bruce held the abbots to ransom, stayed the night, very civilized, and was paid not to ransack the area, so he went off to ransack Lancaster. He had come to take iron ore for swords and weapons. I think we're going back to more like it was in the days of Robert the Bruce – a taking society, must have it, grab everything you can get, people have become too greedy, there's the very rich and the very poor.'

On the way into town Andy pointed out the slag heaps. Much of the town's industrial development had been based on local iron ore, charcoal and water power. 'We had the longest-lived iron furnace, now we've got a cellophane plant, a toilet roll manufacturer and a toxic offshore gas platform – and of course VSEL, Vickers. All the family have worked there, my brother and myself and my dad who still does, but for how much longer is anyone's guess. We call it "Very Soon Everyone's Leaving".'

We walked into town along a fine tree-lined avenue said to be the longest one in Britain. Andy explained that the name Furness was of considerable antiquity, Fur meaning far in Old Norse and Ness, neck of land. 'Far-Ness', namely 'Distant Headland': Barrow-in-Furness's

remote geographic isolation was something that could be seen from afar.

Andy pointed to a building site nearing completion. 'That's Mum's church, each member of our family belongs to a different one.' Ahead of us loomed the cream roof of Vickers' Devonshire Dock Hall which dominates the town's skyline. 'That's home of the Trident submarine and Britain's most advanced shipyard,' he said, with pride in his voice. 'The town should have a lot going for it, and yet we have one of the highest unemployment rates in the country although we border the affluent and appealing Lake District which has one of the lowest.' He stopped to speak to one of the Abbey's wardens who was on her way to work: 'Nick's here to write about Barrow,' he told her by way of introduction. 'Welcome to Britain's longest cul-de-sac,' the warden greeted me warmly. Barrovians felt cut off: with one road in and one road out, they felt marooned from the rest of Britain.

We passed the railway station. 'This here used to be dominated by the Railway Steelworks, but you'll only find them and the wireworks in old postcards.' Andy went over to say hello to two homeless people sitting motionless in a bus shelter: he seemed to know everyone, and especially the distressed and needy. He introduced me and as we turned away pointed to the supermarket trolley next to one of the men. 'That's care in the community for you.'

Before Andy took me to meet his mother, he wanted to show me the day centre he had helped to set up for unemployed people. It was a Portakabin situated in the back yard of the Methodist church. There was a small kitchen and a communal room furnished with donated furniture, a black and white television, radio, tape deck as well as several board games including Scrabble, Monopoly and chess. A sheet of A4 was pinned to the wall advertising a 'Table Top Sale'.

'Hello, Dave, what are you doing?' said Andy to one of the men sitting at the room's only table.

'It's my brown letter, I thought the boss wanted me sick note, instead he gave me the tap on the shoulder and the brown letter. That was last Monday, they gave me forty-five minutes to collect my gear and get out. They don't handle it very well. So that's it, I've got to return the form, that's the sum total of my day; lick it, stick it and shove it.

'They have you like a puppet on a string. I gave my working life to Vickers. I've been there thirty-five years. I've worked on Trident. I've tried looking for other work, but there's not a lot around.'

There were four men in the Portakabin, all made redundant by Vickers, and a group of women volunteers who made lunch for the men who used the day centre. Two middle-aged men dropped in for a quick cup of tea. One of them told me, 'I come here every day, it's something to do. You can walk around town in five minutes, I go to the library, the train station just to see what's down there and the Vickers job club. Meet people, that's what it's about. I've done distance learning and workshops. I've been to Newton Rigg College to do a GNVQ intermediate level in Health and Social Care. I'm now doing a BTEC in catering.'

Bill, who had arrived at the same time, said he was to start at an HGV training centre at an ITEC in Lancaster. 'It will cost me £34.60 a week in travelling expenses out of me £91.40 I receive fortnightly in benefits. I haven't got a clue how I'm going to manage. It's not only me, there's another nineteen in the same boat. I don't think I'll get a job at the end of it, 'cause they're putting blocks of twenty of us through it at one time. They gave me a list of choices, offshore survival, public carriage vehicle, welding, computing, business courses and IT – Information Technology – but I couldn't get on those courses. I was told the previous year the courses were full and I'm now told they're swollen. So there really was no choice.'

The men yawned from nothing to do. The air was thick and stale and steamy from the lack of ventilation. If you opened the door you got a blast of arctic wind and the Portakabin's little windows couldn't be opened more than a crack. You huddled over the ribbons of steam from the hot tea for warmth and you gasped for fresh air.

A former fitter at Vickers came in with an old radio in one hand and a Bible in the other. He wore earrings, one with a crucifix pendant.

'Please take your feet off the chair,' requested one of the women. The man talked to himself before turning on Sarah, the youngest of the three volunteers.

'Who are you?'

'I'm the Homeless Help,' said Sarah.

'Fuck off. I'm here on a placement. A working man can put his feet

on a wooden chair. Who's this fuckin' woman to tell me what to do? What right has she got? I'm a working man, destitute, without money.'

'If you're going to be rude I'm asking you to go.'

'I'm going to go to channels to sort this out. I'm a working man, it's a crime, you have sinned, woman!' He went to the door, opened it and glared at the volunteer. 'Good afternoon.'

'I'll see you again,' said Sarah forgivingly.

'No, you fuckin' won't, not unless I can put my feet on the chair.' He walked out, slamming the door behind him.

'How long has it been like that?' asked Andy.

'Two or three times – he's obviously very ill. His words run into each other. It's as if he's drunk. He becomes aggressive.'

'I saw him at seven o'clock last Sunday morning sitting on a bench with the Bible,' said Mary, the oldest of the volunteers. 'He told me, "The end of the world is nigh". I wanted to ask him, who gave you that privileged information, but I didn't. He's going to end up hurting someone. He's off his trolley.'

'He helped set this place up,' said Andy. 'He's changed over the last one and half years.'

The men reminisced about the great naval boats that had been built in the local yards: the aircraft carriers, the first 100,000-ton tanker, the methane carrier and a cruise ship. These brief bursts of interest gave temporary relief from their mundane routine of sitting around sipping tea, reading the papers, and playing board games. They were filled with the toxin of chronic boredom. The wasted hours and days poisoned their lives and their relationships, depression coursed through their veins and leached away their self-esteem.

Andy wanted to show me the new hostel being built for the Barrow's homeless. 'I'll come along with you,' said Pete, who lived in the same direction. 'Did you hear about the burglary?' asked Sarah. 'They stole the new brick wall.' 'There's no point telling the police,' said Pete, 'they won't do anything.'

As we walked to the building site Pete chatted. 'After Vickers I travelled about all over with McAlpine's, concrete factory work, building work, now that the building industry has collapsed we're all after the same jobs. Travelling raised my horizons. I started reading Alistair MacLean. I've recently started a computer studies course, but there's

no guarantee of a job at the end of it. My family are here. I'm studying French and English for my own satisfaction. I'd leave here and move to Yorkshire or London if it wasn't for my two daughters. I'm a qualified driver, chef, I've done labouring and illegal activities: selling dope.

'If you look around here you'll see the government isn't prepared to put money in anything. The middle class are getting educated, the working class can't afford it. When I was working I had to do a hundred hours a week. Others had no work. It seems to me work should be shared out. You couldn't expect politicians to make those decisions, rich people to take less, poor to have less children. Everyone's looking to the short term. It's not all negative. I've got friends doing reasonably well. Someone who's been working a year or two. There is a lot of catching up to do when you're back in work. Your clothes have all worn out. You can afford reasonably tidy clothes. You can get the fridge mended, basic things like that. The danger is not to fall into the benefit trap, where it becomes impossible to get back on the work ladder because you can't afford to take a low paid job. I have a daughter who's going to be eighteen next month. She's applied for a job in London. It's a Third World job, she'll work for nothing if she has to. It's either college or literally a nothing pay job, or she can sign on.

'I could never save more than for holidays and a deposit for a house which I had for a year or two. Then I lost my job. Job wasn't a factor. Money maybe. My wife wasn't a happy person when I became depressed through not having a job. They all live on Wallney Island where they could walk out, play on the beach sand, come in covered in mud. You couldn't do that in Clapham or Brixton estates, so life is better in some ways. Soon the kids will be grown up and there will be nothing holding me here. But I don't know about the future. I have a bed in someone's house because it's cheaper to live in shared accommodation where you share the bills.

'I don't know if there is anything that is English or British any more. Maybe it all died off when people stopped going to church. One thing that is relevant, my parents believed the strong society should carry the weak. Supposedly, I was one of the strong people. I was a foreman fifteen years ago, I would have been a manager if I had

stayed in work, I'd be up the ladder somewhere. I'd be paying taxes, supporting the unemployed and sick. It seems odd sometimes that I'm not needed. I've spent the last three years out of work. I can take it. It's not hardship for me. I'm definitely one of the underclass because I've got no financial power. So that gives me no choice. No choice but to break the law, which is about the only choice I have – selling some drugs – piling the money into the family expenses. It's difficult to say more. I got caught twelve months ago and got a little bit of jail. If I got caught again I'd be sentenced for a long time. It's not a sensible choice any more. I have friends who shoplift, get prescriptions to sell, or ones with other fiddles – they got to find ways to survive it, they only got their dole cheque. I'm in a different position now, because I won't need the money as much now the children will soon be away from home. I won't have to worry so much about them. If my money runs out I go without food for two days, I wouldn't steal or any of the other alternatives I've mentioned. I did it because I just needed the money for my kids. I bought it in London and dealt it in Barrow. I went once a week to collect my dope. I could do it in a day on the train. I spent the rest of the week selling it.

'Drugs are the big amusement these days for all the people who aren't working. I'm addicted to opiates. There's a few of us keep watching the news to see when the politicians are going to legalize things. It seems like it's inevitable, but it's been a long time. It would be better if it were legalized – we've created a whole class of criminals. It's one of my hobbyhorses: to legalize drugs. I always express my opinion when I can, try and soften people's opinions, prejudices.

'Mum and Dad are working class, rats in my pram, you know what I mean? They've worked hard all their lives, they brought up eight kids, it's a different world now. My mum still teaches, my dad will soon retire, he's a factory foreman. Look, you turn off here, it was nice talking to you. Oh, I don't read Alistair MacLean any more, I'm reading a lot of science fiction, I don't know why I'm telling you this. See you.'

Pete sauntered on down the street. Even living on his grant, he dressed smartly in well-worn clothes; obviously he was a man who felt appearances counted for a lot and wanted to keep them up as much as possible on a tight budget.

* * *

Andy had arranged for me to stay at his mum's. Meeting her, I learned
from whom he'd inherited his calm strength and inner convictions.
Mrs Wheeler was carved from living granite, a tower of strength with
reserves of inexhaustible energy. As we came through the front door
she hollered a welcome from the kitchen.

'Thank you for putting me up, Mrs Wheeler.'

'It's a pleasure, your room's upstairs, Andy'll show you, it's his
room. Your dinner's ready and there's no need to call me Mrs Wheeler,
just call me Margaret.'

Moving around her kitchen between piles of washing, pots and
pans, the dog and her mother, she handed us plates of steaming food.
She had already given her youngest son Richard his dinner, and there
would be one more to serve when Stan, her husband, got home from
Vickers. She was still in her white overall from her full-time job 'fetch-
ing and carrying', as Mr Wheeler put it, at the local hospital pharmacy.
In addition to her paid work, as the only driver in the family she
collected her husband from work, chauffeured her boys when they
needed a lift, which was often, cooked the meals, did their washing,
cleaned the house, cared for her mother and looked after the dog,
Bob, a stray she took off the local dustman. Mrs Wheeler also played
a leading role in her church's functions. She was always too busy with
the chores to have much time for here-and-now pleasure. She was
one of those people who make you feel tired just watching their activity
and thinking about their soul-bracing energy, much of which was
derived from her religious convictions. Her world didn't leave time
for her to catch her breath.

Andy had to get back to Ulverston, so I decided to walk back into
town. It was dark by the time I reached Barrow-in-Furness's fine
Victorian red sandstone town hall. Groups of adolescents had gathered
across the street, colonizing the benches and the stairwell to part of
the shopping precinct. The girls were dressed in the casual wear seen
in the television programme *Beverly Hills 92010*, the boys had walked
off the set of *Happy Days* – baseball jackets and caps, basketball shoes,
loose tee-shirts and lumberjack shirts. All of them chewed gum. They
were watching America.

'Are you from America?' they asked.

'Sort of, my family are from New York.'

'Barrow's half the size of New York cemetery, but twice as dead,' said one of the boys.

The youths came from all over town: from estates that their friends wouldn't dare visit alone and from private housing that would have been worth a fortune in another part of Britain. They were the sons and daughters of the unemployed, but also of a magistrate, and one was the nephew of a police inspector. Life was passing them by in slow motion, conversation was open, but they were children lacking an attention span.

'Here comes Mole,' said a group of girls as a car screeched to a halt, its engine revving furiously. 'Hi, girlies!' shouted the boyriders – youngsters who drive their own cars, as opposed to joyriders who steal them. Two of the girls got in. The car burnt rubber as it sped off towards the roundabout. 'Meet Tophead and Pisshead.' Their deep-set eyes were a shield, as they were for many others. Tophead's defensive stare hid his fear and insecurities. Both of them had been doing buckets (home-made hookahs: a bucket of water is used to cool the smoke) and gone stealing to finance a pour of alcohol. When they moved off to another bench, the girls told me, 'They think doing drugs is smart.' Another car pulled up, the passenger screamed an invitation for them to get in. I asked the girls who they were.

'The Saturday night lads.'

'Why the Saturday night lads?' I asked.

'Because we met them on Saturday night, don't know their names.'

'We go burnin' with them 'cause we haven't got a car, but they've got to have the cry [criteria] – the personality,' said fifteen-year-old Rachel.

'We won't get in anyone's car,' added her friend Sarah.

Pisshead was back. 'A cornish pasty, a bag of chips and they're anyone's.'

'Fuck off!' said the girls.

A trio of young lads with two bottles of cider between them and their baseball caps twisted round so the peaks were on their necks joined the group.

'You look out of it,' I said.

'We are.' Two of them looked cocky and defiant, the third held his

head up high and narrowed his eyes. They went off to pester someone else.

'They're Barrow's Mad Bastards.'

The girls introduced me to their friends Riga, Chicken Legs, Bambino and Mole, as they caught up on gossip. Talk revolved around who was jiggin' it from school, who was splitting up and the Bezza people who were the ones who didn't do drugs, but stuck to soft drinks. Some of the fifteen-year-old girls were already getting drunk after bluffing their way into clubs at weekends. As I left the boys were talking about contraception. Mole told me he didn't use protection. 'I leave that up to my girlfriend.'

'Aren't you afraid of diseases?'

'No, everyone knows everyone here.' An attitude that was common currency among the youth of Barrow.

Tophead offered to take me to the Vulcan and Mardale Grove where his friends wouldn't go. 'It's rough, but if you want to know what we get up to in Barrow, I'll see if my mates will let me bring you along.'

The last buses came and went. Men and women had drifted home from the working mens' clubs, the pubs and bars next to the small commercial district had closed. Most of the town's citizens had long since been asleep. Only the young men and women on the benches remained, their chatter drowned by the sleepy, desolate streets.

I got back to the Wheelers' house just after midnight and found Andy's brother Richard reading John Updike. He'd bought three of his books for £4.50 in one of Barrow's thrift shops.

'I try to keep myself occupied, it keeps me from going round the bend.' Richard had studied mechanical engineering and had got several qualifications, ONC, HND and OND; he'd also worked as an apprentice and a welder at Vickers. 'I think they took on apprentices because it's a cheap form of labour – when you've finished your apprenticeship you're out. I don't think they even take on apprentices any more. I keep looking for a job, but the engineering side of Vickers is struggling for work. Only one or two orders for GEC. I don't think they have any orders for December, sixteen tanks, that's it, then they're making tobacco-making machines for China. Life's so uncertain around here,

that's why I like maths, because there is a given answer. I'm going to the Vickers job club tomorrow, see what they've got, I usually go once or twice a week.'

He agreed to take me with him, although outsiders were not allowed into their job centre. Richard was also thinking of following in Andy's footsteps and getting an unpaid job in the volunteer sector. But as I was to discover the following morning, agencies in Barrow had to turn many willing volunteers away, such was the demand even for an unpaid job. The voluntary sector was the only growth industry in Barrow – jobs created to help the jobless. Chad Varah, who started the Samaritans movement, had spent two years in Barrow as a curate and it made me think that the town's and the Samaritans' theme song could have been REM's 'Everybody Hurts'.

In the morning there was the usual battle for the house's only bathroom as Mr and Mrs Wheeler got ready for work, and Richard for the job of trying to find work. I agreed to meet Richard at midday outside the Vickers job centre. In the meantime Mrs Wheeler suggested I go to see one of her friends who had recently set up an advice and information centre that also offered counselling and support, education and prevention of substance misuse which, as I had already seen in Leicester, Halifax, Newcastle, and Glasgow, was becoming endemic across the generations. I had heard the previous night that it wasn't just the soft drugs that were being used through buckets, bongs and spuds; the youths had told me that bags of brown were being sold on the street and Temazepam and Tamalgesics as well as the anaesthetic Kitamine were readily available.

Rosie, who ran the small office out of a tiny terraced house in the centre of town, faced an uphill battle. All the furniture had been donated, the photocopier had been purchased with a grant and her secretary-cum-administrator was a volunteer on a college placement scheme. 'There's a philosophy here, "I've got a headache now, I need a pill",' she said. 'The town is awash with people on prescriptions – even my grandma gets a regular prescription.' As I had seen in Newcastle, some hard-up pensioners would sell their prescribed drugs and, as I later discovered with Tophead, youngsters traded prescribed drugs as I had once traded stamps. 'If we're not careful,' said Rosie, 'we're going to end up with a bit of gang warfare here. Parents often see

drugs as a problem, but not their own drinking habit of five pints a night, because it's legal.'

I walked through the town's compact shopping precinct and then to the Vickers job centre where I met Richard. The security guard didn't check our ID and we took the lift to the third floor to look at the job vacancies. There were many men combing the notices for jobs elsewhere in the country: once they had finished with the small notices, they combed the classified sections of the national and local papers. Staff were on hand to assist the jobseekers with enquiries as well as desks with telephones that had been put at their disposal. Richard couldn't find anything that matched his qualifications, or that he hadn't already tried.

'I'll get the *Evening Mail* on the way home, you never know your luck.'

I managed to borrow a recruitment video from Vickers – ironical to say the least, as the town had a cloud of redundancies hanging permanently over their heads. Over images of a submarine arrowing its way through the seas, the commentary explained that VSEL was at the forefront of 'pioneering spirit, revolutionary thinking, one of the prime movers in global defence, supreme in the art of stealth . . .' and of Barrow, 'a coastal town on the northern sweep of Morecambe Bay, twenty miles from the Lake District . . . pace fast enough to be efficient, slow enough to be comfortable . . .'

Richard asked me if I would like to see where he worked at Vickers. He couldn't take me inside, but we could glimpse part of the complex. We crossed over to Barrow Island. In the water were several submarines that had been decommissioned and were waiting to be sold. The tenements opposite the factory were bleak: washing weighted down with plastic bottles of water hung between the balconies of neighbouring flats above the middens. In large lettering GET RIGHT WITH GOD AND DO IT NOW was daubed on the wall of an empty factory shed. The sun came low across the gargantuan Devonshire Dock Hall and cast long shadows across the streets and into the dwellings. By the time we got to the shipyard gates, the shift was leaving, a trickle of men and bicycles – how different from the pictures I had seen on the walls of the VSEL offices where the workforce squeezed through the gates shoulder to shoulder, the street invisible between the river

of humanity, the black mass of workers scurrying away on foot, push-bikes and buses in the mad rush to get home.

Returning to town, at the back entrance of the supermarket in the shopping precinct Richard stopped to say hello to a group of men he had once worked with. Dennis, Brian and Jack had all worked at Vickers. 'Who didn't?' said Brian between swigs of cider. He went on angrily, 'Denny can still do the job of any skilled turner. They think that just because we stand here and drink, we don't have a fucking brain. I've got more trades than most. "You're only winos, you want to shut you're fucking mouth up," that's what people tell us.'

'There's more trades and skills standing around here: caulkers, grade A welders, platers, shipwrights.'

'Shoplifters!' said Stan. 'That's where "slinging" – how to tie a rope and knots around things and move an exact load to a certain place without hurting somebody – comes in handy: pick-it-up-here-and-move-it-there.'

A woman came over and joined in the conversation. 'Listers went bust. We're all signwriters for the government now, for the social – signing for my benefits.'

'This is our life.'

Brian burped. 'Excusez-moi, vitamins repeating on me.'

The group increased until we were eight in all. 'It's a nice little town with good people, we've had good times here. And bad times. Some places you go you're made so fuckin' unwelcome,' said Denny, who had tried to find work in Manchester and Blackburn. 'Here I've got Scots friends, I get on well with them.'

'It's what makes the world fuckin' go around,' said one of the newcomers to the group. 'This is where we meet all our friends. The numbers have dwindled drastically 'cause they died – not only drink – let's put it down to body failure. Whatever you die of, it's just bloody lack of breath, that's all it is when you get down to it.'

I left the group and Richard, who had an appointment to tend a pensioner's garden as a favour, and went in search of the Connors. I had been asked to look them up by Rachel, who was the girlfriend of Graham who'd introduced me to his parents and friends in Halifax. Her mother and grandmother ran their own music shop. They greeted me warmly and told me that Rachel had said that I might drop by.

They insisted I have a cup of tea and told me how proud they were of Rachel, who had qualified as a teacher even though she hadn't yet found work as one. She was working as a secretary for Yorkshire Youth and Music in the former Dean Clough mill in Halifax. I could see now that she had inherited the perfect background for her current position through her mother, May, and grandmother, who breathed and lived music. Some of old Mrs Connor's early memories were of walking over the fells when she was eleven years old with her father and ten to twenty men, stopping to play brass band music at the farms in return for a meal or whatever the farmer could afford.

'They were very hard times, the 1930s were the worst years, we were distressed. You could say that is how I got into music,' Mrs Connor said. 'My father was an iron ore miner, he was a workaholic, he would do anything, at seventy he said it was a crime for a man in the prime of his life not to be working. He walked three miles uphill every morning to work in the slate quarries. When he worked in the mine he came home covered in red dirt, not the black dirt of coal mines. I would wash his pit clothes twice a week. He was also a basket maker. He would go out into the forest, buy a section of land, get transport to bring them back. I've seen him shave it this thin – Kleenex thin – sections six to eight feet long. He'd boil the wood, the bark softened to strip the wood off, then he'd cut the wood down into thinner strips and thinner strips, shave it paper thin and then plait and weave it. They were oak spale baskets, the colloquial term was 'swill', famous for collecting crops in them – potatoes and turnips – or the washing. He made one for Queen Mary, when she passed through Broughton. That's where we came from. I've lived in Barrow for forty years, but I still think of myself as a Cumberland girl. I came here when May's daddy died, no illness, found him dead in the house.'

'He doesn't want to know about all of that,' said May. 'Tell him about the music and how it's all changed here.'

'I'm getting to that. I saw my first talkie in Workington, it was the first place to hold a competitive musical festival – I couldn't get over the massive queue. Al Jolson was the singing fool or whatever it was called – I thought it was rubbish. You'll laugh at me, but the talkies publicly murdered the art of playing the piano. The pianists played from memory [for the silent films], they were brilliant performers in

their own right. When the Wurlitzers came they were able to adapt and made a lot of money in variety. Any night they played a couple of hundred tunes to fit the scene – melodrama, trash, love scenes, the William Tell Overture, "Hearts and Flowers", they were very clever, but then I'm just an old-fashioned so and so when it comes to music. I sat entranced at the women playing the grand piano on a dais to the side. That was one of my first memories. I was so little, we grasped at anything that was entertainment. I can't understand why young people can't get more out of life today. You can't understand why they have to get drunk to enjoy themselves. I'm not against drink, but I could just get drunk on Kali, forerunner to Vimto, or Coca Cola and Pepsi. It used to be like Ireland, there were ceilidhs where someone plays a fiddle, tells a tale, sings poems, ancient stories, folklore. Father played nearly every instrument in brass band.'

'Mum, I think you should get back to talking about Barrow,' May interjected.

'I'm telling him the story. You used to have to find your own entertainment – mind you in our day Barrow had six or seven cinemas and several theatres, one could afford to go. The original theatres reflected the class divisions, the lower working classes were sent to the gods, this was the gallery sixty to seventy feet up, the upper lower classes were referred to as the pittites and sat in upholstered-backed benches, the lower middle classes were housed in the upper circle, the upper middle classes and the upper classes sat in luxury chairs in the dress circle, but the upper classes could have the isolation of a private box. This continued until the years between the First and Second World Wars. Each auditorium had its own atmosphere. I remember going to the opera with a full orchestra, Gwen Catley was singing *Rigoletto* . . . growing old you remember things, I can tell you what we did before the NHS. Anyway, I promised myself to learn the songs to *Rigoletto* in a year, I was twelve then, they were wonderful days. Gwen Catley sang for people in World War One and World War Two, I could probably sing for people in World War Three.'

'You'll probably cause World War Three,' May joked. 'She did everything for everyone. She entertained the troops and prisoners of war during the Second World War. If a church needed money, she'd do a recital, whatever its creed, and entertain at old people's homes.'

'They were different times. Farmers came down from the hills covered in muck, smelling, but they clapped like mad. I'm pig sick of the word "resources", everyone's current thinking is it's the government's duty to pay for everything. Some people have become as grammatically ignorant as the pigs in Drocada. This used to be a flourishing town, like Whitehaven, Workington and Maryport up the coast. There used to be Iranians and Chileans, now it's all going downhill and further downhill. The men who planned this town had a vision. Now no one can wait. Instant coffee, instant everything – they can't wait a week. Our last customer wanted a present for his wife's birthday tomorrow, he's a typical man.

'People would move from Barrow to find work, but no one can sell their house. They're all on a precipice. I worry about my two grandchildren, Rachel and Leanne. Leanne is married to a radiographer at Vickers, he takes photographs of welding pipes that go in the nuclear submarines. They don't know whether to start a family. It's a hell of a worry, he could be out of work tomorrow. I would say they were middle class, but I'm not, I'm upper working class. We had a hard life and a community, they have a hard life, but no community.'

Mrs Connor and her daughter began to get ready to close the shop. A regular came in to buy a guitar string. After he left, May explained it was a sign of the times. 'They used to come in and buy a packet of guitar strings every week and a book of music. Now they ask if they can put £3 down for the music and pay £1 each week for the next three weeks.'

I stood outside the shop as they set the alarm and padlocked the grille over the shopfront. 'We didn't rob or steal because we never had anything,' said Mrs Connor. 'Nowadays if they can't get it, they take it.'

They gave me a lift in the direction of the Wheelers, with a guided tour thrown in. 'That was where Her Majesty's Theatre stood before they demolished it,' pointed May. 'That was the Gaiety Theatre and Picturedrome which became the Essoldo and was also demolished to make way for a centre for the disabled. There were other cinemas, the Palace which is now used for bingo, the Regal, the Coliseum with its elaborate façade. Pop groups came here, too: Cliff Richard and the Shadows, Tom Jones, The Supremes, Jerry and the Pacemakers, the

Three Degrees. We played games like Tin Can Alley outside the Imperial in the street without any bother. Games seem to be lost. You don't see the parents sitting out in the street with the kids as before and you don't dare let the kids out to the park with a nice boating lake.'

They told me to drop into the shop whenever I felt like it. 'If you have time for a meal, telephone us. I'd like to write down part of a poem by Norman Nicholson before you go. Make sure you come by and get it,' said Mrs Connor.

Mr Wheeler and Richard were sitting down to dinner on their laps in front of the television when I got in. The front room was decorated with dozens and dozens of porcelain thimbles commemorating royal weddings and members of the monarchy. Mr Wheeler looked tired, as well he might: like many of the people I was to meet during my journey he wore the scars of a life spent on the factory floor. He had lost the sight of one eye when a steel pin pierced his pupil at the Rolls Royce plant in Hulme and many years later he lost several fingers at Bowater Scott's when a machine accidentally switched on and jammed. He handed me a present, a pencil-length brass model of a submarine that had been built at Vickers. As I was beginning to discover, the British islander has something of the pirate in his head, but with great reserves of nationalism and tolerance in his heart. Later that evening in the pub, Mr Wheeler introduced me to some of his friends, who had over the years created a small cottage industry making wheelbarrows, stepladders, shovels and pails with materials that had been destined to keep Britain's Imperial fleet ruling the waves.

Richard's spirits had lifted: there was an ad for labourers in the *Evening Mail*. He'd got home too late from gardening to call the number, but would try first thing in the morning. He reminded me of my appointment with Tophead: he'd been surprised at how open the youngsters had been, but as elsewhere I guessed that as an outsider I posed no threat to them.

I had probably been over-confident that Tophead would show up. Sitting on one of the benches I chatted to the same groups of young men and women. Louisa, a fifteen-year-old, like the others was as curious about why I had come to Barrow of all places as I was to

discover what their lives were about. After two hours I was thinking of leaving when Tophead came across the road. 'Are you coming?' As we took off and headed for the Mardale Grove and Vulcan estates, Louisa asked me for my address and I obliged. 'That's to inform your family of your death when you don't return from the Vulcan.' As we walked Tophead told me he'd felt so wiped out the previous night he'd slept rough. I asked him about his parents.

'Nowt, my dad lives in Burnley, he gets drunk all day. He left Vickers and got divorced. He's self-employed, fixes washing machines and electrical appliances. My mum works in a school with young children. I don't see my dad, I see my mum, I live with my grandparents.'

We walked along dark streets, the tightly packed pebble-dashed houses adding to the gloom of the autumnal night. At the road junction Tophead told me to wait while he checked with his friend to see if it was all right to bring me in. He returned minutes later to say it was. On entering the house I met the parents who breathed drunkenness at me. 'They're pissed on cherry,' said Tophead once we got up to the first-floor landing. The house had once been decorated, but it was filthy and graffiti covered every wall. Entering their son's bedroom at the top of the stairs, it occurred to me that the parents might have objected to a photographer entering the house (my cameras were clearly visible).

The group of young men sat in a semicircle around the television set where Manchester United were playing in the European Cup, but their sole object of attention was the bong, a version of a hubble-bubble made from a large empty bottle placed in the centre of the room. They inhaled large amounts of hashish, washing it down with quantities of cider and Coca-Cola. This room too was covered in scrawled graffiti and drawings, one a caricature of a young man labelled Acid Head Arnie. In one corner of the room was a pair of women's tights and a cooking pot which they had used for stewing magic mushrooms.

Tophead didn't want to stay. He collected a plastic shopping bag and one of the young men who said he wanted to get some sleep before school in the morning. The three of us headed for a rendezvous in the street. On the way Tophead explained about the trade in drugs. They bought Temazepam in capsules which were treasured for the gel that could be squeezed out, melted and taken intravenously. These

they took to Carlisle where they could sell them at a premium and in return buy the cheaper tablet form, or chalkies. Sometimes they travelled to Manchester to shop for their 'trips' and smoke – Tophead said they weren't drugs.

I was not allowed to see the man Tophead was meeting, but I saw the car pull up a hundred yards further along the street. It was a smart sedan, with a year-old licence plate. I imagined the man could well have been respectable in his everyday life, but what he was doing on a regular basis was buying stolen goods from the children which in turn financed their habit. Tophead came back to us fuming: he hadn't handed over the car stereo which was in the plastic bag because the man already owed him £50 which he claimed he didn't have. Tophead got increasingly agitated – I couldn't tell whether it was simply anger at not receiving some cash, or whether he was withdrawing and needed a fix.

Crime fighting seemed a long way off. The local police force was, as elsewhere in Britain, partly composed of 'specials', volunteers who in Barrow were putting in up to 63 hours a week, sometimes more. Some of the specials were only a year or two out of the same school these boys attended. One of them told me she was expected to tackle everything from co-ordinating Neighbourhood Watch schemes to working with regular officers on traffic control and drugs raids. 'I want to become a regular,' said Sarah, 'but there's no point promoting us, because they'd have to pay us.'

Richard re-read the ad in the newspaper. He was like a sprinter limbering up for the starting blocks – he desperately wanted a job, any job, but the ad did say they opened at nine o'clock. He looked nervously at the kitchen clock. At ten to nine he couldn't stand the tension and tried the number. There was no tone, just one long signal. As he thought, the lines wouldn't be open till nine, but he tried once more just in case. On the stroke of the hour as *The Big Breakfast* finished on television, Richard dialled the number and found the line equally dead. He handed me the phone to give it a try. He then called the operator who informed him it was a mobile phone number. He called the newspaper who apologized: they had misprinted a digit. Richard got through to the job agency at ten past nine. The vacancy had been

filled. I asked him to find out how many calls they had taken: 75, and he heard the telephonist being told to stop taking calls and to take the telephone off the hook.

Bad news seemed to come in large doses that day for the Wheeler family and for thousands of other families in Barrow. The *Evening Mail*'s headlines screamed in bold letters:

VSEL TAKEOVER IN 24 HOURS.

When I saw that I headed back to the house. Margaret wasn't at home, but I found Mr Wheeler talking to his mother-in-law.

'I tell you there'll be no one left once this takeover happens.'

'It'll be like a ghost town here,' Grandma Wheeler replied.

'It already is.'

What could I say? I offered to make a brew. 'Stan has only four drops of milk,' said Grandma Wheeler.

I returned with two cups of tea. They were talking about Stan's future; he was telling Grandma that Scott's paper tissues had recently announced hundreds of job redundancies, a multinational franchising transport was downsizing and it was no better up the coast where jobs were being lost at Nestlés. 'They call it industrial restructuring,' said Stan fatalistically.

That evening I asked Mr Wheeler if I could go with him to his working men's club. He didn't feel up to it, he'd go to the pub where I was welcome to join him. But Andy was there and agreed to go with me. Barrow has a handful of working men's clubs including the Conservative Working Men's Club, which seemed to be a contradiction in terms. Each club had its nickname: the House of Lords, the Kill One – 'You need to kill one to get in, it's so busy,' Andy explained. We had a drink in each one and ended up in the Greengate which was all male except for the bar staff. I spoke to a man I had seen in the Connors' music shop. He wasn't surprised by the news of the takeover.

'I worked for ten years at Vickers as a technical author. Three years ago it was, on a Thursday, they announced there would be redundancies, on Friday they identified the people who were to be fired, on Monday they read out the list of names. I moved out pretty quickly – the manager gave us ten minutes to leave our desks, because

they were worried about the damage we could do to the computers. I couldn't move back to Scotland, I can't afford to. Look for work here? It's pointless, 8000 have been discharged out of the yards in the last couple of years. At sixty-two it's a waste of time – at 45 they tell you you're too old. I've paid my National Insurance since I left school and I get sweet sugar all, because I've got savings of over £2000. I stop at home and look after the wife who has a defective heart valve. I'm building up kitchen units and I've just finished decorating three rooms.'

Because he received no benefits, he was not counted in the lists of unemployed.

The following morning's financial pages were full of possible takeover bids. Speculators in Tokyo, Zurich, New York and London were capitalizing on Barrow's misery. Shares in VSEL were rising, as were the stocks of the potential buyers of VSEL. GEC, a major contender, was said to have a cash mountain standing at a shade under £3 billion, and the winner of the takeover bid would also stand to inherit VSEL's reserves of over £300 million. Elected politicians and shareholders were all eager to squeeze a profit if not a cash bonanza out of the impending deal; a friend of mine in London described this computerized trading in shares as the casino of ether. As the threat of more job losses hung over Barrow, city dealers appeared like an invisible conquering foreign army. The power of transnationals had the same effect as Genghis Khan or Darth Vader. Deregulation, lack of government interference, the free market would in Barrow's case dispense with the needs of society; job losses hung over the town like the ever present drought that hangs over sub-Saharan Africa. Plans to regenerate Barrow were limited to the council's Development Action Programme to stimulate tourism in the area with a Dock Museum, a Wild Animal Park and a Colony Gift Corporation for the manufacture of candles. 'They have a shop and cafe,' said the tourism development officer when I visited him. 'Of course the number of jobs created is difficult to say. Direct jobs created is fairly small, but people coming to the area must spend, tourism won't solve all the problems, but it will solve some,' said he hopefully.

Vickers said that they were hoping for contracts which would ensure work for 4000 people in Furness. It was like a pilot telling the

passengers of a plane that's about to crash that there are parachutes under their seats. I had begun my visit to the area by meeting people with nervous and emotional disorders; I left a town dying from the lack of investment.

Mrs Wheeler has kept in touch: she left messages of good wishes both at Easter and Christmas. I returned her calls and she was thrilled to tell me Richard had finally got a job in his chosen trade as a welder in Bromsgrove near Birmingham. She sounded ecstatic, as if she had given birth. When Richard was home for a weekend he told me, 'It's a good laugh – being in work and that, it's great!' Mr Wheeler is still in his job at Vickers, but Andy was leaving the hostel due to difficulties with George.

Louisa, whom I had only met briefly and who had asked for my address, wrote to me:

> Hi Nick,
> How are you. I'm doing OK! But now and again I get a bit
> lonely. So just make sure you keep in touch, when you go off
> on your travels ok Nick, have you been working? or just
> walking round taking pitcures [sic]
> Love Louisa x x x
> ps. wright back soon ok Nick.

I occasionally look at the lines Mrs Connor wrote out for me, part of the poem by Norman Nicholson on the closing and dismantling of Millom Ironworks:

> . . . They cut up the carcass of the old ironworks
> Like a fat beast in a slaughter-house: they shovelled my
> childhood
> On to a rubbish heap. Here my father's father,
> Foreman of the black furnace, unsluiced the metal lava
> To slop in fiery gutters across the foundry floor
> And boil round the workmen's boots; here five generations
> Toasted the bread they earned at a thousand degrees Fahrenheit
> And the town thrived on its iron diet. On the same ground
> now
> Split foundations moulder in the sea air; blizzards

of slag-grey dust are blown through broken Main Gate uprights;
Reservoir tanks gape dry beside cracked, empty pig-beds;
And one last core of clinker, like the stump of a dead volcano,
Juts up jagged and unblastable.

 ... An age
Is pensioned off – its hopes, gains, profits, desperations
Put into mothballs. A hundred years of the Bessemer process –
The proud battery of chimneys, the hell-mouth roar of the
 furnace,
The midnight sunsets ladled across a cloudy sky –
Are archaeological data, and the great-great-great-grandchildren
Of my grandfather's one-time workmates now scrounge this
 iron track
For tors and allies of ore bunkered in the cinders and the
 hogweed.
And maybe the ghost of Wordsworth, seeing further than I can,
Will stare from Duddon Bridge, along miles of sand and
 mud-flats
To a peninsula bare as it used to be, and beyond, to a river
Flowing, untainted now, to a bleak, depopulated shore.

LIVERPOOL

Bowed But Not Broken

ON WALLS ALL over Liverpool are expressions of heartfelt emotion, declarations of love and screams of hatred. They are messages and statements, scribbled and scratched on advertising hoardings, derelict housing, gable ends, public lavatories, sports pavilions and shopping centres. Like the flame that burns in memory of the unknown soldier, the scribbled, anonymous graffiti speak to us of the ghettos' pain and frustration. As the train neared Lime Street station the message in white paint on a long, blank wall was a call to the marginalized youth of today's ghettos: ROB THE RICH NOT EACH OTHER.

I had taken a circuitous route to Liverpool. The ticket hall at Barrow's railway station was empty and I had to tap on the window to attract the clerk's attention. The train rattled along the tracks, past stations whose names read like an incomplete line in a game of Scrabble, occasional letters having disappeared because of inclement weather or vandalism. We passed sad little harbours, mobile homes and remote farmhouses nestling at the bottom of crumpled hills. However much the coast had been bridged, tunnelled and barriered, the Irish Sea remained a powerful natural force lapping against the shore. Grass grew between the tracks with seemingly no one and nothing to stop nature's encroachment. The sea was grey, choppy and windswept. It was also filthy: what was left of the fish population must have been gasping for breath. At the once important fishing town of Whitehaven a group of boisterous, angry, pallid young men joined our rusty carriage.

'Fucking coppers! Black bastards!' they yelled out of the train at two white policemen as we pulled away from the station. A group of girls on the platform gave us the finger, shouted to the policemen and then ran off and hid. The weather was cold and foul and was now accompanied by the loud and bellicose roar of the young men. 'I'll

burn yer fuckin' hair off!' one of them shouted belligerently at a passenger who ignored them.

'I'll burn yer fuckin' underwear off!' yapped another.

'Kiss my willy.'

'Well get it out then,' said his mate, standing in the aisle between the seats.

'Hey, can I look at page three? Nice pair of boobs.'

'Shut up, yer fuckin' four-headed bastards. This is what a dick looks like.' The train was pulling into another station and the group began to shout 'Posse! Posse!' in unison.

The conductor came to inspect our tickets. 'You fuckin' smackhead!' said one of the young men as he checked their rail passes. The conductor ignored them and moved on to the next carriage. Some of the unruly crowd ran up and down our carriage. One of them lit a cigarette and started coughing his guts out.

At the terminus a girl their age asked them the way to the toilet. They told her to lift her skirt and pee on the track. 'Be careful,' they warned her. 'When you hit the electrified lines, the pee jumps back at you.' They roared with laughter and sauntered off.

As I stood on the steps of Liverpool's Lime Street station I marvelled at the sight before me. For one brief moment I could have been in Athens. Facing me was the mighty St George's Hall, built in the 1850s and perhaps the finest Greco-Roman building in Europe, where Charles Dickens had given public readings from his books. The rich legacy of the Victorian age reflects the city's past wealth when it became the second most important city in the British Empire and its buildings and institutions, which dominate the commercial centre close to the River Mersey, reflected its status in the world. Then the port handled nearly half the total exports for the whole UK, and millions of people from many European countries came here looking for ships bound for the USA, Canada, Australia, New Zealand, South Africa and South America.

I was collected at the station by a friend I used to go with to watch Chelsea games from the Shed, who had moved to Liverpool to be with his girlfriend. Frank looked like a hard man with short cropped hair and a swallow tattooed on his bicep. He wore a tee-shirt showing Tintin holding a Molotov cocktail made from a bottle of lager and

with a handkerchief tied across his face, Zapatista fashion, to hide
his identity; but his tuft of distinctive hair stood on end above the
mask. The caption read, 'Oh my God, we're doing it . . . We're fuckin'
doing it.'

'What's that all about?' I asked Frank.

'It's Tintin on a South London council estate, rebelling against the
realities of poor housing and the lack of local amenities.'

As we drove Frank pointed out several recent landmarks. 'That's
where David Ungi was blasted to death last Monday.' There were
bunches of flowers outside a house in a residential street where he
was gunned down by masked men. 'That's the pub I was drinking in
last week, it was burnt down on Tuesday night. Over the road, down
there, the Royal George pub was fired at on Wednesday, and last night
in the early hours of the morning a house was hit by gunfire.'

In the following weeks there were several more shootings during
which time the police seized machine-guns, ammunition and silencers.
There was also an outbreak of pitched battles involving eighty police
officers with riot equipment which evoked memories of the 1981
Toxteth riots. The police had already announced that all Merseyside
officers would be issued with bullet-proof vests and promoted a pledge
from the Liverpool police chiefs to 'fight fire with fire', in an effort to
halt the escalating gang warfare in the Toxteth area. Much to their
annoyance, I was able to photograph one of the officers in a police
vehicle clutching a semi-automatic rifle as he patrolled the streets of
Toxteth.

Frank rented a flat in one of the great houses near Sefton Park
built by the shipowners, bankers and merchants who had made their
fortunes from the slave trade triangle of the Caribbean, West Africa
and the USA. Many have now been converted into student flats and
the neighbourhood is sometimes referred to as 'Robbers Paradise'. The
doorbell rang several times before we went out again. 'Do you want
a rabbit?' asked a boy on the intercom. 'No,' said Frank. This was
followed by two more calls: 'Do you want your car washed?' and 'Do
you want any shopping?'

Sefton Park, like other Victorian parks I had visited, was a sad,
vandalized relic, the statues' stone inscriptions removed and replaced
by obscene graffiti. The striking Victorian palm house had virtually

all of its several thousand panes of glass smashed. A scheme had been
initiated to Sponsor-a-Pane towards the reglazing and refurbishing of
the building. I remarked to Frank, 'It's amazing all the other pavilions
are boarded up.'

'It's amazing they haven't all been burnt to the ground,' he replied.

Until now many of my contacts for my journey had been through
Siobhan, who I would come to realize owed much of her natural
aggressiveness, defiance and questioning to her Liverpudlian Catholic
Irish background. In common with many people across Britain her
roots lay across the Irish Sea and, like many of them, her skin tone
was the colour of a head of Guinness. She was passionate in her defence
of her city.

'Everyone makes derogatory remarks about Liverpool. So you must
write, "It's sunny, leafy and warm".' Which it was, so let me confirm
that I arrived in Liverpool on a day when the city basked under
burnished blue skies of Iberian intensity.

Through Siobhan and Sid, a half-Somali, half-English acquaintance
from London but a native of Liverpool, and chance encounters in the
street I became acquainted with the unique Liverpudlian character.
On my first evening Siobhan took me to meet some friends of hers,
one of them the mother of the comedian Alexei Sayle. He and I had
something in common: we had both studied painting at Chelsea School
of Art in London, and like my own mother she had kept his childhood
drawings. Molly lived in a compact end of terrace house. Her living-
room was decorated with reproductions of famous Impressionist
paintings, but pride of place went to the picture of Ho Chi Minh
which had been presented to her by the North Vietnamese for her
work as Merseyside secretary for the Vietnam Campaign for Peace.
Among her collection of keepsakes were copies of the *Vietnam Courier*,
programmes to the theatre productions she had played in, and profiles
of her work as a member of the Communist Party.

Molly was of Jewish Ukrainian and Latvian background, but as she
explained in a broad Liverpudlian accent, 'Ee, we didn't bring Alexei
up Jewish, we didn't bring him up anything – we brought him up a
communist –' she started to say 'I regret', but stopped herself. 'Ee no,
I don't regret,' she continued. 'It's sad. I feel betrayed.' Like many
socialists she was depressed by the prevailing fashion for market forces;

few had stayed solidly loyal to the socialist ideals. She began to talk about Stalin. 'Everyone makes mistakes, but he was always Uncle Joe to us. My husband was Joe. He never believed in rigidity, that was the communists' problem. I never believed in democratic centralization, but it wasn't all the Soviet Union's mistakes – the West is also responsible, everything is down to money today.' She recalled how in her first job her fellow workers were surprised a Jew had to work in a factory. 'They thought all Jews were rich.' She told me how she had been inspired by Rosa Luxemburg and reminisced about her trips to Czechoslovakia, her involvement with Vietnam, and she chuckled at the ridiculousness of never having been allowed a visa for the United States, because of once having been a member of the Communist Party. Molly wore a personal alarm for a necklace, because of a stroke which had among other things stopped her from continuing her work as a lollipop woman, but it hadn't diminished her energy and her bright red hair seemed to match her passion for life. We took her to dinner with her best friends Jim and Jacqueline.

Jim, a retired Irish-American merchant seaman, regaled me with tales of ports he'd called at. 'In Rio I fell off the harness and nearly drowned whilst repainting the ship. In Shanghai I bought a piece of jade for Jacqueline, but wasn't allowed off the ship. The Chinese who came on board tried to convert me to Christianity – I told them if you get me a case of beer, I'll convert. In Zaire I was so drunk on gin I was sick and puking out of my ears and nose as well. I wasn't interested in the sights, just the bars.' He didn't seem to have relinquished his love for the drink; out in the garden and leaning on the house wall for support he told me, 'Alaska's so cold you'd freeze your ass off unless you drink a quart of bourbon every four hours.' He described himself as 'a dead cod fish mouth' – to this day I'm not sure what it means.

Because Jim tended to hog the conversation it was difficult to talk to Jacqueline. She wanted me to visit the infants' school she had once taught at, as she thought it would present an extraordinary picture of the lives of some inner city children. Jacqueline talked sadly about the school and how she missed being involved in their activities. It sounded as though it had represented an important part of her life, one she treasured in spite of all the difficulties and traumas. She was full of

admiration for the head teacher. 'I'll call her tomorrow and ask if she wouldn't mind you getting in touch,' she promised.

In the meantime I headed for Toxteth, where Sid had grown up. His father, a merchant seaman, had moved to New York, his mother to London. He suggested I get in touch with his schoolfriend Ibrahim and with Joan, who ran a butcher's shop on Granby Street, Toxteth's main street.

I walked the short distance from Liverpool city centre, turning right at the Catholic cathedral ('Paddy's wigwam') and continuing along Hope Street past street women in faded skirts till I found myself in the shadow of the great brown hulk of Liverpool's Anglican cathedral, the largest in the world. In the great stone cavern the smallest sound echoed across the magnificent vaulted ceiling, but it was empty of worshippers. I continued past shops and houses with sheets of steel and wood across their windows with 'To Let' and 'For Sale' signs above them. A large piece of graffiti read NO VAT ON FUEL FIDDLE THE METER.

I entered a shop and, glancing up as I passed the cans of tinned food, saw myself framed on a closed-circuit television set. The merchandise was protected by metal grilles and sheets of perspex. The shopkeeper sat with his hands on the counter behind a small square gap in the metal bars. I bought a Mars bar and asked for directions. As he returned my change, he said thank you and looked over my shoulder to the front door. One young boy held a can, the other had his hands in his pocket. Their silence was ominous, they ran their hands along the perspex wall, stared at the shopkeeper without saying a word and left.

As I walked up Granby Street I felt a constant sense of menace. It was like being on an army patrol: my senses were tuned to a high degree of self-preservation. An armoured police Land-Rover with bullet-proof glass sped past. Scrawled across the gable end of a row of terraced houses, most of which had been bricked up, was an arrow captioned 'Police Camera Found'. I had already put my cameras out of sight in my camera bag, but as I continued along the street I felt all eyes following me.

Adding to the desolation of the area were the empty shops, the vacant lots, and side streets of terraced and semi-detached houses strewn with debris. Entering the Somali district, groups of children,

youths and unemployed young men crowded in on one another, forming little huddles. The youngest children climbed into an abandoned shop, lowering themselves down through the roof of the lean-to extension from which they had removed the tiles. Their sisters and mothers, Somali women dressed in long coats and scarfs, walked by with the purpose the men lacked.

The traditional English shops had long ago said goodbye. Islam prevails. Halal meat is the currency. I tried several butchers before I found Joan. Her shop belied the grimness outside – it was bright and clean with the produce neatly organized: dried fish stored in plastic dustbins, dried okra and red peppers in glass jars, and tripe, goat meat, mutton and lamb chops in her refrigerated display counter. Joan carried one of her many grandchildren on her hip. Now a widow, she had been happily married to a Sudanese man twenty years her senior and had converted to Islam.

'I believe in it, like. After all, they've got all the same people: Jesus is Isa, Abraham is Ibrahim. We suffered a lot of racism. They weren't ready to accept us then. We opened a cafe but we used to have so many bricks thrown at us that in the morning I went around with a bucket collecting them, it's no exaggeration, there were that many. After the trouble with the whites attacking us, we got the Teddy Boys doing it, but they later became our friends.'

Joan and her husband opened a club after the cafe and then a fish and chip shop in Dingwell; eventually they opened the butcher's shop, the same one she works in today.

'We first catered to Pakistanis and Arabs, but then the Pakistanis opened their own shops, they didn't want to know us then, they looked down on us. So we've gone from Arab to Pakistani to Sudanese to Somali and now that one of my daughters is married to a Nigerian we've got all the Nigerians – whatever is going we're there.'

She was the proud mother of eleven children. Their spouses included an Englishman, an English-Irishman, a Venezuelan, a Somali, and a Nigerian. 'My grandchild with the Venezuelan father is called Ali Maximilliano, Ali after his granddad and Maximilliano after his Spanish side.' Unknown to me at the time Ali attended the school Jacqueline had taught in, the one she was trying to get me permission to visit.

As I stood in the shop chatting to Joan, her regulars came to buy their cuts of meat and she introduced me to them. At first they were suspicious of me, and some remained so for the duration of my stay. 'Can't stop,' said one customer by way of excuse. 'Are you sure he's not from the housing?' 'The Corporation?' said another. A middle-aged man bought his tripe and Joan encouraged him to talk to me. 'Is he undercover?' he enquired. 'I saw *Operation Commission* on television.'

Those that did open up talked of conditions similar to those I had met in Newcastle: property that was now worth less than a tenth of what it was twenty years before, residents too poor to move elsewhere, fear of the youth, too intimidated to call the police. But there were also stories of community solidarity. When Joan had her car radio stolen in a prosperous neighbourhood, news travelled quickly after she got home. 'I went up to bed above this shop and next day I found my car unlocked and someone else's car radio installed in it. I was all jumpy, I didn't know where it had come from, but the people in the neighbourhood had obviously heard how upset I was.'

'To think that twenty years ago this street used to be packed with people and shops – look at it now,' said Rita, who'd dropped by to say hello to Joan. The violence had slowly extended its boundaries, sweeping across the neighbourhood like a cancer. The bank closed after armed robberies became too regular, the betting shop was robbed monthly, and recently twice in one week. 'Another shopkeeper, a Pakistani, was driven out for calling the police. They trashed his shop, they pulled down his telephone wires so that he couldn't call the police. Everyone was watching, I saw it. There was a feeling: if there's a problem, we'll take care of it ourselves, there's no need to call outsiders.'

Some of the older residents who came into the shop had witnessed the 1981 riots, and since then the mini-riots as well as the murder of two toddlers run down by joyriders outside Joan's shop. The two closes opposite were renamed in their memory: Daniel Davies Drive and Adele Thompson Drive.

'I still remember the riots clearly,' said Joan. 'It was the first week in July, 1981. My husband sat outside our shop for three days and nights. The launderette got burnt down, the chemist got broken into.

I watched the fires from my room upstairs – there must have been forty separate fires. I heard shots and wondered what was happening. CS gas was being used by the police, because of the force of the attacks they faced. The destruction was immense, shops and garages were looted, but nothing happened to our shop because my kids were brought up here and they knew all the other kids.' Another customer told me, 'I think the damage came to over ten million. They even stole the geriatric patients' possessions at Princes Park Hospital.'

It seemed to me that the major factor contributing to the riots, the overwhelming feeling of hopelessness among young people, was still in place. As I was to discover later, the lack of job opportunities, and a major shift of work centres from the inner city to industrial estates were only some of the conditions leading to feelings of hopelessness and powerlessness. These were exacerbated by racial tension against minorities, particularly the Somalis and the black community, who suffered serious deprivation and discrimination. Parts of the neighbourhood had been cleaned up, new closes of modern housing had been built, but large areas were crumbling. Even among the new, signs of decay had begun already: the small areas of green had become patchy through dog fouling and neglect, damaged fencing went unrepaired, broken street lights went unreplaced.

Not surprisingly no one wanted to talk about the gangland murders, tit for tat attacks and killing for killing's sake. Everyone was frightened – frightened for their children who might be caught in the street as gunmen opened fire, frightened because they knew who was involved, who belonged to which group and who was wanted. In this closely knit community many were related to someone in the extended families of those being hunted or doing the hunting. The residents I got to know called it a fight between two heavily-armed factions for the turf of drugs and protection rackets – two groups with the same business interests. Rumour had it that a sixteen-year-old had been involved in the original murder and he was pointed out to me as he drove along Granby Street. It didn't seem possible that he could have used a weapon, but when I eventually caught up with Ibrahim he told me that some youngsters were armed: 'Sometimes they're just showing off, but if they've got one they're prepared to use it. They'd lose face

if they didn't.' Joan told me that everyone was bracing themselves for
more trouble after David Ungi's funeral. 'That's when his brothers
will want to avenge his death.'

I found Liverpool a divided city, more so than many other areas of
Britain. Here as elsewhere your postal code could be a strong clue to
your cultural and religious background. It was a city divided not just
by colour, but by class and religion. I have always found it strange
that those who have often suffered most from discrimination are them-
selves so quick to discriminate. Patrick, a secondhand bookseller, was
not one of these, but he did tell me that at book fairs you were branded
once they knew where you came from.

'If you tell them you're from Liverpool, you feel their jaws go in.
"You're not going to rob our books?" they're thinking. If they live in
leafy places, if their post office gets robbed, they're always from Liver-
pool. People are generally wary of Liverpudlians. If you've got no
money, no education, and no opportunities you either take to the
bottle or "displaced creativity" – you steal to survive. We have an
expression here: "If it's not nailed down you'll lose it."

'You've got to have a historical perspective: crime is a cottage indus-
try to Liverpool. During the great emigration movements between 1830
and 1930 emigrants often encountered "runners" who pretended to
be helpful, recommending lodging houses and ship brokers. But the
runners were confidence tricksters, street pirates who snatched your
luggage and only handed it back if they were paid large fees for their
dubious advice. Now that the motorways have opened up previously
buffered areas, modern pirates have made other parts of Britain their
targets. With this shop here, you need to renew your mental health
act every single day, you have to because the people are so sharp. If
I'm not alert they'll ransack this place.'

As Patrick saw it, it wasn't just football and the art of thieving that
put the city on the world map. 'Liverpool has had a disproportionate
influence on the planet,' he said. 'Liverpool has been responsible for
changing the planet's lingua franca from French to English. It was the
Beatles through their lyrics that reached the far corners of Iceland and
Japan. The people of Liverpool's creativity hasn't just gone into sur-
vival, but through music and art creates a new synthesis. For me
Liverpool is the centre of the universe, if I wasn't enthralled by the

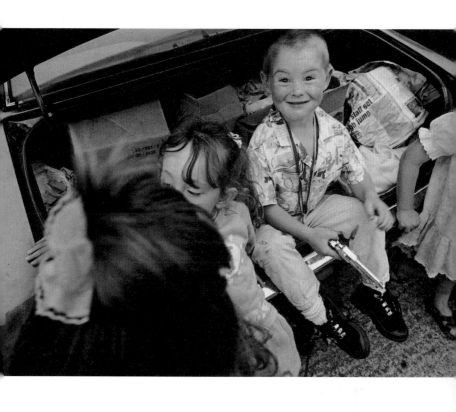

Car boot sale: Penrhys, South Wales

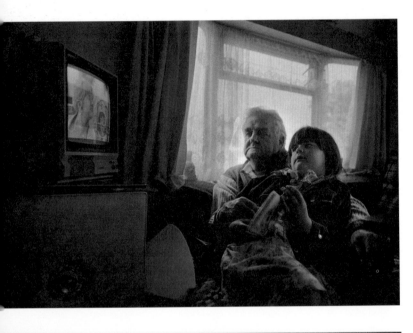
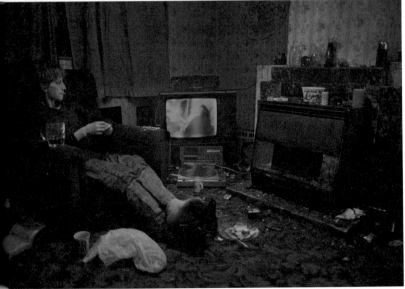

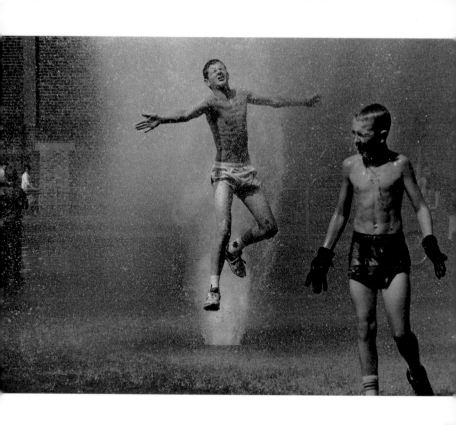

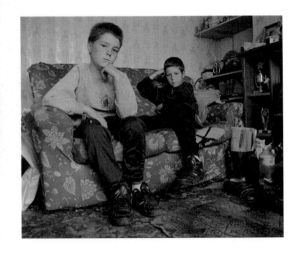

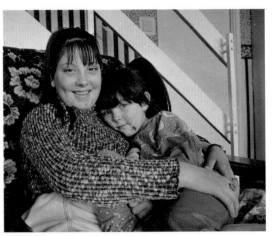

NO VAT ON FUEL
FIDDLE THE METER

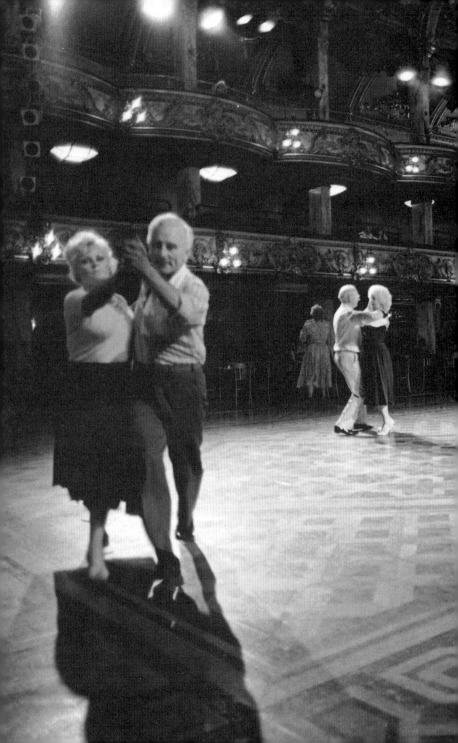

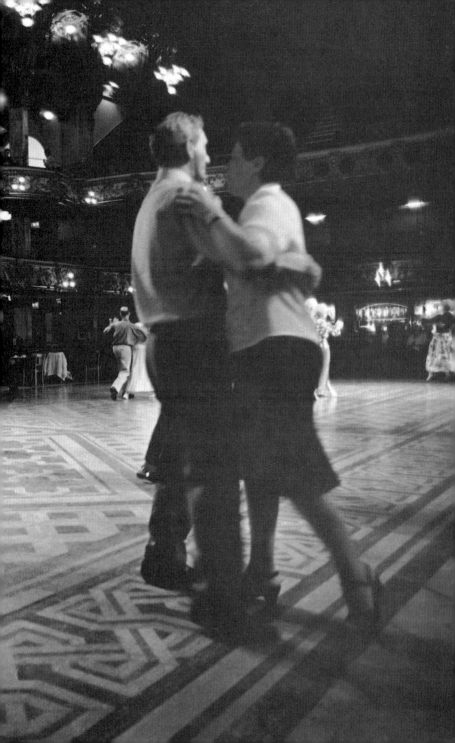

ABOVE West End, Newcastle

OPPOSITE:

ABOVE Parkhead, Glasgow
BELOW The Celtic Club, Glasgow

'Kevin Keegan', Newcastle

place, I'd want to get away: for people who don't make it, this is a graveyard of dreams.'

On my way to meet Siobhan in Everton I became aware of a glaring absence in Liverpool. Unlike any other British city I had visited, people from the Indian subcontinent were almost conspicuously absent. I asked the only Asian shopkeeper I came across why this was so.

'There are no jobs. If it wasn't for the university students, there would be nothing, a ghost town. We don't do any business in the summer, without the university we'd be forced to close the shop which was established two hundred years ago. We've had to let two permanent employees go. I've come out of retirement to help my wife, it's just me and her now. Our four children have become an accountant, a civil engineer, a computer programmer and a solicitor; they have moved to London, Portsmouth, Wolverhampton and New Zealand.'

Unlike many, Siobhan was beginning to fulfil her dream of becoming a documentary film director. She had just received her first commission from Channel 4 to direct a programme following a group of men and women marching for the Orange Order on 12 July to celebrate the 305th anniversary of the routing of the Catholics by William of Orange at the Battle of the Boyne in 1690. She called Liverpool, 'the last sectarian city of England'. I met her outside a church in Everton, near a wall painted with the words 'Fuck off Taigs' and 'Ulster Volunteer Force for God and Ulster'. Siobhan had attended a sermon given by the Reverend Ian Paisley, who had bellowed to his congregation that there should be no backsliding towards the Papacy: 'The road to Rome is closed.'

Liverpool owes more than just a passing resemblance to New York. To take the Mersey ferry is similar to taking New York's circle line or ferry from Staten Island, and here too are buildings that once dominated the world's movements of capital and labour. The two cities share a vibrancy, and Liverpudlians have New Yorkers' aggressiveness, but it is a response to what life does to you, a mechanism for coping with the constant reminder of the price of failure in such metropolises. Liverpool could also be called a mosaic of nationalities, like New York: millions fleeing political or religious persecution, family troubles or economic hardship had used the port as a transit point. Many stayed

and found work, and adopted English as their mother tongue, although there are some, for example in Liverpool's Chinese community (the first in Britain), who after fifty years still don't speak a word of English. The immigrants made a significant contribution to the local economy. Even now, as Britain becomes culturally homogenized, Liverpool like Newcastle retains its cultural and linguistic separateness.

I never thought I would rue the break-up of any class system, but in Liverpool I began to see how the demise of unions and working-class solidarity had cast a vast section of the population into an abyss. In the place of the former working classes were the excluded – the unemployed who no longer had a voice, like their counterparts in the United States and elsewhere in Europe. This group, particularly the young, rarely if ever voted, because they knew that nothing would improve for them; and in turn the politicians didn't need to address their concerns or redress their grievances because they didn't form a constituency that would elect them. These people were socially and politically excluded, as families and as a class. There are two avenues for an intelligent child: you go into education if it is open to you, or you end up reacting self-destructively against the system. Many would survive without ever getting into trouble, but if they were not to be influenced by their peers it would require a Herculean effort on their own part, and a good deal of luck.

Jacqueline had called me to say the head teacher had agreed to my visit. I asked if I could arrive before the children so I could talk to her. She said that only some taxi drivers would take me to the school, but it was near enough for me to walk. I followed a route that many of the children would take, past the graffiti on a blank wall that read COP KILLA L.A. STYLE, the vacant lots and the close where the two children had been killed by joyriders not much older than themselves.

The school was situated next to an abandoned church. The building was under siege: its walls were ringed by a layer of razor wire to prevent youths from climbing into the school grounds and the front door was permanently locked: you had to ring to gain admittance. Windows were protected by wire mesh, skylights had been replaced by perspex, then overlaid with metal bars which had failed to deter

the youths, so they had been replaced by steel sheets. Showing me round the old building, the head teacher told me they had sealed it as best they could to prevent vandalism.

'We left a one-foot window, not realizing that they would also try to gain access through it. They smashed their way in and lowered a ten-year-old inside. We've had pools of water from where the children have removed the roof tiles and felt.' She pointed to some patches of bare brick. 'That's where the leaks have caused the paint to crack and peel. We've had flooding on the school floor because the kids have blocked the drains. Before this term began we lost our Inset day, a day for the new staff to familiarize themselves with all our facilities, because vandals had entered the building and the teachers were forced to spend the day cleaning up. They had cut the wires to the alarm system and waited for twenty minutes to see if anyone would come. When the alarm stopped ringing they broke into the school and set about trashing it. Pulling down all the wiring to the alarm system, tipping over the books and furniture, throwing paint around. Some of them went to the toilet in the middle of the room. Once our intruders mixed up all the puzzles and then did a pile on the centre of them.' The school's equipment that couldn't be nailed down, and some of it that was, was marked with indelible ink with the school's name prefaced by the words 'Stolen From'.

I was introduced to Sheila and Helena, two of the most dedicated teachers: they were in by eight o'clock every morning and didn't leave until six. The teachers never knew how many of their students would show up for classes. The excuses varied: stomach ache, lack of clean clothes to wear, 'flu, visiting their dad in prison. More often than not there was silence from the parents who didn't communicate with the teachers at all: some couldn't fill in forms, because they couldn't write.

'We have parents who don't have a pen or pencil in the house. Others send their children late to school because of the difficulty in telling the time, not the one hour we gain and lose because of daylight saving, but because they don't have a clock or a watch in the house.' Some four- and five-year-olds took themselves to school. 'Some parents don't come and collect their children,' said the head teacher. 'We have a list of relatives in case of accidents or emergencies, but sometimes we've called all the relatives and still there is no one to

pick them up, so we have to call the social services. Some have never been on holiday or seen animals. We used to have a rabbit, but one time when the vandals broke in they threw it in its cage over a wall. The rabbit suffered serious injuries and one of the parents paid the vet's £87 bill. We asked the parent to keep the rabbit. Now we only have a couple of fish and some toads. The rottweilers some of the parents bring to the school have tried to eat the fish and we have to be extremely careful that the children don't end up drinking the water with the toads.'

None of the trials and tribulations of running this infant school seemed to have depleted the head teacher's tremendous energy. She was the epitome of sweet gentleness and worried so much about her children. She saw everyone as equal to herself, from the teachers to the tea ladies and cleaners, all of whom rallied around and helped out where necessary. Everyone talked about the happy atmosphere. Amy the cleaner told me, 'It's like a happy family here, we all muck in, everyone takes part.'

When the head first explained to me that her primary objective was not to teach reading and writing, but to provide the children with a safe environment, I was surprised. But I quickly became a convert when I saw the children's attitude towards the school. Many of the children arrrived with tired or sad or distracted eyes. No sooner had they passed through the classroom door than they began to perk up. 'Good morning, Damian,' said Helen, who had already spent two hours preparing her classes. 'Good morning, miss,' he pealed back as did the other children. Whereas I had seen some of these children nervy and withdrawn in the street, they livened up in school. They chattered and played freely. They were eager to answer questions and would sometimes do so out of turn. As they sat cross-legged on the floor, Helen rallied them like troops – she cajoled them, encouraged them, and made sure no child was left out of the activities unless they fell asleep because they had sat up all night watching television.

Out of a class of twenty, four lived in a 'conventional' family set-up. The others lived with grandparents, an aunt, or a single parent; two of the children were conceived by artificial insemination, and the second mother in this two-woman-parent family was about to give birth to the third child. 'You couldn't have more dedicated or loving

parents,' said the head teacher. Many of the children were not so fortunate. There was the four-year-old boy whose mother went to London for three days and stayed six months, leaving him with an aunt. When the mother returned she took a new partner who poured petrol over himself outside her flat and set himself alight. He died several months later, and the boy told his friend that his mother had done it.

There was a five-year-old girl who sat in class undoing her shoelaces and remained constantly agitated; another boy skittered like a butterfly from one task to the next, unable to concentrate on one exercise. They lived in squalor at home, with alcoholic mothers, older sisters who were addicted to crack, and abusive fathers. They witnessed the taunts between partners and the family fights. One child was in the casualty ward of a local hospital having 'slipped' and burnt her bottom, legs and hands on frying fat. A child in the custody of an aunt watched her stab another aunt. The father of one of the children had been shot dead in the United States. His picture had been pushed through the letter box and her mother went wild with grief, waving the picture in front of her child.

Government-funded agencies had replaced grandmothers: health visitors, school nurses, educational welfare officers and the social services and the NSPCC were ranged against the nightmarish forces of families that had collapsed under the effort to survive. When these children reached the next stage in school, they would also have educational psychologists, teams of teachers for educational special needs, probation officers, youth workers and juvenile and community liaison officers, but fear of taking the wrong course of action often prevented remedial steps. This infants school used to have a 'cuddle corner' in the classroom for the children who needed reassuring after witnessing the riots in 1981, but teachers were no longer allowed to hug traumatized children. 'Anyway,' said the head teacher, 'some of the children wouldn't let you touch them – they'd scream because of what must happen at home.' Love and touching between caring human beings was the most elusive commodity of all.

The children behaved and looked older than their years. They wore studs in their ears and make-up, and strutted like peacocks showing their feathers; some of the young boys imitated the dress of US gangsta

rappers, with their underwear showing above their baggy track suit pants. One of the teachers pointed to a four-year-old who was already a compulsive shoplifter and had been banned from the local shops. 'You can tell some of them are going to be "winners",' she said. But there were plenty of losers. Two four-year-olds were caught simulating sex on a bed reserved for children who felt ill. A five-year-old-girl had been forced by a boy to put his penis in her mouth. The teachers thought this girl might have been telling stories, and they asked the boy's parents to investigate. Two weeks later the father shamefacedly admitted it was true. The boy had been given the idea by his older brother, who had in turn been influenced by television.

I have not mentioned the school's name, or the name of the head teacher, because similar scenes happen in dozens, possibly hundreds of infant schools across many of Britain's inner cities, where syringes are found in school playgrounds and where bricks get lobbed at the teachers' cars. It was random chance that brought me to this particular school. The Merseyside Police Air Support Group told me the damage caused by school vandalism in Liverpool amounted to several million pounds yearly. An academic at Liverpool University had produced graphs and charts to show that there were patterns to this behaviour, that in most cases, major attacks and arson on schools recurred within a week of the first attack. The chief inspector of the Air Support Group said they had tried to convince the authorities that they needed a second million-pound helicopter for 'prevention' and 'intelligence gathering', which would have saved the council money spent on repairing vandalized schools. I saw for myself that the police helicopter, armed with the latest technology in thermal imaging and microwave links, could be scrambled within minutes of a 999 call.

During the morning tea break a council worker came to replace part of the roof which had had its layers of felt, insulation and plastic sheeting removed. Before the job was finished he was called to another school for emergency repairs. 'In the past I've locked the school gates to prevent the workmen from leaving,' said the head teacher. 'When they say they need to break for lunch, I tell them I've prepared lunch for them, otherwise they disappear and we don't see them for weeks, they're kept so busy.' Even during school hours teenagers targeted the building with catapults and ran riot on the roof.

'If you chase 'em,' said Amy, the cleaner, 'you get a mouthful and bits of roof thrown at you – it gets them aggravated and makes it worse.'

Amy had lived in the area for twenty-two years. 'I like it here. Our Lisa has recently moved back.'

'Have you ever had any problems?' I asked.

'I've never had any problems.'

'What about the car that crashed into your neighbour's front door on Friday?' said the head teacher.

'Well, I saw them go by. I think they were about twelve years old, driving a small car. They went up and down my street and before you know what, they had crashed into my neighbour's house and scarpered off. Otherwise no problems, really.'

'And the time someone walked all over your car, and what about the drunken driver who drove into the gas pipe across from you?' said the head teacher.

'I'll still walk to school at two in the morning when the alarm goes off. Did I tell you that they tried to get into our Lisa's house? They were chiselling out the window frame at three a.m. when she woke up.'

Understatement is not just a characteristic of the British sense of humour, it can be a way of coping with the most trying circumstances in life. Pat spoke of the 1981 riots matter-of-factly.

'I was standing outside my house, stuck to the steps out of fright, watching people whizzing down our street pushing rails of clothes and Tesco supermarket trolleys full of carpets and hi-fis.

'It was very noisy,' she added as an afterthought.

Before I left the head teacher asked me if I would like to go along with a school party on a half-day outing to the seaside. 'I want to show them there is life outside this area,' she said. 'You could take pictures of the trip.'

As I crossed the schoolyard on my way home I watched a child panic. His father had come to collect him and the child's legs buckled underneath him: he didn't want to go with him. 'Shut your mouth!' the father thundered. The boy whimpered and went along with tears streaming down his cheeks. Under normal circumstances it's often difficult to get children to go to school, but here the reverse was true

– children didn't always want to go home. They hid under the tables and started screaming when their parents came to collect them.

I was having great difficulty in getting hold of Sid's friend Ibrahim. When we arranged to meet, he failed to show up. The Somali community were extremely wary of outsiders and I suspected Ibrahim was no different. He suggested that I should contact the elders if I wanted to know about the community. However, if my experience of Halifax and Bradford was anything to go by, the elders were out of touch with their children's and grandchildren's lives. Ibrahim agreed to meet me at one of the two Somali community centres with a friend, but he explained it would be much harder for him to arrange a meeting with Somali women. Eventually I managed that too, but not through Ibrahim.

The roots of Liverpool's Somali community, like those of the Chinese-Scouse and Yemeni-Scouse communities, go back several generations to when their young men worked as sailors, mainly as ordinary seamen, cooks, laundrymen, and stokers on British ships for a fraction of British wages. Many of the original settlers moved on, mostly to London's East End and to Sheffield where they went in search of work in the steel industry. In 1990 the civil war in Somalia caused hundreds of thousands to flee. Most went to neighbouring countries in the Horn of Africa, but some with family in England came as refugees. Thousands of miles from their homeland tribal suspicions lingered, and the two community centres reflected the tribal schisms they thought they had left behind. As I waited for Ibrahim, I began talking to some of the older men. They served me tea and asked me to try a traditional dish similar to a pancake. I ate it under a painting of a schooner while some of the men in smart hats played cards noisily or watched *Star Trek* on television.

Ibrahim arrived with his friend Mahmoudi. I could feel their underlying suspicion, their anger and bitterness. It wasn't just the white community that blamed the Somalis for taking their jobs, but the black Afro-Caribbean population. The reality was quite different: there were between two and three thousand Somalis and only ten or fifteen had jobs, mostly with the local council. The recent refugees had fled Somalia to escape bombs and famine, they had sought greater security,

but they had become subject to other forces that they could neither see nor understand, apart from the negative impact on their lives. The refugees were like ships that had lost their anchors, carried across deep waters into uncharted territory and without the means to alter their course.

Ibrahim explained, 'Many of the refugees have come from a rural background, neither they nor their parents can read or write. It's like a fear of death – there's great insecurity. We don't have a word for trauma in Somali, but the children are suffering from the shock of war and death in the family, and this is made worse by the cultural shock.' As he talked he peeled a stalk from a bundle of *khat* he had placed on the table, separating the soft, leafy stem from the rhubarb-coloured bark, then put another sprig in his mouth. He reduced the sprig with its tiny leaves to a green pulp and started all over again by reaching for the bundle. 'The best time to get people to talk is when they're chewing,' he advised. Mahmoudi, who was from Sheffield but studying in Liverpool, said that many of Sheffield's Somalis were preparing for another exodus, 'not because of bombs, but by the war of racist attacks'. Like the white Liverpudlians who blamed the refugees for taking their housing and jobs, Ibrahim intimated that fifth genera-tion Somali-Scousers were being overlooked while council resources were going to the new settlers. Everyone felt they had been abandoned.

As we walked down Granby Street together, a boy on a bicycle shouted across the street to ask Ibrahim who I was. 'He's okay, a friend of mine,' and the boy cycled back down the side street. Ibrahim explained some of the tensions. 'The drug sellers think those who don't buy drugs think they are superior, because they are Muslims, but you can see for yourself the temptations are there to get involved, because they see the dealers driving nice cars and throwing their money around.'

It was nearly the end of my stay in Liverpool. I had decided to spend my last day on the school trip, but fortunately I had finally found a Somali woman who was prepared to talk to me afterwards at the school as long as I didn't use her name.

'I saw you with my nana,' said Ali Maximilliano. The children were beginning to arrive at the school for the outing. A double-decker bus

was parked, waiting for all the children to assemble. Some arrived without socks, one with no jacket. I thought nothing could surprise me any more, and yet they still did. One of the teachers said a six-year-old boy who had joined the school this term arrived still in Pampers.

The head teacher was talking to one of the mothers in her office. Once the woman had left she explained that several parents owed dinner money. One owed £24. 'We told her she would have to take her child home if she didn't pay up – you should have seen her face, it was an absolute picture. She soon paid up, because she didn't want the child home, but we can't not feed the children; for some it's their only meal of the day. We try and raise money by selling apples at five pence, but we're out of pocket this week because we're going to give them away during the outing.' The head had the optimism of a survivor, one who always saw the positive side of things. 'We've never had our dinner money stolen because strangers believe all the children must be on free meals. In fact seven out of ten do, because their parents are on income support.'

This infant school was starved of money for repairs, for books and for stationery, but remarkably it raised more money through jumble sales than similar schools in affluent neighbourhoods. They also received donations of off-cuts from a card company, rolls of wallpaper from a DIY shop – they used the back for drawing and writing – and reams of paper from a local newspaper. 'You'd better not mention which one,' said the head teacher.

The extra cost of running such a school – the vandalism, the damaged furniture, the broken equipment and the wear and tear other schools don't have – wasn't taken into account by the funding authorities. But as we all left to go to the bus I marvelled at how well the school had managed. It was well-stocked with books that encompassed everything from life in a Pakistani village to the rule of the Egyptian Pharaohs, and every wall that wasn't distended from water seepage was covered in cheerful posters including Van Gogh's *Starry Night* and another of Zimbabwean musical instruments.

The children boarded the bus, helped along by parents and teachers. Some children weren't going on the trip and others who had been expected were missing, possibly because their parents hadn't bothered to make sure their children arrived in time. One of the young trainee

teachers already looked tired from the effort of corralling the children, but she managed a smile as each one boarded the bus. The head teacher hoped the outing would lift everyone's spirits.

The bus made its way along the Liverpool docks, the children's faces so close to the windows that their warm breath clouded the glass. They rubbed off the mist to get a better view of the city merging into the skyline. We soon reached green fields and the children came alive. The grown-ups got caught up in the children's excitement and Helen orchestrated the nursery songs that were sung with great gusto.

'Look, cows!'

'Oooooh, they're black and white.'

'I don't know how they get it up like that,' said five-year-old Sonia, pointing to the bales of hay.

Tony nudged Ali, pointing to a field of cabbage. 'There's enough to last you a lifetime.'

'It looks as though it's going to rain,' said Ali.

'Ee, it isn't,' said Tony.

'Is.'

'Leave off,' said Ricky Lee to the boy sitting next to him.

And so the chatter went as the bus travelled from green fields through leafy suburbs and back to green fields. The sky darkened and we willed it not to rain. The children in the aisle craned their necks and knelt on their seats to get a view.

We arrived at Freshfields, a wooded area by the sea, with our group in fine fettle. Each grown-up took charge of three children, but we had hardly stepped on to the track which led to the beach when the heavens opened, sending everyone scuttling back to the bus. The torrential downpour soon passed and we all scrambled across the sandy dunes, rolling and sliding and tumbling down the bank. Tony stood mesmerized by the sea. The children looked happy as they played; they built sand castles, picked up stones and bracken. Helen, who was constantly teased by the other teachers for collecting everything, had already gathered some driftwood to take back to the school. She was indefatigable, one moment collecting all manner of nature's free gifts, the next swinging children on her hip or playing hide and seek.

The children screamed in delight at the sight of the tide moving across the sand towards their feet. They oohed and aahed, but they

were not allowed in the water and hardly a single child disobeyed an order. When their names were called they drew closer to their minder with little fuss. As at school they behaved well, and talked and moved freely. They felt protected, and with this sense of security came comfort and confidence in themselves.

Everyone wanted the day to last longer, but when it was time to return to the bus no one complained. Although a few wandered ahead of their minders, the rest walked back in fours, hand in hand, like small daisy chains. For Tony, this had been his first outing. When I asked him if he had been on holiday, he told me he had, to Granby Street. 'Dad is always lazy, he stays in bed all day, Mum gets us breakfast all the time, she lets us watch television. Social gives them money. They've got money, anyway, they've got tenners and fifty pences and hundred pences. I go and watch telly – Sky. I turn over all the channels. I don't like films on the nick. I want to be a fire engine man, 'cause if my house gets on fire I can put on water.' He broke ranks and started kicking the air. 'I can jump up and doing flying kicks, I'm good at punching and fighting scallyfaces. I learn them at home, Taikwando, I want to be a black belt because they tell everyone what to do.'

Sara and Abigail told me they watched videos at home, too. 'Then we go to me bedroom,' said Hannah, 'and play school. We've got rubber stamps, chalk and a chalk board. We play the teacher, no one wants to play the children. I don't know why.'

'The children weren't that good, that's why,' said Abigail. 'I have two toys at home, a Beetle and a motorcar. Tomorrow I have to be with my dad, he's a solicitor, on Sundays I don't know who I'm going to be with,' she said as we climbed back into the bus.

On the bus ride home Helen started a game: she imitated the sound of an animal and Abigail would have to name it. 'Oink, oink.' 'Pig.' Before long other children had joined in the game. But soon they began to fall asleep – they were tired out. Tony, Ali and some of the others were slumped in their seats or over each other's shoulders or resting their heads against the cold window. I think we were all more exhausted than we had been in a long time, but we felt renewed as a result of it.

* * *

'Please don't use my name,' said the older of the two women who sat nearest me in an empty classroom. 'I don't mind,' said her friend, 'in fact, I want you to use my name, it's Samsam. I hope this will give you a better idea of what it is like for a Somali woman to live in England.' As the older woman spoke she adjusted her headscarf with the strong, thick hands of a woman who had done a lot of manual work. She had moved to Britain over a decade before the outbreak of the Somali war. Her seaman husband was dead and she had brought up her children on her own. 'It has been very difficult for many of us to adjust. I'm afraid for the way my children are growing up; the influences of television and the lack of religion. All my children speak English, one of them, my four-year-old, refuses to speak Somali. If I speak to her in Somali she'll answer me in English. My children consider themselves British. The oldest one, when asked to choose a box on an application form, didn't tick Black-African, but Black-British, because he said if he ticked Black-African he wouldn't get the job. He didn't get the job anyway. I've had a lot of help from my English neighbours. When I first moved to Liverpool, people were so friendly, they would come up to you in the street and ask you where you are from. Now if I go outside L8 I'm afraid. I can go to the city centre, but sometimes people shout, "Paki!"'

'I never considered myself black, but since coming to England I do,' said Samsam. 'Everyone calls us black, but they also call the Chinese, the Pakistanis, the Yemenis and even the North Africans black.'

Samsam was a student and the older woman had a part-time job: this was unusual. 'How many Somali women work?' I asked.

They looked at each other. 'There's Jamila . . .'

'Miriam . . .' They started to count on their fingers: '. . . four, Fatima, five . . .'

In all eight Somali women from a community of a couple of thousand had jobs. Four of those were in part-time jobs and almost all of them were funded through the council.

Samsam had escaped from the war. 'My mother is still in our village in northern Somalia, my brothers and sisters are in Mogadishu or here. Three days after I got here, I felt so lucky to have survived, to be alive, I believed it to be Allah's will. I've since become a devout Muslim. My friends who knew me in Somalia can't believe it, I used

to wear mini-skirts and was not very serious. I'm now studying to become a nurse and have only just began to wear the *hejab*, the headscarf, but every day in the street, in shops, at the university, in the canteen, people spit at me, hit my head, or pull my scarf. I suffer because of my belief. When I tried to get a nursing job in London I was told either you take your scarf off, or you don't get the job.'

Both women wished the war in Somalia would end in peace so that they could return to their homeland. However, for second and third generation Somalis Britain was their home. In the dying hours of the afternoon on my last day in Liverpool I met an elegant, well-read, half-Somali, half-English young man in a bookshop.

'Let's get the record straight,' he said angrily, as I questioned him about the descendants of the most recent immigrants. 'I'm not half anything. Neither am I a victim. The media might portray me as one, but I'm surviving. Racism is institutionalized in this city, I know where I can go, I don't need to be told. We don't need signs like South Africa: "Don't drink from the fountain", "Don't enter". We know our place, it's a mind-set that has been imposed on us. The black man's holocaust is still going on, fourteen million Africans a year are dying of dehydration, stuff you can pop into the chemist for here, but you can't get there. You hear white people saying they're scared of sitting next to a black man on a bus – what about us having to sit next to white people? If you get off the train you don't see us. You drive along Princess Avenue, the main thoroughfare, you might see kids playing either side, but there's abject poverty one minute's walk off the beautiful boulevard. Oh, yeah, you can see how many of us work in McDonald's, but we've got pride, not just to be sweeping your streets.

'Good jobs now require skills that schools in poor areas do a dismal job of teaching. If you don't already have a brother or sister in one of the schools outside your area, you can't get your children in. Geographical boundaries limit the equality of opportunities. If you don't like it you can appeal, or you have to beat the system, invent a house purchase or have relatives living in an area with good schools.

'Do you know there were Africans in Britain before the English? They were soldiers in the Roman imperial army that occupied this island for three and a half centuries. Did you know that the first group of Black Africans came to England in the summer of 1555, before we

had potatoes, tobacco and tea and before Shakespeare was born?

'The other day a friend of mine said he wanted to be reincarnated as a white man. I said, "Why would you want to do that?" "Just think about it. Life, it'd be bliss, living in such ignorance."'

I had come to understand part of the Scouse mentality. No amount of decay can extinguish their obstinate energy and irrepressible spirit. Like my friend Siobhan, and many of the teachers and children I had met, Scousers won't put up with emotional camouflage, or as Patrick put it, 'with any shit'. In the dying light as the sun slunk away from the Mersey, I looked out of the bookshop window to where the cost of the city's human suffering was summed up in two words of graffiti – RESCUE ME.

SALFORD

Against the Odds

LIKE OTHER GREAT industrial cities, Salford is to all intents and purposes derelict. Once it was a dirty, bustling place with cramped, ragged terrace housing, but with a unique, clearly defined character all its own. Most of that has gone now, and no amount of government regeneration schemes and European handouts can bring it back. The destruction was immense: housing was levelled and the residents were scattered to different corners of Salford. In its place came concrete tower blocks, highways and bypasses, so that it is now possible to drive through without stopping. The city stayed the same only on the map. Planners had declared that people shall not live where they work and, in so doing, destroyed the very fabric of the city and with it all sense of community. Now the planners have decided to reverse the process.

Jaimz, fourteen years old, his baseball cap twisted to the side, sat motionless as a statue in a hole in the bricked-up wall of an abandoned shop. Behind him was a second protective wall against which he rested his back. He took a packet of Rizlas from underneath his sweatshirt. Slowly and meticulously he skinned up. The sweet sting of marijuana smoke drifted across the covered parade.

A drizzle was falling and little gusts of wind swept the waste paper and pellets of dust and plastic bags around us in spirals. The litter came in all shapes and sizes: bags from Morrison's and the Co-op, Walker's salt and vinegar, mild Silk Cut, the plastic and paper making harsh scraping sounds as they scuttled back and forth along the pavement.

The rustle of litter was broken. A car careered around the corner, its engine wailing, its tyres retching as they strained to hold the road, the smell of rubber replacing the aroma of marijuana. I looked at the

212

woman who had emerged from the general store to stand under the protective canopy of the covered parade with a trolley laden with shopping. She stood with her shoulders hunched, her head drooping slightly with her eyes fixed on the pavement, hands in her pockets. 'Bloody griefriders,' she mumbled.

The wind blew the plaid coat against her scrawny frame. 'You don't see this in Spain,' she said, shaking her head slowly, mechanically.

'If you're from Spain and you come to Salford, you don't come to Little Hulton,' I replied.

She couldn't believe that anywhere in Spain could be as bad as here. Every time she heard the screech of the approaching car rounding a bend it reopened the wounds of her discontent.

I had no introductions to this neighbourhood, but as I walked around this estate it appeared that many of the residents had fled, adding to Britain's long list of inner city refugees. Entire cul-de-sacs and groves were boarded up, especially around Wildbrook Road, with the message 'All materials of value have been removed from this property' on the boards covering the windows.

This estate had been built on fields and farmland as overspill for the residents of Salford when their back to back terrace housing was demolished. Although Little Hulton was part of Greater Manchester and three generations had lived here, it didn't feature in the city's latest A–Z street guide, or even the one for Bolton. Some of the residents thought I might find it in the A–Z for Wigan, but they weren't sure.

Approaching Little Hulton from Bolton I thought I was going to find a pleasant setting with generous views of the Lancashire plains. However, on either side of the A6 signs of the winds of change were as marked as the menhirs that form the stone circles of Stonehenge. One of Europe's biggest slag heaps or 'slackies' provided recreation for those with mountain bikes, but the coal miners had gone. The great steel mills and brick works lay as in a moonlit silence; the Smith Kline-Beecham factory, covering acres of land, was deserted except for the solitary figure of a watchman at the gates in a fortress-like fence erected to protect the property against vandalism. Shops, building firms and industrial estates were closing down or downsizing. In the distance you could see church spires and the chimneys of vast mills

in the middle of lush meadows like pins in a bowling alley, but like the Yorkshire mills they had expired, overtaken by a world that no longer required man's labour.

'The pace of bankruptcies is slowing down,' said a man in the local pub. 'That's because most of them have already gone bankrupt,' said his friend. They told me there were over a hundred vacant houses and flats in Little Hulton. 'The council has been trying to get tenants, they put an advertisement in the *Sun* last year – I think they called them "green belt homes".'

'They described us as a close-knit community,' laughed his mate.

I walked around several of Little Hulton's estates, along worn pavements with weeds growing between the slabs. The roads were potholed and the bushes streaked with black dustbin liners, opaque milk cartons, and daisy-coloured margarine containers.

In the lobby of the local housing office I studied the flyers for free meat from the EU and others requesting donations for Bosnia. The housing officer said that they hadn't been fighting off applicants resulting from the advertisement in the *Sun*. 'We had two hundred responses from as far away as Scotland and Newcastle; eventually we rehoused forty people. It's been a real battle, but we've got a great product, good solid brick housing, not concrete high rises, front and back gardens, and the overall fabric of the housing is good, even the stuff that has been empty for long periods. If you walk in today we could rent you a house for £41. There's a pleasant environment and we believe we can turn the area around, it's not beyond hope. The biggest factor in the decline has been the lack of jobs and lack of travel facilities to other areas. We're out on a limb, we're in between everywhere, with no train station, and it costs £3.20 to go to the city centre and back.

'Let me see if I can put you in touch with someone who has moved in to the area. You might be in luck. If you go to see Pete McKenna in Pennington Way tomorrow, he'll see what he can do for you. It's an old people's home and he knows everyone on the estate.'

A large group of children were playing on some derelict wasteland. When abroad I try to give the impression of having been there many times: I make my actions and gestures deliberate, as though I know

precisely what I am doing and where I am going. As I crossed the vacant lot I felt vulnerable. I carried on and the children came towards me. Individually they would be restrained and wary, as a group they were fuelled by courage. They hovered around me, keeping a distance between us, but with their eyes fixed on me. I felt like carrion.

'Don't you know we're all thieves?' threatened a boy who could not have been much more than twelve years old. I felt a pair of eyes somewhere behind my shoulders, one or two feet away – not more. I neither retreated nor stood so still that they would interpret it as fear, but I tried not to encourage them to think I wanted to challenge them.

'Can I take some pictures?'

'Fuck off.'

'Are you from the papers?'

'The *Sun*?'

Behind their apparently disorganized manner lurked a well-judged performance. They were wounded souls, they had epidermic sensitivity. I reminded myself I was twice their age, but they held all the cards. One of the boys moved forward and put his hand on my camera bag to test my reaction. Some of the boys and a girl were warming to the idea of letting me take pictures; others remained hostile.

'It's for a project about Britain, they won't be published for a while.'

'Don't believe him. He'll sell the pictures, and make loads of money.'

'You'll see a picture of us and underneath it will say "thieves".'

'How much are your cameras worth?'

'Givusyer cameras.'

These children often believed what adults said about them: if they were expected to be bad, they were bad. The local youth club was derelict after a fire. There were no other community provisions for them and they didn't want to stay home. They were almost certain to be doing something wrong, probably breaking some law, breach of the peace, trespassing, burglary, damaging private property. This was just part of the pattern of boys' and some of the girls' lives in such neighbourhoods. Standing around was likely to arouse suspicion. When the police called round, they knew most of their names. All the time the children walked a tightrope, crossing the line between right and wrong, legal and illegal.

They were already aroused and under stress – their tempers shortened as the day passed and the sun waned. They were waiting for any excuse to light their short fuse. A dam of anger builds up in their minds. They had already rampaged through a former old people's home, as they had the previous day and the day before that. We crossed the empty site in front of the derelict building. The children's shrieks and cries and screams perpetually ring in the residents' ears. In the street they had put someone's garage door on the ground and bent it to provide a take-off ramp for their bicycles. A sign on one ramp read 'Keep Clear'. A helmetless six-year-old in a billowing tee-shirt faded from many washes leaned into the ground as he did figures of eight on a miniature motorbike across the waste land, pavements and street, wrenching the throttle every time he returned to an upright position.

The children offered to take me through the derelict building. It was a charred hulk, the protective boards ripped from the doors and windows. Inside it was pitch black as we climbed the four half-flights of stairs, and a young boy told me to hold on to his shirt to guide me through the darkness. The children swarmed all over the building, clambering over chunks of plasterboard and doors torn from their hinges, using a fuse box as a toehold to get on to the roof. They were as blasé as steeplejacks and as irresponsible as lambs.

When I asked a question they loved to interrupt. They spoke out of turn and over each other, louder and louder, until they were shouting to be heard. The parents put their hyperactivity down to diet, the water, too much sugar, but in some it was extreme nervousness, a kind of suppressed hysteria. Many of the children felt betrayed and abandoned and the walls of their homes have closed suffocatingly around them. They had grown cynical; they had no beliefs to hold on to and that had created a vast emptiness. Their coolness was a result of lack of affection, they told themselves that nothing mattered anyway, their hearts felt limp and yet their capacity for love was enormous. Everyone and everything was failing them, their parents, their brothers and sisters, their teachers and sometimes their friends. But most of all, many felt they had failed themselves. They felt horribly isolated. I have heard adults described as 'mimophants' – as fragile as mimosa about their own feelings, as tough as elephants about other people's.

It was an apt description of children in such neighbourhoods.

The street gangs and posses had become substitutes for families. While they were supposedly at a friend's or their nan's or aunt's, they took to the streets and lived there most of the time. The adults no longer scolded children who were playing dangerously or stepped outside the law – they tried to ignore them, even though they might have been 'our Jimmy's' cousin or nephew. As the tribes of boisterous children searched for diversion, their behaviour often eclipsed their real qualities. They lived in the prison of repressed emotional injuries, and the anger and energy span out of control. Rebellion stirred in their hearts, and few would have the firm foundations of family, financial security and environment that can be a ladder to personal and job successes.

Sweat ran in rivulets down Pete McKenna's face. He was bent over the stove of the sheltered housing's communal kitchen preparing 36 midday dinners. 'Neil warned me you might drop by, I don't know if I can find you anyone who has recently moved into the area, but there are plenty of folk here who moved in when the estate was built. Would you like some dinner?

'Meet my wife. We work voluntary, cook the meals twice a week – Wednesdays and Fridays for around forty people. We also make them soup on Tuesdays and Thursdays before they go to the bingo. I was a plastic moulder for thirteen and a half years, done regular twelve-hour nights on that, then I got made redundant. Once you get over the fifty mark you're over the hill. My work had always been labouring or semi-skilled, no trade. I started doing the dinner three year ago. We charge £1.25 for dinner, sweet and one or two cups of tea, or three if they want it. What we collect for meals on Wednesdays pays for Fridays. Fridays pays for Wednesdays. It's not subsidized and we don't get any grants, but we did get a grant to have the kitchen enlarged and buy some equipment, like. We don't get any help for the food. The pensioners come in with a handful of coppers which they throw in a jar which we use for sugar, tea, milk, salt, pepper, mustard, horseradish, all the little extras like serviettes. You don't want to hear me prattling on, you've come to meet some of the folk. Let me just finish this and I'll take you in, introduce you, like.'

We helped two volunteers carry the plates of meat and steaming vegetables loaded with thick gravy into the dining-room. 'That's Ann Drury, that's Welsh David, that's Mavis, Fred and Frank and Farmer David,' said Pete McKenna as we stood at the head of one of the tables. These pensioners had been navvies, joiners, cleaners in overalls, they had been stevedores and machine operators.

I sat at their table and they talked about the estate and their lives. 'There's now't wrong with the estate, it's grand housing, it's t' families what they put in them. Look at the house on our corner turning into a mess. It's frequented by drug dealers and users. They think if you put a bad apple amongst good apples, the bad apple will become good,' said Welsh David.

'If you see a young girl not pushing a pram, you know she's visiting,' frowned Mavis.

'I can't understand how young 'uns want t' be doing with drugs, burgling, hanging round street all hours of day and night.'

'World ain't wot it used t' be.'

'O' t' families are out o' work.'

'We used to look after owld folks,' sighed Anne Drury. She recalled life as it used to be and remembered such faces and personalities as Harry, the burly milkman in his blue and white striped apron, who had acted as the unofficial social services and kept an eye on isolated pensioners.

I asked them about the move from the city centre to this estate. They reminded me of the Scottish Highlanders describing the clearances, only here the aristocratic landlords were replaced by the government and local councils. But the rich mosaic of cultural and social life that had existed in the old streets hadn't completely disappeared.

'They moved us from our houses and thrown us up in t' air and we floated down on new estates. Families were split up.'

'The old houses were pretty grotty.'

'When I came here I didn't know there were birds. We were lucky, we were moved with the whole street.'

'I got robbed on Christmas Eve. The police did nothing.'

'We're frightened to go out, but we still go out. We knit, read, watch television, bingo. Plenty for us to do. It's not too bad for older people. They built a youth club for kiddies – it's been robbed twice,

they smashed windows, they burnt it. Roof's gone, it's a disgrace, they ought to pull it down. They tried to burn phone box down. You can look across the road and you'll see half t' shops are closed.'

'What's wrong with the old country?'

'It's lack of jobs, lack of discipline, boredom and the lack of facilities. We made our own fun, played music with a piece of paper over a comb. We kept ourselves away from boredom; did errands. Here they want a bit of change, they want money, they'll rob you.'

'I think it would be better if they showed less violence on television. They show them how to break in and burn the houses.'

'A three-year-old says, "I'm going to throw stone at bus" – they're learning off the others. If you did sommit wrong, you wouldn't need bobbies, someone would have clouted you, you'd've got home and you'd gerranother clout by yer mam. Now you can't cane or hit 'em even if they're your own children. If you belt a burglar they put you in jail.'

'It's livable,' said Fred about the estate. 'We wouldn't move, we know what we're living in.'

As they ate their sweet they talked about how it was for them growing up in Salford. 'We were living in poverty, we were born in poverty,' said Welsh David. 'We went out to earn a few coppers, and were happy to contribute. Children now have been given everything. We appreciated what we got, they don't. We didn't steal – they had nowt in the house, burglar would have been wasting his time.

'The only books we had were club books and one book for insurance, death and birth certificates, one book for the doctor's man – six pence off your doctor's bill which you never paid off and one book for father's wage.

'I've had three operations this year, years ago I would have died.'

They remembered communal activities and reminisced about the bands in the park, but they remembered the harsh realities, too, the tyrannical teachers and parents, being too poor to save and the unavoidable hazards. They had been liberated from the drudgery of factory work and menial tasks, but they carried the scars of their labour. In some of the most deprived areas of the north of England, mortality rates for some groups have worsened for the first time in fifty years, according to medical research.

'We lived under a chemical factory,' said Rose, who was from Widnes. 'We never saw the sun through the thick black smoke that filled the sky. It was the worst place on God's earth. Everyone in our street worked for the factory unless you worked for the baggie, the shirtie or the jellie, but that were for women. It were the bronchitis capital of Europe, they died like flies. You should come and visit us at home, you'd think you were visiting a funeral parlour only we're sitting upright. I'd rather be on the *Canberra*, only because it's got a nice name. My husband fought in World War Two, a bridge too far, a bridge too near and all that. I had five brothers and six sisters, but only five came back. We didn't miss the dos and weddings and all that then, we missed them. I remember when there were eleven of us, there were always some standing and some sitting, we used to have to shuffle the chairs around.

'As I was telling you, we never saw light, we lived opposite the foundry – we never knew if it was morning or evening, we never had a clock, but meals were always on time, never missed Mass, because we all knew what time of day the trains passed. That's when the railway lines were all over the place. We never had no social security in them days, but if you were poor enough you got relief: they'd ask you how many kids you had, how many rooms, how much food. Tell 'em everything except for the colour of your knickers. I wrote a poem about it:

> For food they had to make a claim.
> First their address and then their name.
> How many kids? Are they all yours?
> Making them feel they'd crawled out of the sewers.
> You say that you're poor, you say that you're sick.
> Don't you mean lazy? Don't you mean thick?

'I got an A-level three years ago and I'm seventy-five. I watch the magpies building their nest from my window, I don't use binoculars because the sunlight from the reflection might bother them and they'd leave. You'll meet my husband if you come to the house, he's got amphysemia. He doesn't blame t' factory, he's so glad it brought him work.'

Some of the group suggested I visit the Harrises, a couple with two

grandchildren, Kevin and Sean, who looked after their invalid mother. 'The grandad has had to go back on the taxis to support the family, they don't want their grandchildren going into care. Imagine that, having to start all over again at seventy.'

All these pensioners had led hard, tough lives, but they had a resilience and self-reliance that had come from the penury of their lives. 'I'd rather be a payer than a drawer,' said Frank, but many no longer had that choice.

I was staying in a flat some ten minutes from Little Hulton. Gary, the owner, was perpetually fretting about finding a job – it had overtaken his life to the extent that he had become a man possessed by a vision that didn't exist. 'I'm up every day at seven, I've stopped smoking, I don't drink, I've knocked the spliffs on the head, that's why it's so frustrating.' Every day he went to the library to look at the jobs sections of the newspapers. Gary had once been involved on the fringes of the music business, had run a club and had promoted several bands that went on to make big names for themselves. He left the club business because of the difficulty in stopping drugs from coming in and the pressure from protection rackets run by the security firms that you needed to hire for the door. Now he was prepared to take anything.

'When you look at the papers, they dangle carrots in front of you, great sums of money, but they are all direct sales, only commission, no wage. I've tried them, sometimes they give you leads, sometimes you spend days and days at it for ten quid. You don't lose money, but you're running around like a blue-arsed fly. I wish I could start all over again, I wish I had studied harder, got more qualifications, but sometimes I go for a job interview and they tell me I'm over-qualified, under-qualified, not enough experience, too experienced. I'm wondering if it can get any worse. The stress and despair in my life is making me go bald. Then I see these ads for hair loss which cater for desperate people. I think I'm becoming one of them, I ask myself how can I pull a bird when I've got no signs of a livelihood, what have I to offer? It's sickening. I feel like running away, but to where? I've tried to find work in Bristol. I've tried to find work in Leeds. Sometimes I think there's no bloody work, I call the local employment agencies and go

to the job centre, but I'm beginning to think I'm only wasting money on the telephone calls and bus fares. The spliffs used to be one of the few compensating moments when I could forget all my troubles.'

When I rang Mrs Harris: 'You'll be wanting to speak to the boys, won't you? I can't guarantee they'll be in, but Kevin usually is. They're ever such good boys. Their mum is always home, you've probably heard, she's got multiple sclerosis.'

Kevin was eleven and his brother Sean a small ten-year-old, very wiry and slight for his age. Sean had a thick accent and talked at tap-dancing speed, so rapidly that it sometimes sounded as if someone had turned up the metronome. He was always in motion. I've since stayed in touch with Sean and Kevin and if Sean answers the telephone I rarely understand his quick-fire replies, so I move on to the next question. Kevin was the quieter of the two. Where Sean liked to be outside kicking a football in the streets and playing golf with a stick, Kevin stayed indoors painting landscapes with fantastic mountains and castles. I visited them several times: they were courteous boys with quick smiles. I never met the grandfather who at the age of seventy had gone back to driving black cabs to supplement the family income, so that they could, as Mrs Harris put it, afford the luxuries, 'a telephone and a video'.

'And not shop at Netto's,' said Kevin.

'She's only been there four times,' said Sean. 'We wouldn't be able to have as much water and lecce. Water's 50p a day.'

Sean and Kevin had started to look after their bedridden mother when they were eight and nine years old. 'I started looking after me mum a couple of years ago when me nan went into hospital when she got asthma and angina, so she couldn't look after our mum, so we got the hoist,' said Kevin. 'I get up as late as I can, eight o'clock if possible, and give me mum a drink.'

'It's because me mum was shouting at me dad, she was doin' the cooking, she was in the wheelchair and fat fell all over her legs and he wouldn't come,' explained Kevin.

'He left her for one or two hours before he called the doctor,' said Sean.

'He stuck her in the garden.'

'Back garden.'

'And left her there. Some women next door seen her and phoned the doctor and then that was when they went to court about me and him.'

'Me mum got full custody of us but me dad got to see us every fortnight,' said Sean.

'In the courtroom me grandad said, "that's not a father",' said Kevin.

'He said, "I've been more of a father to them than you 'ave," ' added Sean. 'And then they had a big row about it in the court and me dad expected me mum to pay to look after us every weekend. Then when she stopped paying him, he didn't come for a couple of weeks. So he took us for a couple of hours because he wouldn't take us unless he got paid. And then that was when he got married to Pat. We were invited to the wedding but me dad didn't come and get us. I wasn't bothered.'

'I couldn't care less.'

'I don't like him.'

'He can be all right sometimes. Otherwise bad. Not coming down or making excuses, he's got a cold or looking after the baby.'

'Mum's got multiple sclerosis. You call it MS.'

'I wouldn't even know how to spell it,' Sean interjected.

'She's had it since she was eighteen, she's thirty-six, been in a wheelchair for twelve years,' the grandmother explained. 'Their dad never encouraged her, left her.'

'Went out and got drunk every night,' Kevin said. 'We had to get her into bed, feed her.'

'I feed her more, Kevin feeds her too quick. She's got this thing she can ring if she wants us.'

'Baby monitor.'

'It's your turn to do the dishes tonight.'

'I'm doing the vacuum cleaning.'

'We also cook things, like when we have pea soup. It's horrible, that, it's sickening, so I cook myself something like pizzas or spaghetti or toast. I cook eggs, beans, spaghetti, toast.'

'I do spaghetti, pizzas, tomato, toast and scrambled eggs,' said Sean, not to be outdone by his older brother.

'I said eggs.'

'You said eggs, I said scrambled eggs. We also help with the shopping.'

'Because me nana has angina.'

'And asthma.'

'Mum nearly died because one of her lungs collapsed.'

'She went on to a life support machine.'

'We only went in when she had a drip.'

'When she was better.'

'She was in intensive care twice in three weeks. I'm scared in case she dies. I think about it a lot, nearly every day,' said Kevin.

'Now she's got all that stuff for breathing, she's much better, so I don't think about it much, only now and then.'

'I wish me mum could walk.'

'I wish I didn't have to see me dad.'

'We don't want our dad to have us, because when we have a job, he'll want us for our money.'

There was a knock on the door. Sean rushed to answer it. 'It's Ollie, he wants me to go and play marbles.'

'Tell him you can't!' his nan shouted as she continued to peel potatoes. 'You've got to get your mum up.'

Kevin and Sean went to get their mother. They helped turn her over so as to prevent her getting bed sores and Kevin helped her on to the toilet.

When they were out of the room Mrs Harris told me, 'If anything happened to me, their grandad wouldn't be able to look after their mother. She'd have to go into a home, a man can't look after a girl, like, you know what I mean. If the grandad could cope with these two, he'd have them. I think if anything happened to their grandad, my fella like, you know what kids are if they don't have a man behind them, I wouldn't be able to tolerate them. If nothing happens they'll stay here for ever.'

Kevin and Sean wheeled their mother into the living-room and she gave me a warm smile. She lay in the bed like a bean in a pod, hardly able to move. She could tilt her head this way and that, gently and slowly, but with effort. She had prematurely grey hair which caught the television's glimmer, her arm rested by the bed's railing, her knees were bent so that her legs formed a z, and her hand by the railing

dangled limply. When she spoke she had a cat's voice, tiny, warm and raspy. She was immensely proud of her boys: 'They do a wonderful job . . .' Her voice quivered and I didn't catch the end of the sentence. As the boys continued to chat, and Mrs Harris continued to peel the potatoes, she lay smiling and nodding and corrected the children's more wayward thoughts.

Maybe it was force of circumstances, but in many ways Kevin and Sean were among the most well-adjusted children I have yet to meet. Not many children were as dedicated and devoted to their family and there weren't many who had to care for a sick parent.

'We know Tracey who looks after her mum and her sister and brother,' said Kevin. 'She's my friend, I can take you over there. And Rob, who lives with his nan, that's all.'

'And Steven, his mum's all right, but he still lives with his nan,' said Sean. 'If we're talking about more than one Rob we call them Robbos. Rob's sister is called Grace, everyone calls her Greasy Gracy.

'I wished I'd saved up for my holidays, I've only got a pound.' Sean pulled some change from his pocket. 'We're going to Pontins.'

'We've been to Butlins,' said Kevin.

'And Rhyl in a caravan,' said Mrs Harris.

In many areas of Britain I had discovered that racism was institutionalized. In Salford there were no 'only white' neighbourhoods such as I had found in Leicester, Halifax, Newcastle and Liverpool, but less than ten minutes' walk from the city centre shopping precinct I discovered one of those inner city streets that make the hair on your neck stand on end. I stopped to ask for directions at the end of a street that looked as though it had expired: deserted, dirty and without a single car parked along the pavement. Unlike the unfussed, straight-forward talking of the pensioners in Little Hulton, a reminder of the men and women who had brought Britain its wealth and position in the world, I found this street mean and rough where the men were brutes or louts and all the women worn out trying to survive.

I had been given the address of a pregnant teenager, but there were no numbers on the house doors so I asked a couple of sharp-eyed, sallow-skinned youths if they knew where Trisha lived. Their pinched lips, acne spots and warts were the common disfigurement of an age

of junk food. One of the two boys held a dagger, the other a large rottweiler with a big voice and bared teeth straining at the end of a leash – bought and used as a weapon rather than as a playmate, to burnish his ego or in response to the numerous burglaries that happened in this street. The rottweiler, which was nearly extinct at the turn of the century, is now the crime-ridden inner-city estate's most popular breed. The two youths took it in turns to hold on to the leash, but they were the ones who howled and mumbled, snarled and menaced.

I climbed the worn steps of the grim close. On the landing someone had scrawled: 'Fuck your law we're not criminals we're just poor'. I rang the bell and the door was answered by a neat and tidy thirteen-year-old. As I entered the flat I could hear a woman in floods of tears: 'I can't take it any longer, I'm going to commit suicide.'

The room overflowed with children. The woman with tears streaming down her cheeks repeated, 'I'm going to commit suicide, I'm going to commit suicide. I can't take any more abuse – it never stops, the neighbours are always complaining.' Nicola, the child who had answered the door, handed her a Kleenex. 'I can't move from here,' continued her mother, Marie. 'The neighbours say I'm always slamming the window, the doors. Once the window slammed shut and smashed, the wind had caught it. I can't take this much longer, with my illness. I have headaches all day long – I can't take this on top of it all.' Her three daughters and her son sat silently watching her. Another neighbour sat next to Marie on the settee trying to comfort her. 'I wouldn't take the abuse, I'd rip her head off. I've got a 26-year-old son and I wouldn't take that from him,' said the neighbour. 'Her kids get abused every time they go by, they shout golliwogs and Mars bars and black bees, they caused £400 damage to her car when she had one.'

The maisonette was too crowded. Marie didn't have the heart to kick her two oldest daughters out: they had nowhere to go. The eighteen-year-old, Sandra, had just had a baby and she was concerned about her ability to take care of it. Marie's entourage consisted of nine-year-old Michelle, eight-year-old Wayne, her only son, Nicola, sixteen-year-old Jemma, Sandra and her baby and, since Easter, her niece Trisha, just turned seventeen.

'The housing came round to ask me questions. I've been waiting

three years to be rehoused. Four years ago this flat was given to me as temporary accommodation! I've never seen this housing officer before. He came to discuss the neighbours' complaints! I was blamed for water leaking into their flat, but two years ago the council diagnosed it as the pipes. They accuse me of throwing drugs out of the window. I don't do street drugs, the drugs I have are for my sickness. Because we're black they think we're doing drugs. Why are they picking on me? I'm falling apart. I can't take it.'

The daughters continued to look on helplessly. Nicola tried to console her: 'It's not loads and loads of abuse, sometimes they call us nigga and jungle bunny. Take no notice of them.'

Sandra, cradling her baby, explained that their dad had suffered from manic depression and had had a nervous breakdown because of all the abuse that had happened in their lives. 'He's from Ireland, that's why some people around here call us the vice versa family.'

'His problems started the day he married me,' said Marie.

'He still comes and sees us twice a week and takes us out, but he couldn't cope with living with all the racial harassment. We left our previous flat and were moved into a homeless unit before we were moved here. It was just a big flat with loads of people and we got skited [abused] there, it was unbelievable.'

'I got a black eye,' said Shane. 'Nicola, show him where you got your lip split.' The scar was still visible.

'It's not just what you can see,' said Sheila, the neighbour. 'Shane has difficulty concentrating on his homework with the flat so crowded.'

'I wish we could move from here,' said Nicola.

'Where to?' I asked.

'America or Moss Side.'

Sheila told me, 'The racists are the ones who are going to be moved! Talk about injustice.'

'Have you been to the police?' I asked Marie.

'I've been to the police, they said I've got to go to the council. But it'll cause worse problems. Sheila said she would testify, but she's still got to live in this street. I don't see why we should have to leave this neighbourhood. I was born here. My mother moved here forty years ago. She was threatened with knives, but she was always protecting us. They've learnt to respect me mum because she's got big sons. Me

dad's mother was a slave and me dad's dad came to England. Me dad is cousin to President Mugabe.

'If you're coloured, you're the last to get a job, the last to be housed. People younger than me, not in my situation, get housing. And I'm worried if we moved to another area we'd still be harassed and called choc-ices, black on the outside, white on the inside. We can't go anywhere.'

Mush, an Asian hip-hop rapper from Rochdale, was driven by a belief in rap's power as the poetry of our times to fight the decay and racism. He and his friends could no longer enter parts of Rochdale because his posse had fought for the neutral territory between his estate and an all-white estate; although they had won the battle he had lost the war, because, as he put it, 'They would beat seven colours of shit out of me if I went back there.'

He and his group the Kaliphz – Jabba the Hype, 2 Ton Hogweed, Chockadoodle and Sniffadawg-NAD (Nasty And Direct) – were on the threshold of critical and popular success. They had toured Britain and had recently played a gig in Brooklyn, New York. The influences were obvious. Mush had a gold K displayed prominently on his front tooth and a goatee beard; he wore a woollen ski hat and baggy pants so vast that his legs floated invisibly inside them, and worn so low around his hips that they showed his shorts underneath. During a rehearsal at Manchester's former BBC Playhouse he removed his sweat-shirt to reveal a tattoo of a Ninja Turtle with a Palestinian headscarf. When the Kaliphz got rapping they bounced around the stage like pucks in a pinball machine. As the Kaliphz spokesman and lyricist, Mush uses the name '2 Phaaan Da Alien' within the group (he got the name from the feelings of alienation when he first came to England; when he called me and someone else answered the phone he intro-duced himself as Mr Khan).

I sat alone in the auditorium listening to their songs fashioned out of their battle to crush racism and neo-facist groups such as Combat 18. It was a message that they repeated in their newsletter 'Pride of Kolor': they rapped, 'We believe in an eye 4 an eye, tooth 4 a tooth, knife 4 a knife and a life 4 a life ... 4 the Nazis, we ain't going out like a muthafucking Gandhi pacifists, we fuck them up whenever we

see them.' 2 Phaaan was worried that his message was too rebellious. 'Our record label don't want us to get too political. "Those bands fail, remember liberals buy records," they warned us. But we don't want to be doing Asian Rap, we'll be Asian rappers that do an African-American thing. People are too used to nice little Pakis in silver suits,' he said after the rehearsal. 'The record business is full of snakes. The system's too big, you can't beat it.' Mush was at times visibly worried by the fine line that separated them from both the big time and the also rans. 'I've got to twenty-eight, what else have I got? I can't start all over again.'

That message was mild compared to what he had in store for me latter that evening. Mush had put me in touch with Supa C who ran a pirate radio station called Sting FM. Supa C had a special guest from London on his show that night and he said I was to wait outside the Playhouse where I would be picked up at seven o'clock sharp.

At seven o'clock precisely two BMWs with tinted glass windows pulled up outside the Playhouse and I was escorted to one of Salford's numerous fortress-like council tower blocks. As soon as I entered the one-bedroom flat I faced a sign which read, 'Look All DJs! Under *no* circumstances is anybody allowed in the studio: Mums, Dads, Bros, Mos, Pets, or even God Almighty! You won't laugh when your arse gets busted!!'

Sting FM broadcast from the living-room, but heavy cables ran from room to room. The two turntables, tape decks, a television set and microphones were set up on a wooden conference table pushed against a wall pinned with messages, calendars and the radio station's mobile telephone hot line number. The transmitting aerial was on the balcony which had a panoramic view of Hulme and beyond.

Unknown to me I was there to listen to a live broadcast by the London-based rapper MCD. When MCD and his woollen-hatted crew walked into the studio everyone exchanged greetings by knocking clenched fists with the welcome, ' 'Nuff respect.' In between promoting his latest album tracks, MCD had a message for his audience. 'They'd take the black keys of the piano if they could, and the black in the zebra crossing ... Thanks to the white people, their negativeness makes us fight positive ...' After what I had witnessed in the afternoon I could understand the sentiments, but MCD wasn't preaching

reconciliation and integration among decent people of both races as Dr Martin Luther King had once tried to do: this fiery oratory sought segregation, his constituents were the angry young black men living in misery and poverty and he preached an uncompromising message to them. He wanted the young men to adhere to a strict code of conduct, he preached that the blacks were the chosen race and about black superiority, but he also called on blacks to abandon drugs and alcohol, to provide jobs and training through their own shops and restaurants, he emphasized a return to traditional values.

I didn't know if it was my presence, but during the broadcast a certain tension in the air was palpable. Mush, who had arrived halfway through the broadcast, felt it too; he took MCD's promoter into the next room and asked if they had a problem because I was of 'the Caucasian persuasion'. It wasn't that, they assured him. We later learnt they had been uncomfortable because of the presence of Mush's English-Somali girlfriend. Women, according to MCD, were expected to concentrate their energies on housework and child-rearing and to dress modestly; they were not expected to be in a studio. When MCD's rap songs ended and his fire-breathing call to separatist, self-imposed and adversarial action was momentarily on hold, someone else's album track with a roll call of revolutionary leaders filled the airwaves across Greater Manchester: 'Elijah Mohammed, the Ayatollah Ruhollah Khomeini, Malcolm X, the Prophet Mohammed, Martin Luther King, Saddam Hussein, Marcus Garvey . . .'

Mush suggested that I should visit Glodwick, a 'black' neighbourhood in Oldham. While the first Bangladeshis had settled in Britain before the Second World War, they didn't arrive in any number until the late 1950s. Then, in response to labour shortages, the new migrants found employment in the textile mills and most found accommodation in areas like Glodwick which were close to the mills. Three immigrant communities were concentrated in the area, coming from Bangladesh, Pakistan and the West Indies. The working class English community had been driven away by lack of work. The West Indians had mainly come from Barbados; many were skilled workers who found work in factories, as bus and rail conductors and drivers, and in the local hospital as porters and cleaners, jobs for which they were over-

qualified. As I entered the neighbourhood a piece of graffiti warned
REDNECKS STAY OUT. I found a terraced house with its front door
open and its hallway carpeted with children's shoes: obviously the
house had been converted into a mosque or a Quranic school. It would
be a good start to find a member of the community I could talk to.
I knocked on the front room door. It opened on to a room crammed
with young girls sitting cross-legged on the floor, reading from the
Quran. The teacher was a Pathan (they called him an Afghan even
though he was from Pakistan) and spoke little English, but he intro-
duced me to Janghir, a young man who helped tutor the young boys
who studied under another teacher on the first floor. Janghir agreed
to show me around the area.

The streets of terraced houses were littered with rubbish. 'We con-
sider ourselves clean, but look at this,' Janghir said as loose pieces of
paper floated along the street like butterflies. 'We try to clean it, but
by the time we get to the bottom of the street, the top is full of rubbish
again.' Daubed on the wall of an empty shop were the words BAD
IMRAN: these members of the English Pakistani community had not
forgiven their most revered cricketer for marrying a non-Muslim.
There were few women in the street. The dark headscarves of those I
did see were gently lifted by the northern breeze, revealing faces of
delicate beauty. The vividness I had observed in some areas of the
sub-continent was not in evidence: they had been taught by prolonged
exposure to the damp and dirt and hostile stares of the natives to
cover their natural brightness with subdued, lacklustre garments,
reserving their brilliant white or patterned textiles for weddings, special
occasions or inside the home. The men who had arrived in the 1950s,
before their wives and children, had held on to their customs; their
culture was frozen at a point some forty years back, which meant that
in many ways their homeland was now more westernized than their
own community in the West. Back home in the cities some young
affluent women had begun to wear off-the-shoulder tee-shirts and
tight dresses which showed some leg and thigh and even a hint of
breast. That would not have been possible for an Asian woman living
in Glodwick.

Janghir introduced me to a street gang who hung around outside
a newsagents teasing the younger members of the community. They

were surprised that I had come to Glodwick. 'There are no whites here,' they said unthreateningly. 'They don't come through here. If they do it's by mistake. If they don't stop at the traffic lights we know they're from Oldham, they're scared to stop. If they stop at the traffic lights we know they're outsiders.'

I asked if I could question them about their daily lives. 'What's innit for us?' said one of the more vociferous members of the group. 'Nothing,' I replied. But they were happy to answer. 'We're in business, but out of work, if you know what I mean,' said one of them. Another complained bitterly that he had been fired from his council job. 'I was progressing and doing well when they stopped me from working here. There are thousands of us in Oldham and yet only a few of us have a council job.'

We walked on. 'Janghir,' I said, 'I thought there were no whites here – look, there's a white person at the end of the strret.'

'No, he's got a skin disease,' said Janghir.

'Listen,' he went on. 'You'd be better off without me. If they see you with me, they'll think I've come to proselytize. I don't think anything will happen to you – just be careful with your cameras.'

Before he left me we crossed from the Pakistani neighbourhood into the Bangladeshi one. At one point in Glodwick, next to a parade of shops, there is a triangular point where three communities abut each other. These three tightly-knit communities, which are now as English as roast beef, traced their roots back to very specific places in the Commonwealth. It seemed they had one thing in common: everyone was bored. The 'Barbadian' English leaned against a railing watching the 'Pakistani' English standing by the newsagents, the 'Pakistani' English, when not teasing the youngsters, watched the 'Bangladeshi' English, who sat on the low brick wall of a closed community centre, staring into space or chewing blades of grass absentmindedly. Janghir left me with a large group of English-Bangladeshi teenagers. Like the Kaliphz they were dressed like American rappers – loose-fitting jeans, baseball caps turned so that the peak faced the wrong way round, and expensive trainers with the laces untied.

I returned to Salford and called to say goodbye to Kevin and Sean before leaving. I also wanted to meet their friend Tracey who was

another young carer. They seemed to have a great admiration for Tracey, and the work she did for her family, and I was keen to meet a child who was admired by children I felt were heroic in their own right.

I found Tracey, her mother, her younger brother James and her baby sister Sarah at home. 'I was expecting you, sit yourself down, over there,' said the mother. Sarah was laid out on the sofa, 'My youngest is sick. Would you like a brew? Put the kettle on, Tracey.' While Tracey was in the kitchen Sarah vomited on to the sofa. 'Tracey, come here, clean it up. She hasn't eaten for three days, hardly drinks.'

'Have you taken her to the doctor?'

'No.'

'I think you should.'

'Tracey! Get my shoes.'

Tracey brought her mother's shoes and her asthma spray, and dressed Sarah.

'Is it all right if I stay and talk to Tracey and James?'

'It's fine by me.'

I admired Kevin and Sean, but Tracey, in addition to caring for her mother, had assumed the role of parent and housekeeper. She was no longer a child, but not quite a woman. Broad-shouldered and strong, at times she seemed like a twelve-year-old womanchild. Her bedroom was decorated with numerous dolls that hung from the ceiling and she had several certificates and awards pinned to her wall, one for maths, one for swimming 325 metres, as well as a prize for coming first at Pontins and another first in a local swimming race. She was a sensitive child and, like Kevin and Sean, taking care of a parent made her feel needed, but the task was obliterating her childhood.

I felt tired just hearing about her daily routine. 'I get up at seven-thirty, come down, put all the lights on, and make me mum a cup of tea. I take it up with the tablets and an asthma spray. Then I get the children's clothes ready, then if they need ironing I iron them. Then at eight I get the kids up and ready. I dress Sarah. I make the tea and toast. At half-eight I go to school. Sometimes I'm late going to school because I'm dressing them two, I can't get there on time. Me mum sits around till dinner-time then me grandad picks the baby up and tidies for me mum, he makes the tea and goes home and when I come

in I heat the tea up, do the dishes and then about seven o'clock me auntie comes. We go out to play for an hour or two until she gets us in and then when we come in I make supper and watch telly in me room.'

'And then we wake up and do the same thing,' said James helpfully. 'We've been doing it since me dad left us three years ago.'

'Of a night sometimes me mum is really sick, she bangs or crawls into me room and I get up. If I hear a little tiny noise I wake up dead quick. If me mum's sick I jump up, put on a pair of pants, wake James up and run down to the phone which is five minutes from here at the bottom. When I run to the phone I get dead hot and I panic, and I get tired, I feel like stopping. When I run down I'm frightened because it's dark and I'm worried someone will jump out – it's dead quiet. And then when I've used the phone I'm scared in case I go home and something has happened. It happened not last week but the week before that. It happens three or four times a month. It's usually about half-twelve, one o'clock. We used to have a phone but it got cut off because we couldn't afford the £500 that we owed.

'I usually get up at half-seven of a Saturday, get me mum her tablets and go back to bed. I put the telly on before I go back to bed so I don't have to get up; I leave the kids in bed. After I've got them up, when I've done the kids and the breakfast and I'm in the middle of the dishes, me mum comes down and sits for a bit. She then gives me the money for the messages and I look at the fridge and the cupboards and see what we need, and then I write them down on a list and then I go get them. I look for the bargains, they don't always taste as nice and our James and Sarah don't like them. Me grandad gets the main things, but I get the lemonade, the biscuits, the tea bags, cheese, bacon, packets of meat, soap powder, like. I get tins of food, all the little things and milk. Sometimes our James comes in and drinks the milk – I don't like that, it costs 50p a bottle and we need it for breakfast so I have to run down to the shops again, come back and put all the food away. I give me mum all the change, sort out how much everything has cost, and then I go out with me mates.'

'When our Tracey goes out she takes the baby with her,' James said.

'I take the baby everywhere I go, unless my mum is in hospital, and then I don't have to do anything. Me grandad does everything.'

'The baby used to call her "mum",' said James.

'No more, she knows who her real mum is now.'

'She won't go anywhere without our Tracey.'

'It's too much, having children, I'm always tired when I get home. When I want to go to the towny with me mates I can't, because I've got to take the baby with me and they don't want to knock with me when I've got the baby. Me schoolmates don't know I look after me mum. Two mates know, they were a bit surprised, because they've been to me house and seen me mum, they know. On Sunday me dad takes me out. We went to the fair yesterday. Some Saturdays me mate asks if I want to go to the baths. I borrow money off me nana and I take the baby with me and take her in the baby pool and then me friend says, "I'll mind her for a minute so you can have a swim." I like swimming and I do dance and drama of a Wednesday. The rest of the time I just sit down and do nothing – that's why I'm going dead chubby, because I don't do no sports except for swimming. I want to move from here, I hate it here. I want to go by my nan because there's a sports centre where there's lots to do: darts, snooker.'

Tracey's mother brought Sarah home. She had a bag full of medicine and syrups. 'Lie on the couch, babe,' said Tracey, but Sarah ran to her, sat on her lap and wrapped her arms around her.

I tried to make conversation with Tracey's mother.

'Did you teach Tracey how to cook?'

'She's one of those kids who knows.' She lit a cigarette.

'Mum!'

'Tracey goes mad when I smoke.'

Mush has moved to Cheshire and his group the Kaliphz have made their first appearance on *Top of the Pops*. He has not compromised his ideals and language despite pressure from the record company.

Kevin and Sean are still caring for their mother.

Marie and her children remain in the same situation, but the racist family who lived below them have been rehoused.

BRIGHTON

All Washed Up

AS I TRAVELLED across the industrial north of Britain I kept thinking of Malthus's dictum in 1798: 'The power of population is indefinitely greater than the power in the earth to produce subsistence for man.' The Industrial Revolution made it possible for Britain to expand by increasing production, especially for export to its dominions. In Bradford and Manchester, Liverpool and Newcastle I saw the remnants of greatness and they are impressive – halls and municipal buildings and museums full of treasures, fortunes and cities built on the loot of empire. But the West and Britain's dominance has been eroded, justly. Modern conditions are different as we prepare to enter the next century. Politicians, technocrats and businessmen who should be preparing the perilous exercise of steering the correct course are often the most unprepared.

I felt a great affection for the north of Britain. I found the people friendly, generous and open, if not gregarious, and I admired their resilience to adversity. I regretted having to head south and lingered a while longer, travelling through Doncaster, Grimsby and Cleethorpes – which could have been the world's prime meridian, rather than Greenwich, as the Humberside resort also sits on the line of zero longitude. A monument marking the meridian is at the centre of Cleethorpes' lovers lane and a couple in a local pub told me they had joined the zero degrees club, as opposed to the air travellers' mile high club.

In Grimsby I met a former mayor who gave up his afternoon to show me round his town. We drove through grim estates of prefabricated housing, put up in 1945 with a ten-year life expectancy which had been extended a further twenty years, some of which were still home to two families. He pointed to the municipal vandalism which

he regretted presiding over – the fortress-like shopping precinct which had replaced residential streets. I asked him if Grimsby was twinned with any other towns. He said no, but they had a death pact with Bosnia.

The relentless growth of the human population combined with modern technology has had a direct effect on Grimsby's inhabitants. In the 1950s it was the world's largest fishing port, with 176 deep-sea trawlers and more than 10,000 people directly employed in fishing. On my first night in the town I went to buy fish and chips to be told they didn't have any fresh fish. In thirty years Grimsby's fleet didn't so much dwindle as disappear; there are now three trawlers left and about seven hundred people are directly employed. Old photographs of the harbour show so many vessels berthed side by side that it was possible to walk from one side of the port to the other by crossing the decks of the fishing boats. Grimsby is now building a modern harbour development for the fish the EU no longer allows them to land. Grimsby's fishermen are up in arms over the quota systems for fish conservation.

On the night I went to the harbour, there was a solitary Faroese trawler, and in the early hours of the morning I watched the single gang of fourteen lumpers landing the catch into the large, empty hall where a team of 'draggers' and 'sorters' got the fish stacked in boxes, ready for the merchants to buy at auction. The work is well paid if you put in the hours. 'I'll work twelve, fourteen, eighteen hours a day,' said a lumper, 'because I don't know if there will be work tomorrow.' Days and sometimes a week or two can go by without work. Another told me, 'It's all part-time jobs here, it's a part-time country.' When the gangs and teams require extra labour, it is difficult to recruit good hands who will work at top speed through the coldest hours of the night, so unused to hard work are the youngsters.

The local union used to be a closed shop. 'It was hard to get a job down here, it was like the Mafia but without the violence,' said Frank, who'd been working as a carter for thirty years. 'That was the one thing that was positive that Maggie done, but now the bosses are working us too long hours. There's no insurance, no regulations, no laws, no tax.'

I asked a young lander if I could take his picture.

'Sorry, no pictures for security reasons.'

'I've got security clearance from the harbour authority.'

'No, social security!' Everyone laughed.

Like the industrial museums of Halifax and Bradford and the former pit villages of north-east England, Grimsby's National Fish Heritage Centre is a modern mixture of museum and garish fairground where visitors can 'experience' a typical trawler trip to the fishing grounds of the North Atlantic. In many of these places, noises and sometimes smells are included and visitors are encouraged to play with interactive displays, twiddling knobs and pushing buttons. Bygone industries are turning Britain into a theme park with a modern profit for a few. The armies of workers – blacksmiths, platers, ironsmiths, riveters, fitters, electricians, plumbers, shipwrights, caulkers and joiners who built the trawlers, engineers who overhauled the engines and realigned the propellers, boiler makers who re-tubed the steam pipes, chippers and painters who spruced up the 'old rust boxes', tug boat crews, crane drivers and transport police in the fish dock, compass adjusters, sea chart suppliers, medical staff in the port, 'needle-fillers' and net braiders at home – exist only in sepia-tinted photographs. Fish and chips, a part of Britain's national identity since 1865, could become a distant folk memory set in a display box which can be smelled at the press of a button.

Brighton, like Grimsby, rose from a humble fishing village, but that is where the similarities end. Beginning in the eighteenth century Brighton became a fashionable seaside resort with piers and a Royal Pavilion. A defunct hydraulic tower in the style of Siena's Palazzo Pubblico is Grimsby's only monument of any note.

As I drove into Brighton I passed bowling greens with men and women dressed in clinical white outfits, and property boards signposting houses for sale by a company called Dez Rez. At the seafront I was struck by the fine Regency buildings; but I soon discovered that behind this façade Brighton, like much of the Britain I had visited, was in serious economic decline with social deprivation to match comparable sized towns in the north of England. Starved of investment, the West Pier was marooned at sea, the donkeys had long ago been put out to pasture and the horses' dilapidated seaside stables converted

by homeless people into shelters where families and transient friends huddled together under blankets from the cold.

In a former fisherman's arch I found a group that had been established to help young gamblers. They brought me tea on a wine case cover marked Grand Vin de Bordeaux.

'We get ten members of the media contacting us every day. Don't get me wrong, we're not trying to be unhelpful – not talking to the media is our policy. Why should the young gamblers with problems speak to you? Now if you were going to pay them £15 I would ask them if they would want to,' said the youth club worker. Several days later I was contacted by their head office; they said they would be willing to help, but added, 'The south gets too much media attention.' In the north they had complained that the north was getting too much media attention, and yet here in Brighton as elsewhere, if you walked away without a story they craved for you to do one – on their terms. Publicity was their life blood. Some voluntary organizations reminded me of the worst forms of censorship I had found in some developing countries, where government press officers shepherd you around and try to manipulate the tone and content of the story. I decided to go it alone.

I stayed in a students' flat on Marine Parade with glorious sea views that inspired artists such as Constable, Turner, Sickert and Ruskin Spear. The students suggested I walk along the sea front to Whitehawk, a neighbourhood that was separated socially and economically from the city centre's regeneration.

Whitehawk estate is sandwiched between Kemp Town racecourse and Brighton marina. The day was particularly bright, the sky was dazzling and the sea shone like glass, but the warm sun had disappeared by the time I was faced with the chilling reminder of what it is like to live in such a neighbourhood. On a piece of ground beneath the racecourse children played with scraps of building materials, while a dog lifted a leg on the charred carcass of a vehicle stolen by joyriders, its contents stripped and smashed. I tried to enter into a conversation with a youth sitting on a brick wall with a baseball bat half-hidden behind him: he was in no mood to talk. I walked past the estate's only community facility, a family social centre, vandalized and derelict with little or no money to rehabilitate it or to run activities within. In the

middle of Whitehawk's main shopping street is the neighbourhood's only pub which had been boarded up and rendered derelict by arson attacks.

The terrace of shops was a rainbow of nationalities: an Italian cafe, Asian newsagents, and a Liverpudlian chip shop. I went into a greengrocer's and spoke to the owner, a local man. He told me he couldn't employ young people because 'they can't add or multiply. They need a calculator, we're old-fashioned we do it in our head. All I can say is I'm glad I'm not just starting off.' His son was working as an apprentice in a design studio for £1.25 an hour. Outside the shop at a road junction I found a group of lads smoking a joint. They didn't want a rubbish job, just to get a bit of money. 'Sit down and sweat is not for me,' said one of them who had just left school. A second lad said you need a college degree to work at Asda: 'I don't think it's worth it myself.'

'Most jobs are YT, you get £34 so I get more on the dole.'

Simon, the oldest of the group, had lost his job as a kitchen porter. 'It's just a case of finding work. I'll take anything that comes. I can always get money, I usually borrow it, there's always someone's giro.'

'What activities do you get up to?'

'Normal ones: puff, E's, ganja, trips, whizz, pink smarties.' Not one of the four boys smiled; they sat staring ahead or at the ground, barely lifting their heads to answer my questions.

'Do you go to the shops?

'The Paki over there.' A car roared by, possibly doing eighty miles an hour. A mother down the road by the shops had grabbed hold of her child's arm violently as he approached the edge of the pavement.

'What about football?'

'I support Sheffield Wednesday.'

'Why?'

'Because my dad supports Sheffield United.'

On my second day in the neighbourhood I found Simon and two boys sitting in the same place. They passed a joint round and Simon gestured to offer me a drag. He agreed to take me to see a local dealer and we went to a semi-detached council house with a small front and back garden.

There I met Gerry, the drug dealer. His girlfriend Susie came down

the stairs dressed in a bathrobe. 'She likes the glamour of the crime,' said Gerry, introducing me.

'I'm bored,' yawned Susie. 'I'm not going to exist today. No mail? I only got out of bed 'cause I heard an American accent. It's a bad neighbourhood, you better be watching yourself,' she warned me.

'Her brother went to Oxford,' said Gerry. 'On her step- or is it half-brother's side she's got six mothers and seven fathers. Now her mother lives with a Brummie – I don't know if she considers him a father. It's a lovely big family. When they go to the pub, he doesn't have to pay for the drinks, the landlord's too scared.' Susie went back to bed. 'She doesn't mind sleeping in all day and smoking ganja.'

He gave Simon and me a cup of tea. His living-room was spartan. On the wall above the fireplace was a Thai mask and next to it a West or Central African standing figure. On the opposite wall three ducks floated towards the ceiling. The Scandinavian furniture was from IKEA, and on the all but empty shelves there were two books by Wilbur Smith, the Macmillan Encyclopaedia and the Oxford Minidictionary. On the floor next to a modern steel basket filled with rolled up posters was a mobile phone and answering machine.

Simon suggested Gerry show me his spare bedroom. 'You can bring your cup of tea with you,' said Gerry pleasantly. We climbed the stairs and he opened the door to a pharmacopoeial garden as dazzling as the sky outside. The windows were covered in transparent polythene. 'That's to stop people from seeing in, but it still lets the light in,' explained Gerry. 'I nicked the sodium street lights from Bournemouth. With that light the plants are growing great.' He pointed to the beds of weed in his tropical greenhouse, then pulled back partitions made of dustbin liners and opened the wardrobes which were lined with silver foil. 'I wanted red light for flowering, I got all the leaflets on lights, I've tried covering lampshades with foil, but I'm sure there's a better way. I have the heat on all day, around thirty to thirty-five degrees to get a very hot and humid atmosphere. Most people use jump leads from the mains to the socket so that they can fiddle the meter. I do mine a different way, and I got this brilliant timer from the council heater to use for switching the lights on and off.'

'Aren't you afraid of being caught?'

'I've only just begun growing my own. Up to now I've had it under

the floorboards and the police dogs aren't trained to sniff pills or smoke – northern lights, but a lot of my customers are into bush stuff and most of it is stashed elsewhere. I've had a couple of close shaves. The police were here a year ago, they lifted my posters out of that basket to see if there were any drugs hidden in it, but they didn't find any because they were hidden in the bottom of the rolled-up posters. I now sell to a couple of coppers, one's become a good mate, buys a tenner every Friday.'

Gerry invited me to return later that day. 'It's too early to be doing deals. If you come back late afternoon you can see for yourself.'

Woodingdean, still part of Brighton, is situated three miles further west. If Whitehawk's residents consider themselves excluded from Brighton, Woodingdean's residents, particularly the young, reckon they are living in the South Coast equivalent of Siberia or Outer Mongolia.

From the top of Whitehawk and Kemp Town racecourse to Woodingdean the landscape is empty. Crossing the South Downs the racecourse's grandstand glints weakly in the distance. Woodingdean is on the outskirts of Brighton, but it felt like a separate town. Its mixed housing estate, perched on the Downs, looks like an ordinary housing estate: the housing is varied, with some private, relatively expensive homes adjacent to council properties some of which have been bought by their tenants. The blocks of flats are primarily for elderly residents. Woodingdean had grown from a hamlet of about two hundred people to around 14,000 residents in just over forty years. There used to be a Sunblest bread factory, a furniture manufacturer, four banks, three doctors, three butchers, a baker and three greengrocers. Now the factories and manufacturers have nearly all closed, there are few shops left, the baker has gone, and there is only one doctor, one butcher and greengrocer and no bank or building society for its 14,000 residents: the nearest is in Rottingdean, several miles away.

The estate is often used as a short cut for the students and staff of Sussex University on their way into Brighton town centre. The only time people stop is at the single set of traffic lights. The only public transport into Brighton is a limited and expensive bus service, which was beyond the means of many of the young people I was about to

meet. It was cheaper for them to get high on drugs than to get to and from Brighton town centre on the bus.

The young people were easy to find: they congregated in groups on a street corner near the off licence, outside the fish and chip shop and in the poorly equipped parks. I had thought that transferring my journey to the south of England would help me to shake off the sense of oppression I had felt on witnessing the lives and futures of young and old people alike in the north. I was quickly disabused.

I met a group of mothers who had set up their own project to get the children off the streets and stop them intimidating pedestrians. They called it the Green Van Project and they travelled around their neighbourhood pulling up to the pavement whenever and wherever they saw groups of young people. They dispensed advice, lent an ear, joked and teased them. Like Anne, the lollipop lady in Newcastle, and Big Frances in Glasgow, there was no shortage of heroines. Sometimes the children flagged the van down and it was also a means of taking groups of children to leisure centres and skateboarding parks. Like many of the neighbourhoods I had visited there was a code, a sort of Geneva Convention among the youngsters. The women who worked on the van had earned their respect. But with that innate sixth sense of a grown-up's mettle the children knew which ones were weak and could be exploited and which ones were strong and could be trusted.

The children who came towards the van like homing pigeons were often too high to be in full control of their faculties. Some of them came over hands in pockets, shoulders hunched. A fifteen-year-old dropped his cigarette as he leaned into the van to say hello to Margot. 'Where the fuck did that fag go?' He searched blindly on the ground, his hands sweeping over the pavement, his gaze unfocused and out of synch with the rest of his body. 'Give us a fag, Margot,' he pleaded. Behind him one of the boys kicked a tin can across the street and into the gutter. They shouted at friends and abused pedestrians young and old. As two young girls passed one of the boys yelled, 'Two Babes!' All these youngsters were smouldering volcanos waiting to erupt.

'Don't eat, don't interest me any more,' said the boy who had given up retrieving his cigarette. 'Even me mum is moaning that I haven't eaten for two days.'

'He's off his nut,' said his friend.

'You can get off your nut because everyone else does,' said an amateur athlete, trying to reassure him. 'Do you know they don't do drugs tests on amateurs? I've travelled to Brighton, Hove, Rottingdean, London, Portugal, South Africa, different cultures, it's a different buzz,' he explained to the group of young boys and girls now clustered around the van.

'What's that scar across your cheek?' asked Margot.

'I kicked this guy who hit me girlfriend. I didn't mean to. I was off my nut, on sniff and all that, I didn't mean to hit him, it just happened. I've been doing drugs since I were ten. I don't think I've lost it. I could live to 135. I've never stuck a needle in. Never would. Sold birth control tablets, asked me girlfriend for her month's. Now it's bareback riding, straight up her. Makes my dollar and pays my rent at home. Sell a bit of drugs, get a little power. Worked for a businessman who goes around in his helicopter, I'll never earn that much, some deal to try and get there. I'm sorting my head out,' he said wistfully.

Margot warned him about the risks of unprotected sex.

'If you're snogging and then going at it, I ain't going to say I'm going to put a rubber on. She's going frantic, pluck me. I'm not going to say hang on you're going to have AIDS.'

The young men smoked and drank cans of lager, Margot and Joyce at the wheel of the van asked the underage children to throw the cans away and stop smoking. One of them leaned into the van and squeezed Margot's hand so hard she had to kick him to get free. She was nearly in tears of pain from the cut her ring had made into the adjacent finger. She closed the van's sliding door and we drove through Woodingdean. Some of the youngsters hailed the van and we stopped. Unprompted they'd complain they were bored, they had nothing to do. They wanted to do something exciting.

Simon sat on his bed under a poster of Freddie Mercury. Occasionally he looked out of the window, beyond the hostel's garden where grass sprouted forlornly, to the graffitied end wall of an abandoned house. His shelves were empty except for a solitary birthday card. Simon was mild-mannered and intelligent but he had the look of a man possessed by an anger and grief from which there was no escape. As he talked he smiled and cracked his finger joints. He made me a mug of tea

and asked me if I liked the pop group Queen. I asked him about the burn marks on his arm.

'My dad says I got scalded.' It was the beginning of a tragic story about the consequences of a lifetime in care, a lifetime without parental love and guidance. 'My mother kept getting us, me two sisters and myself, back from care on the condition that she cleaned up the house, but I kept getting kicked back into a home, she thought I might be too much of a handful. She never put the girls away again. I was placed in care permanently when I was five and it was only much later when I was thirteen that the social services found me foster parents in Somerset.'

As Simon's story unfolded it was impossible not to feel the hurt and damage and the tremendous burden of guilt that he carried with him. He was twenty-five years old and he clung to his school reports, bus and travel tickets, photographs, police statements and social service reports, along with the numerous attempts to make contact with his mother and father, as cairns marking the passage of his life. When he was arrested and jailed in Spain and Portugal his accomplice wrote down the day-to-day events of their European tour in a journal. I read the daily catalogue of breaking and entering shops and supermarkets and holiday villas: sometimes they burgled the villas while people were still sleeping, or if they were unoccupied they cooked and slept in them. When they wanted to move on to the next resort, they stole mountain bikes, cars, delivery vans or travelled without tickets on trains.

I only became aware that Simon couldn't read or write when he handed me a confidential social services report written twelve years before. He told me someone had read him the first page, but he had never found anyone to read the remaining three. The report begins in July 1972 when Simon and his two sisters were first received into care when their parents gave up the tenancy to their home and moved in with their grandparents. Two months later the children were returned to their parents. In March 1973, the report goes on: 'Simon was found sleeping on a single bed which was soaked with urine and there were faeces on the floor and walls. While Simon and Julie (Simon's younger sister) were in hospital for investigation into possible non-accidental injury, they were sedated at night because they climbed

out of their cots, and the hospital found them very difficult to control.'

They were returned to their parents, but within a year his father had left home and gone to live with another woman. Neither Simon's mother, father nor stepmother were prepared to look after him. A 'very caring and experienced' foster mother was found, but she could not manage Simon's difficult behaviour: his stubbornness, his naughtiness, his soiling and wetting himself day and night for which the report said, '[he] could hardly be blamed as he had suffered so much rejection.' Rejection included a mother who failed to collect him two weekends in a row when he was ready and waiting for her at the school entrance and a father who failed to keep appointments to visit and left Brighton for several years without informing him.

As I continued to read the report Simon began to talk about his past. 'When yer parents split up,' his voice was soft and gravelly, 'you want to grab attention, shit yer pants, piss yer bed, shit like that. I started running away from school to visit my mother and stepmother who'd left my dad. I couldn't concentrate on anything, I was always feeling so uptight I couldn't listen in classes. I couldn't understand why I had to be in care when I had a father and mother, two sisters, a stepmother and four "sisters". I injured the youngest girl at the school by putting razor blades in her bed. I started shoplifting and went to court charged with the theft of torch batteries and breaking gravestones. I don't know why I did it, I just did, it was stupid.'

I was trying to listen while reading the last page of the report. 'Simon's parents have not been consulted regarding fostering at this point as they made it patently obvious throughout the years that their attitudes to his welfare have been totally selfish and they have little or no regard for his well-being. I feel that if necessary a family from anywhere in the country should be considered.'

Simon showed me photographs of John and Brenda, his foster parents, outside their vicarage in Weston Super Mare. 'My foster-father is a Reverend but I call him Batman because of his clothes and he calls me Batboy. My foster-mum says I can call him John or Mr Hayward or Reverend. I get on with my foster-parents, they're Christian believers, they got me converted. I ring me foster-parents, I keep in touch when I can. But I liked my stepmum. For eight years I kept running away to see her. My dad married twice while I was in care,

my stepmum has a photo of us with my face scratched out, gospel truth. When she got married to my dad she was jealous. I was angry but I couldn't scratch her photo out. I got to really like her. I wished she were my real mum.' As he talked he showed me snaps of Weston Super Mare, the sea front and the town.

'After school I came back to Brighton because I wanted to see my stepmum and dad and real mum. I did a lot of stupid things. There was a racing car in a hotel garage, I let the tyres down to piss 'em off. I was slightly bored. I locked the doors to the football club's toilets, bent the bars out, let the window drop without smashing, then I climbed out of the window. I got hold of the window to force it closed. It was like that for five days, till they could unlock it. I did some daft things. I did something tight to an old geyser. I found a little part-time job as a gardener which was advertised in the post office. One day I found the window was open, I climbed in, he had some antiques and all that, I decided to look through his trousers to make some extra money. I found an envelope with £250 in it. What would you do? I asked myself. His missus had just died so I took £40. I don't regret it, he was paying me naff all – £1 an hour – so I decided to take interest of £40 off £250.

'I moved back up here in 1989. I had me own place in 1990. Had a few prats in, a bit of smoke, even using my flat to bring stolen goods in and get rid of them next morning, all that palaver for a year. I packed the flat in, I couldn't be hassled with it all the time, it did me head in, had too much energy to burn off so young, get out, be wild – you know what I mean.

'I don't have a lot of friends. My next door neighbour comes around to ask me if I've got some smokes. He's a right fuckin' arsehole, gives me grief about my music, no respect. He's lived with his parents, he's never been wild. He's always had someone to look after him.

'Bob is my best friend, went all over Europe doing jobs with him.' Simon cracked his knuckles, a grinding sound, gristle on bone. 'Bob was always running round shouting "Enculé." "What's wrong, Bob?" I'd ask him – obviously if it was "enculé" it wasn't good. He spoke excellent French. It was easy for me to learn. The first time I went on the ferry it was the biggest buzz in the world. Ferry going side to side, it was really excellent. Over there for six weeks, did loads of villas and

brought loads of goodies back. You know what I mean. Every time I did a place, I'd get worked up, excited. Have a shit on the floor. I can't explain it. You'd get this mad rush, like smoking hash. Damn worked up. You gotta release a dump of shit. Did a gas place and church, nothing to nick just a fuck around. We started nicking from superstores, bakeries and Carrefours – that's like Safeways – even restaurants and bars and houses. I'd walk into this place and say, "Have a shit as well, Bob?"

'The nicking's just a mad rush, you get put away if you get nicked, you can't get a job apart from maybe a gardening centre or the council. It's really bad, that. That's the way they get treated when they get out. I've been made redundant because I did this, did that, so they blamed me. It's better to do it abroad than here, at least you can sign on or get something because otherwise they don't trust you. I loved my last job as a kitchen porter. I got fed and got to bring other people's leftovers home. I especially liked it at Christmas, the banquets and the Christmas dinners. When someone's passport went missing I was blamed. Here you gotta respect other people's property. Abroad it's daft, it's an adventure. You gotta live life what you can before you get too old. I do quite a few jobs here. It's a gamble – if you don't get nicked, you don't go to prison. I've finished with going abroad. I've got to think of positive things. I've been trying to convince myself the things I've been doing are not very Christian. Back off a bit. It's like being baptized again, you know what I mean.

'I can't write, because of skiving from school to see family. I can read a bit, it's getting better, I can say that. What am I fuckin' doin'? I should be at college learning English.

'I've fucked it up in a seriously big way. Like when I came up from Somerset and the children's homes, I should have gone back to Somerset to my foster-parents. I would have got a decent job and me own place and been able to read and write better. I had so many good friends. I'd be okay. I do regret that. My family aren't really interested in me. I've tried to see my mum – I go to Lancing every couple of months but she doesn't want to see me. She no longer answers the door. Gerry, you could say my stepdad, does. The first time Gerry answered the door, he went into the house and said, "It's Simon", and I heard her say "fuck", "shit", "tell him to fuck off". I hadn't

seen her for two years. The last time I went round I did get to see my
mum but she said she was sick. "Why don't you come back another
day, I don't feel well," she said. She's never sick when I'm not around.
Just an excuse for me not to see her. She can't be arsed to see me, it
wastes my time and money to go and see her, that's what it's like with
the stupid woman. My dad lives in Brighton or somewhere in the
Brighton area. He's on his third marriage to a younger woman – I no
longer know how many brothers and sisters I've got. I haven't got a
clue where he is, and to be honest I can't be bothered to get off my
arse to find him any more.' He cracked his knuckles again and fidgeted.
'I do mention my address to everyone I meet in case they see him.
But I expect that if I got to see him it'd be, "Right, okay, 'bye."

'I once met up with my dad, we walked around town together, and
believe it or not, he introduced me to people as the oldest of all of
'em, but he doesn't care at all. I came back to be accepted by my
mum, but it doesn't matter how hard I try. It's still like a concrete
wall in my fucking face. What pisses me off, Nick, is I'm not asking
to move in, I'm just asking for a bit of respect, to acknowledge me,
that I exist. She might blame me for the divorce. What could I do? I
was only two years old. I always wanted to know my mum, I want to
know the truth, it's not all my fault, I was so young. That's what
happens when families split up, they go senile. My mum blames dad,
me dad blames me mum, my stepfather blames me dad. I want to
know more about it, I want to know what happened. I'm old enough.
I'm really curious to know what happened. Not the social services
with pen and paper. It's like part of my life has been blocked out,
never know what it is. It's not like I'm going to turn. They once blew
up for no reason. There's more than meets the eye. I could understand
them better. I'm dying to find out what really happened. No one will
tell me. It's like going on a holiday trip, you want to know how did
it go? What happened? What did you see? It's just annoying they can't
tell me, it's been over for the past twenty-one years for me. I'm sure
those who've had a good or bad childhood, their mums and dads tell
them about their past. Some might not want to know. That's all it is.
It's part of what's missing for me and I'll never know.'

I looked at Simon as he cracked his knuckles again. There was
something so warm and yet so famished about him. He wasn't a bad

boy, just a sad, lonely boy who carried enormous guilt and was filled
with self-reproach every waking and sleeping moment of his life. He
could not have been friendlier and, considering his self-confessed orgy
of burglaries, the fact that he could not pay for his television licence
preyed on his mind. He looked up. 'I'm getting cheesed off with the
dole. I'm getting to the stage where I want a job, earn £100, £150
a week, a decent wage and be able to start buying some Queen
videos.

'I think I'm a good lad. I think . . .' he stopped mid-sentence. 'I
think I am, but nobody wants to be close to me.'

Gerry's telephone and mobile were ringing at the same time.

'Give us twenty minutes?' he requested the caller on the telephone.
'Are you still at the garage? . . . Which garage? . . . Upstairs . . . The
pub. I'll meet you at ten past eight . . . What did you want? . . . A
Louis of Moroccan? Come on, I'm not going halfway across town to
give you a Louis of Moroccan!

'For fuck's sake, I can't be arsed to go across town for a tenner,'
replacing the receiver and tapping into his mobile. '. . . I don't have
it tonight. I'll have the bush tomorrow.

'The phone and the mobile haven't stopped ringing, it's always like
this in the late afternoon when people are coming home. I like to be
finished by half-eight, time to shower and go out.' The telephone was
ringing again. 'Nick, sit yourself down.'

'. . . Grant, bear with me, I've got another call.

'. . . Who's that? . . . Hello! . . . Oh fuck, me machine's broke.

'. . . Grant? Me call waiting button's fucked.

'. . . Grant? . . . Grant! . . . Who's that?

'The whole fucking thing's fucked up now.' The telephone was
ringing again.

'. . . Peter is that you? Me call waiting button's totally knackered. I
lost both of you . . . What? . . . Let me get it straight: a half of bush,
a quarter of red, a half of skunk, a Louis of red.' He hung up.

'Don't you write anything down?' I asked.

'No, sometimes I'll miss someone out. Next day someone rings and
I think, "Oh shit, I forgot" and they were waiting outside.'

The telephone was ringing again. '. . . It's you and only you . . . The

bar. What time can you get there for? . . . See you half-eight . . . 'Course there is.

'. . . Fuckin' 'ell.'

Gerry's business was booming and I sat in the living-room as Susie cut up drugs on a worktop in the kitchen into Louis XVIs, Henry VIIIs, Audi Quattros, Arthur Askeys and Wizards of Oz – quantities of cannabis, skunk and hash. Some of their regulars came to the back door. Susie explained, 'If the gate's open they know we're open for business. We don't have to worry about the neighbours who look on to me from the back there. I know every one of them.'

'Susie, I need a tenth and an eighth of red,' said Gerry from the living-room.

'I'm getting the tea,' said Susie. Like Gerry she was wearing Armani jeans and a white tee-shirt, which boosted their Ibizan suntans.

'Fuck it,' said Gerry. 'I'll get a half ounce and chop it up myself.' He didn't bother with the digital scales for weighing gold, which he'd bought off a Jewish gold merchant at a car boot sale. 'Where are the bags?'

A customer who was waiting for Susie to finish pouring the tea handed Gerry some little self-sealing plastic bags.

The sheer ordinariness and regularity of young men and women dropping by was startling, as if they were popping in to see a favourite cousin who was dispensing slices of birthday cake.

As if reading my thoughts, Gerry said that if the government legalized drugs they'd hang a sign over their door: 'Established since 1979, purveyors of fine Red . . .'

'The business has been doing great since we opened up at home, it's done the Indian shop in, no one has got the munchies any more, they just nip in to the Indian to buy pints of milk or a four-pack of Stella. He sells loads of skins, packets of Rizlas. He's not going to talk to the police, he won't hand me in, because they've got loads to hide.'

Gerry offered to take me on his rounds. As we left the house the answering machine clicked: 'Hi Gerry, you're out, I'll try the mobile phone.' The first stop in the car was for a middle-aged man who bought a tenth. 'Must go,' he said, leaning into the car, 'I've got the kids at home.' We pulled up at a bus stop where there were three

youngsters, one sucking on a lollipop. 'He'll be a hairdresser, or at least he will be in two years,' said Gerry, who told me he didn't sell to children. The next customer was the son of a doctor in a comfortable flat in town. He gave Gerry a watch: 'We've been best mates since we were six or seven.' Before we reached his next client the mobile phone died. 'It's meant to have an eight-hour battery, normally it's okay, I get up at twelve and it takes me through the day, but today I got up at nine. I try not to show outward signs of money. I drive around in this shed, a good car would be too on top. You've got to think of everything. I use me mirrors a lot, turn right and see who's following and all that shit. I could always become a cab driver.'

An electrician next: 'Sorry Gerry, I don't have enough money. Can you do me another lay-on?' Gerry agreed and handed him one of the small haberdasher's pouches. In the car he told me, 'It's the only list I keep, for lay-ons and money distribution, it's hidden behind the skirting-board. My largest lay-on has been £1700 but most of them are for around £10 or £15, I've got about thirty of those, but I also give me friends the money I make so I'm not going to get caught with it and I can't have anything in my name. When I've made 30K, I'm going to quit and buy me own shop or start a business – that's what you need to start one these days.'

In an hour Gerry had made six deals and reckoned he'd taken about £45. 'It's been a slow evening. Everybody's on something and into doing a bit of dealing. Most dealers are pretty settled with their regulars – I call them me clients – but I'll do a bit of poaching. We've also got to watch the stash nickers, "tax men", they follow you to see where you stash your goods then they nick it. That's why I call them the tax men: every businessman has his taxes at the end of the year, so drug dealers have to expect to pay some.'

When Gerry finished his round he took me to his supplier. 'Procter's got loads of money, he takes bigger risks, you've got to to make his kind of bread. Doing small deals you can make as much, but it's twenty times the work.' We pulled up to a refurbished Regency house with expensive flats and an intercom system. On the pavement smartly dressed children hopped on a pogo stick.

Gerry pressed the intercom: 'Rat One to Rat Two.'

'Why rat?'

'Because our friends think we were shagging other girls when we had girlfriends.'

Outside Rat Two's door we could hear his mobile ringing. 'Procter, it's Gerry. We're outside your door! Rat Two, it's me!'

Procter answered the door. 'Hi Gerry. Who's your friend?' Gerry explained.

'No real names or addresses,' I explained.

'You're going well under if you do.'

'Long as it's not concrete,' I joked.

'You'll be six foot under the new part of the train station.'

The conversation was no longer stiff and cold, like the edge of a bread knife, perhaps because he had made his threat clear.

'Sunshine, Alex just gave me a tinkle,' said Procter. 'Told me that very cheap stuff was horrible, people started complaining. It's taken me a long time to sell it and I've still got more of the stuff.'

Procter's flat could have made the pages of an interior design magazine: a fine Le Corbusier steel, wood and black leather recliner, a Joe Tilson lithograph, several tall stacks of CDs. He had once worked as a Ministry of Defence laboratory technician checking armour and paint specifications; before that, as a paratrooper, he used to train people to shoot. He was smartly dressed and the only outward sign of his army life was a Protestant tattoo with the words 'No Surrender' tattooed under a sword piercing a heart. As I sat on the sofa, Gerry and Procter talked business.

'Ethadrine's a sleeping tablet with a whizz effect,' explained Procter in a voice as smooth as snake oil. 'If you're E'd up on a Friday and you go out on a Saturday, take five or six Ethadrines and it kicks you up again. It's not as tense as whizz and it doesn't kick your head in.' He had testers – samples of everything. '£50-worth of these and you can sell them for double.'

Gerry left without concluding any purchases. In the street he confessed he only had fivers and tenners, which would have looked silly to Procter. 'It'd break my mother's heart and my father would disown me if they knew what I was up to. She's a VDU operator and my dad's an engineer, but they've both been made redundant. I tell me mum I work on commission, I tell her I'm up in London on Thursdays

and Maidstone on Saturdays. They want me to settle down. They have three sons and no grandsons. They want me to have a steady job.' He added, 'I'm worried I'd be in the newspapers, I think I could manage prison.'

We entered a pub with loud music that made conversation difficult. 'Nick, meet Chris, James, Simon. What will you have?' said Gerry, pushing his way towards the bar.

'Gerry, I saw the most beautiful girl in Safeway's the other day,' said Chris, shouting over the music. 'Well, I saw her tits first, the tits are more visible when there's summer weather. Then I looked at her legs, fantastic, then her face, gorgeous face. But what do you say to a girl at Safeway's salad bar? Her husband and kids might have been in the next aisle. So pretty, so beautiful, a bit light, like a breeze would have blown her away.'

Gerry bought everyone drinks and continued to do so throughout the evening with his crumpled fivers and tenners.

'I don't smoke draw any more,' said James.

'I abstained, but it didn't last long. I'll reabstain again,' said Simon.

James worked for the British Council in London, Chris was looking for work and Simon worked for an insurance company.

The pint glasses built up on the counter and I later discovered Simon had spiked one of them with a quarter of a sheet of acid and switched the glasses around. It was like a three-card trick, with acid instead of the king of diamonds.

'These places are so boring,' James complained, 'once you've been here E'd up. I find I can only come back on an E or two or three, otherwise I stay away. Better to have never taken one.'

Gerry had a lot of friends. They came up and chatted to him, sometimes he'd buy them a drink. I stood opposite Julian whose features were soft and fresh, almost pre-pubescent, with mesmerizing sky-blue eyes the like of which I had never seen before. He wore a tee-shirt which read 'Million Dollar Babe'. He picked up on Gerry's tales of London.

'London just appeals to me,' said Julian. 'It's ace. Big shopping malls. Traffic. Big buildings. Brighton is too trampy, like. Not clean. Tramps are all over the place and people think you're a rent boy. There is a positive thing, plenty of gay bars and clubs to go to. A lot.'

I asked about his tee-shirt. 'I abhor the idea of a relationship. I like
the idea of dancing and teasing. Around here I'm known as a tart, I
bet every gay guy around here would say I'm a tart, but I'm only
seventeen and too young for a relationship – if I had one I'd feel
trapped, you could say I'm fly-by-the-seat-of-my-pants. That's why
I'm called a million dollar babe, because you've got to have a million
dollars to have me. It's totally true.'

Unlike the others he didn't smoke, do drugs or drink, 'I'm a choco-
holic. You know those 170 gram Cadbury's Dairy Milk? I'll have two
of those a day. I'm surprised I'm still a beanpole.' I found it difficult
not to stare at those piercing deep pools of his eyes, and I wasn't
alone: everyone else who came into contact with them was bewitched,
not just the gay men. (Julian referred to them as 'Marys'.)

Julian asked me about my work and I told him about going to
Whitehawk and Woodingdean. 'I wouldn't recommend a gay guy to
go there. I'm a fairly effeminate guy, so if I see yobbos I butch it up
a bit and don't look at anybody.'

Brighton was full of half-fashionable, half-artistic circles of people as
well as a large community of elderly people who retired there in search
of a tranquil existence enhanced by the sunshine and sea breezes; but
the town also had one of the highest proportions of people sleeping
rough, who had come in search of jobs and warmer weather. Among
them were artists who tagged walls with street dialogue, the local
council always one step behind, as were rival artists who often daubed
out graffiti to replace them with their own. Taggers could get very
territorial. One piece stencilled over the painted silhouette of a private
eye read: 'If you try to understand the universe you'll understand
nothing. If you try to understand yourself you'll understand the
universe'.

The large gay community, like the elderly and the homeless, came
from all over Britain in the hope of finding security in numbers, but
it was often illusory. Soon after I arrived in Brighton there was an
attack by two men wielding machetes in a park known for cruising
and two gay men were injured. Ten men reported the incident to the
police, but none of them would come forward because they didn't
want to reveal their identities. They were often 'respectable' married

men: teachers, social workers, local politicians, solicitors and account-
ants looking for anonymous sex. Previous attacks which had been
published in the newspapers or on television only led to further
assaults. The machete incident went unreported and the following
night gay men were once again the target of random assaults: this
time the police responded quickly, the men were apprehended and
two witnesses came forward.

On my way back to take pictures of Brighton's marooned West Pier
I passed a red and white caravan set up on the promenade by the
Labour Party. Two young blond models, wearing red sweatshirts, black
riding boots and pearl necklaces, could have stepped out of the pages
of *Country Life*; when one handed me a copy of the party's *Rolling
Rose* newspaper, I asked her if she voted for Labour. She told me she
had been hired by a PR agency. 'This is a job we have to do, it doesn't
matter which party we work for,' she said in a county accent. Labour
were making inroads with traditional Tory voters. They were organiz-
ing garden parties and a draw with the prize an all-expenses paid trip
to meet Tony Blair and John Prescott in London for tea. The caravan
played Latin American salsa music and a party stalwart sold sweatshirts,
coffee mugs, baseball caps, keyrings and lapel pins to several young-
sters. I had noticed in the former industrial towns and cities of the
north of England that among Labour's core voters, the poorer house-
holds of trade unionists and industrial workers, they no longer
expected Tony Blair or his Labour Party to defend their interests. They
felt they had been abandoned in favour of intellectuals and professional
high earners from middle-class constituencies. From this evidence they
seemed to have judged correctly.

The afternoon sky was motionless. The cloud cover seemed like a
steel curtain welded on to the horizon. Several times it looked as
though it was going to rain, but the raindrops were lost in space before
they reached the ground. I followed the road from Whitehawk and
the marina along the coast to Rottingdean, a village with verdant
stretches of perfectly manicured grass punctured here and there by
quaint cottages which had once been home to Rudyard Kipling,
Edward Burne-Jones and the chairman of Reuters. Tourists now
patronise its tearooms and pubs. From the village green with its pond
and memorial to those who had perished in the two World Wars the

road climbs gently as the horizon closes down on the heights of the Downs where one of Woodingdean's parks was situated.

The park's popularity as a young people's rendezvous may be accounted for by the free access, no warnings to keep off the grass, and no parents to supervise them. There are now clusters of youths where urban lovers used to sit or stretch out in the late afternoons and evenings kissing and fondling. The grey daylight found its way sparingly into the park and among the clumps of trees where the forms of youths absorbed some of the deepening gloom. As I approached them I felt their glances glide by me and turn back on to the object of their desire – the cone or bong at the centre of their circle. Their glazed eyes showed no suspicion, but were cold as the grey day. They stared at the banks of mist that were beginning to form on the horizon. The sense of desolation was both inside them and in the gathering gloom. Each person assailed by feelings of guilt, chagrin and disappointment kept his own discontent to himself like a guilty secret. Torpor stole over them as they swallowed or inhaled moments of ineffable bliss. They felt secure and tranquil, lulled into a state of harmonious indolence. Only a ghost of their former boisterousness remained; the weed and pills were the safety valve through which their discontent could be dissipated. Some lay on the grass, their faces masks of unconcern. They were guests, if only for a few moments, of a kind of respite, a moment of oblivion, a truce, a reprieve – and why not? they would ask. It was an escape from the despair of boredom, the despair of the future, of everyday life, into some half-real, half-imaginary reality.

'Fuck off, Mike!' said Pete as Mike came crashing on to his lap like a tree that had been felled.

'Think drugs, talk drugs, eat drugs,' said Mike with slurred speech, trying to get to grips with his body, before slumping in the opposite direction into a pile on the ground.

'Mike'll take anything that doesn't say, "You will die". He's done every kind of smoke, every powder, every pill you can imagine, he'll pop the lot,' said one of the three girls in the group. According to Pete, Mike often treated his body as a laboratory for exotic pharmacological experiments.

Pete explained he couldn't go downtown. 'I got into a fight and

some kiddie got his throat cut, he thought it was me. One of his mates got me a week later with a bottle. I won't press charges – if he gets done and gets out he might give my name in. There's already people looking for me because he's been arrested. My mum can't cope with it. I try and blank her.'

Pete wasn't the only one who was afraid of retribution. 'Tommy passed on some bad trips doing his mate a favour, he got a death threat over the phone. "I'll carve you up," he was told. For the sake of £2 it's not worth stitching them up. He didn't dare go to his best mate's funeral who died from a car accident in case he'd be seen.'

Luke, a giant fourteen-year-old who was the youngest of the group, started swigging from a lemonade bottle. He called it snakebite. 'I just make dodgy shit, I mix it all up: vodka, coke, cider, lemonade – if it doesn't taste good I add something else.'

I had an appointment and two of the young men left with me to walk to the chip shop. They told me only four of their class had found jobs: two worked in a bread factory, one as an apprentice mechanic and the other one was a drug dealer.

'Drugs is a big thing in our group,' said Baz. 'It's every day, you've got to go through something – puff, but now, in the last few weeks we're fascinated by E's and Mazies – twenty mill and a couple of beers, some go over the top 140 mills and crash out on the floor for the night.

'We do it for the fun of it, nothing better to do, boredom and peer pressure could be part of it. And the routine. You have to try it, but once you've tried it, it's just cheap. You need loads of beer to get you going unless you're a lightweight and it's expensive. But a Rickie, a sixteenth of Mull, does it for you.

'I enjoy it sometimes. I can't resist it, I'm in a room they're all doing it. I think why not, I've done it before, I know what's going to happen, so I do it. We don't see it as illegal, we've done it so often. We've all said we're going to give it up. But I know I'll still do it every once in a while, maybe not sucking a cone, but smoking a J. I can give it up, I know I can give it up, I'll smoke it in smaller quantities, I'll always want to remind myself what it's like. One day I think I want to change, I'm getting bored. Nothing happens. Maybe that evening I think, why change? Sod it. I can imagine what us lot look

like. Talking, arguing, we mostly argue and smoke Mull. Now I'm out of school I realize what an idiot I've been. I wish I was back there with my mates.'

With many of the youngsters I had spoken to, I saw three stages of drug-taking. The first stage was all enjoyment; during the second stage it was still a pleasant experience, but with some problems attached – they would tell me their nose started bleeding or they felt faint and unable to stand up. Paranoia began to settle like a mist on their minds. By the third stage the only aim was the high, you imbibed to get high or you were high because you imbibed although you were certain you could give it up when you wanted.

Baz was talking about doing burglaries to pay for his moments of oblivion. 'One or two of us will burgle shops, 'cause they'll get it back, I do sports shops because they make so much money on trainers and football shirts.'

Whenever anyone passed us, whether on foot or in a car, they acknowledged Baz. The late afternoon had been wan and miserable, but without rain; now as night replaced the washed-out sky large raindrops splashed on the ground and quivered on the chip shop's window panes. A crowd of youngsters, mainly girls, had gathered on the corner next to the off-licence. 'Do they hang out here in winter?' I asked Baz. 'Yes, even when it snows, 'cause that's a real laugh.'

I wanted to talk to the mothers and fathers of the youngsters who hung around the streets. The women were the more easily identified and committed parents; the men, even if they acknowledged paternity, did not always pay their fair share and forcing them to do so often pushed them further from their children. It seemed to me that people and politicians concentrated on women as mothers and ignored men as fathers. Some of the women I met had chosen to leave a bad relationship. What was more important, a nuclear family or a woman's life? When I asked one mother if I could talk to her ex-husband, she said, 'He might talk to you or punch you in the face.'

The mother of two troublesome teenage sons said her neighbours blamed her for their behaviour. 'My ex-husband left me to set up another family. I'd agree with Jo Brand who said we should pay more attention to the fathers in this situation, the ones who leg it off faster than a Jehovah's Witness from Bates Motel. It's time someone had a

tête à tête with these guys, or head-butted them. How can we teach our youngsters what a family means, what giving to your community means, what raising good children means, when there's no sense of shame? No one should feel satisfied if any member of our community is suffering or in need of help and we can do something about it.'

Mrs Wilson, another of the mothers, watched unblinkingly as her standards went down the drain. Her two boys had an unusual gift: they pushed everything beyond the limits of bad behaviour. Simon, the younger one, burped, then laughed.

'Have you got a light, Mum?'

'No.'

He tore an envelope in half and screwed it into a torch to get a light from the gas fire. 'Have you got a pound? It's snooker tonight.'

'No.'

He sat down on the sofa and broke his mother's glasses.

I left Mrs Wilson to visit a mother in the council housing section of the estate. The glass panel to Mrs Thomas's front door was boarded over. When she came to the door she began with an apology: 'Someone was after Stephen and he threw a brick at the glass.' An older door lay face down in the front garden. 'They kicked the previous door in. As I mentioned on the phone, I've only got an hour because I'd rather you weren't here when Stephen comes home. He doesn't like the idea of me discussing his problems.'

We sat in the living-room, Mrs Thomas on a sofa with half its back missing. There was a scorch mark in the middle of the carpet and the only pieces of furniture other than the sofa were an armchair and a television set. Mrs Thomas caught me looking around the room.

'I've only got the telly left. I'm not bothered about it, it's rented. I know it's a terrible attitude, but everything of value has gone, my video is at my mum's, the rest was burgled or stolen. Where would you like me to start? It's all so different now, I've lived here since I was twelve – I'm now fifty. As a teenager we could walk the streets, go to the parks and never have a problem. I went to work at fifteen, so I wasn't hanging around the streets for long. I could go from one job to another, I could talk my way into one, now they hang around the street from twelve years old and for the next ten years they're on

the streets. I don't know about the non-council areas, there's a lot of discrimination between those areas and the council ones and within the council estate between the private owners and council tenants like myself. There's never been anything for the young people to do here. Most of the building and development took place here when I moved in the late fifties, there's been no new infrastructure since that time. It used to be cheaper to get to Brighton beachfront, money went further around, we're worse off now.

'It used to take us a good hour to walk into Brighton; my sons expect to go by car, even to the video shop. I take Shane, my youngest, to school to make sure he gets there. I believe he's paying protection money. I don't think he can stand up for himself. He's a big boy but he gets bullied partly because I told him not to hit back and because he's such a big boy he'd hurt someone. His father's angry that he doesn't hit back, he blames me for him being soft. My middle son Damian, who's now fourteen, was taking drugs at ten. Cannabis, speed, LSD, anything he could try. He's lucky to be alive. After inhaling gas he thought he could fly so he jumped from the top of a ledge and landed on his face – he was in hospital in a coma for three weeks. I got him out of it by occupying him every moment of the day. I took him fishing, if he's on the end of the pier he can't get into trouble. He slept in the corner of his room because he kept seeing a green face at the window. He's always doted on his father but his father doesn't take much notice of him.

'I think Damian jumped on the bandwagon after Stephen who was into everything. Stephen started by sniffing glue, gas and aerosols, he's stolen me rent money and sold me clothes and jewellery just to buy what he wanted. He's been taken to court and cautioned so many times I've lost count, he was fined £400 recently and I've just discovered he's been out stealing so that he can pay the fine. I've even informed the police on a couple of occasions of what was going off. It's been pretty rough at times, I can't remember it all. Stephen has been violent to me. I've had him on the floor, I'm not that type, Nick, honestly, that was three years ago, I was in the thick of it. Also, because the neighbours knew they were burgling I was branded, because I'm a single parent. I find it difficult to hold my head up at times. I was in quite a responsible job at the time, in an office dealing with accounts,

a day centre for the mentally handicapped, the police were always turning up because they had arrested Stephen. As a result I made a lot of mistakes, the audit one year was pretty bad, I got it in the neck from the boss. I was lucky to keep the job.

'One lighter incident, if you can call it lighter, two fire engines went past with the bells going. I said, "I hope they're not going to my house." The next thing I knew Stephen called me saying the house was on fire. I didn't panic. I don't panic now, I've passed that, dear oh dearie me. If there's a lull sure enough something is going to happen.

'I've tried everything, grounding them, thrown their friends out of the house. But the moment I turn my back that's it. This settee was broken because friends of Simon and Damian wanted to roll up a spliff, but my sons wouldn't let them so they smashed the settee and kicked the door in. One of the boys still wants to get my Stephen. I want to move. My kids have done everything I stand up against. I don't do drugs or smoke, I drink a little. I used to blame myself – this is my fault, I should have done it this way or that. I do find talking to other parents it's the same, they blame themselves. I go around telling them not to blame themselves, but I still blame myself. I think I blame myself because our marriage broke up. I've brought them up right, like my mum and dad brought me up. I would never have dreamed this would have happened to my kids. I ask myself, what have I done to deserve this? Their dad comes to see them but not very often. He's not very helpful. His answer was a good clout around the earhole, they needed more than that. Children need less shouting and hitting and more loving and hugging.'

Before I began my journey, I thought of the British as tough and melancholic and unapproachable, but I was discovering there was another side, at least with the people I had met. They were indeed tough and melancholic, but they were not that difficult to get close to: emotional distance was often a means of self-preservation. Mrs Thomas was an honest woman who was appalled to hear herself telling her children petty lies, mostly in an effort to keep their thieving and drug-taking at bay. She had the determination of a missionary to try and get them an education to keep them on the straight and narrow, but her children had slid so far. They had usurped her pleasant house

and her space, they had stolen her possessions, wasted her money and had lost her her friends and neighbours.

Outside the rain was still falling, a fine rain diluted by the mist. What had begun as a brilliant morning with bright sun and blue skies had turned into fogbound darkness. On the corner of the somnolent streets as streams of water coursed into puddles above blocked gutters, the group of girls and boys still stood in a pack near the off-licence which had closed for the night, like ghosts in the mist. Beyond the corner was anguish and night.

I've since spoken to Simon on the telephone. He remains tormented: sleepless nights, the silent struggle with his mother and father, his brooding and his suffering over the past is still with him.

'Bob's friend is renting me a flat,' he told me. 'He charges rent off people for his council flat even though it's illegal. I'm working on a farm although I'm practically working for nothing bagging vegetables – three hundred bags a day, work that could be done by a machine and going home stinking of shit. I'd like to get a different job but I work from eight-thirty in the morning and I can't find the time to look. I made an extra £10 last week on a hash deal which took my earnings to £70 last week. Whenever I've asked Les for more, he said you know where the gate is. He doesn't trust me with his daughters. I get the same attitude from Les and Peggy as from everyone else.

'I don't want to see Bob again, he's done a shitter on me. Went through me suitcase, sold all me gear, my Queen video, my wax waterproof jackets, tapes, grey tracksuit what I got given from the farmer. I don't think I'll see him again. It's like trusting. The only thing I regret is I won't have anyone to spend Christmas with.'

SUFFOLK

Rural Matters

ECONOMIC OPPORTUNITY IS what drew farm boys into cities. They left the land and with it the traditional environment where every family was part of a community and child-rearing was shared among aunts, uncles, grandparents, cousins or friends who kept a watchful eye on the children. Overcrowding, lawlessness and lack of jobs have created domestic and urban distress which has many city dwellers dreaming of moving out to a quiet country house in the hope of stemming the drop in their standard of living and quality of life. I was told that Suffolk is such a place, where the quintessentially picturesque English market towns offer an idyll of pubs, ponds and village greens. However these days, thanks to the car, security gates and electronic garage door openers, you can drive to and from work without the risk of coming into contact with a stranger or a neighbour, whether you live in a city or the country.

It was just as well I drove to Suffolk, for I stayed in the village of Sweffling where the local bus service calls once a week. After the rivers of steel, the dust, the noise and the perils of the endless traffic that orbits London, as if antediluvian monsters are in pursuit of one another, I found the silence almost eerie.

My first stop took me to a pub in Lowestoft. After Dartford and Chelmsford the land became flatter and flatter as I drove, losing its folds like a bedsheet with its creases smoothed out by hand. The distances increased until I felt very small between the high skies, flat sea and distant horizons which remain one of my abiding memories of Suffolk. But as elsewhere, what I hoped to find was not so much to do with the visible world as with some deeper internal landscape. I became enchanted by the people I met, their strength and resilience, like Michael and Judith who were in love on the dole. I admired them for their tenacity and for creating so much from so little.

I had made contact with Bert Shaw, who ran the Workers Educational Association from Ipswich and had set up a group of mainly unemployed people in Lowestoft, teaching literature, history and natural history rather than vocational subjects. They met every fortnight in a pub which fitted the image I had been given of Suffolk. The saloon bar doubled as the home for the Burma Star Association and the Dunkirk Veterans Association, its walls hung with portraits of the Queen, Prince Philip, and Lord Mountbatten, as well as a black and white picture of Bill and Aileen Slim taken at Imphal in 1944 with the caption, 'Styles of hats may change, but the Burma spirit remains unchanged'. I was early and went to the toilet marked Gentlemen as opposed to 'Ladies and Other Ranks'.

The group was passing photographs of cabbages around. 'I find nature pleasant in its incongruity, I don't like neatness in an allotment,' said Terry. Many of the group had an allotment and compared notes on yields. 'I'm trying to teach how to enjoy being unemployed,' said Bert. This group of unemployed people were mainly middle-aged, but also included a couple in their early thirties and a man in his early twenties. 'Judith and myself use the WEA as a filler,' said Michael. 'We've found it very stimulating. We can't afford a holiday and we can't get away from the current environment, although we did go away for one week to the Lake District last year with a subsidy from the WEA. We paid £25, plus those with allotments pitched in with vegetables.'

'We're a completely mixed bunch,' said Terry. 'I qualified as a skilled welder at fifteen. Then an hour's wage bought you a gallon of beer and five cigarettes, good beer as well, before I was old enough to drink it.' Terry had also worked as a blacksmith ('best working experience'), on forklifts, as an insurance clerk, on a production platform and an offshore oil rig, in a factory on quality control and stocktaking and at GKN as a design engineer in the tool room. 'If I needed money I'd drop back into welding. But when the bottom fell out of the Middle East market I came back home and found everyone else in the same boat. So I can no longer find work even as a welder. I'm working as a volunteer at the Waverly Women's Education Centre and I've worked part-time in the library, on removal vans and for a salvage company that went bankrupt.'

'The class members choose the subject they want to study. We do two terms a year and we meet informally, like today. When there are no classes we use the group to give each other support and help. Now that we meet here rather than at the family or women's centre there are more people,' explained Bert.

Before I finished the sentence asking them what it was like to be jobless, there were howls of protest. 'We're not jobless,' said Rose, 'we're just not wage earners.'

'I used to work at a recycling plant in Ipswich. We were all on the dole and worked a full 39½-hour week as volunteers. Bert taught us all about the different grades of paper,' said Michael.

'You should go and visit it,' suggested Bert.

Patricia, who was sitting next to Rose, told me the local canning factory and the coach builders she'd worked for had gone, but she was one of the group who was a wage earner. 'Bird's Eye were recently offering short-term contracts,' she told me. 'When I applied fifty-eight were taken on, there were 4500 applications and it wasn't advertised or in the press. I'm a machine operative, the C–90 that closes them, source product, anything on the line I can do. I only got it because I happened to be at the Job Centre, I had a week and three days until my entitlement was going to run out, they mentioned the job to the person in front of me. I had been unemployed for eleven months, but they had only found me courses and training schemes that were of no use.'

'We still have confidence and hope,' said Len. 'We're looking at it the wrong way, too many people are looking at a job as the way out. It's like being a German POW, looking at cutting through the fence to escape or to someone with the wire cutters. You've got to look at other ways to get out, you should be looking to catapult, tunnel, climb – so many people have so many talents. Look at my oldest boy, he's dyslexic, he was never going to be a professor, but he's found work in a chicken factory. I'm happy with my lot, I've achieved most of my personal pinnacles whilst I was unemployed, I know I'll never be rich, but I would like to go to the Grand Canyon because I've been told looking out over it is like being God.'

Michael and Judith were urged by the others to tell me their remarkable story.

'We met in a pub,' Judith began.

'It was at the north end of town,' said Michael. 'I wasn't expecting anything to come out of it. We weren't looking for a relationship. Both of us were unemployed at the time, so we had a lot in common.'

'Michael helped me with my applications, he kept encouraging me. Each time I finished a word processing course the package I had just completed became obsolete – they kept moving the goalposts. Anyway I had just done another word processing course when Michael proposed to me.

'We arranged to have the wedding reception at our house. Our relatives helped to buy the food. It was a team effort. We had it in the house because we didn't have the money to hire a room. We couldn't afford the church so we used the registry office – that way we didn't have to pay for the choir or the organists. I think the church quoted £100, which is a lot of money if you're on the dole. The registry office was a total of about £25. My wedding dress was given to me by friends. I altered it a bit to make it slightly different. My fancy hair piece I made myself. My bouquet – I already owned some silk flowers, so I adjusted them. I must admit I had to buy my shoes, I think I got them on sale for £9. I did buy some tights which were about £2 because they weren't ordinary ones. I had a friend who trimmed my hair free, she still does, and on the day of the wedding my sister plaited my hair for me. Michael luckily already had a shirt and tie. He bought the suit from Oxfam for £9.95, the tie was borrowed from my father.'

'I had my own ties from when I was employed, but they didn't match the suit. The shoes were lent to me by my brother.'

'We did get a lot of household presents: a set of shelves were the most useful, a punch bowl set and a silver plated dish for parties which we've never used, because you've got to be in a financial situation to entertain. My parents got us a couple of secondhand white chests of drawers which they bought off my sister. Some friends bought us a giant tin of paint, I know it's not very romantic, but it was useful because our house was undecorated, we've nearly used it all up. They also gave us the paint brush, roller and tray. The one thing Michael did save up to buy, he must have saved up like mad, he bought a really good bottle of champagne – he didn't tell me, it came as a complete surprise.'

'Obviously we didn't have a honeymoon, so I saved up from Christmas to October. I was not intending to get married without champagne for my wife, myself and my family.'

I left Lowestoft in the early afternoon. I wanted to get away from large towns and base myself in a rural setting from where it would be possible to visit the coast, a small town and the agricultural or farming community. As I travelled into mid-Suffolk all outside disturbances fell away like crumbs from an upturned bread board. There were no barking rottweilers or screaming kids skulking and running amok. No mothers pushing prams or fathers swearing at their children. No buses or cars or motorbikes thundering down the road, engines roaring, exhausts belching, and rubber straining to keep contact with the tarmac, bouncing through pot holes. Each village had its traditional red telephone box as well as matching fire-engine-red Victorian letter boxes, sometimes set into the wall of the local pub. Was this corner of Britain living in a time warp, where the clock had stopped somewhere in the 1950s? In the tiny village of Kingsbrook, winner of the Sovereign Chicken Trophy Best Kept Village in Mid-Suffolk, the local male youth congregated outside the parish church. I stopped to have a chat with them, and they referred to themselves as 'sad gits'. The ill wind of the city was beginning to infect the country, too. They dressed in the latest casual style with the hallmark baseball cap reversed in a sign of rebellion.

'I just want to get drunk,' said one of them.

'The best thing is riding cars and motorbikes.'

'I want to go to America, but I'll never make enough money,' said the youngest of them, aged fourteen.

'We enjoy a fight with other groups if they show up here. Aaaaah!' He shouted at a car packed with a group of young people as they sped past. They were cheeky and pumped up with strut and swagger, but they weren't badly behaved. They wanted to escape this everyday life, to become that other person, the wild, carefree extrovert which beats inside every nine-to-five person. They were bored.

As I approached Leiston the raindrops appeared incandescent in the mid-afternoon sun, like crystals falling from a chandelier – nothing to do with the nearby Sizewell nuclear power station. A young man

with a banner next to his tent protested, 'Closedown not meltdown.'
I joined two young women in a fish and chip shop. We waited for
our chips without saying a word. A television screen played MTV
while the radio played Radio One. I stood in line behind them at the
counter to pay for our styrofoam trays of locally grown new potato
chips. The chippie dropped their pound coins on the counter one
after the other and did the same with mine moments later. She saw
me frowning and explained, 'There are a lot of false ones here. If you
drop them on the counter, the lead ones go thud, the real ones ring.'

My car was parked outside the town's Tudor fronted cinema, where
Lisa and Maureen stood eating their chips and I began talking to them.
Lisa was from Ipswich and Maureen was local, both were winsome
teenagers who had been forced to leave home. They wore chaste,
neatly-fitting clothes that gave them a touch of panache. Lisa, small
and as light as a bird, as slim as a will-o-the-wisp, was quiet and
unassertive. Maureen, the younger one, continued to talk and told me
they were in supportive lodgings and looking for work.

'Can you lend us a couple of quid?' said a young man, digging into
Maureen's chips.

'I haven't got a couple of quid to lend you,' she apologized.

'No one lends you money because no one has got any money around
here. It's one fuckin' skint town.' Within seconds he was asking another
person for money.

I resumed my questions about life in Leiston and Maureen suggested
I drop by their lodgings as long as it was all right with Mr and Mrs
Fuller with whom they were staying. Lisa said she didn't think she'd
feel like talking.

Having arranged with Mrs Fuller a convenient time to meet Lisa
and Maureen at her house, I arrived to find both of the girls out. 'Do
come in,' said Mrs Fuller, who called herself a house parent. 'I've had
all sorts here: pregnant teenagers, persistent offenders.' She wiped her
brow. 'I hope you don't mind, I'm just finishing off some tidying. The
worst problem is keeping the place clean, their own rooms and the
communal parts. I should only be doing my own bedroom and bath-
room, but I end up doing theirs,' she went on as she finished making
the beds. 'My mother taught us to do hospital corners and not just
to put the wide hem of the upper sheet at the top and the smooth

side down. However, as we were given only one clean sheet at a time, when the bottom sheet went to be washed, the top sheet went to the bottom, this time with the narrow hem at the top.

'Unlike my childhood, they're not brought up domesticated now. In our house it didn't matter if you were male or female, both had to do the housework. Father did the vegetables and gardening, but he wouldn't do the decorating. My mum had to do that. Father would sometimes do the dishes, he never considered it beneath him. If we had fish, he would clean the fish for my mother. We also used to live on rabbits a lot. He'd catch them and skin them. Excuse me, the phone's ringing.

'. . . I'll get you fish and chips.

'It's my other half shouting for me to get his dinner ready. Where was I?' I'd only been there a few minutes and already it seemed like an hour. I could imagine what it must have been like for Maureen and Lisa, for Mrs Fuller hardly drew breath.

'Oh, yes! I was telling you about my father. Hugging: that was something I grew up without much of. There was too much work to be done. As we grew up it got less.'

'The work?'

'The hugging. The small child got most of the affection. I know my mum loved me. And the amount of hard work they had to do to keep us clean and fed. The hardships they went through. They never went down to the pub for pints of old peculiar, a good booze up. We knew they went without a lot. We had some of the things other children didn't have. They went without decent clothes. What kind of life do these children face? Quite honestly, it's difficult to say. It's not easy for working-class people any more, it's a bigger struggle every day. I'm sure Lisa and Maureen can tell you what it's like. Most will grow up with their parents unemployed. This is like a northern town stuck on the Suffolk coast. If you go the other side of the A12 it's bow and arrow country, you fall off the edge of the world. But maybe if you grow up in poverty you're more determined to get out. I grew up in poverty, but I didn't have a miserable childhood. I had a healthy diet, lots of veg, not much meat, none of us were overweight! Sometimes I wish I was as thin as I was then, I have a job with it now.

'There's the front door, it must be the girls.' I felt like saying

hallelujah! They had saved me from Mrs Fuller. 'They really are angels, they're the best two I've ever had here, but Lisa is very shy.' Maureen and Lisa stood in the hall, all smiles, and Maureen apologized for being late. Lisa said she was going to her room. 'Why don't you all sit down,' said Mrs Fuller. Lisa hesitated, hovered next to the stairs, but eventually sat down on the settee in the living-room next to Maureen. As I made polite conversation to Maureen, Lisa looked at her nails and was unable to resist the temptation to bite the end of one. 'Can I make you all a cup of tea?' said Mrs Fuller.

Maureen talked about her struggle to find a full-time job: it was her personal Everest. 'I'm earning £19.50 for part-time work in a restaurant, I'm only hanging on in the hope of getting it permanently when the next summer season comes round, although they usually go to university students who do it as a summer job.'

'I used to earn £30 a week at a newsagents while on a training course for retail,' said Lisa, 'but then I lost the job because there was no way of getting there or back, the bus never went when you needed it, so I either had to take a taxi which I couldn't afford or hope there was a friend who could drive me. I then got a job waitressing with Maureen, I wasn't sacked, there was no work, no job for both of us. I had no income for two weeks, all we had was Maureen's money she had left over from work. Because we were below income support level of £36.15 but weren't claiming income support, at the time we couldn't get housing benefit without proof of income. As it hadn't been a national insurance type paying job, just getting bits of paper with £19.50 to prove our income, it served two purposes, underearning for top-up to income support and to prove through a tribunal our irregular earnings to get housing benefit. There's not been a single week we haven't been entitled to housing benefit, the income support people have told me I have to go to Ipswich to sign on and register with careers services in Woodbridge or Lowestoft.'

'Lisa will get £22.10, what the law says you need to live on each week for normal living expenses, but it costs her £5.70 return to get from Leiston to Ipswich, and it might as well take two days by the time the bus goes all around the villages.'

'For me to be registered on careers you have to be willing to go to a training course,' continued Lisa. 'If you don't go on a training course

they stop your benefits. That's really unfair because I've had a job and I've been on the training course, which is the one I've already done twice! If they make me do it a third time, I'll scream. What's the point?'

'I'd lose my part-time job, if they made me do another course, and the opportunity of a full-time job,' Maureen grumbled. 'Ironically I'd be better off chucking the job, but because I want to work I'm sticking it out. But I'm living off bugger all and building up debts and it'd be worse if it wasn't for Sheila [Mrs Fuller]. I owe £5.25 to social security because I borrowed £25 when I first moved in with John and Sheila. Then there's my bus fare to get to work and the rest of my £19.50 goes on food, which means I've got no money left, because I've not got my top-up to income support yet. So I'm working for my bus fare and dinner money. Me mum and her boyfriend have begun to help out. Since I moved out we get on a lot better.'

Lisa began to cry. She buried her head in her hands, but almost immediately got up and ran to her room. 'She's looked so hard for work and she's had her hopes dashed so many times, she gets disappointed something terrible,' said Mrs Fuller.

'It hasn't helped her having a mum who isn't interested, just like mine. Her mum says she only has three bedrooms, so there's not enough room for Lisa. She's more interested in her boyfriend and two sons.'

'When the telephone used to go for job interviews she'd get so excited she started doing her hair and taking all her earrings out,' said Mrs Fuller. 'She's begun to get panicky before the interviews – I can't do this, she tells me, I'm not going to get it. You shouldn't be so mean to her,' she advised Maureen.

'How can I not be, I've always been mean to people. Apparently I've used threatening words to Lisa. I'm not aware of it, I must be doing it subconsciously, it must be coming out of my mouth without me realizing it.'

'Why don't you two keep chatting? I'm going to get some fish and chips before John comes home.'

'Why have you always been so mean?' I asked.

'After I was born, my mum left me in hospital for three months, she didn't visit me. My dad took me home from hospital, my mum

didn't touch me for three months, so after I was told this when I were thirteen that my mum didn't want me, I put two and two together, realized my mum didn't want me then. My mum and dad went away for day trips, they took my brother and sister and left me home. They always treated me differently from them and then I realized why, when my brother told me that, I realized why they treated me that way. I'd get hit on the head, but my mum never bullied me like my dad. My dad used to hit me when I was little, and the day he left he clouted me and knocked me out, I have the scars on my hand where he clouted me with his rings. The day he left he bought my sister lots of presents, nothing for me. He hit my mum, because she called him a bastard, "you don't know how to look after your children". I was five, it was the only thing I remember. The reason it doesn't bother me now, I can't remember a lot of it. I remember all the toys he gave my sister.

'I used to lie a lot because I didn't want to get into trouble with my mum. She was always throwing me out. She done it four times before, she always took me back the next day. I usually stayed at me friends. The last time she threw me out I wanted to go back – before I didn't. She just totally blanked me off, put the phone down every time I spoke to her. I went to stay with me boyfriend, he's not my boyfriend any more. I went on holiday with my best friend to France. Then when we were coming home she said she weren't coming back with me. When I got back to Ipswich, I found I didn't have nothing but a bed and my boyfriend had gone down to Spain and everyone knew that them two were seeing each other behind my back but no one told me. They both came back from holiday together. I couldn't cope, I stayed there three nights on my own – I was really scared, there were a lot of violent people around there, I'd go to sleep with an axe, I'd never done that before. I don't think I cried so much since my mum threw me out. I went to see a housing adviser, he eventually sent me to a housing association and they sorted me out with someone to stay, that's when I moved in with John and Sheila. They're okay. I don't think I can confide in them. Some of the stuff I don't want them telling to people so I go to her daughter and boyfriend. They annoy me half of the time, but I find talking about things helps me, but they're the only people I talk to. I don't talk to my best friend

because she took my boyfriend and I don't talk to anyone from my past.

'I never feel totally happy. I know I should do, I've got a part-time job, I've got somewhere to stay at the moment till I get a flat, and I've got people around me who want to help me and they're not just saying it and I've got a new boyfriend.

'My new boyfriend is going to work extra hours to give me money. I'm nearly eighteen, he's my fiancé. I don't think it's young because when I was living with my mum and sister and brother I had to grow up very quickly. From the age of ten I had to wash my own clothes, we didn't have a washing machine, hand washed 'em, wringed 'em out and hung 'em up, made my own meals and tidied up after me. My sister did the same thing. At fourteen I went out and got a job in a cafeteria so I could buy myself bits and bobs. Then the cafe closed down so I didn't have a job. I started nicking clothes but nearly got caught so I stopped that. My mum did nothing for us. She used to pay for the food.

'The last time I saw my dad I was seven. He came to the house and when he left I asked my mum who he was. She said it was your dad. Apparently he has been married twice since and got other kids. I went to the library where they have these records where you can find people but they've stopped that now, invasion of privacy, and this lady gave me this address to write to this bloke at the council. This bloke is head of the records. I wrote to him, told him all I knew about him to see if he could find him. He couldn't but sent letters to all the councils in Suffolk and I had letters come back from Harwich and Lowestoft and all over saying we haven't got a record of him. The next thing I tried to do to find him, the lady who's looking after my sister, she works for the Salvation Army, I gave her the letters but they couldn't find him. The other day I was watching *This Morning*, programme about missing persons. I rang them but I was five minutes late, so I'm going write to them and see if they can send me the facts sheet. I'll see what I can do after that. I've only got a couple of memories of him hitting me. I used to get the piss taken out of me because I didn't have a dad. So I thought when I was sixteen I'd try and find him and the same with my mum's parents, I'm trying to find them as well. I still love my mum and dad. The only relatives I've got

is my mum and my brother and sister, and another little brother, and a sister on the way.'

Maureen pulled a little picture of her sister Rachel out of her wallet. 'She's pregnant again.'

'Do you want a kid?' I asked.

'Maybe when I'm over twenty-five. I can't handle it at the moment. When my niece cries I can't handle it. I tell her to shut up. I wouldn't want to treat them the way my mum and dad treated me. I want to save to have children. I want some money so they can go on school trips like I didn't. I want my kids to have things I didn't have – a washing machine, food in the fridge and freezer.'

She put her hands over her eyes; her longing and her despair were immense.

Britain's easterly extreme is somewhere in Suffolk. Outside the towns and villages every landmark, clump of trees or electricity pylon was dwarfed by the endless space. Everything was still and silent. There were few walls or hedges to throw back the sound of the car's engine. There was only the noise of the rushing air that came through the car window. The smell of wet grass drying was replaced by the smell of tarmac melting on the road. On the plain the grass was green and young. Poppies occasionally grew in fields along the edge of the road. I had found a pub to stay in: the White Horse in Sweffling had been recommended to me, only it took some time to find as there were seven White Horses in a five-mile radius.

The couple who owned the pub had migrated from Essex. In fact, as with the Scottish Highlands, the glorious images reproduced on calendars, postcards and jigsaw puzzles were an urban view of rural life that didn't convey the deprivation faced by the locals – those few that hadn't been driven out by lack of work and high property prices. Sweffling had lost all of its five shops and its post office, and most of the area's schools and some of its chapels had been converted into desirable second homes. The irony was that there was no one local to clean the incomers' homes and no bus service to bring them there. Mrs Fuller had referred to Sweffling as bow and arrow country, but for one local downing his pint of bitter it wasn't remote enough: 'We've lost to France in Rugby, Brazil in football, the West Indies in

cricket, it's time to emigrate to Norfolk.' His drinking partner added, 'We've had our first burglaries, two last year.'

It was in the White Horse that I met Mr and Mrs Wickham. Mr Wickham had worked at Garratts Engineering Works. 'Leiston grew up around Garratts, it was world renowned. One or two companies tried to continue in the premises, but they failed. It's now a museum. When Sizewell's first nuclear power station came on line during Garratts' era we saw the changes that were about to come, they were programmed to work on tape machines, they didn't need people to operate it.'

'What do you think God gave you a finger for? To press buttons,' said Mrs Wickham angrily.

'It happened so fast.'

'It's because we didn't realize it was happening gradually.'

'Some of us went to Ipswich, Colchester, Chelmsford, Norwich, but very few got jobs. Half remained; curiously some of the odd bods are coming back since retirement.'

'Sizewell split our society. The locals worked damn hard skivvying, low-paid, mucky, dirty jobs, incomers didn't do a lot of work and earned a lot of money. Some wanted Sizewell, to fill their pockets, pubs, bed and breakfasts, estate agents. Now that the building work ended last year there's no money.'

'We used to live in a village,' said Mr Wickham.

'It's the same scenario, the jobs are not there and the vibrancy goes. We had incredible freedom, your parents weren't worried about you being whipped away or abducted. We could bicycle everywhere, there wasn't the traffic there is today. I only got chased home once by Americans from the local airbase,' said Mrs Wickham.

'It's hard being a child.'

'It's hard being a teenager.'

'It's hard being a human being!'

'Live for today, tomorrow's fucked.' I was somewhat dumbstruck by the dictum coming from Mrs Wickham, with her pretty frock and conservative-seeming tastes. I thought she was quoting young people's philosophy, not her own, but she was once again about to surprise me.

I asked them if they could introduce me to any farm workers.

'I know just the person. He's on the phone.' She pulled a pencil out of her handbag: it was stencilled 'Cambridge Labour Party' in silver. I remarked that the pencil was Tory blue, not Labour red. 'Well, that's the face, hopefully, not the heart. The blue is at least sky blue.'

'Don't worry, he won't bite,' said Frank as I got out of the car. He thrust out his countryman's hand, fissured like an ancient stone slab, in greeting. 'He nipped the copper at the end of the road when he got out to have a wee. He's nipped me and a dozen dogs, I bit the dog back, that cured it!'

Frank was as thin as a twig. He only had a couple of teeth which stood as bold as lighthouses in his mouth, for he was always smiling. His flat cap had got wet so many times that its peak no longer fitted the top: it was more like a beret stretched over his head. I immediately took a liking to Frank, who had the toughness but also the curiosity of someone born and bred within the circle of the horizon. His conversation was measured and gentlemanly and punctuated with great wit and laughter. Mrs Fuller had told me that if you grow up in poverty you're more determined to get out, and there was no finer example than Frank who had spent a lifetime trying to survive. He had recently been made redundant with two days' notice after thirteen-and-a-half years working for the same farmer.

'Tea? I've just made it.' Frank had been watching cricket on the television placed in the corner of the room on a stool. We sat under a bare light bulb at his dining table, a solid wooden picnic table with matching benches either side. The sun came flooding into the room, but the only warmth came from the Calor gas heater's single flame. In the corner of the room was a double glass cabinet which held two books, Yellow Pages and a recipe book called *Perfect Cooking*.

Frank flicked the Sellotape-bound remote control to the news and weather. 'Look at them ministers in their black sedans in Brussels, how would they like to travel for forty hours without water?' said Frank referring to the current debate on live animal exports. As he talked he filled drop nets with seeds for the birds.

'I've lived all my life within a twenty-mile radius of here.' His voice had the accent of an antipodean but also of somebody from a place where time is measured by the angle of the sun. 'Dad was a farm

worker, also done twenty-three years in the army, he came out a sergeant major. He was in the Royal Norfolks and the Gurkhas, he went through Burma, Dunkirk, through India, he seen the world a fair bit. We used to have a house and some land where we used to live. We used to hire it as a tenant. With the profits we made from the cattle, ducks, geese and turkey we paid for the land once a year at Michaelmas. Now you have to pay for most of the places a year in advance if you can get hold of the land.

'I used to hire from private people and parish land. I also used to have a full-time job then. I got up at half past four in the mornings to get to work at seven, left off at four at night, came home and worked till midnight, half-past or the early hours of the morning picking up all the hen, duck and geese eggs to turn them and then when they hatched I used to have to put them in paraffin brooders to keep them warm to keep the chicks alive. Half-twelve went to bed, sometimes you didn't go to bed for weeks on end, used to have a high backed chair and I used to sit in there, put my feet up and the alarm on. When it rang in the morning away you go – have a bath in the evening at the end of the day. In those days you used to have a big open fire with a boiler that used to hang to heat the water. That was thirty years ago, when I left school: I'm forty-nine, the same age as me tongue but older than me teeth. When I came home from school I wasn't allowed to come in until I'd done my work. They dished up at six o'clock, if you were in at twenty past, the dog's ears would have dropped, you knew he'd had your tea and you wouldn't get anything until dinner.

'When we moved out of the parish you couldn't keep the land on, and the next parish's land had already been taken up. We kept on Mrs Fenner's land and Dan Prior's, used to be the blacksmith in the village, used to be mainly horses in them days. We moved because my father worked for the same people only on a different farm. Apart from the big farmhouses, they were all rented, tied cottages, owned by the landlord. Several people worked on the railway, I can't think of the name of the railway, East Suffolk something. There were signalmen, a station master, the station's still there, but no one works there. There were the linesmen who went and tapped the lines. There was a gardener, can you imagine that! I think he was also the porter.

He's no longer alive, neither is his garden! They all lived in railway cottages. They've all been sold off and all the villages that belonged to the farm. Once he got rid of the workers he didn't need them. Then the houses became twee cottages for the commuters and retired people. It's no longer the village I knew. There used to be two to three hundred people, thirty children in two families! Sixty children in the school when I was there. The school has since been sold as a private property. Now there are five children – with the best will you couldn't have a dance, disco or barbecue.

'My brothers were not interested in farming. They went into haulage and worked in Harleston making agricultural machines. It's still open but they employ one hundred people where they used to employ eight hundred. They swallowed up all the people here, they took them off the land. There was a shortage of people to work around here when it got going. That made everyone about here sit up because they'd earn about £50 flat rate whereas on the farm it was £30. I went on nights from ten till five, stuck with it for one week. It were absolutely boring doing the same job every two minutes and the noise was unbelievable. I put a piece of steel in a jig, the jig in a machine, then you'd press a button, a drill piece would come down and drill two holes and then you'd take them out and put them in a metal container, chuck 'em in most of the time, and used to have to count them to know how many went in a box and how many you'd done in a shift. And that's what you did for seven hours a night. The idea was I could come home at five, feed the animals, go to bed and then get up depending on what time of the year, this was spring time, and then go mind the cattle. We work all hours God sends us, especially in the summer.

'My last job ended in 1995. I worked for him for thirteen-and-a-half years. He told me dinner time on a Wednesday I was finished on Friday, "We won't require your services." I shall never forget that, I finished on the 28th October, it was my birthday on the 31st October. He told me to be out of the tied cottage. He wasn't allowed to do that. I had been paying £1 rent a week, so he put it up to £200 a month paid in advance on Friday night, "because we can't turn you out of your house for the next six months". The thing was, they paid me redundancy money because I couldn't get the work anywhere, but the redundancy money he paid me he got back in six months. He gave

me several weeks' work during the harvest, but the amount depends on whether it's wet or dry. Years ago they used to have one machine to cut the peas, then five machines with a gang of five cutting them, eight people to load them on the lorries and pull them across, one fitter to sharpen the cutter blades and thirty lorries to take them to the factories. Now they don't pick them they have a FMC – a pea machine, it strips them out of the ground, processes them or vines them; nips the pods that drop the peas – it's all automated and they only need eight lorries on a shift and a few men in the field. They can now do a hundred acres every twenty-four hours, we used to do forty acres, it's unbelievable. Some days we could do more, some less depending on the weather conditions, now it doesn't matter if it rains or there's a thunderstorm.

'The farmer isn't going to take me on at £139 to £150 a week when he can get someone young on a training scheme for £35. That's what happened to me, he took a young lad on and two months later laid me off and kept him on. Next week for two weeks they're taking three schoolkids and not paying them nothing. They're going for work experience. Three of them boys are going to do two men's work.

'When I worked for him, he'd say come and do this, do that, while you were having breakfast. There'd be a lot of hassle over breakfast. The law states you can have ten minutes for breakfast, but we'd have to stand up to have it, not sit down. We used to work an extra half-hour on Fridays so we could get fifteen minutes every day. Harvest time or what have you if you were carting the grain you'd start at seven in the morning, you'd work through to four or five the next morning and you'd eat while you were driving along. When you'd tip the load of grain you'd sit for three or four minutes for a cup of tea and then you'd turn around and go back for another load.

'Things have got so humpty,' said Frank from the kitchen. 'Have a look at this.' He opened one of the cupboards. It was bulging with small brown pay packets. 'They go back to 1982.'

'Why are you keeping them?'

'Don't ask. I don't chuck anything away. Since 1982 until I was fired, no week was the same pay packet.' Some of the envelopes still contained copper coins.

'We have enough milk, bread and marge, the only thing we need

to live for a month. We have a deep freeze full to the top, chickens, duck, bread and veg. Until now I've never been on the dole. If I can't find myself work, I'm damn sure the job centre can't.

'I keep a variety of chickens and pheasants and rabbits. The employers who made me redundant threatened me that I couldn't keep them if I stayed in this house. That garden out there wouldn't grow rubbish when I came here. There are flower beds now. They gave me two months to take down all the pens I'd made. I didn't because for one month it poured with rain. It took me four and a half months to build them. I won't take all of them down, even if they give me a court order, I wouldn't be tally with them. I'd leave it. Before I could make money out of it, not a living, but a good profit in the spring and the autumn when you sell the chickens, but now people can't afford to buy, everyone's short of money, they can't pay their mortgages. Light Sussexes used to be £10–15; now you can pick them up for £1.50 to £2. You can buy a pair of silver pheasants for £20, two years ago they would have fetched £60 or £80.'

Frank showed me around his garden. He introduced me to his children's rabbits and guinea pigs. 'Tomorrow I'm going to the market to sell my chickens and ducks. Their feed comes to £6 a fortnight – it's too dear, so I'll sell them and try and buy a pair of pheasant or a pea fowl.'

As we returned to the house, his wife pulled up in their car with their four children. He introduced me to his family and they settled down quickly to do their homework on the picnic table under the bare light bulb.

'I've got hundreds of books,' said Frank. 'The children keep them in their rooms. I never had time to read as a child, I had to work. They know nothing compared to what we had to go through.'

After I got back to the pub I telephoned Frank to ask if I could go to the market with him. Then I took a short walk before going to sleep: the combination of pure air, space and silence was intoxicating.

We set off for Norwich market at six-thirty on Saturday morning. Frank was in fine fettle; when I arrived he'd already loaded the chickens and ducks into the back of his car and tied the boot down. 'Before we go I thought you might like to see this.' He handed me a copy of the *Eastern Daily Press*, pointing his finger to an advertisement he'd

placed requesting work. 'It cost me £16 for two weeks and an extra £1 for the black border to make people read it. I've also been advertising in Hertfordshire for three months but I haven't had a single reply. I've still got it in.'

It was still cold when we arrived at the market. The sprawling warehouse-like shed was divided into pens for cattle, sheep, and fowl and rabbits which smelt of sawdust and animal dung. There was also a car auction room and stalls for household items and groceries. In each section there was a buzz of chatter as prospective buyers and sellers caught up on the latest news and gossip. Several men came up to greet Frank, who explained to me that he had been paid in the past to bid on other people's behalf. He spoke of the many subterfuges that were employed in trying to strike a bargain. The auctions in each category took place in an atmosphere of great bonhomie, but with Frank at my side I became aware of the subtle ploys and money-making ruses that the seasoned dealers employed: some of them would have needed no lessons from the best theatre companies. Frank's estimates, whether for the heifers or bulls or his own sale of chickens and purchase of pheasants, were never far off the mark, and he returned home minus the chickens and ducks but with a pair of pheasants.

Saturday was a busy night for pubs in Suffolk. I stopped at one in Southwold and spoke briefly to some German doctors who were working in Great Yarmouth because they could only find part-time work in Germany. Dr Jenner was an obstetrician from Wiesbaden who was happy to be in England: 'I earn less but the cost of living ratio is good.' The smell of hops from the local brewery filtered across the bijou residences and quaint and tidy streets into the pub. A local man overheard our accents as he waited to be served. 'German, eh? Do you know British elephants carried parts of a power station for the Germans across the North West Frontier Province? My grandfather served with the Royal Horse Artillery and he served with the last elephant battery in the North West Frontier Province. Damned hot place, you know: when they took siestas the Pathans came down and pinched your money bags – your balls.'

With no rooms available in Southwold and the pub in Sweffling full, I headed back to Leiston. I found a room and went out into the streets where the youngsters wandered in packs.

I thought I recognized one of the lads with a tattered and faded blue denim jacket and jeans: it was Tony, the young man who had asked Maureen for a couple of quid. I introduced myself and he and two of his mates invited me back to their place for a beer.

Their house was the kind of place that makes you lose faith in humanity. The kitchen and the lavatory were lit by single naked light bulbs, the bare concrete walls appeared to be sweating as beads of condensation dripped down their blistered surfaces. The kitchen and bathroom floors were soaked with dirty water, the sinks were clogged and the toilet was loaded with enough dirty paper to start a bonfire. The kitchen sink was awash with cigarette butts and every available surface was covered with empty milk bottles. Tony explained that they had only just had their electricity reconnected. However, the group sat in the living-room, the only light escaping from the television set. There seemed to be no relation to life or time as I knew it. In the inky darkness my eyes began to adjust: there was a circular map of the moon above the fireplace, a Jimi Hendrix poster and a set of scales on the mantelpiece. The radio, the tape deck, the fireplace had all been pulled apart so that their innards were revealed like a Meccano set.

Tony and Pitt had come to Suffolk from the north-east in search of work. They told me how they had floor and sofa hopped.

'I slept in a car on the beach, in old barns, and tucked-away church-yards. I got housing benefit for a sofa. I thought I could walk into a job. All I could find was weeding in fields on a piece-work basis for less than £10 a day. It were full of East Europeans and Russians who dossed down in tents in someone's back garden and were charged £32.50 a week for the privilege,' said Pitt.

'I'm a qualified chef,' said Tony, 'but all I could get was a job with fuckin' Bernard Matthews.' He talked slowly, his eyelids dropping as if about to go to sleep. Pitt talked in the same manner, slow and mellow – it was as if ghosts were lurking in the room, but I realized it was another substance that was waiting to take over their minds and bodies.

'I ran away to get away from the gangs,' said Pitt. 'We became heads.' Pitt reached for the tape deck and inserted Stiff Little Fingers. Their movements were slow and gentle as if they were engaged in a

session of Tai Chi. In the background Alfred Hitchcock's *Psycho* played on the television with the volume turned off. 'Everyone drops by, Lou Reed, Frank Sinatra, Marlon Brando.'

The third member of the group, who didn't live in the house, went to the kitchen. From where I was seated I could see him, but I could hardly bear to watch as he casually took a fix. First he took a sachet from a kitchen cupboard, pouring the contents into a spoon. Then he heated the spoon on the ring of the electric cooker. The mix was quickly heated and was drawn into a syringe. He dropped his trousers and stuck the needle into an open wound in his groin. The syringe, still in his groin, wobbled about as he used the bottom of his tee-shirt to wipe away the blood. The hit was not the false love of E, but a release – a temporary escape, an artificial equilibrium from the dullness and exasperation of life where hope is denied. Nothing could touch them. If they had the chance, this is the way they would feel all the time.

'I went to the doctor to ask him for Temazepam to make me sleep,' said Tony. 'I told him I was working, he wanted me to go through withdrawal. He asked me what I needed to keep us off the street stuff. I told him the script, but then you become addicted to the methadone as well as smack [heroin]. It's mostly brown, proper white comes in, but not very often, crude opium occasionally. It comes from Poland apparently. They'll never be able to stop it. They'll give you clean dobrees [syringes] at the needle exchange in Saxmundham. One lad says he's got AIDS. I've got hepatitis B. You need two shots, I've had one, haven't got around to my second, I just remembered when I said it, I forgot to go. I'm on a twelve-week waiting list for an appointment with the CDT [Community Drug Team] in Ipswich, I'll probably get a script in fourteen weeks. The chemists watch you take it, but some take it and then once they're outside the chemist they spit it into the mouth of their friend who's waiting for them.'

I had to remind myself that this was a small town in rural Suffolk.

I stood outside the nondescript industrial unit near Ipswich's docks close to the centre of town and looked at my notes from the WEA meeting in the pub in Lowestoft. Bert Shaw had suggested I speak to Barry, the manager, or Martin, the assistant manager, of the recycling plant.

'I'd be happy to show you around,' said Barry, 'but there's not much to see and there isn't a lot of training for sorting one paper from the other.' None the less the two units were a hive of activity. They had eighteen people working there, including the driver of the vehicle they had purchased to collect the paper and a disabled man who checked on the bottle banks to make sure they weren't full.

'Five years ago we raised £60 from collecting paper, now it's £450 to £500 a week turnover. Initially we only collected domestic, now it's commercial as well. There are eighteen of us, mostly unemployed, but also volunteers or on government training schemes for six months. Half of them come off the training and stay as volunteers, no one is meant to be doing more than sixteen hours a week because if you're down here you can't be looking for work, technically disqualified, but as there is no work around here we do because it's given us a purpose in life. Martin is the very first person to get paid. He's got great skills, used to be an assistant manager of a Co-op, he's our unit supervisor, he puts in a full week, thirty-five hours and is being paid what he would get on the government training scheme: £46.80, that's his £36.80 dole money plus £10. He's in the office.'

Unlike Barry, who was married with three children, Martin was twenty-three and single and lived with his mum.

'Out of what I get paid £25 goes to my mum and housekeeping, and then I pay my debts off, £10 or £15 depending on my extravagant lifestyle. Excuse me, Bill! . . . Here's a list of orders to go around the houses, commercial premises and shops.'

'What happens to all the money that is being made?' I asked.

'We keep on ploughing it back into the business. We've just bought a vehicle for collecting the paper, we've bought a computer to work out the best routes and list our regulars, there's the rent, we've just taken on this second unit, there's not much left after overheads. What is goes to helping the unemployed.'

I remembered Michael and Judith saying how they could never have gone on holiday had they not been subsidized. The success of this venture was not only bringing self-esteem back to the unemployed but also giving them opportunities that would not otherwise have come their way.

As I left the recycling unit a young man came knocking on the door

looking for work. 'I'm a printer, I've got a clean driving licence and I've driven forklift trucks.'

'Do you realize there's no salary, you work here as a volunteer?'

'Yes.'

'Why do you want the job?'

'Otherwise I'm sat at home. I've spent two years looking for work, it'll give me the chance to meet different people.'

'Can you start on Monday?'

A huge grin spread across his face. 'I'll be here first thing Monday morning.'

Maureen wrote to me:

> We're still hoping to get our own flat and a little cat and a little dog and then I'll be happy, because at the moment I'm nowhere near to any of them. I still haven't found my dad so I don't think there's much chance of that now. I'm better off than most people who were on the street, I should be grateful for what I've got because I want so much more and really it's not possible and these people in the street maybe they don't like staying there but no one is going to help them so why is anyone willing to help someone like me. I don't have a lot but what I've got I'm grateful for. I wish I could be nicer to people though. I find it really hard to be nice to people after being so mean to people all my life. That's about it. I always told my mum my ultimate goal would be to help someone worse off than myself. I still do, even though my situation is pretty bad. I still like to help people.

CORNWALL

Out on a Limb

AS I HEADED for Cornwall I recalled Heather, at the cafe in Brixton, telling me, 'It's like another bloody country.' I had already discovered a Britain where accents, conversation, mannerisms and food had real regional characteristics. However, in certain respects I found that Britain was becoming more homogeneous, not as a result of national or European directives, but because of the proliferation of the many tentacles of the media which were dedicating people's minds to one goal – consumption. Before, the aspiration to do better than my father, to get a better job, to be better educated were benchmarks; now the fathers are unemployed, there are no jobs, no purpose in schooling. Young people looking for an identity, whether in Leicester, Halifax or Manchester's Little Hulton, can only find it through consumption: Nike trainers, Gore-Tex jackets, mountain bikes and drugs.

Cornwall seemed very, very far from Suffolk. Along the M4 corridor new suburban sprawls appeared on the edges of several cities: Reading, Swindon, Bristol, Taunton and Exeter. Great patchworks of maze-like red brick town house estates reached towards the motorway exit ramps. With mass unemployment in many of Britain's former industrial centres, men and women and whole families were heading south in search of work. As they do so Britain's population centre of gravity moves further and further south; once it was in Derbyshire, now it is in Leicestershire, but it continues to move south-east. According to current trends, a study suggests that in the year 2771 the centre of population will hit the south coast at Worthing.

After Exeter the road topped and bottomed in the crests and troughs of hills. The grass was a deep shade of green blown flat by the wind and the sky was filled with tumble-dried loads of clouds. In the distance

flocks of sheep appeared motionless alone or in clusters, like white snooker balls in fields of verdant baize.

I stayed in the village of Cardinham, between Bodmin and St Austell. This area of Cornwall sits on huge china clay deposits which have been mined for more than two hundred years. The excavations have scoured out deep quarries and huge amounts of debris that have been tipped on the land. The disused pits have been flooded with water and appear as tranquil lagoons, while the huge dumps of sand have been heaped up into great white pyramids and tors that give the area its surreal appearance.

Many people continue to come to this part of Cornwall in search of a rural idyll that was England forty years ago. This aim is often at odds with that of the local people, who want to keep up with the pace of technology that is developing elsewhere.

I stayed with Jane and Adam, whose house was set deep in the countryside several miles from the lunar landscape of the china clay pits. To reach their house I travelled up and down steep, narrow roads framed by enormous hedgerows – it was like riding a toboggan run: one moment the earth was coming at me, the next there was nothing but sky as I ascended the next hill. Cardinham and the larger village of Mount nearby are dry parishes – there are no pubs. The Methodists saw to that by buying the last pub back in the 1930s, but recently the parish had relaxed its adherence to teetotalism and allowed alcohol to be served in the village halls for weddings or parties.

Adam introduced me to one of the village shopkeepers. He wore a bright green Fred Perry tennis shirt and a matching neatly pressed viridian jacket with a badge on the breast pocket bearing the letters APT: the Association of Private Traders, which, he explained, had gone out of existence twenty years ago. Adam asked him for the key to the reading room, which had been built with the timbers from the local tin mines. As we opened the door a shaft of light spread across the room and over the snooker table.

'Frank Smeth lost the tip of his finger in a grass-cutting machine,' said the shopkeeper. 'He kept his artificial finger in the snooker ball box so he could make a bridge for the snooker, otherwise his hand wobbled. He died ten years ago and the son-in-law has taken it down to his home to keep for sentimental reasons.'

On the wall opposite, beyond the snooker table, I was greeted by a sign with three commandments: 'Swearing and gambling is strictly forbidden, no intoxicating liquor to be consumed on the premises, ladies are not admitted to the room'. It felt and smelt like a world that time had forgotten. Its dusty shelves still contained many of its original books such as Dr Law's *Considerations on the Theory of Religion* and a 1909 issue of *National Geographic* magazine; one of the most recent was *Judson of Burma*, priced 1/6d and printed nearly forty years ago. This part of Cornwall was still a safe, secluded haven in the world. When I asked Jane and Adam for a key so that I could come and go when they were out, Adam laughed. 'We don't have a key; we don't even have a handle to our front door.'

Jane, like many people I was to meet, had moved to Cornwall from London with Adam who had spent his childhood there. He had left Cornwall to become an electromagnetic engineer.

'I used to have a good job with a good salary and a car,' he said somewhat bitterly. 'I used to travel all over the south of England to pubs and clubs, amusement arcades and fairgrounds to repair their machines: bingo machines, pinball machines and jukeboxes. When the microprocessor came along they could train someone in three weeks for my job. There used to be one hundred to two hundred relays with up to ten contacts, and when it didn't work it was my job to find which one had the fault. Now it doesn't take a genius to replace a couple of microprocessors.' Adam was also a talented joiner and carpenter and when he couldn't find building work he spent his time renovating his house. 'We can get work through friends in London because we charge less than Londoners. Quite often two of us will take the coach and sleep on the floor, so we have no overheads and can undercut the competition. There's rarely any work around here.'

The area was for a long time dependent on the clay pits and fishing. It was always a difficult existence where the wives looked after a few acres to supplement the husbands' insecure earnings in the mines. The husbands scratched a living 'tiverting' – piecework, where you dug out so much and got paid for it according to world markets. Even today, families like the Palmers who lived next to Jane and Adam found that they were at the mercy of changing markets and even the Lord of the Manor for grazing rights. One moment the demand was

for more buttermilk, the next, just as they'd geared up for the previous change, less was wanted. Their land was poor land, facing the gales that blew from the sea and washed away the valuable topsoil. It could no longer support the whole family. One son had become a motor mechanic, the other a steel fabricator, but they all came together for baling and harvesting. Fishing, clay extraction and intensive farming all came into conflict with ecological priorities, bringing incomers and outsiders into direct conflict with the local community who, while concerned with the environment, did not want to see any further employment losses. As well as being restricted by environmental regulations, new technologies had caused the farming, fishing and clay industries to shed hundreds of jobs in a region that offered few alternatives.

As elsewhere in Britain the divide between the haves and have-nots was marked and in many ways mirrors the divide between the industrialized nations and the developing world. One part of the world has access to the latest technologies while the rest languish in a preindustrial landscape with no or little access to modern educational and recreational tools. Geographically, Cornwall, like many other parts of Britain, was on the periphery of Europe and would have to fight twice as hard as other regions to retain more than an economic toehold.

Jane had recently returned to college to do a course in computer studies, and she was busy trying to get the local council, social services and large corporations together to finance and support a network of computers linked to the Internet. Although there were those who proudly and unabashedly ignored the digital revolution, you were a Luddite at your own peril. Information technology was transforming the workplace, eliminating whole classes of jobs and putting further pressure on white- and blue-collar workers – those that were still employed had to work harder to make up for those who had been made redundant. Jane was determined to get new tools such as the Internet to keep local children and adolescents involved and in touch with the new dynamic world of ever-changing technologies. Her efforts would make it possible for them to be part of the new order rather than excluded from it. She set up computer terminals and Internet links at local fairs and shows where children found it hard to tear

themselves away from a keyboard that gave them instantaneous access to people in Britain and beyond. They seemed to have the innate ability of birds who follow migratory patterns without being taught. Before sitting down at a console many of these children had been bored and involved in street crime: now the problem was to find the means to give them permanent access to the Net.

From Cardinham I travelled down the side of a hill to the Fowey and Par estuaries between Plymouth and Falmouth. This part of the coast encapsulates both the charm and the horrors of the south Cornwall coast. Fowey is protected from both winter gales and overdevelopment by steep, wooded slopes that shelter it from the outside world. The pretty, isolated town is a favourite for tourists and a port of call for motor yachts, sailing boats and more recently small cruise liners. Most of its bungalows and cottages have been bought as retirement or holiday homes. The small town of Par, which lies on the opposite side of a peninsula, is everything that Fowey isn't. There are no steep slopes and all traces of the woods have gone. Its port is grimly functional, with large drying and storage sheds for the china clay waiting to be shipped by the carriers that berth at its docks, leaving the harbour coated in a fine white dust. Par town centre has no retirement homes, holiday cottages or souvenir shops, but there are uniform council houses – homes for the former workers of the china clay industry. The only tourists to visit Par are the furniture and antique dealers who come for the sales at the local auction rooms of the dealers Phillips: a sign above their premises read: 'London, New York, Paris, Brussels, Zurich and Par'.

'Handsome day,' said the publican at the Par Inn near the harbour gates. As elsewhere the St Piran, the Cornish black and white flag, fluttered in the gentle breeze outside the pub. Inside, the warm hum of chatter came from groups of pensioners, some sitting in a corner about to start a game of euchre, others playing darts and shove ha'penny, and Danish sailors playing pool.

'It used to be packed in here,' said a man using the bar as a support. 'How many bar staff did you used to have, Griff?'

'Four.'

'There were more ships then, they were smaller with bigger crews. This was the first pub and the last pub before the docks. Women came

here from all over, some were local, they did a bit of social work part-time, if you know what I mean.

'It's people like me coming here that are ruining it. I came from Gloucester when they closed the rail depot, but now that's all gone from here too. They have a saying here, "They that can't schemy must lowster" – they that can't use their intelligence must work hard – if only we could. It's changed a lot here, I used to know everyone either side of the street in all the streets. I used to work at the railhead for ECLP, when they started shedding jobs, people moved. I moved too, because of work or rather lack of it. I moved two hundred yards and now I don't know anyone in the street. Isn't that right, Griff? Everyone used to know everyone. They never called the police in here, but recently the pub's lifeboat collection box was stolen. Now the boxes are kept on the bar.'

Behind him on the counter was a huge copper mountain built out of loose change contributed by the sailors and locals for the Mermaid Appeal, the Cornwall Breast Cancer Centre and the Crohn's Disease Appeal. 'If you want to meet young people you should go up on the estate. You could ask for the three young girls who work in one of the shops up there. I think one of them's called Amanda.'

Away from Par the estate consisted of semi-detached houses built on one of Cornwall's more gentle slopes. Outwardly it had fewer signs of urban deterioration than some of the estates I had visited, but it seemed as sombre in spirit – an old car waiting to be repaired and untended gardens mismatched with the immaculately tended lawns of those who clung stoically to a quality of life that was declining on their doorstep. I found a group of adolescents sitting in a row, drinking from cans of lager, all of them under-age. They looked grey – in need of sunshine or a good night's sleep. I introduced myself and asked if they knew where I could find Amanda or her friends. They pointed to a house across the street and told me her sister Steph lived there. Lingering, I listened as they continued to chat among themselves.

'What are you going to do with Sammy when she gives birth?' one of the boys asked his mate. The others waited expectantly for an answer which wasn't forthcoming.

'What are you going to do if it's not your colour?' teased another.

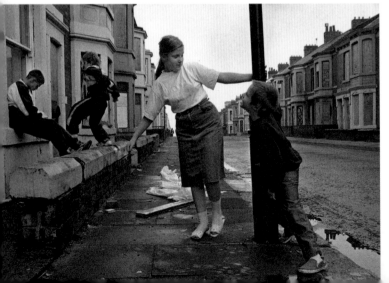

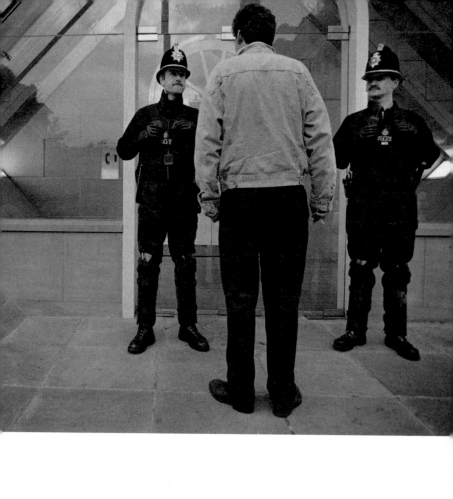

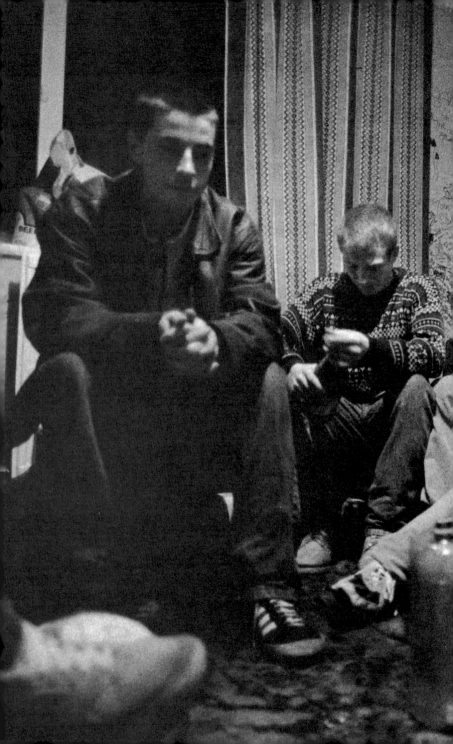

ABOVE Blackpool

OPPOSITE:
ABOVE Brighton
BELOW Grimsby

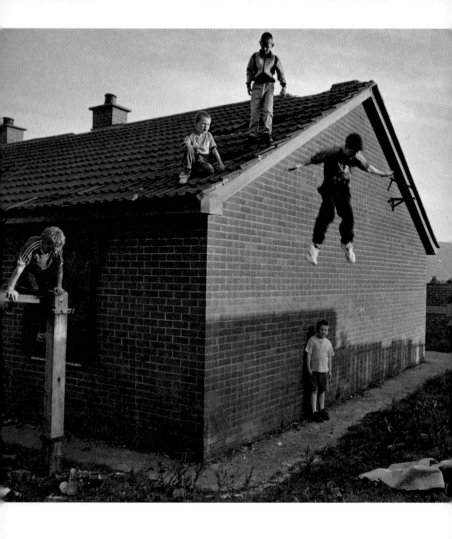

PREVIOUS PAGE The peace wall, Belfast

ABOVE AND OPPOSITE Charlie's bunker, North Belfast

OVERLEAF Shankill, Belfast

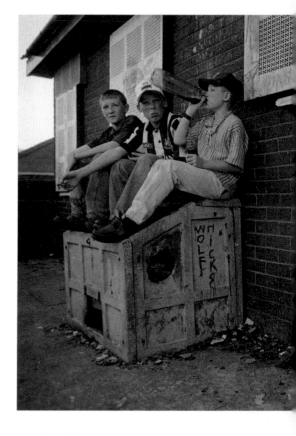

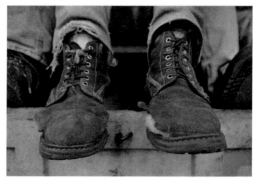

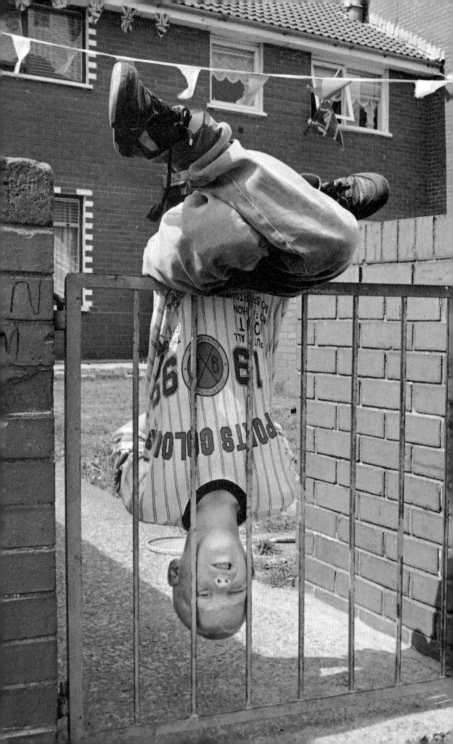

'I was doing eighty in that car I nicked last night.'

'No you wasn't.'

'Yes I was.'

'You were doing seventy-five.'

'What are the women like in America?'

'They're all fuckin' horrible here.'

When they talked their eyes met only fleetingly; more often than not they looked sideways, down at the pavement or across the road or blindly beyond. They scanned mechanically. They had been immunized by ennui and boredom, nothing could occupy a central place in their attention. Their drive and ambitions seemed extinguished before they had begun. Each member of the group was alone with his thoughts. They were a monument to waste, and soon they would be irredeemable.

As I crossed the road I heard a woman cursing followed by juvenile lamentations: Steph shouting at her brother. 'No, Amanda isn't in,' she told me curtly. When I called a third time she invited me in.

'Last time you called around and I was out, the neighbours thought you were a burglar. Did they do anything? Like fuck. You'd have thought they would have done, they just had their video stolen while they were sleeping upstairs. I told Amanda about you, she's always around with her mates if you want to hang on.'

Steph was seventeen and smoked like a volcano. Her living-room was stark. The carpet was underfelt that looked as though it had shrunk, so that it was more like a rug. The television was on the floor between a settee on one side of the room and two armchairs on the other. What clothes weren't falling out of the cupboards were drying on the arms and backs of the furniture. Above the fireplace she had hung a photograph of her eighteen-month-old daughter Paige. 'Cost me £25! I've had her picture taken twice.' She climbed on to the settee, opened the window and screamed, 'Shut the fuck up!' to the boys across the street. The longer I stayed the more foul-mouthed she became, notwithstanding the presence of her younger brother. 'Go and get Amanda,' she ordered him. 'I'll give you a pound.' Still he wouldn't go. 'For fuck's sake!'

As we waited for her sister, Steph told me about the fights she'd had with the baby's father. 'It used to go on all the time behind closed

doors, you know with the windows closed, the door shut and the curtains closed. Then two weeks before last Christmas we drank all the Christmas beer. We were steamin'. We had loads of friends over, I like having loads of friends around, and then he laid into me. I kicked him out, but he tried to come back. I wouldn't have him. He tried getting back in the house, he climbed up the drainpipe, threw bricks through the window. I moved back in with my mum. None of us get on with her, she's always shouting. Anyway I tried to get the council to rehouse me, they told me to move back in this house, they weren't going to give me anywhere else, it was take it or nothing. I moved back in, but it had been vandalized. Graffiti all over the walls.'

The neighbour's music had begun to interfere with her story, Steph climbed on to the settee and once again leaned out of the window to scream at her neighbours. When she sat down again I asked her if she would consider having another baby.

'No way. I couldn't, look at this place, I can't even afford to do it up. I'm slowly trying to get it redecorated, a coat of paint to cover the graffiti and I need a carpet. My mum gave me the settee, it's not great, but you see, the previous one I could have bought for £300 cash, but instead I got it on HP which made it £500 and I had paid about £200 when they took it back.' She stood on her settee with her head out of the window. 'Give us a fag!' she shouted in her smoke-shattered voice to her neighbours. When she turned round Amanda and two of her friends were flopping into the chairs and settee.

'Paige, show them what you can do,' said Steph, and handed her daughter a small baby doll which she took and cradled in her arms. 'Batter the little doll,' Steph ordered. Paige started banging the doll against the floor. 'Punch the little doll.' Paige jabbed the little doll repeatedly in the face. A proud grin spread across Steph's face.

Amanda and her friends Jodie and Sarah were wearing clothes as sleek as greyhounds. Sarah, a thoughtful child who at twelve years old looked the same age as Vicki and Amanda, wore a tank top that left her midriff bare. Amanda, hyperactive and three years her senior, wore faded jeans and a top the colour of hot cyclamen. Vicki, also fifteen, was impulsive and pregnant; she wore a long dress with buttons down the front. Their sallow, freckled faces were cold and hard, eyes sharp as flint, lips made up with a touch of rouge, bodies lean and already

unleashed. They talked and moved in a way that presented themselves as nonchalant and devil-may-care. Even at this age they used their femininity, their sexuality and prepossessing looks, in a way that had the older boys and men staring at them, courting them, desiring them. However, as I was soon to discover, behind those sinuous curves they could play hell with people's emotions.

Amanda made some tea. None of them could sit still for a moment, they fidgeted around the room getting up and sitting down as if in a game of musical chairs.

'If you want to write about our lives –' said Amanda.

'It's robbing and drugs,' Vicki interrupted.

One of Vicki's hands was marked with an acid face, two minute blisters for eyes and one for the mouth made by a cigarette lighter. Sarah had a tattoo, a green dot on each knuckle. 'All, coppers, are, bastards,' she explained. 'If you get four dots in a square with one in the middle, it means: Find 'em, Follow 'em, Finger 'em, Fuck 'em, Forget 'em.'

Their agitation was like tinder waiting to ignite, fuelled by impatience, frustration, irritation, inquisitiveness and disillusionment. I spent several days visiting the three girls. Their lives followed a similar pattern: school, where they were considered sensitive, bright and knowing – Amanda's sister Steph had been rated an intelligent girl full of promise. The teachers had high hopes for her which evaporated when her pregnancy cut short her education; in the evenings they pretended to be at each other's houses so that they could stay over at Steph's. At weekends and some nights the three girls worked in a local corner shop for 50p an hour.

'Every time we work there we go robbing, Twix, Mars bars, six fuckin' Snickers, two bags full of fuckin' sweets. We sell them to the kiddies and buy draw,' they told me on my first visit to Steph's house.

In their first story, like many that would follow, they escaped the world of reality for the world of fantasy. 'We were going through my mum's drawer and we found this white powder in a glass. We dabbed a bit on our tongues. Nothing much happened, so we took some more,' said Amanda.

'Then we started cleaning like fuck,' said Sarah.

'Polished the picture frames, the windows, the tables,' Vicki giggled.

'We were vacuuming.'

'We were pure blotto, pure mashed.'

'That was three years ago, that was the first time we took whizz.'

'On Hallowe'en night we went to this back garden, fuckin' good den, we put blankets in it. It was nearly twelve o'clock at night. We did a ouija board. This glass went somewhere, the roof fell down, the sides fell down, everything fell down on us. Our clothes were scattered all over the back garden. Lee says, smash the glass or the spirit will escape, and it bounced along the ground. Any night, at midnight, get a mirror, look at the alphabet backwards and you're meant to see the devil, a cat with horns, an outline.'

'We pretended we were playing Devil Baby, we jumped over Sarah, we rubbed her eyes.'

'She didn't know where she was.'

'She was chanting "Devil baby".'

'She was pissed out of her fuckin' head.'

'She sat in a pram. A white thing went flying across the room, it was her knickers. We pulled her blanket away; she was naked.'

'Stacey's house is supposed to be possessed. Stacey was out, meant to be looking after a kid. Things went flying off the walls.'

'Shelley's got the power, spiritualist thing. She can talk to the dead, we were holding hands. She was speaking to Marilyn Monroe, all holding fingers, shaking like fuck, she were hearing, she was saying what were going on, we kept our minds blank, but were scared as shit. We went up to the bedroom, we were still scared as shit, so we ran down the stairs and ran out.'

'She didn't have no feet, just hovering.'

'I know I walked past a witch.'

'Pure shittin' ourselves.'

Amanda, Vicki and Sarah, like many I had met, had no notion of time; they lived entirely in the present. The only set times that marked their lives were when their favourite soap operas were on television, the hours they put in at their part-time jobs, and school, although they were often late and sometimes absent. After I'd missed them several times at her place, Steph walked me round to her mum's where they were expected for dinner. Steph and Amanda had three sisters

and a brother; all the sisters had different fathers and I would have needed a forest, not a family tree, to work out who was related to who, and how. As Steph, with her daughter Paige and Alex, her only brother, walked me to their mum's house, Alex tried to explain.

'I've got one real mum and a real dad I never see, I've got four stepfathers, and one, two, three – three stepmothers. My four step-sisters are from my mum who got married to some bloke who got married to a person first and had two kids, she lost him and got married to someone else, had a kid with him, then she got married to my daddy who had just two kids from someone else before me and my sister and one from someone else afterwards. They live in a flat somewhere. I think the oldest is twenty-one, I don't know how old the others are. I used to see them but I don't any more . . .'

Steph left me in the living-room with her prematurely middle-aged mother. Her massive form suggested the years of slaving at housework for her six children and a grandchild, a heavy load to which she often no longer had the energy to respond. She stared unmoving at the television from her armchair. The patches of amber and the long streaks of raking shadow cast by the street light and the broken garden fence would shift, nothing would be the same again, but like a painting she remained immobile. She had the tired, locked-up desperation of mothers who have had too many men hang around like bad debts. Few things are more painful than being trapped with a fellow who thinks he's charming and children who believe you are to blame.

When Amanda, Vicki and Sarah arrived late for dinner it was waiting for them. Amanda's mother gave them a pleasant but dismissive smile. They ignored her. They ate on the floor, on the settee, on their laps, and as they came and went from the kitchen, it was obvious that the television was the focus of mealtimes – the dining-room table was a dinosaur. From breakfast till bedtime the 24-inch screen flickered with dreams, products and services which promised pleasure. Drugs and television were their opiates; both left a keener hunger and made reality even more loathsome: there was no other magic in their lives. The television images seemed to intoxicate them, they seemed to turn away from the screen a little drunk or a little desperate – for a while they had lost themselves in happiness.

The girls exchanged light-hearted banter, jeered and urged on the

game show contestants and imitated the advertising jingles. They mostly ignored Amanda's mother when she addressed them.

'I've had enough. I'm tired of cooking for all of you. Amanda, you can tell your friends to bring their own food next time.'

'Do you want us to pay for the electricity?' Vicki answered smartly. Every answer was always a put-down or a challenge.

'I'll bring my own gas stove,' said Sarah.

Each word was like a blow to Amanda's mother, because she knew that if she didn't cook for Sarah, she would go without food for the weekend. Sarah's father collected her from her mother every weekend and took her to his sister, who refused to cook for her, so he gave her 50p or £1 to buy chips. As Aristotle wrote in the *Nicomachean Ethics*, 'Anyone can become angry – that is easy. But to be angry with the right person, to the right degree, at the right time, for the right purpose, and in the right way – this is not easy.' No one knew this better than Amanda's mum. She remained in the armchair, resentful of her inability to control the children.

Time and time again men had promised her it was going to be different; worse, in the process she had lost the respect of the thing she held most dear, her children. All of them loathed their fathers, but as they were absent they took it out on the only parent present, their mother. As we walked down the garden path Amanda turned to her mother standing in the doorway, 'That were a fitty pastie!' When they tried to be affectionate, they left it too late and were simply exasperating.

On our way to Steph's, Vicki joked about Amanda's mother's best friend who had appeared as they were leaving the house.

'When God asked her how many ears do you want, she thought he said beers and asked for a half. When he said bellies, she thought he said jellies and asked for ten and when he said chins she said a double.'

We passed three young men in a car parked under a street light. 'Amandaaaa,' said one of the boys with his feet up on the dashboard. Vicki turned round and gave them the finger. 'They're probably waiting to do a job,' she said conspiratorially. 'They'll rob you then sell it to someone who knows it's yours, but then they'll sell it on. You can buy blow from them. If you haven't got the dosh, you can get it on the sub, then burgle later on to pay your debt.'

'What's he doing here?' said the boy in the back of the car.

'He's writing about life in St Austell, robbing and drugs.'

The girls were by turns sly, exultant, excited and defiant. They stared at the boys face-to-face and they had as much energy and pugnacity as them.

We sat listening to music with Steph's neighbours and their baby who had the mewling cry and snuffly breathing of the newborn. Did I know what 'gobble' and 'blow job' meant, 'mechanical digger' and 'bag of fog', the girls asked. Vicki started skinning up, building the neatest joint I had seen: she placed the Rizlas neatly on the armrest, rolled the resin between her fingertips, which turned brown in the process, pulled out the tobacco of a Silk Cut, sprinkled it on to a piece of card on her lap and diced it before layering it along the Rizla. Then with her delicate fingers she rolled it once, twice, three, four times until it wrapped tight. She held each rolled end between thumb and forefinger like a corn on the cob and slid her tongue sensuously along the gummed edge of the paper. She tore a small strip from the card and slipped it into the roach till she felt it hold, tapered the other end and lit it. As she passed it on to Sarah she looked momentarily liberated from all worldly forces.

'Don't you worry about the baby?' I asked.

'Doesn't matter if you do draw because it's better than smoking. I wouldn't take a trip, that's when lampposts start chasing ya, and you got spiders in your hair.'

After Steph had finished dragging the smoke deep into her lungs she added, 'It doesn't matter if I draw, other pregnant mums are jackin up.' This was the same Steph who three days before had told me she didn't want another baby because she couldn't afford to redecorate her house. 'I found out today, the doctor said I'm five weeks pregnant.' Her voice had the strange neutrality of someone discussing the weather or the price of baked beans.

The neighbour tried to stop Vicki from taking another drag. 'It's not right to smoke. It does your baby in, it damages what's it called – the placenta – no I don't mean the placenta, it's the you know what you call it.'

'The baby's head isn't even formed yet,' said Vicki.

* * *

As I drove along the south Cornwall coast I found, as I had along the
East Anglian coast in Suffolk, Canadian car stickers and flags flying
from the docks and masts of fishing vessels. It was part of the on-going
crisis that threatens the fishing industry. They were signs of solidarity
with the Canadians in the Atlantic fishing dispute which had broken
out with the Spanish two years after the local conflict when Cornish
fishermen were involved in skirmishes with French boats.

'I'm one of the lucky ones,' said Fred Trevelyan as he washed down
the deck of his fishing boat in the port of Mevagissey. 'I own her, if
I didn't I would have gone to the wall.' Fred came from a long line
of seamen. 'My grandfather on my father's side was one of the officers
on the *Cutty Sark*, my grandfather on my mother's side was a sailmaker,
and my great-uncle went on "J" class yachts in races and regattas,' he
said proudly.

He was one of the few fishermen left who hadn't been forced out
of the business by regulations and dwindling fish stocks. 'I keep on
reminding myself how lucky I was to not have had a loan. Many of
the fishermen did and have had to sell their boats. A lot of them have
gone into market gardening. A few have turned them into pleasure
boats for the summer tourist season. I take it in turns to fish with
another boat of the same class as mine – one day on, one day off.
They were going to impose quotas, a limit to the days a boat can go
to sea, but it has been suspended for the moment. All the fleet went
to Plymouth to blockade the port; if there were going to be restrictions
no one would have abided by it. It's no good just stopping the British,
they're not stopping the French and the Spanish, they don't have a
limit to the number of days at sea. If they do they don't abide by it,
or the size of the mesh, we just watch them at it. Earlier this year a
British trawler's nets were cut by the Spaniards,' he said indignantly.

There was also deep resentment over Spanish and Dutch fishing
boats registered under the British flag and whose catches come off the
British quota, although sold abroad. Many of the Spanish boats were
based at La Coruña, the port from which the Armada sailed in 1588.

As I criss-crossed the countryside around St Austell it wasn't so much
the lure of the wild craggy coves and pretty beaches that caught my
attention, as the imposing man-made hills of the devastated landscape.

They were a constant reminder of the central role of the china clay industry in the material life of the local people and their towns and villages. China clay is the largest bulk mineral export from Britain, apart from North Sea oil and gas, with sufficient reserves to last for at least another hundred years; nevertheless, prospecting in the granite moorlands of Cornwall and Dartmoor continues. Since the first discovery of clay in 1746, more and more applications have been found for its use and with them the methods of extraction and processing have changed. It is sometimes referred to locally as white gold because of its economic importance. The landscape is an open-air museum of the industry's history with disused chimney-stacks, sheds, railway sidings and the sad remains of curious metal growths, skeletons of steel machinery, half-buried in the ground like rusting dinosaurs amongst the foliage and the roots.

Many of the villages I drove through lay in the shadow of the hills created by 'stet', the waste from the clay pits. The unrestrained development had once made the local rivers flow white from the sand slurry and mica residue, and the towns permanently appear like Alpine villages after snowfall. The lagoons and great tips are still growing, but they are being camouflaged with grass and clover and populated by imported sheep. In the words of Charles Thurlow, a local historian who guided me through the process from quarrying to its point of export, they are hoping to create a Cornish Lake District. However, locals were ambivalent: they complained about the incessant noise, the giant dumpsters, and living in the shadow of the mountains, but they wanted the work, they didn't want any more job losses. On entering the quarry it was easy to see how man could be proud of his achievements. Even where much of the work was automated, there is a dignity that comes from being able to see the fruits of one's labour. The white walls of the man-made craters were full of the cold marble and rock colours of very high glaciers and among these walls and giant dumpsters the people appeared as Lilliputian specks. The canyon walls were being blasted day and night without interruption, hewn with powerful water jets and bulldozed to provide the clay that goes into ceramics, plastics, paint, rubber, pharmaceuticals, and paper filling and coating.

To find people linked to the industry I was directed to a caravan

park in the shadow of a landscaped stet. The caravan park was divided into two sections. One was for caravan owners with mesmerizing polygonal and brightly-coloured chalet homes that had individual touches so that no two looked alike. Often they had fenced-off gardens, some with Union Jacks, satellite dishes and painted gnomes as sentries. The second part of the park was reserved for rentals. These caravans were moored on concrete blocks and looked so old that they might fall apart in a strong gale. They had flimsy windows and walls trimmed with sheets of corrugated aluminium, while some had a pole attached like a mast with a television aerial. Plastic toys and bicycles lay scattered across the communal ground. Some caravans which to me looked only big enough for a couple housed families with children – and grandchildren when they came to stay.

I walked up to a group of residents sitting in the grass in the centre of a block of caravans.

'It cost us a brave bit of money for the deposit, it seemed even more by the time we had to pay for the electric, gas and water,' said Matthew, one of the youngest in the group.

'You have to get on here, because we're all unemployed, we're always here, we don't have the money to go elsewhere. Except for master man, he lives over there,' said Hart pointing to a caravan that resembled all the others.

'He knows everything about naval history,' said Matthew. 'Ask him about the *Nimitz* and he'll tell you how many guns it's got, what type, how many crew, speed, weight, length. He knows all the British and US ships.'

'He goes to Plymouth Navy Days every year. You've heard of people doing joyrides in a car, he could do it in a ship, there's nothing he doesn't know.'

As their naval expert crossed the lawn where we were sitting, Hart called out, 'What's your favourite film?'

'*Sink the Bismarck.*'

'See what I mean?'

Matthew invited me into his caravan. 'We're not allowed animals,' he said, pointing to his cockateel. Sitting in a tartan armchair under a Manchester United scarf that he'd pinned above a window lined with empty beer bottles, he switched on the television set. It was *Home*

and Away then – zap – *Neighbours.* Julie was on top of a tower.

'Jump!' Matthew urged. 'I'm glad she's dead. Are you sure you don't want a cup of tea? How about a beer? I'd offer you a joint but I haven't got any blow, I find it makes me mellow. If I'm pulling a bird, I used to avoid the subject of where I was living. Some people don't like this sort of thing, but if you say you've got a place of your own, you've got more of a chance than if you say you're living with your parents or in a B and B – even this caravan sounds more permanent. I always wanted my own key, not rely on anybody else.

'My girlfriend moved out recently, we never discussed why. I think the site was getting her down, the burrows block the light and in winter the wind comes howling through here. It gets that cold you spend all the time in your bedroom with the TV wired up. You don't get out of bed. It's cheaper to heat one room. Anyway in winter I never stray too far from the caravan, I don't have the money to go out and have a good time, I'll sit here in my anorak watching the box. I'm happy. Worry free. When I say worry free how can it be worry free when it's that sort of money every fortnight? The only bad thing is that amount of money. If ECC [English China Clay] do close around here it'll get a lot worse because there won't be any jobs at all. It'll be even worse for me because there'll be even more trying for the same job. My problem is transport. To get to most places around here you need a car, but you can't get a car because you can't get a job, because you've no car, it's a vicious circle. I used to have a job in Bodmin, in the meat factory. I was up at four and it would take me two hours to cycle there, I was knackered by the time I got there. I couldn't face the blood. On the positive side I ended up with legs like tree trunks, pure muscle. I wished we lived in Holland because it'd be flat and 'cause I'd only have to go down the road for some pot.

'I'm tempted by crime. Everyone is, from lack of money. It's like I said about smoking a joint, it makes me mellow. If they stopped it crime would soar because everyone would go mental. The pot calms you down, a couple of joints, you don't want to cause trouble. I suppose if it becomes a habit you could get into crime, there's that about it but you can't have it sweet all the time.'

Matthew's neighbour knocked on the door and came in without waiting for an answer. Matthew continued to talk. 'You're going to

ask me how I see myself in ten years' time. In ten years' time I'd like to describe my lifetime's achievement in a photograph married with a kid, not necessarily married, but with a kid. That'd be me. Everyone's ambition, but they don't like to admit it. I can't see myself on this particular site in ten years' time.'

'You never have a happy life with kids,' the neighbour put in. 'They tie you down for sixteen years.'

'Marriage scares me,' said Matthew, ignoring his neighbour. 'I've no ties at the moment, I still feel there's a lot more for me to do. I think I can do more than work in a factory for the rest of my life, but I haven't even got that at the moment. My mum's ambition is to see me walk down an aisle.'

Thomas, a friend of a friend of Jane's, had agreed to talk to me. He was at the front door of his isolated cottage in the heart of ECC country as I arrived.

'Right on yer proper,' he said, extending his hand in greeting. He wore a tee-shirt which revealed a 'Made in Cornwall' tattoo and another with a drawing of the Grim Reaper. I stared at the fine artwork. 'I had to do it, I chose the most macabre tattoo. It was quite funny, not funny for my mum. We went together to Redruth, she had tears in her eyes when I got out of the car. I still had to have it. The "Made in Cornwall" was a birthday present from my girlfriend, the girl out there.' He pointed to a pretty waif sitting next to a child in the back garden under an oak tree. 'That was years ago, I confused a good friendship by making her my girlfriend, but we're good friends again. She's staying here at the moment to sort out a few problems.' There were other tattoos, most notably one of a Celtic cross. 'I could keep you here all day if I went on to tell you the history behind each one, but you came here to talk about ECC.

'Sit down, make yourself at home. I'm not materialistic, I've become spiritual. I've just been given this by my new girlfriend.' Thomas handed me *The Book of Runes*.

'I can date my family back to 1700 to William Trevyner. Cornish is different from England, even though we're attached to it. We're different people, like Scots or Welsh, my accent is different. I know I'm Cornish, I don't have to prove it to anyone. I'm quite proud to be

Cornish, more so than English. I used to look at England as the aristocracy, the Parliament, the Queen, I feel I have a separate identity. I feel the English are pompous and hooray Henrys, or greedy people. We're just workers of the land, but I suppose we're also in the rat race. But I wonder what it would be like if they stayed their side of the river and we stayed here. I'd be guaranteed an affordable house, my birthright, a plot of land. I could have it for my family to pass down to the next generation. Sorry, I keep drifting from telling you about ECC.

'My dad worked in ECLP, that's how ECC used to be called, and my granddad worked there before him. It was terrible in them days, my granddad had respiratory problems from having inhaled the kaolin dust, they used to frighten people into not making claims. There are still accidents but they're not serious or fatal, it's usually to do with bad siting of the equipment, mainly tripping over valves, slipping and falling in the mixture of water and clay, but there are parts of the industry like the bricks made out of molochite which are razor sharp and can give you nasty cuts and gashes. Anyway I worked for one and a half years at ECC, starting at six-thirty and finishing at four on the hand drill – what a job, like a pneumatic drill you see the council workers with, but it rotates as well to drill a hole in the granite to put dynamite in a borehole. It was a dead end job. I couldn't do with being in the same place for too long, it was driving me stir crazy. I started stealing a lot of gear, I stole for the hell of it, not for the money, for the fun; I couldn't make the money stretch, I wanted to buy the girlfriend drinks. I was justified stealing off them. I want to think about this before I blab off my mouth.

'I felt there was nothing for me when I left school. I'm not an academic, really, I'm a worker and the only jobs were with ECC. I'd have to work for them even though I didn't want to. My friends were pushing buttons or occasionally cleaning out a pipe, doing the same thing day in day out, the boredom. I needed to be stimulated. I was anti-society, anti-government, anti-everything. I built up a tool collection, spanners and sockets and silly things from ECLP. I kept them for my own personal use. At the time I didn't think I was doing wrong because they raped our land, being strong Cornish. I felt very angry when I left school because I thought I would never own my

own house, a Cornishman's house is his castle. Looking back every-
thing seemed pointless. There was nothing to do as a child, I wanted
some fun and the only fun was the other side of the law. Dad was an
electrician, didn't see nothing of him from the age of eleven upwards
till now. I still haven't seen him at all, although he still works at ECC
as a shift worker. My mum started off as a silver service waitress, she's
now a part-time care assistant in an old people's home and does
everything from the painting and decorating to the cleaning of holiday
homes in Charlestown. This is her house, the condition of her having
it was that she worked the land – the house, the rates and the telephone
rental were free. When I was at school aged eleven she would work
as a waitress and then came home and did the farming. My mum's a
grafter, she's still a pretty hard worker. I think she's in her fifties,
around that sort of mark.

'My look at the future now is not as bleak as it used to be. In fact
it's not bleak at all. I've got a new job as a tree surgeon. I'm not so
attached to things any more, you can't take it with you. The land
belongs to nature. I would like to have kids and I wouldn't, I'm afraid
not to be able to provide for my children, comes down to stability in
a relationship. It's not easy for a couple to stay together, it's quite easy
for one to walk away and see their children on a part-time basis. The
rich can always get out, start again, the poor have to fend for them-
selves. The poor are fucked, excuse my language. It all boils down to
money at the end of the day. The greed of money. It's like vehicles –
I always wanted the best, flashiest car, but now I'm happy to run
around in my tin can on wheels because that's all it is at the end of
the day.'

Thomas's former girlfriend came in from the garden with her
daughter. 'Nick, this is Tess and Louise.'

'It's so wonderful out here,' Tess sighed with Louise cuddling up
against her side. 'The only thing, it's in the middle of nowhere sur-
rounded by hills and sheep. Where men are men and sheep are
cautious.'

'I've warned her dad that if his new girlfriend lays so much as a finger
on her, I'll batter her,' said Steph. 'He's twenty-two now, his girlfriend
– I haven't met her yet – is fifteen.' Steph had agreed to allow Paige's

father to see her for the first time in six months. 'I want her to have a dad. It's important, I didn't have one. She should be back soon.'

Earlier on in the afternoon I had gone to see Amanda, Vicki and Sarah at the corner shop. In the quiet moments the girls set about pilfering whatever they felt wouldn't be noticed. The best opportunity came when they had to restock the shelves. 'We can't steal the whole carton, but when we restock the shelves the extra packets what don't fit on the shelf go in the drawer . . .' A customer entered the shop as they spoke. 'We'll see you back at Steph's at half-five,' which was my cue to let them get back to serving the customers and stocking their rucksack at the back of the shop.

As I waited for them in Steph's living-room, her former partner returned with Paige. 'I hope you've fed her!' scowled Steph, glaring at his back as he removed Paige's coat.

'Of course I have.'

'Yeah, but what?'

'Crisps and chocolate.'

'That's all right then.'

Amanda, Vicki and Sarah arrived triumphant. They threw their rucksack on the ground. Paige sat on her plastic tricycle toing and froing across the room, the chocolate spread over her face like a clown's make-up. Sarah and Vicki emptied the backpack and the merchandise came cascading out – chocolate bars, sweets, cigarettes, cash. They started to shuffle the goods when there was a knock at the door. 'Fuck! If we don't get this stashed they could tax us for the lot.'

The girls scrambled to hide their goodies under the settee and armchairs. 'Go on, open the door, Vicki,' said Amanda, regaining her composure.

'Nice day, girls?' said the leanest of the three young men. 'Got anything for us?'

Amanda calmly pulled out the backpack from under the armchair. 'Just a few packets of fags, chocolate . . .' She tumbled only a sizeable fraction of the original jackpot into the middle of the floor, all that had been shoved back into the bag. The thin young man reached into the pile and picked up a packet of cigarettes, opened it and offered them around. When they had lit their cigarettes the three of them reached into the pile and filled their pockets with their fancy and left.

Once the door was shut the girls smiled at each other and withdrew the stashes that hadn't been discovered. They started counting up their takings: '170 cigarettes . . .' 'Last week it was Embassy No. 10 which was lucky because that's what I smoke,' Vicki remarked. 'Five Snickers, two boxes of Smarties . . .' It had been a good haul, and they weren't concerned that their boss would discover what they were up to. 'He won't find out, anyway he's employing us illegally, we're under age, we're not allowed to sell ciggies and alcohol.'

'I've been hittin' the pipe, pure buzzin',' said the neighbour poking his head into the open window at the back of the house. 'Anyone up for a pure session?'

Within seconds everyone was heading for the front door and the neighbour's garden. 'The master man makes a brave glove,' said Vicki. 'No one's leaving this fucking place till you clean up!' shouted Steph.

They didn't do buckets as I had witnessed in Barrow, they inhaled draw straight from a plastic bag which they referred to as a glove or a lung. But the neighbour also had a set of beakers taken from a school's chemistry lab.

The speaker faced outwards from the neighbour's kitchen ledge and played loudly, a few more neighbourhood residents joined the group, Steph held Paige on her hip and soon left, cursing loudly at a young man who had joined us. The neighbour's partner stood to the side with her baby, but unlike the others she didn't drag on the glove or the laboratory beaker. Few of the newcomers asked me who I was. They thought I was a teacher at one of the local schools.

Several months later I returned to give Steph some pictures I had taken of her and Paige. The door was ajar and she shouted from the kitchen to come in. Paige was crying.

'If you don't shut up, I'm going to ram my finger down your throat, thicko!' she screamed at Paige. It was as if I had just stepped out of the house and gone back because I had forgotten something. Nothing had changed.

SOUTH WALES

Ridges and Valleys

PENRHYS HAS BEEN in turn famous, forgotten and notorious. For four hundred years, from the Middle Ages until the Reformation, the ancient Celtic well and the medieval Marian shrine were among the most famous sites of pilgrimage throughout southern Britain. Mair o Benhrys was celebrated in poem and song. From 1538, when the shrine was destroyed, Penrhys was forgotten, except for the two farms of Uchaf and Isaf which bore the ancient name.

As soon as I crossed the Severn Bridge westwards I noticed the bilingual road signs: *gwasanaethau*, services, and before long Caerdydd, the Welsh capital, from where I struck north into the Rhondda Valley. I had always been curious to know what sort of people former miners and their families were. My only previous experience of a mine, its village and community had been in Bolivia and it remains one of the most marked and claustrophobic experiences of my life. My visit to Tower Colliery, the last remaining deep pit in South Wales, just beyond the Rhondda on the other side of the Rhigos pass, turned out to be as memorable as my childhood visit to the Eiffel Tower. The village of Penrhys and its people would reveal a resilience to the penury of prospects as horrific as the shanty towns of Rio de Janeiro's *favelas*. Looking back I think how lucky I am not to have been born in Penrhys, or the 'site' as it was called by its residents; but I also felt something of the extraordinary spirit of the place. By the time I left, nearly a week after I had crossed the Severn Bridge, I could understand why some who had chosen to leave Penrhys wished they were back and others who remained did not wish to leave despite having been terrorized and burgled countless times.

As I drove into the valley I was immediately struck by the claustrophobic line of small, interconnected towns and villages strung out

along the valley floor. The locals call it the Long Street – the legacy of an industry that changed the face of this part of South Wales. Like the lure of lost cities and the apparent riches to be made in America's Wild West, the discovery of the first seams of coal had a galvanizing effect: a black Klondike was in the making. Thousands and thousands of men and their families poured into the valleys in search of work, from Britain and also from abroad. The population of Rhondda's two valleys, Rhondda Fawr and Rhondda Fach, grew from 542 in 1801 and 951 in 1851, to 16,914 twenty years later; by 1924 it had grown to 169,000. Since then the decline has been equally steep: by 1984 the population stood at 80,000. At the peak of coal production more than fifty pits provided work for 40,000 miners. Mining was the central fact of life in the valleys; but the last mine closed in 1990, and the collieries that once dominated the towns and villages and provided work for almost every household have been bulldozed. In Trehafod, before the valley splits in two, a heritage park has preserved the old workplace and memories of the miners as museum pieces. According to the Heritage Park's brochure:

> Before reaching the coal face you are able to detonate your own explosion and, of course, hear and feel the effects resounding around you. At the coal face the noise and heat reach almost terrifying levels. In the distance you are able to see shadows of men hard at work, the toil of their labour laid out in front of you.

As in other parts of Britain, this theme park was a way of recycling a sanitized version of the Rhondda's turbulent history for general consumption in an effort to stimulate the economy and provide jobs. Later, one of their guides, a former miner, told me, 'No one is going to suffer pneumoconiosis [the black lung disease], and so far no one has been killed in a roof fall.'

I continued along the valley floor of Rhondda Fawr, passing memorial gardens, cemeteries and mass graves of the miners who had lived a life of hardship, deprivation and often tragedy. Thousands have died in accidents as a result of the discovery of black gold. I was told that in one year alone, 1887, the South Wales miners' provident fund dealt with 10,000 cases of disablement, one man injured in every four who

joined. I drove past the listed Glamorgan 'Scotch' Colliery Power House where massive police reinforcements were drafted in by Home Secretary Winston Churchill to protect non-union members from striking miners during the dispute that led to the infamous Tonypandy riots in 1910. I stopped in the village of Ystrad at a Chinese chippie and ordered sweet and sour chips from Llinos, a pretty young woman who spoke with the warm, low, gently rising and falling accent of the Welsh.

Llinos had just graduated from Manchester University. She spoke French, Welsh and English and was expecting an honours degree in metallurgy and materials sciences. General Electric had offered her a job in the airplane engine manufacturing division. However, during her finals GE telephoned her to inform her that circumstances had forced them to withdraw the offer: she was made redundant before even taking up her first job.

'My sisters Cerys and Heulwen also work here. Cerys is studying dentistry and speaks Spanish, but the chippie is the only job we can find,' said Llinos chirpily as I dug into my chips. She tried to teach me to pronounce her name correctly. 'It's pronounced *thlenos*; put your tongue at the back of your teeth, breathe out . . .' I tried to get my tongue around her sisters' names without much more success. They were the Welsh words for a kind of bird, for love, and for sunshine, and the names suited the girls' bright demeanour, fair hair and fresh complexions.

'How do you get to Penrhys?' I asked.

'Have you got a car?' asked a couple standing behind me.

'Yes?'

'You don't want to see your car again?'

They warned me that Penrhys was a tough, violent estate where crime was rampant.

'A couple of years ago the local community policeman was awarded an OBE,' said the man.

'They should have given him the Victoria Cross,' said his partner. They advised me that if I wanted to see my car again I should leave it in Ystrad and take the bus up the hill. 'They leave every twenty minutes from across the road,' said the man, helpfully pointing to a bus shelter where a young man was relieving himself.

As I said goodbye to Llinos, another customer warned me, 'When they built a youth club, they were so worried about the problems they had to design a vandal-proof building without windows. We tell our children if you don't behave we'll send you to Penrhys.'

Another customer was no less encouraging. 'They should burn it down – with the people in it. Even the women get done for GBH. Do you know what the difference is between the rottweilers and the women of Penrhys?'

'No.'

'The rottweilers wear the lipstick.'

Leaving the floor of the valley by a spur in the road my car climbed the steep gradient in second gear. Penrhys sits astride a whaleback that forms a promontory between Rhondda's two valleys. At the top of the first plateau the character of the estate immediately revealed itself. High on this mountain ridge I found myself in the midst of a maze of houses large and small. Many were ruins, burned and vandalized. Boards to keep vandals out had been ripped from their moorings and had disappeared, undoubtedly to be recycled. This left the way open so that six-, seven- and eight-year-olds could scavenge for copper wire and wood from window and door frames. The empty houses and vacant plots bore silent testimony to a youth who had been brutalized and in turn had brutalized the earth. The empty dwellings appeared as black mouths where fires had licked at the rooms that had been picked clean. Horror followed horror – empty houses steel-shuttered and the hulks of stolen cars abandoned and burnt in the houses' parking bays – until the realization came that I was in the midst of a ruin as great as any after a battle or siege.

The estate had been a creation of 1960s utopian planning. It was built in 1966 when the National Coal Board asked for new homes to attract new miners from Durham and to provide better housing for local ones from Rhondda's dozen communities. By the time the estate was finished in 1968 the pits had closed. Above all it was to be a symbol of hope for Rhondda by stemming the population flow to the M4 corridor. It was said during my visit that the estate had been modelled on a Tuscan village; the houses fitted together with great thought – shops, a leisure centre, a pub and a club – to form a complete city. Its fantastic views of the valleys and its location, clinging to the

upper slope of the green mountain like a village set on a sugarloaf, ignored the atrocious weather which often kept the residents in the clouds for days at a time. Similar to MacKay country in the north of Scotland, living in Penrhys was like living on the edge of the world buffeted by winds of North Atlantic ferocity. In its sublime isolation you could also feel trapped, with the valley a thousand feet below. Of 30,000 trees planted in 1970 by local children in a landscaping campaign, only 3000 survived: the rest fell victim to vandals, sheep and the drought of a long hot summer. For much of the autumn and winter the estate's mystery was heightened by ghostly wisps of cloud that clung to the mountain and by the lack of people in the street.

I had been warned of the personal consequences that a visit to Penrhys could entail. I was exhausted from the succession of bleak towns, villages and estates I had visited and by encounters with lives that offered little hope. I had to remind myself that I was only a visitor and not one of the three thousand citizens who lived here.

As I walked from my parked car around to the community centre's main entrance a group of young mid-adolescent boys approached me.

'Give us your cameras,' they ordered, testing my mettle.

'No. Why should I?'

'To buy drugs.'

'They're not worth anything.'

'We'll try and sell 'em.'

I walked on; they followed me for a few steps, then turned around and went off in the opposite direction. They had no horizons other than to fill the empty hours with petty crime, which sometimes provoked retaliation. Everyone was slowly being pushed into brutality and racist abuse. Some were rumoured to support a Cardiff-based branch of the Ku Klux Klan, although I discovered the only foreigner on the estate was a Hungarian theological student. For a brief moment I was tempted to turn back.

Fortunately I continued, because while some of the stories were to repeat themselves in a different location, part of Penrhys was turning a corner and some young men I met on the estate and in nearby villages had found a positive direction to their lives, continuing in a long line of radical militancy inherited from their forefathers. Martin Short, a friend in London, had given me the names of two of these

men, Red and Trevor. Martin knew the estate and its residents well and suggested I contact Jaws as soon as I arrived in Penrhys.

Jaws worked as a security guard at Penrhys's community centre. I had spoken to him on the phone from Ystrad, and he told me where to park my car. When I arrived on the site I realized the logic. It was directly below his window, an ideal observation post at the top of the community centre which was South Wales's serrated concrete version of Hitler's bunker. This white elephant costs hundreds of thousands of pounds a year to maintain and protect. You couldn't ignore it. It was massively there, a giant carbuncle on the landscape. According to Jaws, nothing short of a tactical cruise missile could shift it.

Jaws and Trevor were two of the security guards who kept a twenty-four-hour vigil on the community centre. They would be best described as large and larger. Ivor's muscles rippled the moment he sneezed or twitched, every inch of his body had been put through some rigorous body-building ritual. It would have been impossible to pinch him – his skin was stretched like a drum. Jaws, on the other hand, was large and unfit, and I could not have hoped to meet a nicer or kinder person, but he would never need to raise more than a finger in anger: he was respected by everyone. He was one of those rare individuals that no one could find a bad word for.

After Jaws finished his shift he took me to the local pub, instructing the relief duty to keep an eye on my car. We walked through the community centre's shopping precinct, which now consisted of a single partly boarded-up supermarket. Children loitered in the gloomy pass-ageway covered in graffiti. Five youngsters sat on a narrow ledge, the hallway echoing to their taunts and calls to those who used the tunnel as a rollerskating track and football pitch.

We sat in the corner of the pub drinking lager and black under a wrought iron line-drawing of a colliery pithead. It had been executed by Ivor, who had five City and Guilds certificates and a degree in art and design, as well as being a qualified welder. Jaws introduced me to his girlfriend Lorna and the others in a group of friends.

'Welcome to the road to nowhere.'

'Welcome to Giro City.'

'Penderosa.'

'Benefit Mountain.'

'High Chaparral.'

Penrhys's nicknames rolled off their tongues. Only Jaws, Ivor and Dai the barman had jobs. 'Of course, a few are hobbling,' said Jaws.

'Not Jaws,' said Lorna, 'he can't tell you a lie, it's not that he wouldn't, he couldn't.'

'There's ninety-five per cent unemployment on the site. When the pits were open it was the other way around, ninety-five per cent were employed. The vans and buses were so full that you'd have to get to the bus stop early to get a seat,' said Dai, who'd once been a miner.

I was introduced to a large, pretty, blond woman.

'If you want anything, give her your order and she'll see to it that you'll have it by the end of the week,' said Lorna.

Here the economy was black and nearly everything was hot except for the weather. Many of the residents appeared smartly dressed, the best trainers, the smartest jeans, the brightest shell suits, and the latest sunglasses.

'I'm doing them a good turn, and they're doing me a good turn,' said Rita of her shoplift-to-order sprees. 'I gotta survive, that's why I shoplift. I've got two kids to feed. I never steal off the estate. I was recently done for shoplifting – a can of paint to redecorate my kitchen. I'd rather do seven days than pay a £90 fine; the goods only came to £60.'

When Gareth, sporting a new pair of sunglasses, entered the pub with his dog everyone exchanged greetings. Dai protested, 'Only guide dogs for the blind are allowed in the pub.' A startled silence descended over the room. Gareth thrust his face and arm forward in the blind snout-like way of a lizard emerging from a rock, seeming to sniff and peer for direction.

'Go on, get her out.'

'I am blind,' protested Gareth. The men at the bar looked a little bemused.

'Guide dogs are alsatians and labradors. Since when are they Jack Russells?' said one of the drinkers.

'Oh?' Gareth fingered his sunglasses and sounded surprised. 'Wouldn't have known had you not told me so. Ta.' Everyone fell about laughing.

Several of the men had tattoos written in Chinese. I asked for the

translation of one and was told it meant 'death'. I sat sandwiched between Rita and Ellen. Ellen seemed older than the rest of the group: her face had the deep lines and leathery skin of women who have had a hard outdoor life. Like all those gathered around the table in the pub, she was warm, welcoming and friendly. When she got up to go she gave me a kiss goodbye on the cheek; later I was hugged by men in the continental European way, I was finding these Welshmen and women more open, friendly and tactile than anyone else I had met in the British Isles, although I'm sure part of their openness was the fact that I had had an introduction from Martin. Only after Ellen left the pub with an invitation to drop by her house – 'I'll make you faggots and peas' – and a suggestion that I meet her and her children at church the following morning, was I told she was a white witch. There had been a lot of tragedy in her life, but it was told matter-of-factly: 'Her boyfriend died from an overdose three days before the marriage. Her second boyfriend also died. She looks after her mother-in-law and three children, one's addicted to heroin.'

A local set up his turntables in the pub to provide a disco and everyone danced with wild abandon. Someone stumbled across the dance floor. A drunkard got up and raised the fascist salute. 'Nobhead!' someone shouted at him. Someone else said, 'I'm open-minded; after all, if all the Australians and South Africans came back it'd be even worse!' The empty beer glasses piled up on our table. In the corner of the bar a boy had fallen asleep, and some of the grown-ups' eyes were also beginning to close, their faces oozing sweat from the clammy atmosphere and alcohol. No one had to worry about getting up in the morning, Sunday or not; every day was the same, their calendars were blank, their only fixture dole day at the post office.

The social life that had once been rooted in Nonconformist faith based on the chapels has all but disappeared, as have the big choirs and the drama groups which celebrated the region's coal industry in songs and poetry – although glossing over the often short and brutal lives of the workers. Along the two valleys former chapels stand isolated in a sea of secular materialism. However the church in Penrhys had recently moved out of a shop into a purpose-built centre. John Morgan, the minister, had helped develop local community projects including a cafe, a launderette, a boutique that sold 'nearly new' clothes, and

music and art workrooms, all run by volunteers. At the heart of the new complex was the bright and airy chapel, one of several new buildings converted from derelict blocks of flats. On the way there I bumped into Rita who said she was off to set up a stall at the car boot sale. I met Ellen outside the chapel and she introduced me to her children and the small congregation.

'What are your favourite animals?' asked John of each member of the seated assembly.

'Cat.' 'Dog.' 'Elephant.' 'Rottweiler.' 'Lion.' 'Snake.'

'Gavin, at the back, don't you have a favourite animal?'

Gavin remained mute.

'God's favourite animals are us,' said John. Gavin looked surprised. The children listened raptly.

'Now let's take requests for our prayers.'

'For the Kurdish peoples living in Turkey,' said Ellen.

'For Maude and Nathalie on holiday in Turkey,' said Lindsey.

'For the people trapped and buried in a South Korean department store,' said Glenys.

'Something we know from the mines,' added Ellen, 'trapped in darkness and the blackness.'

There were other requests: 'For Dad's operation', 'Someone new living in my house', 'Eight teeth out', 'For Nigeria'.

'Let us pray for freedom from fear,' implored John Morgan, winding up the service. 'O Lord, we beseech thee to deliver us from the fear of the unknown future, from fear of failure, from fear of poverty, from fear of bereavement, loneliness, sickness and pain, from fear of age and from fear of death. Amen.'

After the service John hadn't much time before leaving on holiday. He tried to take as many young people as he could from the estate to give them a break from the valleys. He had also found a young Hungarian theology student to help out on the estate. For some East Europeans, the Rhondda was in greater need of help than the countries on their side of the former Iron Curtain.

I found Rita at her stall among the other women and children at the car boot sale in the car park between the pub and the community centre. They were wrapped up against the cold like Russian babushkas, but as the sun began to break through the clouds layers of clothing

were removed. The local ice cream van was doing a good trade, the stalls less so. I overheard two young children arguing.

'You talk so much shit, it dribbles down your chin,' said one of them.

'I'm going to get a knife and fork,' said the second child.

'It's only a fucking pasty,' said the first child.

'It's not a three-course meal,' said his mother. 'If you wake the baby I'll kill you!' she screamed after him as he left for the house.

There weren't many men on the estate. Many of them – husbands, partners, brother, uncles and fathers – were in Portland prison. When they were back on the estate they called it 'holiday', because they spent so much of their lives inside, leaving the women to fend for themselves. Life was hard for these women and I wondered what kept them going. They no longer had faith according to churchgoing principles to support them, nor their mothers' stoical acceptance of a lowly role that they must adhere to. Most of these women could no longer be grateful for a family life because their husbands and partners were either away or when at home caused more trouble than help. They might be grateful that they had been relieved of much of the drudgery of scrubbing and heaving by machines, providing they hadn't been repossessed. But as Anita, a friend of Lorna's, told me: 'What use is a fridge if I can't afford to fill it?' Her answer had been to move in with someone off the site: the logic was wedlock and an exit visa. Because of the impoverishment of her daily life, she was willing to commit to a life of reckless romance. The consequences for the men weren't as severe; they didn't need to and often didn't want to make this leap of emotional faith.

Many of the women who remained on the estate still lived the bleak existences of bygone days. They no longer had to tend the fire for meagre warmth in the bitter winters, but several of them claimed that they kept the television on because it was the cheapest form of heating. It is impossible to compare the poverty of the past to today's poverty, but it seemed to me that they had traded one problem for another. Their babies were their future, a thing to love, a meaning to life, an identity and a distraction.

COAL NOT DOLE

It stands so proud, the wheels so still,
A ghostlike figure on the hill.
It seems so strange, there is no sound
Now there are no men underground.
What will become of this pit yard?
Where men once trampled, faces hard,
So tired and weary their shift done
Never having seen the sun.
Will it become a sacred ground?

Nearly everyone in Penrhys has friends or relatives who had worked in the mines. Nearly everyone can name a friend or family member who had been killed, maimed or stricken with pneumoconiosis. When Jaws invited me to his house for tea, his mother spoke about her relationship with the mines.

'My father, Jaws's grandfather, had pneumoconiosis, he couldn't walk up the hill to Penrhys. You either died quick or you died slow. My brother Aneurin was killed when a beam came down on him. He said to his brother-in-law, "reach for the spanner", and it missed him. My sister's father-in-law was also killed in the mines. We lived in a three-storey house, one of the other families' twins died in the same accident as our Aneurin, he was in his late twenties or early thirties. I was working in the Apollo leather factory, it came over the radio. When I came home I found out that Aneurin had been killed. The day of the funeral was unbelievable, you'd have one hearse, the family cars, another hearse, a family car, I'd never experienced anything like that, the line of hearses and families extended for miles through the valleys. After my brother got killed in the colliery I would never, ever have let my children go down the mines. Aneurin had just finished his ordinary shift then doubled back to do the night shift. My husband died, but not in the mines, he died through the love of fishing which Jaws has inherited. When Jaws goes out on a fishing trip, until he comes through the front door I can't rest.'

I wanted to visit a working mine. Coal from the deep seams of places like the Rhondda had once provided the vital fuel for Britain's

Industrial Revolution and for the growing world economy. I thought of what George Orwell had written in *The Road to Wigan Pier*: 'It is only because miners sweat their guts out that superior persons can remain superior.' The conditions underground had improved from the hell described by Orwell, but it was still dirty, hard and dangerous work. I hoped by visiting the last deep mine in South Wales I would discover why its miners had fought so hard to save their pit from closure and something of their working conditions. I telephoned Tower Colliery to see if a visit could be arranged and spoke to Tyrone O'Sullivan, a former electrician who was now personnel director and the prime mover behind the miners' takeover of the colliery. His father, a miner like his grandfather and his great-grandfather, was killed in an accident below the ground. In his gruff, relaxed voice he agreed that I could visit.

To reach Hirwaun the road slowly climbed towards the sandstone escarpments, leaving behind the undulating ribbons of terraced houses, roads, river and railway that followed the steep-sided valley walls. As the road climbed towards the crest of the Rhigos pass the valley appeared like a rift, a carved and twisted gash in the moorland plateau. Below the sandstone the black seams of coal, layer upon layer, a gigantic sandwich of coal upon rock upon coal upon rock flattened and twisted by the ages, lay hidden underneath the green mountains. The black furrows that had once pockmarked the surface of the mountain turf were gone. The land was again much as B. H. Malkin had described it in 1803, before the discovery of coal, as the most beautiful of all mountain districts in Wales, with upper peaks as the 'Alps of Glamorgan'. The great estates have been broken up, but once again the land was being worked by farmers and shepherds and the wooded hill slopes were being reborn. At the crest of the pass the views of the next valley and the mountains beyond were spectacular. At the bottom of the Rhigos Mountain stood the scars of bulldozed land and the complex of buildings with Tower Colliery's pithead at its centre.

In October 1992, the government as part of its privatization programme announced the closure of thirty-one of Britain's remaining fifty working mines, Tower Colliery among them. In London, the government blamed market forces for the death of the colliery; here the verdict was unlawful killing by persons unknown. The demon-

strations and public furore were so great that some of the mines including Tower won a temporary reprieve. However, after the public protests died down, most of them were quietly closed. Only this one went into the hands of its workers. To gain control of the mine they embarked on a massive fund-raising and publicity campaign. In the year the mine was closed they engaged in an underground sit-in and protest marches, sponsored a nationwide raffle and wrote to the Queen. Most importantly, 242 employees raised £2 million by putting their £8000 redundancy payments towards a takeover bid.

'When you're inspired to do something you've got to do, you do it,' explained John Rosser, who had gone from electrician and chairman of the local union lodge to organizing a business plan and becoming director of the mine. 'The banks wanted two types of shareholders: fifteen "B" shares for the managers, 227 "A" shares for the workers. And – they are bastards – we couldn't unseat any of those directors they appointed even if all us 227 workers voted unanimously. Ludicrous!

'The banks asked us if the boys would put up £8000. They had their redundancy money, no bloody jobs, the jobs around were so poorly paid. I said I would have to go back to the men. They put up the £8000 and when I asked them if they were prepared to put up another £6000, there wasn't a bloody murmur, they all put up their hands. We raised more money than the banks lent us.

'Look, if you want to catch the next shift, you better get your overalls and lamp. They should be ready for you.'

I put on a pair of bright orange overalls and new boots. All the miners had the cock-a-hoop smiles of supporters who've just seen their team score. Wendell, in charge of the lamproom, explained.

'We got our self-respect back, the pride that makes us the bread-winner. We took the Conservatives at their own word and became shareholders.' He no longer went down the mine: he had three fingers severed in an accident. 'I started as soon as I left school. My grandfather had hundred per cent pneumoconiosis, that's how he died. My dad had cataracts and twenty per cent pneumoconiosis in his lungs. I still wanted to go down. Ten guys working together is good craic. I enjoyed it. My two older brothers went into trades, one's a bricklayer, the other's an electrician. I never regretted it, except when I lost my fingers.

I had one bump before that; I got buried – badly bruised on my legs and side. The second accident put me off. My wife didn't like me going down the mine, she wasn't happy about it.

'I think we'll make back all the redundancy money we put in to buying the mine in our first year. But I'm not interested in making money, neither are the other boys, we just want to have a job. When the mine was closed for a year I found a job in a factory making trims for Jaguar cars, I hated it, it was so monotonous it did my head in. That's why we're not now extracting as much coal as we could, just enough to make sure we're in work for as long as possible. Our five-member management board who represent us make the decisions, we want to control how much we produce to guarantee long-term job security. We want to play conservative with our stocks – don't like using the word conservative around here.'

'Are you ready?' John had come to tell me it was time to go. Wendell handed me a helmet, cap lamp, belt and battery. 'Good luck!' he shouted as I left the lamproom.

Before entering the cage – the lift that would take us to the pit bottom – I was asked if I had any cigarettes, matches or battery-operated watch or camera; anything that could cause an ignition, including heart pacemakers, was forbidden in the pit. Clearly the strong discipline and the rigid codes of behaviour continued to prevent accidents as far as was possible. The cage gates clanked shut and within seconds we were heading hundreds of feet down into the earth. We walked the first few hundred feet along the pit bottom until we had passed the huge ventilation doors which were once worked by boys and girls as young as six working twelve-hour shifts or more in darkness. On them rested the safety of the pit. The children as well as the pit ponies that had once pulled the heavy tram loads of coal were beyond the memories of Tower's current miners. In their place was a conveyor belt. Each miner took it in turns to parachute on to the belt where he crouched as he was whisked towards the working coal face.

From pit bottom to the coal face was nearly two miles and only part of that was by modern conveyance. During the remaining mile or so, as we tramped into the heart of the mine, I was told about the conditions as they once existed, with an atmosphere foul from escaping gases. However they didn't tell me how every day miners risked being

crushed, burnt, suffocated or drowned. One of the miners did recount how miners used to carry their half-asleep sons to work over their shoulders. 'They went down into the mine before dawn and were up after sunset. This one lad thought Sunday was so called because in winter that was the only day he saw the sun.'

In the large corridor that led to the seam we could walk upright and freely. The ground grew increasingly muddy, with shallow pools of water. I knew from my previous visit to a mine that we had not yet reached the coal face where conditions would be altogether different. Here, a mile below the surface of the earth, generation after generation had for over a century and a half taken to heart the Creator's advice in the Old Testament, to rule the environment, 'be fruitful and increase' and 'fill the earth and subdue it'. However, Tower was where British coal was facing its last chapter; electricity is increasingly generated by natural gas. The supplies of coal that are used are often American, Australian, Colombian and Chinese, which are all cheaper. Fortunately for Tower the coal seams produce good anthracite which is in demand not only in Britain, but also overseas.

In a tunnel perpendicular to the corridor we crouched in a space between the floor and the ceiling that was not much higher than a table top. We had reached the rich seam of coal. The noise of the machinery as it gnawed at the anthracite was almost deafening, and we were in utter darkness, except for the lights on our hard helmets. Even with the mechanical aids that help build the supporting structures, the work still relies on hard graft which remains dirty and dangerous. The heat in the long, narrow pit stall was tropical, allowing the fine dust to collect like sand on damp skin. The ground was inches deep in mud, men crouched as they worked the face for hours at a time. Walking along the face I stooped to avoid banging my back on the ceiling, ducked to avoid my helmet hitting the beams, dodged to avoid the pillars and adjusted my step to use the bases of the pillars as stepping stones in order not to sink in the mud. It was easiest to walk bent double, looking at the ground.

Behind us, opposite the coal face, the roof of the stall had collapsed as the miners moved into the face and withdrew the pillars and supports from behind where the coal had been removed from the seam. The crumpled and collapsed stall was a reminder of the continual

presence of danger which undoubtedly contributed to the intimacy of the working community miles away from outside help. The mood, as it had been on the surface, was buoyant: a manager shouting above the noise told me, 'I used to have to chase and quarrel all the time to get the men to work,' the men in turn told me. 'We used to have the managers on our back all the time.' Their cap lamps shone like headlights in the night, stopping when they reached their target. Men's faces were so black that the whites of their eyes shone like cat's eyes in the lamps' beam. Whenever they could be heard they were quickwitted. 'You're back in the bunker, you!' yelled one of the miners at a manager. 'Don't be so crumpy!' the manager answered. As I made my way towards the corridor that would take the coal out to the conveyor belt, ducking the beams became more of an effort; but at least there was the recompense that one wouldn't have to walk all the way back to the cage. For part of the route, at least, I could hitch a ride on the belt among the glistening chunks of moist coal.

I had a good scrub in the pithead baths above the colliery site, but for twenty-four hours after I left the pit the insides of my nostrils and ears were still black with dust. I grabbed my clothes from the locker and headed for the canteen where I sat with Cardiff and Dai. Cardiff had worked the pit for nineteen years, but had started his working life as a welder for British Steel until forced to look for a different job. Cardiff, like all the other miners in Tower, saw the new regime as possibly history in the making, workers getting the benefit of their labour. They were all converts to free enterprise in possibly one of the strangest twists in industrial history. 'It'll be all right so long as we don't have to wear a blue tie.'

'I wouldn't want to go back to nationalization, that would be silly,' said Dai.

'I'd tell them to piss off,' said John.

'It gives you a bit of get up and go – before, there was no morale, we did a day's work and buggered off home.'

'Morale has gone through the ceiling,' John confirmed.

'There used to be a lot of absenteeism.'

'The biggest absentees were the original owners of the mines,' Dai interrupted.

'We used to speak to the managers in a different way, they're not

shouting down at you any more, they ask for your opinion, and they join in meetings about safety improvements.'

'Before, you just walked past a man, now we help each other.'

'We're exporting to France and Spain, there's interest from Belgium and Germany.'

Some of their rough-tongued philosophy might have disappeared, but what they had once termed the democracy of pit work was no truer than today where each miner and manager was an equal shareholder in their enterprise. If the two new canteen ladies worked out, I was told, they too would be offered an equal share. It was impossible to leave Tower Colliery and not be impressed and moved by the optimism of all concerned. The miners called it the best adventure out of a bad loss. It was one of the most uplifting experiences of my journey through Britain.

High up on the mountain in Penrhys former generations of Rhondda miners would barely recognize what they see. The familiar stoical acceptance of their lowly position, perhaps due to their Nonconformist churchgoing principles, the formulaic routines that filled every second of the day with work and duty, had dissolved like a scene from an old movie. People felt bereaved by the industrial genocide as if they had lost yet another father or son.

'Get the phone!' screamed Rita from the hall where she was talking to the decorator.

'Ma, it's Dad on the phone,' shouted Elise. 'Shall I say you're in the pub?'

'Don't fuckin' lie, tell him to stay another six years in Portland.'

Rita turned to me. 'He's got his hair off because he's heard rumours I'm carrying on. This time when he gets out I'm not having him home. He would kill anyone he thought was carrying on with me – last time he was out, he gave a boy a bump because he thought he'd pinched my kettle and iron. Anyway I couldn't carry on because Elise would grass me up. That's why I no longer take her shoplifting with me, instead I take the baby, my friend does the same only she puts a doll in the pram to make it look like a baby. It's not like I want to do it, my stomach turns every time I do it. I used to need to do it to buy the baby's nappies, like today I get my money, tomorrow I'm okay,

but by the end of the week I wouldn't have been able to send the little one to Porth with the other children and she would have felt chalked if she'd have to stay behind. But now it's become a habit, an addiction.

'I wanted to have an abortion with the last one. I already had two babies. The doctor didn't believe in that. I told him, you buy a pram, a cot. He shrugged his shoulders. He's not fetching my baby up. I was already taking depression tablets. They say we need social workers – the social services need us more than we need them.'

Gwennie, Rita's youngest, started crying. 'I love looking after babies until they start crying. My baby wouldn't stop the other night, I tried everything. So I left her on her own.' Rita got Elise to put Gwennie in her cot in front of the television set. Even at this tender age both children were being fed a constant diet of other people's superior lives. Rita was always trying to keep up; after having her tumble dryer, three-piece suite, freezer, curtains and television set stolen, it was only now that her house was coming together again after one and half years of shoplifting.

As mine after mine was closed and as the job opportunities moved elsewhere, former producers had been redefined as consumers. Without producing they had no money, but they still had to buy. Even when they eventually found a job in a factory, they lived with the uneasy knowledge that they were never more than a step away from redundancy and the dole, thanks to the first two tenets of capitalism – deregulation and market forces.

Unlike any other estate I had visited in Britain, in Penrhys I found the young men interested in politics. I met some of them as they aerosoled a slogan on the side of an empty house: TODAY'S POLITICIANS = TOMORROW'S DOG FOOD. Many of them were more interested in what was happening in Bosnia than they were in the latest tabloid headlines. 'Who gives a fuck if Hugh Grant got a blow job,' said Sharon, the only girl in the group. 'All I can say is well done, man.' Their impromptu meetings, in the shopping precinct, the abandoned houses or maisonettes and in the pathways reflected a much looser, newer pattern than those of previous generations and mirrored the increasing fragmentation of society at large. Sometimes they went on to the mountain.

'We used to go up into the fields and pick mushrooms. They stopped us from scouring them by putting chemicals down. They became

different, instead of needing 150, each mushroom became a real mental head cooker,' said Joey.

'Acid's a lot cheaper than a holiday,' Paul added.

'They never talk about the positive aspects of drugs,' said Sharon.

Two young Cardiff City fans in their team's football shirts sauntered by, ignoring the little group that were now sitting on the steps of a block of houses that were soon to be bulldozed. The group on the steps started beating themselves around the head and chanting at them. They explained it was the Cardiff City supporters' theme song which they called 'Doing the Ayatollah'.

'Those two boys are fucking depraved,' said Joey.

'Defiant,' Paul corrected him. 'The young one's only eight and he's got a hundred convictions, he drove three of his neighbours out. He lives in the only house in a block of four that hasn't been gutted by fire.'

This group passing the time on the steps were responsible for much of the graffiti that read FUCK THE SYSTEM and DON'T BELIEVE THE KU KLUX KLAN. 'When they came up here, we chased the fuckers off the estate,' said Paul proudly. They also went around the estate teaching some of the young children to repeat the slogans. 'You could call us the Anarchist Communist Federation, we believe in anarchy and revolution first, policy second. We're anti-establishment, anti-Socialist Worker. We'd vote for Class War but we can't because it's against our principles to set up a party because then you become part of the system,' said Paul.

He had a skull tattooed on his forearm with an inscription that read 'Death is certain – Life is not'. They variously had tattoos with imagery from Celtic and North American culture and, like those I had seen in the pub, with Chinese characters. Joey had the Chinese character for Death on his forearm and Evil tattooed on his calf. I asked Paul for the English translation of the tattoo on his bicep. 'Oh, that's not Chinese, I was trying to cover up a former girlfriend's name.'

Only one of the present group had travelled out of the Welsh principality for anything other than to participate in a demonstration. 'We don't want to organize anything, we wait for it to happen. Then we'll travel to Cardiff or London and ruffle the fluffies,' said Alwyn.

'Keep it spiky,' Joey added.

'You can't hit the pacifists 'cause they don't hit back,' Paul added.

'I admire the Socialist Workers Party because they organize, they've got their foot in the door, but they won't do anything against the law. I've tried to crowbar information out of Trevor or Red when something looks as though it's going to go off.'

'You can't live by the law you're trying to get rid of – that's why I disagree with the SWP's policies.'

'We're the only ones who want change.'

'We're not prepared to settle for the same routine, do your work, eat your food, get your pay. My mother thinks the Labour Party is a socialist party!'

'Anyway, nothing's going to change around here, it's a one-party state, everyone votes Labour, they even used to call some of the villages Little Moscow.'

They all read the newspaper *Class War*. 'It's about class unity, class pride, we buy it off Trevor. He's like you, always thinking about writing something, wants to know if the world can change, he's got his own band, he writes his own lyrics,' said Joey.

'The pen is mightier than the sword, but the half-brick is best of all,' Paul advised me.

They, like Martin in London, suggested I meet Trevor, who had travelled in search of a utopian society, but he had moved off the estate into nearby Tylorstown. They suggested I look in Tylorstown's pubs and clubs for Trevor's father.

Jaws helped me search Tylorstown's former working men's institutes. They were once a keystone of a self-made and radical society; now they are stale, sad and empty places which survive on the profits of the bar, the cigarette machines and the one-armed bandits. The reading rooms where the workless men gathered in the last great depression in the 1930s have become saloons and games rooms, the library cupboards now hold beer glasses and bingo cards. We didn't find Trevor's father, but we were told where he lived.

We wound up a steep hillside where the squat terraced houses followed the contours of the hill. In a road facing 'Old Smokey', a massive waste tip, we found the house. Trevor was dressed in shorts printed with the Welsh dragon. He hadn't much time before leaving for rehearsals with his brother Red and the rest of the band. He looked extremely fit and led a full life on the dole.

'I'm looking for quality life,' he told me with determination and conviction in his voice. 'I'm not going to work in no factory, no pit. I can't be doin' someone else's shit. I want to be thinking about what are we doing here. Do you know why we are here? Will there always be the haves and the have-nots? Our parents and our parents' parents didn't know nothing, they didn't want anything, and they didn't dare to desire, wages controlled their lives. It was our fathers and grandfathers that ploughed the soil and grew the food, we made the clothes and built the houses, it was our labour that brought the coal that powered the ships and trains and factories and our steel that built them. Did you ever see a rich man doing those things, risking his life for others until retirement – if he lived that long, and if he did it would knock years off his life.

'It is our constant struggle to pay the rent and buy healthy food and clothing – there's no money for anything that you find in the big shops in Cardiff. We never see such things here. The only thing people talk about and are interested in is the lottery. I used to listen to Radio Moscow. I was interested in the communist movement. There used to be flights from Cardiff to Moscow, so I saved up and went. Then I wanted to see the other side so I flew to Orlando. It wasn't much better. So I came back here to Penrhys up the road. In fact, although my father left me this house, I wish I was back up on the estate. I miss it.'

Trevor had once been torn between the desire to escape from a life that was poor, ignorant and mulish and the knowledge that escape would separate him from the good people he knew and loved.

Depending how you looked at Penrhys, life could be monumentally depressing or unflinchingly heroic. The estate was a story of child abuse, drug addiction, murder, suicides, depression and despair. Of families that ruled like dynasties. Of a diabetic old lady who was robbed of her syringes and imprisoned in her own bedroom, of a man with a history of drug abuse who stole the car of the doctor who had just saved his life, and of self-mutilation to trick the Criminal Injuries Compensation Board into paying compensation. But there was also the 'silent majority' of the unemployed, like Gareth who spent his days training and keeping fit and was going to run for Wales in a sponsored race that had raised £75 for charity.

Or Dolly, who could only find temporary work during the run-up to Christmas. She sat at a table in her living-room in one of the bright

new maisonettes surrounded by piles of paper, toys and ribbons. 'I get paid £29.95 for thirteen dozen boxes of Christmas crackers. Each box has a dozen crackers, I can do a box of twelve in thirteen minutes, that works out at about 90 pence an hour. For every kit I complete I get a £4.50 bonus, which makes it more like a £1 an hour, but you've got to work well tidy to earn that much, no distractions, no kids screaming. I often end up smoking or drinking a can of lager to get off the stress. My only luxury is four cans of Guinness a week – I can't always afford them.'

Dolly continued to work feverishly as she spoke. 'The hardest part is curling them once you've cut the ribbon either end of the cracker.' She placed a stick banger in the roll of card, then a toy, a paper hat and joke, wrapped the paper, then the ribbon, cut it, tied it, first around one end, then the other, then curled each end and stuck a decorative bow in the middle of the finished cracker before placing it in a box. 'Others do bows on crackers. I've tried hinges – cupboard hinges – but they were too tough, made my hands bad. I've also attached zips, half a pence per zip. I used to be a machinist making leather gloves one year, mittens the next year. The firm went bust. I left to have a baby – that was a stupid thing to do. I work in a fish shop twice a week in Pontypridd. I'd like a job where I could sit down some of the time and stand up some of the time because I've got arthritis in my hands, arms, legs and back. The only place I haven't got it is my head!

'There were so many boxes of crackers you couldn't get in the kitchen last week. It's hard not to feel nationalistic. The Welsh flag and all of that. The English ripped us off, they took everything and just left us a big tip.'

Before leaving Penrhys I promised to drop in on Ellen. She lived with Ewan, her partner, and his mother. 'Mum's senile, but sometimes I think it's him,' said Ellen as Ewan made the tea. 'It was wrong for the men to go down the tunnels. So much death to our families. My grandfather came from the slate quarries in North Wales. My other grandfather was a preacher, there were eleven brothers, he was a twin. Ewan's grandfather was from Waterford. Everyone from the valleys is a bastard race, Irish, English, Welsh, even Italians.'

Ewan handed me a cup of tea. 'He's never been the same since the explosion down the mine. Thirty-one people died.'

'It frightened the life out of me,' said Ewan. 'The nearest person was two miles away. I went down for another four years, but I was never the same, I saw ghosts. It left a small scar on my mind.'

'Let me introduce you to Mum,' said Ellen.

Ewan's mother was in bed and Ellen brought her tea. 'Let me sit you up.' Mum struggled to grip her mug and began wheezing.

'Mum, don't die yet, I can't afford the flowers.'

I spent my last night in the pub playing bingo. Jackie, Dai's wife, called out the numbers, and fourteen-year-old Kerri helped me mark my card. When I won £6 Glenys looked at me, despondent: 'Maybe I'll win a man. I can't win an argument, let alone the bingo.'

'Two and two, twenty-two,' called Jackie.

'I won!' screamed the eight-year-old who had more convictions than there were bingo numbers.

He went to collect his winnings from Jackie. When he returned to the table his mother said that as she had paid for the ticket he was to split the take with her.

'Fuck off,' he told her.

'Don't you fucking swear at me,' she hissed angrily.

'Just fuck off. Bitch!'

She tried to jab him from across the table. He moved easily out of the way.

'Wait till I fucking get hold of you . . .'

'You can't fucking scare me, slag.'

He backed out of the pub screaming abuse at his mother, who answered each obscenity with a threat.

'Can we all move on to the next card,' orchestrated Jackie. 'One and three . . .'

Over the last pint I told them I would be leaving for England and Belfast. 'It's free to get into England across the Severn, but they charge you to get out, think about it,' said Joey.

Jaws asked me to pass by the community centre before I left and when I called next morning he handed me a present – a key ring and other small mementoes. 'Don't ask where it came from.'

Tower Colliery made £2 million profit in its first year of worker-owned operations.

BELFAST

The Uneasy Peace

History says, 'Don't hope
On this side of the grave.'
But then once in a lifetime
The longed-for tidal wave
Of justice can rise up,
And hope and history rhyme.

So hope for a great sea-change
On the far side of revenge.
Believe that a further shore
Is reachable from here.
Believe in miracles
And cures and healing wells.

SEAMUS HEANEY,
'The Cure at Troy'

ACCORDING TO AN old story an airline pilot flying into Belfast
advised his passengers to turn their watches back to local time – 1690.
In today's United Kingdom I had found that Northern Ireland wasn't
alone in the arena of bigotry. In Liverpool I had watched the Orange
Lodges, once called the poor man's Masons, march on 12 July to
commemorate King Billy's routing of the Catholics at the Battle of
the Boyne in 1690. In Glasgow much of the graffiti was in support of
the Provisional IRA or the Loyalist paramilitaries, the UVF and the
UDA. Even though the ceasefire was into its second year, some of
the paint was fresh.

I arrived in Belfast on a wet Sunday morning with a raw draught

coming off Belfast Lough and the River Lagan and walked from the ferry terminal along deserted streets which on weekdays were packed with shoppers. They had their quota of brand name shops, McDonalds, Burger King and Marks and Spencer: it looked like what it is, a medium-sized modern European city. The last time I was in Belfast was during the 'Troubles' and many of these same streets were blocked by road barriers, some of them checkpoints manned by the RUC backed up by the army in full battle gear. However, since the Provisional IRA had announced a 'complete cessation of military operations' and the Loyalist paramilitaries did the same six weeks later, much had changed. The streets were now busy and vibrant after dark, no longer deserted except for amnesiac drunkards and the hopelessly forlorn and vulnerable, but some things hadn't changed and for some the ceasefire had brought with it new problems, problems that had been held at bay because of the warfare.

I waited in Donegal Square outside the impressive City Hall for Tom Hartley, a local Sinn Fein councillor.

'Welcome to Belfast,' said Tom from his old, beat-up car. 'Get in. I'm sorry about the weather, it only rained twice last week, the first time for three days, the second for four.'

Tom quickly made me feel at ease, which during the months of travelling across Britain I had come to realize had something to do with Celtic roots as opposed to Anglo-Saxon ones. In fact here I was often reproached for saying that I was working on a project about Britain, because for many Catholics, Northern Ireland is not part of Britain or the United Kingdom. But the two working-class communities I was to visit, one Catholic and one Protestant, had much in common. The older generation, like the one on the other side of the Irish Sea, could be prickly, parochial, self-deprecating and negative, but they would do anything for someone in need. The younger generation were suffering from a lack of self-esteem brought about by continuing social deprivation and high unemployment, although the degree of the modern epidemic – the social malady of a lack of identity – varied in each community. Tom took me to his small home where he fed me soda bread and potato pancakes. I tucked into them heartily and he told me to not eat the bread board.

Times had clearly changed. Tom, who lived on the second floor

'because it's safer from attack', no longer used the drop bolts on his steel door: the threat from Loyalists had receded. As he talked about the weight of oppression and the struggle against the British, I looked around. It was decorated with African masks, Buddhas, miniature sculptures of whales, Mexican artworks and a portrait of Che Guevara, the first of many I was to see in Catholic West and North Belfast. Unlike the Scots, some of the working-class Catholic Northern Irish had a great sense of themselves, similar to the minority cultures in England which were ghettoized and yet cosmopolitan. The Catholic community I visited had reinforced its identity by blending traditional Gaelic, contemporary Irish and international revolutionary influences in music and dance, writing and poetry and the visual arts – most impressively in the huge colourful murals on gable ends. They saw no separation between art and the Troubles. I became convinced that the ceasefire would weaken their stubborn resistance to the colonizing process, not just of the British Anglo-Saxon culture, but of the global village with its diet of international soap operas and lowest common denominator fashions. So they would join their brethren I had visited on the mainland who, for all the regional diversities, had lost much of their identity which is so important to the human soul and spirit.

Over soda bread, Tom articulated a belief I firmly subscribed to: 'It's not as much the rewards of the promised land, but the rewards are manifest in the struggle towards it, it's in the getting there.' The younger generation were mainly influenced by immediate gratification – it is hard not to be when you are bombarded from morning to night with glossy images of superior products and lifestyles, newspapers and magazines telling you how to look and what to wear. Many of those I met believed in the struggle, but few wanted to follow in the footsteps of their parents who had participated in it.

Tom read me some poetry, played some traditional music and talked about the years of dogged resistance to the British. He looked at his watch. 'I can talk the legs off a table, and back on again; if I don't stop there'll be no time to show you something of Belfast.' But he continued his history lesson, talking of Britain as a foreign occupying power. He rejected their laws, their legal institutions, their police, their courts – in short, all the structures of the British state.

Wherever we went in Catholic Belfast, Tom was recognized and

greeted warmly. Sometimes people complained about local services, unmended drains and uncollected refuse, or they just wanted to shake his hand and have a chat. In Milltown cemetery, a revolutionary tourist, an American lawyer from Los Angeles in gold sandals, rushed up and asked if she could have her picture taken with him. Tom was visibly embarrassed, but went along with it. In Hollywood there is a chic currency in being photographed with one of Sinn Fein's most prominent leaders.

As we drove through Catholic West Belfast, armoured RUC Land-Rovers were still present, but they didn't seem to have the same ominous power they once had. Although the army surveillance helicopter was always there, still hovering above the city, the closure of security checkpoints, the withdrawal of armed troops from the streets, the levelling of the Howard Street Barracks, were positive signs that a normalization of life was taking place in Belfast. We went up on to the Black Mountain, along a lane where West Belfast ends and the countryside begins. Tom told me both sides used to dump bodies here.

We drove up to a farm and walked on up Black Mountain, from where it is said that you can see the Scottish isles on a clear day. Here, above the city, I looked down on to Belfast and was jolted by the huge man-made scar, the brightest and biggest landmark, the brand new refurbished 'peace' wall cutting across roads and through semi-detached housing, bisecting the almost 100 per cent Protestant Springmartin area from the predominantly Catholic area of Springfield. It is a post-cold war era Berlin Wall symptomatic of the rise in nationalism elsewhere in the world, a turning inwards, a Great Wall of Ireland to keep out marauding foreigners on both sides. The wall was cleaner and brighter, longer and taller – seven feet higher – than on my previous visit, not tall enough for some Catholics, too tall for the Protestants.

Both communities wanted a new wall to replace the old grey iron one which went up in 1969, the Protestants because it was ugly, the Catholics because it was too easily breached. I was told that just before the ceasefire two gunmen came over the wall and shot dead a seventeen-year-old Catholic boy as he sat in the back of a taxi. Looking down on Belfast, Tom pointed out the different enclaves. The well-to-do

middle-class areas remained religiously mixed. They were pleasant residential neighbourhoods with manicured lawns, they had not seen rioting, arrests or raids, they had managed to come through relatively unscathed by the Troubles. The working-class areas, which were some of the most deprived corners in Britain, were predominantly either Protestant or Catholic and under what nationalists consider the occupation of a foreign army. Before setting off for anywhere, Tom, like thousands of others living in Belfast, tried to find a route that skirted enemy territory. In many respects the map of Belfast looked like Bosnia.

For those people I visited in working-class Catholic West and North Belfast and the Protestant district of Shankill, Northern Ireland was still not at peace. The use of guns to effect political change had been suspended, but the threat and the use of terror and violence hadn't. Internal repression to establish communal and territorial control was evident on walls and gable ends. In the Shankill area graffiti signed by the UVF paramiltaries warned that drug dealers would be shot, in the Catholic area of White Rock the IRA warned that petty criminals and drug dealers would be iron-barred, and these messages were repeated throughout Northern Ireland. In these communities, as elsewhere in the world and in Britain, the enemy is no longer on the other side of a battle line – he is right behind you in your own neighbourhood.

As I wandered around Ardoyne I was introduced to Callum who had lost several members of his family to the Troubles as well as seeing two nephews maimed since the ceasefire.

'I could never trust them Protestants,' said Callum regretfully, 'because three members of my family have been killed by them. One sister was killed by the Republican IRA, they were trying to shoot the police, that was three years ago. That was a mistake! Aren't they all? They tried to shoot one of my nephews – although he was a big, big man, he was very soft, standoffish. He was in the sister's house, he had his kid on his shoulder, that was in July 1994, just before the ceasefire. My brother was blown up twenty years ago, he was seventeen years old at the time. He went to repair a car, the petrol gauge wasn't working, he went to get the can of petrol, the car was booby-trapped, it was meant for someone else. Another mistake. It was a mistake we were born.

'You should meet my nephews, they're not afraid of anyone. They're not afraid of the Republicans, the police or their parents. Both nephews got beaten up by the IRA, one was deported – he was told to leave the country, he left but he couldn't stick it in England so he's back and hiding from them. I used to tell them, "Why don't you do ordinary things, go to the cinema, take your girl out?" He said to me, "I don't want to be a weirdo." He doesn't steal cars for gain, but to race them up and down the street.

'As a kid I could have gone up the hills,' pointing in the direction of Ligoneil and Ballysillan, 'but now we're surrounded by the Prot-estants, it's like cowboys and Indians. There are playing fields and a leisure centre with a swimming pool, you see where I mean? We can see them but we can't use them, because it's in a Protestant area. If my daughter was up there I wouldn't call out her name, they'd know she was Catholic. She's nineteen and she's never played in a park. Kids are the future – unless they get it together it'll go on for ever.'

In other parts of Britain certain estates had their problem families. These sometimes became dynasties in which, more often than not, the demonology of some ancient feud was relentlessly drummed into them. When they talked about a rival family or the authorities, these were implacable enemies who ceased to possess any redeeming features. Here this was true not of families but of whole communities. When I spoke to young Catholic and Protestant children the 'Taigs' and the 'Prods' took on strange physical and racial characteristics, although you couldn't tell the enemy by looking at him. Some of the demonizing could be attributed to the high-voltage of volatile youth with nothing to do and no future to look forward to. A sense of superiority conferred something eternal on the lives of these youngsters, it raised them above paltry things and the petty meanness of life. These youngsters, like those on mainland Britain, rejected many of the laws of the state, replacing them with other moral rules, their own set of conventions, which they saw as just and adequate.

As in many parts of Britain the kids hung out in the streets; the youth clubs were shut because the people working there were on their summer holidays when they were most needed. Children were always looking for adventurous things to do and some of them found ways to amuse themselves, like winding a length of rope around a lamppost

so that when they pushed off from the ground holding the rope they would be projected swinging round and round as on a fairground carousel. I came across three teenagers playing their version of conkers with lollipop sticks. Gerry was the reigning champion with 58 consecutive wins. 'We'll take you to Charlie's coal bunker, that's where we hang out,' said Andy, who'd just had his lollipop stick broken in two.

Charlie's coal bunker was the tiny concrete fuel store to Charlie's boarded-up house. The three of them could barely squeeze on to it together. That was where they spent their days, sitting on the coal bunker watching other children jump off the roof of another derelict house. Gerry's toes appeared through his boots, his only pair. Some of the more fortunate ones had been on cross-community holidays to Austria, Germany and the United States. The parents didn't set much store by the scheme: 'What's the point of sending them to a nice environment when they've got to be sent back to this shite?' What they didn't know was that some of their children had remained in contact with kids from the other community by letter and telephone after their return. When they could they would meet in the centre of Belfast which was considered neutral ground. Eleven-year-old Siobhan, who had been to America the previous year, told me that she kept in touch with Emma. 'They say Protestants don't know the Bible but Emma goes to Sunday school and she knows all the 72 books in the Bible. She knows more than most Catholics would. We throw stones and bottles at the peelers [police] because we want them out, because they create trouble and they want our country for themselves, they're greedy. You don't see army helicopters every day in the States do you?' I followed Siobhan and her friends as they gathered pallets and disused furniture for a huge bonfire to commemorate twenty-five years of internment.

'My uncle is an IRA man,' boasted her friend, twelve-year-old Glynn.

'I think he's stupid,' said Siobhan.

'If there are no IRA, the peelers will come in and destroy us.'

'They try to stop the joyriders and break-ins.'

'My uncle decides who gets beaten. If they don't get beaten, they get sent out of the country.'

'The beatings are right,' agreed Siobhan, 'because the drug dealers are threatening other people's lives. The judges will probably say to

them to help the community, help old people, but they won't do it anyway. They need to be taught a lesson.'

'It's cool here except there are a good few kids around here that drink and smoke and they will ask you do you want to.'

'If you don't some will say you're not messing around with me any more.'

Some of their friends were painting the kerbstones green, white, and orange, the colours of the Irish tricolour, while an older group worked on a gable end mural depicting the Irish famine, the first failure of the potato crop in 1845. As I stood looking at the scene one of the muralists told me, 'Providence sent the potato blight, but England made the famine. Hundreds of thousands died of famine and fever even though wheat and barley were exported.'

Callum walked me through Ardoyne. Along its perimeter brick wall that separates it from Protestant Shankill there was a hole that led to a former linen mill which had been converted into workshops to train young unemployed men and women.

'It's called a cross-community project,' said Callum bitterly, 'but you won't find Catholics and Protestants training together. The trust that runs the business centre raises millions of dollars in the States claiming that approximately 50 per cent of the trainees and employees are Catholic and 50 per cent are Protestant, which they are, except they don't work or train together. See for yourself,' he suggested.

I talked to the trainees as they left the industrial units at the end of the day. The Catholic young men emerged through the wall into Ardoyne, many dressed in white overalls: they had been learning bricklaying, plastering and joinery skills. I asked them how many Protestants they worked with. 'None,' they replied. We ran to the other side of the former linen mill and caught up with three Protestant twenty-year-olds wearing blue overalls: they were trainee joiners. I asked them how many Catholics they worked with. They started to fidget, one of them scratched his arm. Callum repeated the question, 'How many Taigs do you work with?' 'None,' they replied. Only at management level did the two communities work together. The management level Catholics were referred to as UMTs – Upwardly Mobile Taigs. 'They'll still be drinking their G and Ts whatever happens.' Talking to these young men on both sides of the fence was to see a mirror image of attitudes

and prejudices. This enmity on both sides had been cherished and nurtured since childhood, the historical hatreds so strongly rooted that they imprisoned the hater and poisoned whole neighbourhoods.

Now that a kind of peace prevailed, senior members of both working-class communities were worried that the aid money would dry up, even though some of them complained that the people getting the money were the priests and the ministers.

'It's not bottom up, it all stops at the top, they know there's money in it. We're not sectarian, but we have to be sectarian to get our money!' complained an outreach worker working with ten-year-olds who just wanted to play football and go swimming.

'If there's a permanent peace,' Callum pointed out, 'we're just going to be like Toxteth in Liverpool, or Brixton in London, there's not going to be the same amounts of money, it's just going to spiral down. All we have is sweat equity.'

It was as I had recently read in *Time* magazine:

> Like the relationship between the First World and the Third World, poverty is a bit like that between the dentist and tooth decay. While there are no doubt many upright aid workers and dentists, the fact remains that decay, whether human or dental, is the raison d'être of the profession. Without want in the South, there is no need for the hordes of Northern experts, consultants and facilitators. Aid has become a growth industry with all the vested interests that go with it.

Callum complained that locals who knew their areas like the back of their hand couldn't get consultancy jobs.

'They ask us, "Where is your honours degree?" My degree? I'm living with it, but because I don't have nothing on paper I, like two or three hundred others in Ardoyne, do it voluntary because we want to live in a better community. But we have to show the consultants the ropes and they get paid tens of thousands for it.'

On the Protestant side of the former linen mill, Aprille, a former mill worker, echoed the same protests: 'The government insists we bring in a management consultant at £25,000 to tell us how to spend £50,000.'

I met her in a community centre on the Shankill Road, now a quiet

thoroughfare which used to be packed with housewives doing their shopping, although the men are still there laying bets and downing pint after pint in the pubs. Some of the shop fronts were boarded up, others were derelict, off-licences now seemed to outnumber the pubs, and I passed Frizell's fish shop which is pointed out on bus tours of the city as, 'where the notorious bomb attack was made in October 1993'. The churches and mission halls were the only buildings untainted by shabbiness.

'My world ended in 1990,' said Aprille. 'After thirty-eight years they closed the mill overnight; we came in at eight in the morning and were told to go home at eight-thirty.' She explained that the same had happened to what was once the world's largest tobacco factory, rope works, flax machinery works and a host of other businesses that had once made Belfast one of the great industrial cities of the western world.

'There were six large mills, 60,000 people where we are sitting, that's how this area started. In the early days if you wanted a house you had to work in the mills and be a Protestant, because the industries were Protestant-owned. I lived in a mixed area. I was born, reared and worked in a mixed area. I had Catholic friends just by the nature of where I was born. I now live in a Protestant ghetto, I moved because of the Troubles. I was put out by the Protestants even though we were a Protestant family. My father was a shop steward for the shipyard, he was a bigoted Protestant, believed in the Protestant religion, "Rome no," he'd say, but he stood up for the Catholics. The Billy Boys told him to be quiet, but he wouldn't keep quiet, so they put a bonfire against the house, the 11th night, preceding the 12th July. My sisters were put out by Catholics, they were in a different position, they were living in a Protestant estate facing a Catholic estate, it was like a great refugee movement with trucks going around, the Protestants moved out, the Catholics moved in, over one weekend, you let me have your house and you can have mine, so no damage was done to the houses by mutual consent.

'That's how the ghettos were formed. They were all united by poverty and deprivation, I'm talking real poverty, but today is no better for the Shankill Road, the government says a family of four needs £251 to be on the breadline, many on the Shankill are struggling on £100. It's the same in the Falls Road. This is where the paramilitaries find their

breeding ground. They offer the young people a sense of identity which the state doesn't. You see, when I worked in the mills as a young girl, I wasn't any better off, but I had a sense of self-esteem. Now the young people come from second and third generation unemployed, in such an environment the work ethic isn't there, the young people have no role model of a working parent, in fact they rarely have any role models other than those that are likely to lead them astray. School achievements are often non-existent, some of them emerge from school barely literate.

'The Protestants expected to find work so they never expected to need education, the Catholic families have been better pushing their children into education because they recognized that education was the only way out, because their great-grandfathers never worked. But at the end of it there are still no jobs. The government comes up with all sorts of schemes, but it's like a bucket with a hole in it, the more you seem to do the more you seem to be losing – it's not a scheme you want, it's a job.

'I was fourteen when I left school. I passed my eleven-plus, but wouldn't go to grammar school. My class, there were twenty-eight in it, sixteen passed, today many of my school chums are doctors, ministers, and vets who were at school with me, education was valued. Now you still have that small pocket of kids who could go far, but the families don't have the money to support them. Working-class issues haven't been raised for twenty years, hopefully peace will bring that up. In the thirties and forties Protestants and Catholics from the Falls and Shankill marched together for jobs. I went to the dances on Falls Road and the Catholics came to shop in the Shankill Road. The Peace Wall and the closed gates stopped all that. Now the children and men don't dare cross into each other's areas, some young people don't even know where the City Hall is.

'I'm Irish, but not in the sense that I'm green, I was born in Northern Ireland, but I live under British regulations. If I'm in Ireland I'm in another country. Politicians make a big thing of it. It's their livelihood. All those marches with the politicians leading us with flags flying. You can't fry a flag in a pan – you can't eat it. The Reverend Ian Paisley says if we go to Dublin it's the road to Rome. If I moved to Dublin I'm still a Protestant.'

Money and investment were coming to Belfast as a result of the cessation of hostilities, but the most deprived communities weren't going to see much of it. In Ligoneil I approached a group of youngsters ranging from eleven to eighteen years old near the leisure centre. Some of them were gambling with coins against a wall.

'I don't really like the game,' said one of the youngest ones. 'It's like scratch cards, but I still do them. I like the excitement, if you're losing, you're thinking ahead – you're going to win next time.'

I asked them if I could have a chat. 'What religion are you?' asked one of the older boys, his expression at once questioning and threatening. 'Atheist,' I answered. 'Is that Catholic atheist or Protestant atheist?' he wanted to know.

I sat on the grass above the playing field. Some of them left their game and followed me. I told them I had spoken to Catholics their age in Ardoyne.

'If they feel Irish they should go back to Ireland, this is part of the United Kingdom, the British Empire. That's what we've fought for and we're not going to give it up,' said one of them, with the rest of the group nodding in agreement.

'They say you should go back to Britain,' I replied. There was no answer.

These young people were worried about their future: they felt that the politicians had got them into the Troubles and now it was convenient to abandon them. 'They used to play God Save the Queen before official events, they don't now,' one of them complained. But not one of them knew any of the other words to the anthem; they knew the date of the Battle of the Boyne, but not why it was fought. They didn't think peace would get them jobs, or only menial ones. 'I can find a job as a cleaner,' said an eighteen-year-old girl. 'I know it's wrong, but I don't want to be a cleaner all my life. I think I can do something better with my life.'

As elsewhere in Britain the youngest members of the most deprived communities had an awareness of other worlds and it gave them high expectations. The one thing the system had taught them was that they had failed. Billy, at fourteen years old, worried about reaching sixteen, not finding work and being put out by his family and having to live in a hostel. A young man who worked in an internationally renowned

fast-food outlet said that they treated the hamburgers better than the people who worked for them. Out of earshot of the others he told me it was the first time he had met Catholics and was surprised they shared the same taste in clothes and music. I found the Protestant teenagers' culture was increasingly secular and inward-looking. The Protestants seemed to be on the defensive in trying to define themselves. They felt they had nothing in common with Southern Ireland, and while they called themselves British they didn't feel completely British, because they knew the people of mainland Britain didn't always see them as such. They were worried that their allegiance to the Union of Great Britain and Northern Ireland was not reciprocated to the same extent by the British Parliament and its people and they saw themselves being sacrificed on the bonfire of political expediency.

Change was afoot and those proverbial all-weather complainers, taxi-drivers, had felt the breeze of change too. They said there was less business, people were beginning to walk and use the buses because they were no longer afraid. I often took shared taxis that followed specific routes, planned so that Catholic taxis avoided driving through Protestant areas and vice versa; now negotiations were under way so that certain main arteries could be used by both communities. The segregated taxis that operated from segregated ranks were usually crammed with a full complement of passengers including mothers with babies, prams and shopping. Little lapel badges often revealed the wide panoply of interests. Women and men wore red ribbons in support of people who had been tested positive for HIV, green ribbons for the release of 'political' prisoners and blue ribbons for the people who had disappeared during the Troubles and had been denied the right to a Christian funeral and burial.

The women loved the peace. 'I don't worry so much about my children playing outside,' said Mary, clutching her baby on the back seat of the cab as we travelled along the Crumlin Road. 'You were always trying to get where you were going as fast as possible.'

'My heart used to stop beating when I saw a grey [an RUC Land-Rover] coming down my street. I used to think they were coming to tell me something had happened to Jimmy,' said her sister.

'Now if you see a strange face on your street, it's a different cause for panic or alarm.'

'It's probably the DSS looking for someone on the double.'

They told me there were no more body and bag searches when they went to the shops and their social lives had been transformed.

In some areas it was hard to believe it had once been the front line. On mild days residents sat out in the street listening to Bob Marley at impossible-to-talk volume: only the clatter of the army helicopter could be heard above it.

'That's what peace does for you, it's very boring if war stops from one day to the next after twenty-five years,' said O'Brien, taking a break in his back garden from painting murals extolling ancient Irish heroes and modern IRA gunmen.

'It's a different type of repression. You can't do what you want any more, you can't shoot and bomb the bastards. Now they can do what they want to you. After all, the judges are paid by the British government and the police,' protested Liam, one of his helpers with a Che Guevara tattoo on his upper arm. 'If there are too many kids helping on the murals, they start writing UP THE FUCKING IRA if you don't watch them.'

With the ceasefire still holding, I joined tourists on the newly-introduced Citybus tour of Belfast. It was called 'A Living History', and promised to take us to the 'scenes of many recent and not so recent significant events in what are probably the most historic parts of the city' – the landmarks of the recent war and sectarian troubles since Partition in 1921–2. The double-decker bus was full, and a second one had to be brought in to accommodate all the tourists. The tour started at Castle Place at the hub of Victorian and Edwardian Belfast. I sat in front of an American family who had heard about the tour on their local radio station in Minneapolis. They saw it as a chance to visit areas where you had to be careful how and to whom you expressed your opinion. 'In Minneapolis we have similar problems; you can drink in this bar, but you can't drink in that one, we have neighbourhoods where it's not that you can't go, you don't want to go.' There was also a large group of Italian women who were on a two-day trip from 'Dublino', a Saudi Arabian family, and a young British couple who were telling two Australian backpackers, 'They show *Home and Away* and *Neighbours* twice in a day, because the story is so unbelievable.'

A gentle meander through the distinguished and elegant city centre

led us to the Queen Elizabeth Bridge. From here we could see the gigantic Harland and Wolff crane at what was once the centre of Belfast's industrial heartland and the world's largest shipyard, which had launched some of the world's biggest vessels, including the ill-fated *Titanic*. On Lower Newtonlands Road we saw our first 'peace line', made up of railings and shrubbery separating Catholic and Protestant neighbourhoods. Cameras clicked and Hi–8s whirred as the driver told us, 'This road was the scene of intense rioting in the early twenties.' The housing had changed, but the prominent Loyalist murals screamed, 'No Surrender': these residents continued to see the Catholics as dangerous Fifth Columnists. The tour included University Square, perhaps the city's most beautiful terraced street. Until the ceasefire it would have been possible to buy houses in this area for much less than their equivalent in Britain, which meant that the middle classes enjoyed relatively large disposable incomes: it was said the proportion of Mercedes- and BMW-owners was higher in Northern Ireland than anywhere else in Britain or Eire.

We passed several sectarian battlegrounds before nosing our way along the Shankill and Falls Road, the most troubled areas of Northern Ireland. The high rise Divis Tower, the only remaining part of the complex started in 1966, was hung with the Irish tricolour and our tour guide explained that during the early stages of the Troubles the roof was occupied by the 'IRPS', supporters of the Irish Republican Socialist Party, 'Hence it was known as the Planet of the IRPS, subsequently altered to Planet of the Apes when the army set up a base on the roof.' Next to the Sinn Fein headquarters on the Falls Road another group of tourists were busily posing in front of an imposing gable end mural commemorating twenty-five years of the struggle and local children offered to pose for money, while other tourists popped into a souvenir shop to buy Republican tee-shirts and carved wooden statues of Gerry Adams. We passed a camp of itinerants with caravans and satellite dishes and were told they were descendants of evicted tenants of the previous century, previously known as tinkers. They cheered loudly as we passed and halfway along Shaws Road a group of young men dropped their pants and mooned our double-decker bus. Everywhere we went the atmosphere was almost carnival.

* * *

'Jesus blessed! The man's a musical genius,' said Callum's wife. I sat in their front room rapt with attention as Callum produced tune after tune on the fiddle, the mandolin, the banjo, the clarinet and the tin whistle. There didn't seem to be an instrument he couldn't play, and he was self-taught.

'My ma and da met in a workshop for the blind, my mum played an accordion in an Orange band.' Callum's explanation of his skills left more questions unanswered than answered. He had agreed to take me to the Waterworks, a park where he hoped I could meet his two nephews. We had already tried to find them the previous day without any luck. They had chosen this location to hang out in case the Provisionals should spot them; they thought that as it was near an RUC police station, they couldn't be dragged into a car.

When we caught up with them they were among a large group of adolescents and young people sitting sipping cans of lager on the embankment between the filthy pond and the little lake. Both Callum's nephews were scarred from the beatings they had received at the hands of the Provisionals. Paddy, the more communicative of the two, was extremely handsome. When he laughed at himself his laughter did not show in any part of his body – it was smothered within it. He had a skin graft on his arm, while his brother sat on the grass next to him with his upturned hand at almost a right angle to his wrist: the tendons had been so badly damaged in a second beating that he had lost the use of it. I looked into the eyes of the rest of the group. They were languid, ardent, bashful, stirring, delicate, remote, proud and adroit. Some reflected an inner pain more fully than others.

Callum left so that they might talk more openly. 'If you're going around stupid drunk, stupid with drugs, the police aren't bothered because you're not bothered with them,' said Seamus, a friend of the two nephews and a little drunk on the beer. 'No one else is allowed to be a gangster, or a robber, you can rob a bank for the Republican cause but not for yourself,' said another youngster who like the others had received a beating at the hands of the Provisionals.

Paddy suggested we walk around the lake so that we could get away from the group. His story was one that had been repeated dozens and dozens of times across the province, and it wasn't only the young that were victims.

'They're more against us since the ceasefire, they're coming out of the woodwork, they've got nothing else to do. The punishment beatings have soared since the ceasefire. The Provos think they've won the war, they fought the war so they think they own the place. They've forgotten about the ordinary person. What they don't realize is that all young people are turning to drugs. It's not just young people – I take them, I'm twenty-three. The younger ones take them and they're getting younger and younger. I wasn't beaten because of the drugs, I did wee stupid things, breaking into houses, stealing cars, I got on as best I could, see what I could gain out of it. I went on and on. I thought it was safe.

'Then I stabbed a guy on Christmas night. They came for me on the 4th January at the Jamaica Inn. The lights came on, I had a funny feeling because there was talk about it in the area, I had stabbed an IRA man's son. They came into the nightclub and switched on the lights, there were seven of them, all of them were wearing hoods. One of them pointed a revolver at my head. "Get off your seat," he ordered. I didn't, so he pulled me off and smashed my head against a stool, in front of a whole nightclub of people. They were too scared to do anything. They told the people in the club they weren't allowed to call an ambulance. They dragged me outside. They laid me down on the ground outside the door in the car park. They started beating my legs with a baseball bat, I think they used an iron bar on my arm. I was screaming. They broke both my legs, two fractures in that leg, a chip fracture or whatever the fuck they call it, four split fractures and a chip lying in the flesh of the other one. I needed steel pins in my legs and a steel plate in my arm with twenty-eight screws, it will stay in my arm for life, and as you can see I got a skin graft on my arm. I also had a bruised chest, back, two badly bruised ribs, broken nose, black eye, and cuts and bruises on my face because I was facing the tarmac when they kicked me in the mouth when they left. One of them bent down and said, "When you get out of hospital get out of the country."

'I knew who they were, when I did get out of hospital I smashed their car windows, sprayed their car hoods with "Fuck the IRA", spat in their wives' faces, shot at them with blanks, not real bullets. That's when they wanted to execute me. They chased me into the police

station, two days later I went to England to get away from them. I admit I'm no angel. I hated England. I missed my ma. Even though I've come back I'm too scared to go back up to Ardoyne. I spent one night there and my ma couldn't sleep that night from worry. I haven't seen her in three months, I want her down here, but I wouldn't want her to come to the park because it's full of hooligans – my sister comes and brings me letters from her. I miss my family, I miss my uncles, I can't call around any more. I can't go around to the chippie and have a laugh with my cousins. If I had money I'd move away, take me ma with me to America or Spain. Other kids have been warned that anyone caught with these anti-social elements (us) could seriously damage your health.

'Sometimes I feel I've betrayed my uncle. Like my family split up, it wrecked the family, I'm not blaming that. I don't know whether the bad crowd caught up with me or I caught up with the bad crowd. My head's gone since the beating, I drink alcohol every day and do the drugs to keep my mind off it. Temazepam to sleep. I hope something good will come of it. But since the beating, they'll either kill me or cripple me if they find me.'

When we had come full circle around the lake Paddy pointed to his friend Seamus. 'He did glue, drugs, it was a buzz to him and the others. Fuck leisure centres, too many rules and regulations, wee girls were not interested in it, so we stole cars to impress them, that was a buzz too, getting chased by the cops, getting away with it, laughing about it afterwards.' Paddy paused. 'Look at us now.'

I walked to the bus stop near the RUC police station with Lisa. Paddy had described her as one of the wee girls, but she was anything but wee. As we left the group one of the boys called out, 'I'll go to the end of the world for you.' 'But will you stay there?' she asked.

Lisa had stood aloof from the rest of the group. She was only just sixteen, slender, pale, with bright eyes and shoulder-length red hair. She seemed the opposite of most of the other boys and girls, with their drugs and booze and extravagant bravado. When she spoke to me she hardly paused for breath. Her words soon came tumbling out like automatic gunfire or a steam engine gathering speed.

'Paddy said your family are from New York, the best time I ever had was when all the family went on holiday to Florida. It was the

first family holiday we ever had and the last. In fact we got back this day three years ago. My brother paid for it all. Me and me mum shared a room.'

I asked if any of the lads was her boyfriend. 'I don't have a boyfriend at the moment. I've had quite a few. I quite like it when I'm going out with someone. They have to be on the same wavelength as me or I get bored of them really quickly. I was eleven when I had my first boyfriend. Everything happened at thirteen, I thought everything would be wonderful. Mills and Boon, I'd read it, I nicked it off my mum. I thought I'd see stars and everything, oh dear! When we finished I thought, is that all there is? I was not impressed with it. He was six years older. I wanted to 'cause we'd all been talking about it, in the girls' toilets, and I wanted to know. I didn't use a condom, never really thought about it. Did it with him about three times, I still didn't see any stars. I still thought it was shit. Told everyone in the toilets, it's a bit shit, don't bother. I find it a bit embarrassing. I've been with five men. It's got better, but I still haven't seen stars.

'I'm protected all the time. I wouldn't want a baby, a friend of mine went on this virtual reality parenting thing, they give you this baby only it's a toy and it is programmed to cry and the only way you can stop it is to hold a plug in its back for five or ten minutes. It's meant to make you think twice about having a baby, apparently it even comes with sticky fingers for smearing on the furniture! Anyways, I don't want to end up like this guy Freddie Mercury. A lot of men tend to put themselves first. I wouldn't want to be pushed around by anybody, only by my brother, he does it physically and mentally. I'll give you the latest on it. He sees me once every four months, but he now refuses to see me because I've got a tattoo. Friends think, well, like you've been through a lot of shit. I reckon I've put up with a lot when I was younger so the rest of my days are bound to be better in the future, aren't they?

'I've got a family but they're not a family any more. I see my dad every Saturday now. My dad is a weekend dad. Cigarettes keep me sane. It really pisses me off, older generations complaining of no respect. It's just a tougher world now. Well it's like there's homeless people in the streets, AIDS, everything's wrong with the planet, like the greenhouse effect. Every generation has its own problems, I don't like them spouting off: "We fought in the war", "I never got up to

that", "We got caned at school" – they carry on as if they were the only ones with problems. There were a lot more jobs in those days. Shouldn't go around blaming every problem on today's youth. As for the politicians, the only jobs they have to do is lie with a straight face. I don't give a shit about politics. I've never really thought about these problems. If I knew the solution, I'd be rich. The only way I could make real money these days is doing something illegal.'

Since the ceasefire, freedom of movement and the normalization of social lives, drugs have mushroomed in the working-class communities. The paramilitaries on both sides have claimed to be community policemen; in reality they have behaved like vigilantes trying to instil fear in their own community. In a local fish and chip shop and the next-door minicab office in Ardoyne intimidatory notices posted on the walls warned, 'If any of the following come to our attention again action will be taken against them', followed by a list of names of young men. The punishment shootings and beatings, where bones were systematically broken with iron bars, steel pipes, hurley sticks, baseball bats and breeze blocks, were referred to as two-packs if they were to the knees, four-packs if they were to the knees and elbows, and six-packs if they were to the knees, elbows, and hands. Sometimes the paramilitaries would call the ambulance service before the beating took place and would have to turn them away because they got there too quickly and the sentence hadn't yet been carried out. The repertoire wasn't confined to beatings. It also included being blindfolded and kidnapped for twenty-four hours, tarring and feathering, having glue poured over your head, head shaving (for the very few women who were 'punished'), as well as curfews, forcible eviction from your house and, as in the case of Paddy, expulsion from Northern Ireland. Virtually all the victims of beatings and shootings within the two communities, Catholic and Protestant, were male and from the extremely deprived working-class communities. However, the young men given last warnings weren't always intimidated by the notices or the threat of violence.

While many people demanded action against drug dealers and criminals I had noticed that young men like Paddy, his brother and Seamus who had been beaten and knee-capped wore their beatings as a badge of honour: they were important enough to be targeted. Some of the kids looked up to them. Aprille, whom I had met in the Shankill Road, had

explained it thus, 'They are young people with no hope, they are *not* no-hopers. The system has failed them. They need to be given a future.'

I decided to take a short trip around Northern Ireland. As I left Belfast in my rented minivan I passed huge advertising billboards with glorious pictures of the countryside and coast over a caption of poignant simplicity: 'Wouldn't it be great if it was like this all the time?' with a command next to it: 'Time to look on the bright side.' The advertiser was the British government and the product it was selling was peace.

The countryside of hills, moors, woodlands and lakes was magical and grand. It reminded me of parts of rural England, Suffolk and Cornwall in particular, with their well-tended bungalows, neat verges and manicured lawns with stone and plaster garden statues. It was as if I was travelling in another age: the mood was relaxed and there was little traffic. I stopped to chat to people in shops and picked up a pensioner who was hitching a lift at a rural bus stop. Everyone was courteous and I was treated to a level of good manners I had only met before outside Britain.

There were reminders of the Troubles, in police stations built like faceless forts and fitted, like their counterparts in Belfast, with security cameras, high intensity lights, and anti-mortar cages. The more built-up the area and the greater the proportion of council housing, the more likely it was that the community nailed and painted its allegiance on the landscape. Some Protestant towns and villages had triumphal arches painted in the red, white and blue of the Union Jack with a portrait of King Billy riding a horse. Catholic towns and villages had their kerbstones painted in the green, white and gold of the Republic. Both Catholic and Protestant towns hung bunting in their respective colours to commemorate the anniversaries of distant and recent battles. In the early evenings the youngsters, like their counterparts on the British mainland with nothing to do, hung out in the streets, beneath roofs and at bus shelters scrawled with 'UVF' and 'IRA'.

I picked up a drunken hitchhiker wanting to get to Strabane and he invited me home for tea. 'If the Troubles start again I'll be up all night when the boys are out,' said his wife. 'The fear you live until the morning, they say you get used to it, but you never do.' On their

estate, like the Shankill and Ardoyne, the warnings had been posted: 'Drug dealers and criminals beware, iron bars are everywhere'. A new form of terrorism had arrived. Two young men on the estate had been beaten, one family had been forcibly put out of their house. A new battleground was emerging as a result of the ceasefire, and the battleground was as it is elsewhere in the late twentieth-century First World: drugs, alcohol-related violence, rape, muggings, and housebreaking.

On my return to Belfast I realized that this city and the rest of Northern Ireland were emerging from a time-warp. Some of the residents of the inner city areas were already nostalgic for a simpler, better ordered past. This mood of malaise was as prevalent as it was on the British mainland, it was as insidious as a lit fuse to a box of dynamite. It would keep both communities looking inward. Young and old alike, cynicism was beginning to define their personalities; with little hope of self-advancement and economic enrichment the older generation would remain nationalistic, while the younger generation would become even more resentful and volatile.

I returned to Ardoyne to say goodbye to Callum and his family. Callum sat in his cramped front room with his daughter and her partner sharing the settee. 'I'm too young to get married,' she had said on a previous visit. She also told me she had practised the Billings method of contraception: 'It teaches you to read the temperature, only my thermometer broke.' In a corner of the room stood the empty bird cage which the family had kept since the cockatoo had died. 'We'd only had it a week, we came in on a Saturday, it was fucking lying in the bottom of the cage. Now we put the children in it,' Callum warned one of his youngest as he raced through the room to the kitchen. 'For every sixty seconds of anger, you lose one minute of happiness,' Callum counselled me. 'You'll find the wife over at Tokyo Joe's, the Chinese chippie, she's helping out this evening.'

I walked the short distance over to Tokyo Joe's and found the same group of youngsters hanging out in the street as on each previous occasion I had visited the area. I thought of what Callum had told me when I first arrived in Belfast, that it was like 'cowboys and Indians'. For all the mobility the world has created, and everyone dreaming of somewhere else, the vast majority of people are stuck in their reservations.

I said goodbye to Callum's wife and joined the group of youngsters, who moved on to a derelict piece of land and started drinking and smoking their joints. Looking at them, I was once again reminded that the single most important factor that shapes our character and influences our mental health is our upbringing. My privileged background gave me a firm platform on which to construct a life, my childhood was nurtured by books, films, family, friends, holidays and access to sports. You can escape any background, but it's a lot harder without those advantages even if they don't necessarily mean you will lead a happier life. Travelling across Britain I had also seen that the big division is still based on age, education and class, but religion and racial discrimination play their part.

In Belfast and and other parts of Northern Ireland, in contrast to mainland Britain, I had seen communities with a soul, with passion, but their ceasefire was possibly bringing them out of one era into a quite different one. The two communities had been like two people in the same desert, each seeing a different mirage. Now the mirage had evaporated, leaving behind fathomless, directionless future. The supreme virtue of looking after oneself was replacing distinctive national or regional or local values. The bombs and the bloodshed in Northern Ireland, the violence on the estates of the British mainland, are rooted in hunger and cold – not the hunger and cold of the starving and totally destitute, but the hunger and cold in the minds of those living in the First World.

Those youngsters I met on my journey through Britain, the ones without a stake in society, threaten the cohesion of their communities. Lives weren't at risk, but much of what makes life worth living was at stake. These youngsters turned inwards on themselves and hurt the people that were closest to them. There were many times I became depressed on my journey – I often wanted to shout and scream and sob as a result of what I had witnessed and at my inability to make any difference or offer any solutions. Sometimes, like them, I wanted oblivion, to forget the agony and frustrations of those who are denied the ladder of privilege or success.

'We're mad as fuck,' said Michael as we crossed Ardoyne late at night.

We reached a piece of wasteland the size of a football pitch and sat

with our backs against a fence, the warm orange street light spilling enough illumination to detail the refuse on the ground.

'Our parents had the mill and God,' said Joseph, popping open the top of a bottle of beer.

'I don't believe in God,' said Patrick.

'I wish I believed in God,' said Michael. 'I'd go to church, I'd pray. I'd become a priest if I could. But I'd first make Jesus walk on water, he'd have to prove to me he could, I'd take him to the Waterworks.'

'Vote Green! Save the trees,' shouted Patrick above the sound of one of the empty beer bottles exploding on the ground.

'Sinn Fein promise us a swimming pool to get our votes, but fuck, once they're elected nothing gets done.'

Patrick, Michael and Joseph looked at Sean, who was stumbling along as if walking the deck of a ship in rough seas. 'His ma died. He took to drink, he's been threatened by the IRA. He's a sad character, stoned out of his box.'

Sean had slash marks down his arm from several attempted suicides.

'My da was in prison for bombing. I don't like him,' said Michael. 'He's always telling me what to do, he's always right. He doesn't smoke, doesn't drink, doesn't eat beef, keeps fit. He's drilled into me about politics – the Brits. I don't give a fuck. He's always right, he can't be wrong. He's got no time for me.'

Two more youngsters joined the group. 'Michael, can you lend us . . .'

'No I can't's the answer.' Everyone was always being hassled for money.

Sometimes their days seemed endless, their minds wandered painfully towards the slopes with no future, no job or at least no job that could satisfy their expectations, they skirted the chasms of loneliness with friends and family who seemed all too inadequate. Everyone wanted a release from the everyday.

They rolled some large joints, some dropped an E, they wanted to get high because they wanted to forget they were poor. Some of them had already been warned and would face a beating by the IRA if caught. Life on the edge was dark, dangerous and erratic.

The joint was passed around, they drew heavily on it. They were

free, soaring ever higher. This temporary release was one man's weakness but another man's resilience of the human spirit.

'We know what good craic is all about – the good life. We haven't got it,' said Michael.

We're all part of the same tribe. You're born, you live and you die.